A Studio of Her Own

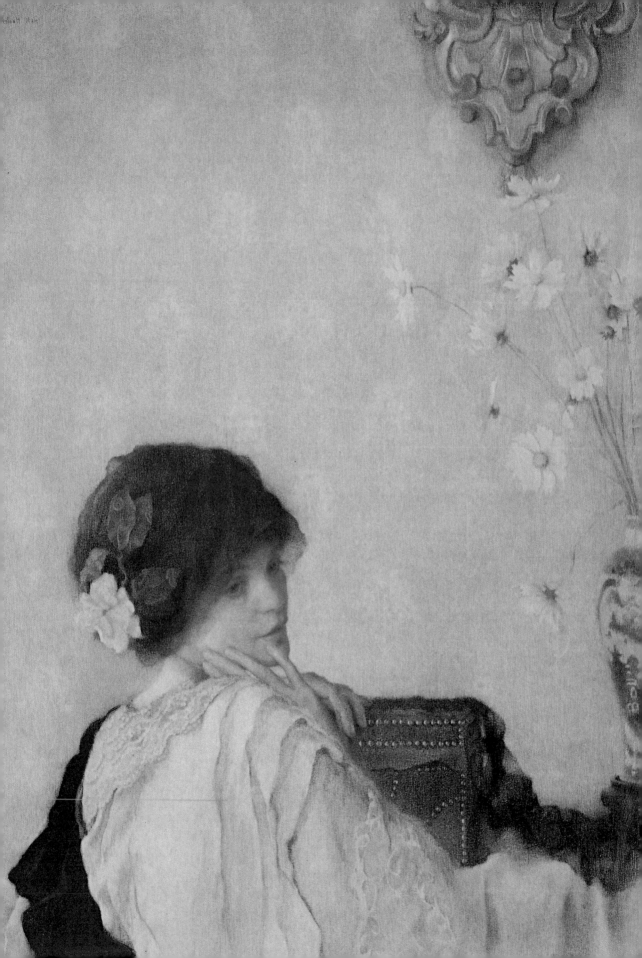

A Studio of Her Own
Women Artists in Boston ⏎ 1870–1940

CITIZENS BANK IS VERY PLEASED to partner with the Museum of Fine Arts, Boston, in presenting *A Studio of Her Own: Women Artists in Boston 1870–1940*. This magnificent collection of paintings, watercolors, drawings, and sculptures represents the finest work of Boston women artists while highlighting their extraordinary contributions to the arts, both locally and nationally.

With today's women serving as leaders in nearly all sectors of our society–financial services, education, government, culture, and technology–Citizens Bank is delighted to showcase the successes of these artistic trailblazers who significantly contributed to the establishment of Boston as a cultural hub. Perhaps the hard work of these pioneers empowered and inspired future generations of women to explore their own avenues of interest and creativity.

On behalf of the Board of Directors, employees, and customers of Citizens Bank, I hope you enjoy the works in this unique collection and greatly appreciate your interest in learning more about the central and ever-changing role of women in Boston.

[signature]

LAWRENCE K. FISH
Chairman, President & CEO
Citizens Financial Group

CITIZENS BANK

A Studio of Her Own

Women Artists in Boston ᔰ 1870–1940

ERICA E. HIRSHLER

with biographies of the artists by
Janet L. Comey and Ellen E. Roberts

MFA PUBLICATIONS
a division of the Museum of Fine Arts, Boston

MFA PUBLICATIONS
a division of the Museum of Fine Arts, Boston
295 Huntington Avenue
Boston, Massachusetts 02115
Tel. 617 369 4367 · Fax 617 369 4368

This book was published in conjunction with the exhi-
bition "A Studio of Her Own: Women Artists in Boston
1870–1940" organized by the Museum of Fine Arts,
Boston from August 15 to December 2, 2001.

This exhibition is sponsored by Citizens Bank.

◆ CITIZENS BANK

Support for this catalogue has been provided by the
Ann and William Elfers Publications Fund.

ISBN 0-87846-482-4

Library of Congress Card Number: 99-069933

Binding: Sarah Wyman Whitman, *Cover Design for
"An Island Garden" by Celia Thaxter* (adaptation), 1894
(plate 9)

Frontispiece: Lilian Westcott Hale, *Gardenia Rose*
(detail), 1912 (plate 48)

Designed by Cynthia Rockwell Randall
Text edited by Sadi Ranson
Printed and bound at Arnoldo Mondadori Editore,
Verona, Italy

Available through:
D.A.P./ Distributed Art Publishers
155 Sixth Avenue, 2ⁿᵈ floor
New York, New York 10013
Tel. 212 627 1999 · Fax 212 627 9484

FIRST EDITION
Printed in Italy

CONTENTS

Color plates follow pages 58, 82, 108, and 132

DIRECTOR'S FOREWORD

IT IS WITH PARTICULAR PRIDE that we present *A Studio of Her Own* at the Museum of Fine Arts, Boston. In 1887, just eleven years after opening its doors to the public for the first time, the Museum presented an exhibition entitled "The Work of the Women Etchers of America." It was the first comprehensive show devoted to women artists to be organized by any American museum. The catalogue essay declared that "an exhibition made up entirely of the work of women needs hardly to be introduced to-day with words of excuse or explanation. Whatever may be thought of the movement in favor of 'the emancipation of women,' it must be admitted that it is a sign of the times which cannot be ignored." Women were also active as students, administrators, teachers, and staff from the earliest years of the MFA and its School.

This project has been made possible by the generous sponsorship of Citizens Bank, which has demonstrated its dedication to furthering the accomplishments of today's women. We thank Citizens Bank for its support in presenting this exhibition, and for its ongoing commitment to the Museum. We also wish to acknowledge the Ann and William Elfers Publications Fund for its support of this catalogue.

A Studio of Her Own has been written and the exhibition curated by Erica E. Hirshler, John Moors Cabot Curator of Paintings, Art of the Americas, ably assisted by Ellen E. Roberts and Janet L. Comey, and I am grateful to them for their good work. I would like to add a special note of thanks to our lenders, both public and private, who have so kindly shared their works of art, as well as to the many scholars and collectors whose enthusiasm led us to discover little-known treasures, both artistic and archival. The descendents of the painters, sculptors, photographers, and craftswomen included here also proved to be loyal and sympathetic friends. *A Studio of Her Own* is devoted to the work of the most talented women artists of Boston at the turn of the last century, many of whom were trained at the School of the Museum of Fine Arts. It is fitting to acknowledge their achievements as we look forward to the women artists of the new millennium.

MALCOLM ROGERS
Ann and Graham Gund Director

ACKNOWLEDGMENTS

ONE PERSON DOES NOT CREATE BOOKS and exhibitions, and I must express my deepest gratitude to the many people who helped to realize this project and to make it a success. I thank Malcolm Rogers, Ann and Graham Gund Director at the Museum of Fine Arts, Boston, and Katherine Getchell, Deputy Director for Curatorial Administration, for their enthusiastic support of this project, particularly for their unwavering belief that a scholarly exhibition devoted to women artists was well suited for our institution. Patricia Jacoby, Matt Siegel, and Linda Powell of External Relations all worked diligently to ensure its financial support.

The topic of Boston's women artists first captured my attention in 1985, and three scholars and friends have supported my efforts over the past sixteen years. Trevor Fairbrother introduced me to the Boston School. Theodore E. Stebbins, Jr., promoted the idea of this exhibition and I am grateful to him not only for his championship, but also for his expert advice and constant friendship. I would also like to thank William H. Gerdts, who has shared not only his vast library, but also his enthusiasm for artists overlooked by other historians.

Ellen Roberts and Janet Comey have dedicated countless hours to the research and administration of this project. The high standard of their work is evident in the biographies they have written for this volume; I want to thank them here wholeheartedly for their contributions. Our research further benefited from the efforts of the students in my 1996 seminar. We are also grateful to Maureen Melton and Todd Gilman of the MFA's archives and library; Stephanie Boye and Sarah Malakoff at the MFA School; and our devoted interns, April Eisman, Karen Pfefferle, and Francine Weiss.

The entire Department of Art of the Americas lent both support and expertise, particularly our Chair, Elliot Bostwick Davis, and Amy Beeaker, Vanessa Davidson, Jeannine Falino, Patrick McMahon, Karen Quinn, Rebecca Reynolds, Carol Troyen, and Gerry Ward. In our Department of Prints and Drawings, I want to thank Clifford S. Ackley for the loans from his collection, Anne Havinga, Patrick Murphy, and Sue Reed. In Art of Europe, George T. M. Shackelford has been a generous friend.

I am grateful to our conservators, especially Arthur Beale, Leane Delgaizo, Gail English, Elizabeth Fiorentino, Andrew Haines, Pam Hatchfield, Irene Konefal, Rhona MacBeth, Annette Manick, Roy Perkinson, Seth Waite, Jean Woodward, and particularly Jim Wright. Much credit also goes to the team of Valerie Foster, Susan Wong, and their staff in Design, who presented the show so beautifully; to Jill Kennedy-Kernohan and Adelia Bussey of our Registrar's Office; and to Jennifer Bose and Emily Lasner. Barbara T. Martin in the Division of Education inspired and informed our visitors. Mark Polizzotti, Cynthia Randall, and Dacey Sartor worked together to create this book, which would be difficult to read without the efforts of its editor, Sadi Ranson, and copyeditor Denise Bergman. I would also like to thank Kelly Gifford, Dawn Griffin, and her staff in Public Relations; Janet O'Donoghue and Jennifer Weissman in Creative Services; and our photographers Thomas Lang, Greg Heins, Gary Ruuska, John Woolf, and their colleagues Kristin Bierfelt, Erika Field, and Angela Segalla.

At the Boston Athenaeum, we are indebted to Barbara Hebard, Hina Hirayama, Sally Pierce, and Michael Wentworth; at the Boston Public Library, John Dorsey, Sinclair Hitchings, Bernard Margolis, and Karen Shafts; in Special Collections at the Boston University Library, Perry Barton; at the Cape Ann Historical Association, Jennifer Joseph and Judith McCulloch; at the Cincinnati Museum of Art, Julie Aronson and Jennifer Reis; at the Concord Free Public Library, Leslie Perrin Wilson; at the Dahesh Museum, David Farmer; at Dana Hall School, Suzette Jones and Stephanie Long; at the Danforth Museum of Art, Laura McCarty; at the Dimock Community Health Center, Jill Burrows and Janet Miner; at the Farnsworth Art Museum, Angela Waldron; at the Fine Arts Museums of San Francisco, Robert Futernick and Joseph MacDonald; at the Freeport (Maine) Historical Society, Randall Wade Thomas; at the Harvard University Art Museums, Evelyn Bavier, David Carpenter, James Cuno, Debi Martin Kao, and Miriam Stewart; at Houghton and Widener Libraries at Harvard University, Tom Ford, Roger Stoddard, William Stoneman, and Robert Zinck; at the Historical Society of Old Newbury, Cushing House Museum, Jay Williamson; at the Isabella Stewart Gardner Museum, Kristin A. Parker; at the Lexington Public Library, Sarah Nisenson; at the Library of Congress, Verna Curtis; at the Loïs Mailou Jones Trust, James Larry Frasier; at the Maier Museum of Art, Randolph-Macon Woman's College, Karol Lawson; at Masco Corporation, Joan Barnes, Jonathan Boos, and Cheryl Robledo; at the Memorial Hall Museum, Deerfield, Suzanne Flynt and Christine Granat; at the Metropolitan Museum of Art, Ida Balboul, Bob Kaufmann, Peter Kenny, Philippe de Montebello, Linda Seckelson, Thayer Tolles, and Barbara Weinberg; at the Minneapolis Institute of Arts, Christian Peterson and Caroline Wanstall; at the Minnesota Historical Society, Brigid Shields; at the M.I.T. Museum, Joan Parks Whitlow; at the Museum of Art, Rhode Island School of Design, Maureen O'Brien; at the Museum of the National Center for Afro-American Artists, Gloretta Baines

and Barry Gaither; at the National Academy of Design, Annette Blaugrund and David Dearinger; at the National Museum of American History, Michelle Delaney; at the National Woman's Christian Temperance Union and Frances E. Willard Memorial Library, Virginia Beatty, William K. Beatty, and Sarah Ward; at the New Britain Museum of American Art, Douglas Hyland; at the Pennsylvania Academy of the Fine Arts, Daniel Rosenfeld and Sylvia Yount; at The Phillips Collection, Jay Gates; at the Schlesinger Library, Radcliffe Institute, Harvard University, Marie-Helene Gold; at the Sheldon Memorial Art Gallery, Jan Driesbach, Cynnamon Jones, and Daniel Siedell; at the Society for the Preservation of New England Antiquities, Rebecca Aaronson, Melinda Linderer, and Lorna Condon; at the Syracuse University Library, Paul R. Barfoot; at Trinity Church, Kathy Acerbo-Bachmann and John Clift; at United Missouri Bancshares, Inc., Richard Ohsmuhs and Carol Sturm; at the University of New Hampshire Library, Daniel O. Cheever; at the Walnut Hill School, Matthew Derr and Stephanie Perrin; at the Whistler House Museum, Catherine Eldredge; at Wellesley College, Jean Berry, Lucy Flint-Gohlke, Melissa Katz, Ruth Rogers, and Wilma Slaight; at the Worcester Art Museum, Rita Albertson, David Brigham, Nancy Swallow, Jolene de Verges, and James Welu; at the Arts of the Book Collection, Yale University, Chris de Vallet and Jae Williams.

Other friends to be thanked include: Barbara Alfond, Terry Aufranc, John Axelrod, Jim Bakker, Sarah Boocock, Jeffrey Brown, Sarah Burns, Elizabeth F. Byers, Teresa Carbone, Betty B. Duveneck, R. A. Ellison, Virginia Eskin, Mr. and Mrs. Danforth Page Fales, Stuart Feld, Tracey Fitzpatrick, Kathy Foster, Bob Grady, John Hagan, Patricia Hills, Susan Hobbs, Martha Hoppin, D. Roger Howlett, Elizabeth Hunter, Nancy Jarzombek, Vance Jordan, Diana Korzenik, Mack Lee, Sandy Lepore, Ying Tin Li, Patricia Loiko, Janina Longtine, Mary Lublin, Bonnie MacAdam, Richard Manoogian, the late Patsy McVity, Marilee Boyd Meyer, Susan Montgomery, Honor Moore, Keith Morgan, Maggie Nowak, James F. O'Gorman, Elsie Oliver, Carol M. Osborne, William and Nancy Osgood, William H. Perkins, Gina Puzzuoli; Matthew Raisz, Remak Ramsay, Martha Richardson, Mr. and Mrs. Thomas Rosse, Margo Schab, Judith Schulz, Alan and Marianne Schwartz, the descendants of Sarah Choate Sears, Gilian Shallcross, Lucy Shevenell, Matthew Siegel, Betty Smith, Jessica Smith, Polly Thayer Starr, Wendy Swanton, Kirsten Swinth, Tom Veilleux, Christine Volbrecht, Marcia and Bill Vose, Alfred Walker, Martha A. Walsh, Linda Wilhelm, Artemis Willis, John Wilson, Patricia Wyatt, Jim Yarnall, and Richard York.

Finally, I offer enormous appreciation to our lenders, both public and private. By giving up their works of art, they have opened the eyes of many to the accomplishments of women in Boston in the late nineteenth and early twentieth centuries. I would like to thank my parents, and to my husband, Harold D. Clark, Jr., I give heartfelt thanks for his support, love, and willingness to give me a studio of my own.

E. E. H., FEBRUARY 2001

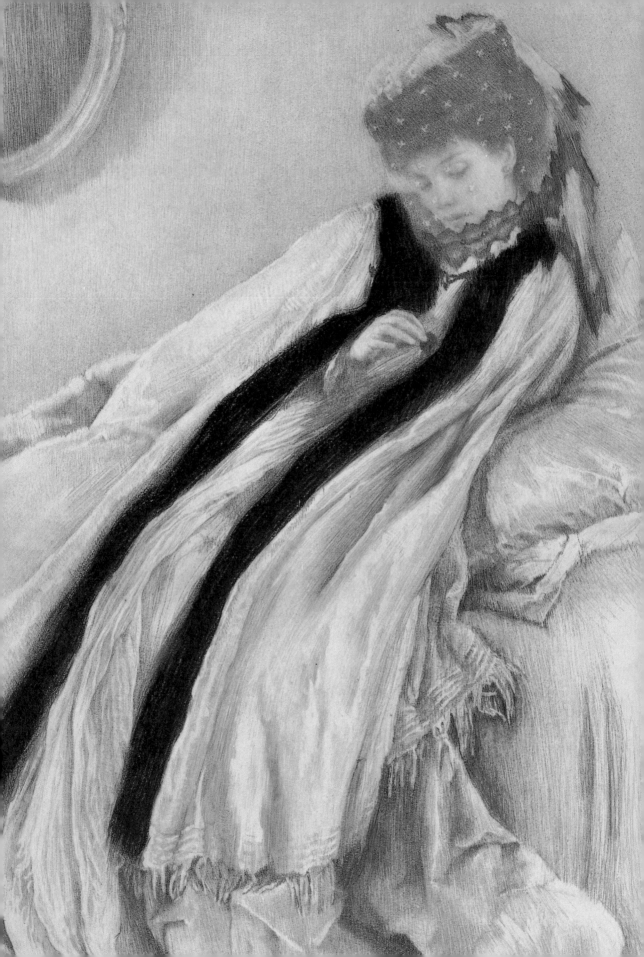

INTRODUCTION

In 1999, when the Boston Public Library displayed the work of a number of local women watercolor painters, the artist Susan Heideman spoke at the opening. Why, she asked, were there so many Boston women artists active in watercolor painting during the 1970s, 1980s, and 1990s? She speculated that the area's rich concentration of art schools and museums played an important role, and that the women's movement of the 1970s had impelled these institutions to add women to their faculties and exhibition schedules. She also noted that "women artists in Boston tended to befriend and support one another, and in my experience still do. This was probably the first significant group of professionally trained female artist-teachers in this area's history. They were, and are, determined and aggressive, dedicated to breaking down gender barriers."

Heideman's remarks were perceptive, yet they also reminded me how little was known to all but a few specialists about the history of women artists in Boston. A century before Heideman's generation began to teach and to exhibit, Boston women had been determined to enter the field of art on the same footing as their male colleagues. In the 1860s and 1870s, they fought to receive the same training in art schools, to serve local institutions as both teachers and administrators, and to combine a career with the demands of their private lives. The Boston painter Elizabeth Bartol wrote that good work was "neither masculine nor feminine." She noted with obvious pleasure the careers as artists and teachers that several of her colleagues enjoyed, and added proudly, "women are helping women."[1] The city's women achieved great

Lilian Westcott Hale, *The Old Ring Box* (detail of fig. 75), 1907

success as painters, sculptors, photographers, designers, and metalworkers (among other media). *A Studio of Her Own* relates their fascinating stories.

The challenges aspiring women faced and the accomplishments they attained as they became professional artists were not unique to Boston, but could be found in most of the nation's art centers during this period. Boston provides an especially interesting model, however, for as writer William Howe Downes commented, "Every year we see more and more of these sisters of the brush and palette coming forward as doughty competitors to the men, and nowhere do they threaten more serious rivalry than in Boston."[2] By concentrating its focus upon a single city, this study unveils a supportive, intergenerational community of women artists. These women were linked to one another in many ways—by their aspirations, training, affiliations, friendships, and common environment—and thus they shared much more than the common accident of their sex. This book seeks to transcend the simple survey of women artists, which all too often includes individuals united only by their gender. Instead, it explores both the individual lives and talents of Boston women artists and the integrated relationships that enabled many of them to excel.

For that reason, I have included works of art in a variety of media, for many artists at the turn of the last century worked in more than one. Such artists as Sarah Wyman Whitman felt equally at home in creating paintings in oil and pastel, windows in stained glass, and designs for the covers of books. Sarah Choate Sears made traditional watercolors and pastels, while experimenting with the new medium of art photography. Madeline Yale Wynne studied painting in school, then went on to create not only two-dimensional works of art, but also sculpture and jewelry. The elevation in status accorded the decorative arts during the period of the Arts and Crafts movement presented an unprecedented opportunity for women to move their artistic endeavors from the domestic sphere of the home and the charitable cause to a more public one of exhibitions and commercial sales. Once again, Boston was a leader in this development, and its women helped to organize the nation's first Society of Arts and Crafts, founded in 1897.

At the same time, many Boston women sought training in painting and sculpture, media more typically associated with men. They braved the threat of scandal to study from the nude human figure, traveled away from home to improve their artistic education, and exhibited their work to much acclaim across the nation. The women painters of the Boston School were among the city's most admired artists, although only now are their talents being rediscovered.

In order to focus my discussion, I have selected artists who, for the most part, were trained in Boston (either privately or in one of the various art acade-

mies established in the city in the 1870s) or whose careers were centered in the area. Several well-known women, despite their considerable accomplishments, were therefore disqualified. Cecilia Beaux, who summered on the North Shore for over forty years and who painted a number of portraits of Bostonians in her beloved Gloucester studio, so identified herself with Philadelphia and its institutions that it seemed dishonest to claim her. Like Beaux, Theresa Bernstein painted in the Boston area during the summers for many years, but her artistic affiliations are clearly based in New York. Anna Klumpke likewise seemed securely established elsewhere, although she worked and exhibited very successfully in Boston for a number of years during the 1890s. Some women artists refused to put down roots anywhere, and while painters like Jane Peterson are often linked with Boston, she was trained in Illinois, New York, England, France, and Spain, and she crafted her brilliant landscapes all over Europe, the Middle East, and North Africa; only her marriage at age forty-nine to a man from Massachusetts led her to focus upon New England.

For similar reasons, despite her Boston roots, her period of study with William Morris Hunt, and her close friendships with a number of Boston women, Maria Oakey Dewing makes only a guest appearance in these pages. No matter how fine her work and how close she came to meeting our requirements, we decided with great regret that Dewing was a New York painter. An artist need not have been born in Boston, however. Despite their training in Philadelphia and Paris, both sculptor Meta Vaux Warrick Fuller and painter Elizabeth Wentworth Roberts firmly established themselves in the Boston area: Fuller in Framingham, where she worked for almost fifty years, and Roberts in Concord, where she became a founder of the Concord Art Association.

In 1930, the painter and writer Philip Hale playfully remarked that every Boston woman had studied art, and that therefore a good half of the city's eight hundred thousand citizens must be women artists.[3] This book includes just over forty of them. It is not meant to be a dictionary, although readers will find alphabetically arranged biographies at the end of the volume. There is no doubt that someone's particular favorite will be missing from these pages. Instead of writing little about many women artists (and Boston supported an enormous number of talented and successful women), I have chosen instead to examine fewer of them, studying each in more depth, linking them to one another and to the artistic issues of their day.

In most cities, as scholar Lisa Tickner has noted, "it was a cruel and not insignificant irony that women gained entry to the academic curriculum only at the point at which the power of academic institutions was being challenged by

avant-garde developments elsewhere."[4] In Boston, however, the academy retained its strength for a much longer period, as modern challenges to the traditional art establishment were presented and thoughtfully rejected. The talents of an accomplished group of women coincided with this singular community of artists who believed in the power of beauty and in the obligation of art to uplift and inspire. Women became an integral part of that society, and played key roles in the history of art in Boston.

A Studio of Her Own is published on the occasion of an exhibition at the Museum of Fine Arts, Boston, and the demands of borrowing and displaying works of art have also played a role in the selection presented here. However, it is my hope that the book will survive long past the closing dates of the show. The sculptor Harriet Hosmer once wrote to the clergywoman and writer Phebe Hanaford, "I honor every woman who has strength enough to step out of the beaten path ... [who has] strength enough to be laughed at if necessary ... everyone who comes after us will have to bear fewer and fewer blows. Therefore I say, honor all those who step boldly forward, and, in spite of ridicule and criticism, pave a broader way for the women of the next generation."[5] This book is dedicated to future authors and to the books that remain to be written.

A Studio of Her Own

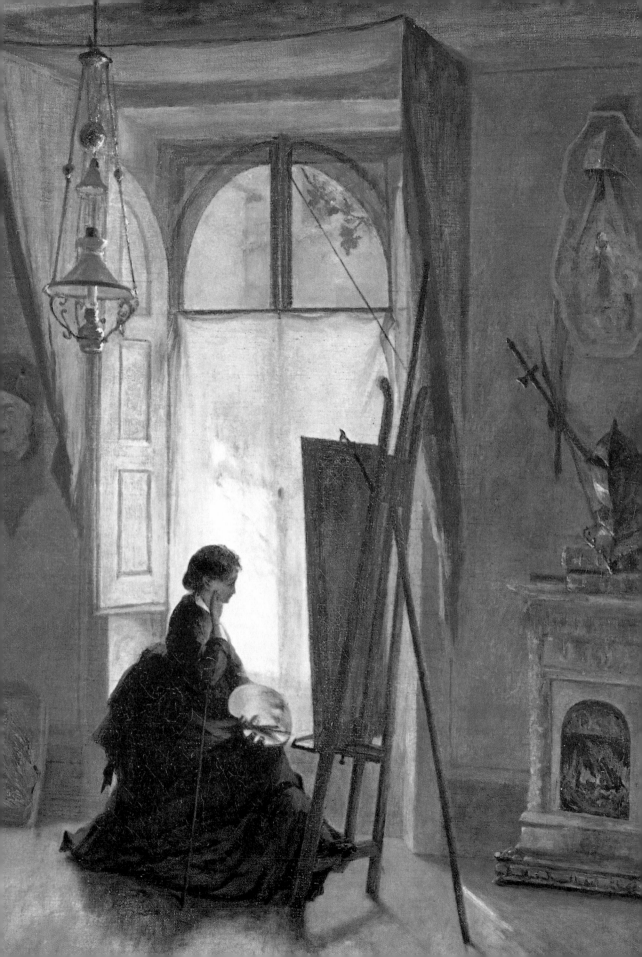

"I predict an hour when the term 'Women in Art' will be as strange sounding a topic as the title 'Men in Art' would be now," remarked the well-known Philadelphia painter Cecilia Beaux in 1915.[1] That day has yet to occur, despite Beaux's considerable accomplishments and those of the many hundred American women artists of her own and subsequent generations. Yet there was one period and one place where "women in art" did not conjure up notions of dabblers—either old maids who threw themselves into their art to compensate for their "failure" to marry or young girls who hoped a pinch of artistic accomplishment would help them to avoid the fate of their sisters—but rather invoked images of successful and competent professionals. This was the situation found at the turn of the last century in Boston, Massachusetts. "Women are so free in Boston," wrote a Connecticut painter in 1893, on the point of packing her bags for the city. Writer William Howe Downes commented on the achievements of such women three years later, noting, "Every year we see more and more of these sisters of the brush and palette coming forward as doughty competitors to the men, and nowhere do they threaten more serious rivalry than in Boston, where ... the democracy of art regards neither sex nor 'previous condition of servitude.'"[2]

Between 1870 and 1940, hundreds of women in Boston became professional artists. With characteristic jocularity, the painter and critic Philip Hale declared that by 1930 they were "too numerous to mention, for almost every Boston woman has studied art, and by the last census one learns that there are eight hundred thousand people in Boston.

1. Edwin White, *Studio Interior* (detail), 1872

About half of them must be women and therefore artists."[3] In Hale's own case, it was certainly true; three women in his immediate family were painters: his aunt Susan Hale, who regarded herself as an amateur but exhibited at the Boston Art Club; his sister Ellen Day Hale (pls. 41, 42), who first studied art with William Morris Hunt in the 1870s and then continued her education at the Académie Julian in Paris; and his wife Lilian Westcott Hale (pls. 47, 48, 50, 52–54), who trained at the School of the Museum of Fine Arts, established in 1870. Their combined experiences are representative of the increasing opportunities and acceptance of women artists during this period.

As early as 1889, the Boston columnist for *The Art Amateur* emphatically stated, "There is nothing that men do that is not done by women now in Boston."[4] That year, when Edmund Tarbell was named the chief instructor of painting at the School of the Museum of Fine Arts and the city was recovering from its first impassioned encounter with the cosmopolitan artistry of John Singer Sargent, such a pronouncement stood as a strong acknowledgment of women's achievements in the arts. It also served as a reminder that Boston women were known, and had been recognized for years, for their accomplishments in a variety of disciplines. In 1880–81, when editor Justin Winsor, the librarian of Harvard University, published his four-volume *Memorial History of Boston*, he included a chapter entitled "The Women of Boston," which cited the opinion that "never before to women were nobler opportunities open than those which the near future promises."[5]

<p style="text-align:center">≈ ≈ ≈</p>

The author of this optimistic statement was Ednah Dow Cheney, a prolific writer and public speaker, who worked tirelessly for education, abolition, women's health, and women's rights. Some forty years before she contributed to Winsor's *History*, Cheney had attended the influential "Conversations" of the celebrated essayist Margaret Fuller. Fuller had had a profound influence on Cheney and many other women of her generation—Cheney remarked that Fuller had "opened the book of life and helped us to read it for ourselves."[6] Fuller, the daughter of a Massachusetts congressman from Cambridge, was the author of the 1845 feminist manifesto *Women in the Nineteenth Century*, a groundbreaking treatise arguing for the equality and political rights of women. Although Fuller died in a shipwreck just five years later, her philosophy remained particularly strong in Boston and Cambridge, and the men and women she influenced carried her legacy forward through the century. Cheney gave lectures about Fuller and her work, and she wrote that although Fuller's message was not confined to Boston, "it was here fully felt; and it lingers in all the life and character of Boston women."[7]

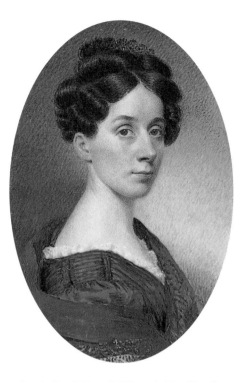

2. Sarah Goodridge, *Self Portrait* (detail), 1830

In her 1880 essay, Cheney outlined the history of women in Boston and also enumerated the current state of affairs: forty-eight women studying medicine at Boston University (and continuing their clinical training at the New England Hospital for Women and Children); women able to own their own property, a right granted by state statute in 1855; women attending the theater and sitting in any part of the auditorium without a male escort. Women authors were using their own names on books without compromising their acceptance by publishers or by readers; women were not only teaching, but also offering such innovations in education as the establishment of kindergarten programs by Elizabeth Peabody. A woman had been able to serve as editor of the city's major daily newspaper (Cornelia Walter Richards, who ran the *Boston Evening Transcript* from 1843 until her marriage in 1848), and women had formed an impressive roster of public speakers, including Angelina Grimké Weld, who addressed the Massachusetts legislature on behalf of antislavery activists.

Many abolitionists would come to be linked with the suffrage movement, which had begun as early as 1776 in Boston, when Abigail Adams complained to her husband John that "whilst you are proclaiming peace and good-will to men, emancipating all nations, you insist upon retaining an absolute power over wives."[8] In 1854, six years after the initial suffrage rally in Seneca Falls, New York, the first convention in Boston in support of women's rights was held. In 1874, the state legislature voted to allow women to serve on the Boston School Committee (pointedly undermining the resistance of several members), and women were granted the right to vote for School Committee in public elections in 1879.

In the visual arts, Cheney noted that the city had a history of women painters and mentioned the success of both Sarah Goodridge and Sarah Clarke. Goodridge (fig. 2) had earned a reputation as one of the city's leading portraitists, although her chosen medium, small-scale watercolor on ivory, contributed to her disappearance from local art histories. She had her own studio in

3. Sarah F. Clarke, *Kentucky Beech Forest*, about 1840

Boston by 1820, and with the support of Gilbert Stuart and the patronage of such distinguished citizens as Daniel Webster, she painted two miniatures a week and earned enough of an income to support her family. The poetic landscapist Sarah Freeman Clarke, a student of the revered painter Washington Allston and a friend of Margaret Fuller's, initially had provoked critical comments not by her work, but by her visit to the inaugural exhibition at the Boston Athenaeum in 1827 without a male escort. However she soon earned favorable notice for her own accomplished canvases, which she showed at the Athenaeum regularly from 1832 to 1860 (fig. 3).

<p style="text-align:center">⌒ ⌒ ⌒</p>

More than these painters, Cheney noted, the most visibly successful Boston women artists to date were sculptors, and their fame was international, since most of them practiced their craft in Italy, not New England. Among the first was Harriet Hosmer, the daughter of a local physician, who "ran faster and could shoot straighter than any boy in Watertown" thanks to her father's enlightened ideas about education.[9] She studied drawing and clay modeling privately in Boston in 1849–50 with the English sculptor Peter Stephenson, and learned anatomy from her father, who later arranged a tutor for her at McDowell Medical College in Saint Louis. While some scholars have cited Hosmer's disappointment

with the limited opportunities open to women artists in Boston as the reason she settled in Rome in 1852, it is just as likely that Hosmer was equally frustrated with the general situation of the arts in America, particularly for sculptors.[10] In an 1853 letter to a friend, Hosmer explained that "America is a grand and glorious country in some respects, but [Rome] is a better place for an artist."[11] Such sentiments were echoed throughout the century by many painters and sculptors, male and female alike, who were hampered by the lack of available or adequate training in the United States, the paucity of original works of art from which to study, and the general disregard for the importance of the arts in American culture. The widespread belief that Europe was a superior place for aspiring artists held sway throughout the nineteenth century, and continued just as strongly when the art capital of the western world shifted from Rome to Paris in the 1870s.

Hosmer joined a tradition of American sculptors working in Italy that had begun in 1825, when the Boston-born Horatio Greenough first traveled abroad. She soon became the center of a community of women sculptors almost invariably described in Henry James's terms as having "settled upon the seven hills [of Rome] in a white, marmorean flock."[12] Several were from the Boston area, including Edmonia Lewis, Margaret Foley, and Anne Whitney. Despite their absence from the local art scene, the accomplishments of these sculptors were well reported in Boston. Examples of their work were also available for first-hand examination. Hosmer's *Zenobia* was displayed in Boston in January 1865, an exhibition that drew record crowds of over fifteen thousand to the gallery of the enterprising Mr. Jenks, who expanded his hours and encouraged visitors to see the sculpture both by daylight and gaslight.[13] Hosmer's close friend Cornelia Carr, who lived in Cambridge, owned her *Sleeping Faun* (the version now in the Museum of Fine Arts, Boston, fig. 4), and Hosmer's whimsical *Puck and the Owl* entered the collection of the Boston Athenaeum in 1876, the gift of a local collector. Harvard College commissioned Edmonia Lewis to craft a bust of Henry Wadsworth Longfellow, and Anne Whitney first earned notice in Boston in 1864 for her *Lady Godiva* (private collection), which she displayed at Childs and Jenks Gallery to heated reviews, despite the fact that her subject had not yet removed her clothes.[14]

After her great success with *Zenobia*, however, Hosmer was accused in the British press of having defrauded the public. Her work, several journals proclaimed, was not her own but instead the production of an Italian craftsman. "Had Thorwaldsen and Vogelberg [two of Europe's most famous neoclassical sculptors] been women," Hosmer complained, "we should long since have heard the great merit of their works attributed to the skill of their workmen."[15] She

4. Harriet Hosmer,
Sleeping Faun, after 1865

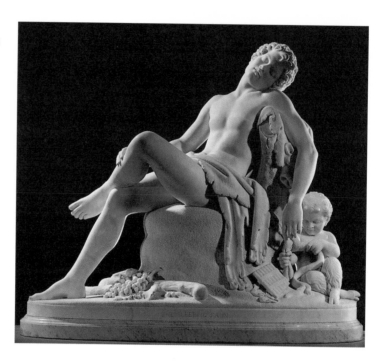

took the charges seriously, however, and sued the publishers for libel. She spent
months writing her own essays to clear her name, describing her technical
processes and explaining that the use of studio assistants and marble cutters was
common practice. Save for a full-scale *Queen Isabella* that she completed for the
1893 World's Columbian Exposition in Chicago, however, Hosmer was not pro-
ductive after 1870. Her style seemed increasingly old fashioned, and she was
uninterested in the new realist imagery of younger sculptors who worked pre-
dominantly in bronze rather than marble. Her last years, which she spent in
Watertown, Massachusetts, were relatively quiet and disengaged from the art
world. Nevertheless, in her life and career Hosmer fulfilled a role that she strong-
ly felt was necessary to improve the circumstances of women. As she wrote to
the clergywoman and writer Phebe Hanaford, "I honor every woman who has
strength enough to step out of the beaten path … [who has] strength enough to
be laughed at if necessary … everyone who comes after us will have to bear fewer
and fewer blows. Therefore I say, honor all those who step boldly forward, and, in
spite of ridicule and criticism, pave a broader way for the women of the next gen-
eration."[16]

Hosmer had found that her professional needs, especially the artistic train-
ing she craved during her early years, could not be met in Boston. These prob-
lems became the topic of much discussion and some productive efforts during

the 1850s. Ednah Cheney acknowledged in her 1880–81 essay the importance of an educational foundation to enable women's eventual achievements, and in this arena she took a leading role. In early 1851, Cheney visited Philadelphia, where she was introduced to the School of Design that had been established there by Sarah Peter in emulation of courses in industrial art newly offered in London.[17] Cheney also consulted with the French painter Rosa Bonheur, the leading woman artist of her day. Bonheur offered classes for women and gave Cheney a tour of her facilities, but when questioned about her teaching practices, Bonheur replied merely, "*Bon Dieu elles dessinent, et moi, je les corrige* [For goodness' sake, they draw and I correct them]."[18]

In Boston in 1851, Cheney and Dr. Josiah Foster Flagg formed a committee and founded a school similar to Philadelphia's, located first in a room in the Warren Street Chapel on Warrenton Street and later on Summer Street in downtown Boston. "Young women applied in large numbers," Cheney recalled, most of them aspiring to professional careers in industrial art rather than as painters or sculptors. Unfortunately the London-trained instructor (whose name Cheney refrained from mentioning) proved unsatisfactory: "Such a compound of plausibility, superficial fascination, vanity, conceit, ignorance, and impudence it would be hard to discover in a well-dressed Englishman," Cheney recalled.[19] Although skilled at linear drawing, the teacher proved incapable of more advanced instruction, and was forced to resign. He was replaced by the painter Albert Bellows, and then by Stephen Salisbury Tuckerman, who expanded the drawing classes to include studies from the antique. Ellen Robbins (a childhood friend of Harriet Hosmer's) studied there with Bellows and Tuckerman, and later wrote that "all my success in later years was due to Mr. Tuckerman's teaching." May Alcott Nieriker (Louisa May Alcott's sister) also reported that Tuckerman's instruction at the School of Design was "able and inspiring" and she praised his adherence to the British example known as the South Kensington plan. But her fellow painter Elizabeth Bartol, who documented the early history of women artists in Boston, found it a frustration: "There was no life class of any kind," she recalled, "and what would have been done later for the aspiring student if the school had lived I cannot even guess." Cheney, as a founder, was more charitable. "The school as an experiment was perhaps premature," she remarked, "but it showed the great amount of talent among American women …. I think this school was one of the failures that enriched the ground for success."[20]

The work of the School of Design, which had all but closed by 1860, was taken over by the Lowell Institute, an organization that had been founded in 1836 to provide free lectures and courses to the Boston public by the leading

thinkers of the day. Classes in drawing had been offered since 1850, and were open to both sexes. As scion of one of the region's most profitable textile manufacturing families, John Lowell, Jr., would have been quick to recognize the benefits of training in industrial art, and the courses at his institute were intended for mechanics and artisans, although several aspiring artists also enrolled.[21] In 1863–64, the institute's drawing classes were taken over by William Rimmer, one of the city's most eclectic and irascible characters, who pursued his considerable talents in a variety of fields, including painting, sculpture, business, and medicine.

❧ ❧ ❧

Rimmer had been teaching art anatomy in his rooms in the Studio Building on Tremont and Boylston Streets for two years; after his affiliation with the Lowell Institute ended, he opened his own school, which continued until 1876 (save for four years, 1866–70, when Rimmer went to New York's Cooper Union School). Thereafter he taught at Boston's newly founded School of the Museum of Fine Arts. Through these varied efforts, Rimmer became one of the city's most important early instructors for women. Ednah Cheney described him as an inspiring teacher and "a remarkable man rather than a great artist," but Elizabeth Bartol credited him with bringing "a new light" to Boston's art world, describing him as "an earnest seeker, a man who united the anatomical knowledge of a surgeon to the most extraordinary facility in free-hand drawing."[22] He was a firm believer in art education for women, and his various classes attracted many women students, including Bartol, May Alcott Nieriker, Elizabeth Bigelow Greene, Susan and Ellen Hale, and Anne Whitney. "I believed," Rimmer wrote, "and still believe, that art intellectually is as independent of sex as thought itself ... I saw no reason why the same knowledge should not be conferred upon the one as on the other."[23]

Rimmer taught by example—he sketched on the blackboard and expected his students to study and copy each drawing. He emphasized artistic anatomy, lecturing on the bones and muscles that formed the human body and describing their integral relationship to one another. He drew them individually and then in concert, eventually working his way to a complete human figure (fig. 5). In a method seen at other contemporary art academies, he detailed a variety of facial expressions and physical types. Rimmer also presided over the most controversial aspect of artistic education for women, the study of the nude model.

Life drawing was the foundation of a traditional academic artistic education, and it would become a heated symbol of women's quest for equal opportunity in the arts. The most eloquent and frequently cited description of the problem was written by an angry parent to the president of the Pennsylvania Academy of the Fine Arts in Philadelphia in 1882:

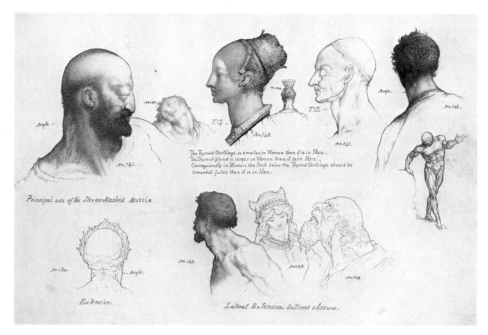

5. William Rimmer, *The Neck Muscles in Use — Illustration from Art Anatomy*, 1876

Does it pay, for a young lady of a refined, godly household, to be urged as the only way of obtaining a knowledge of true art, to enter a class where every feeling of maidenly delicacy is violated, where she becomes so hardened to indelicate sights and words, so familiar with the persons of degraded women and nude males, that no possible art can restore her lost treasure of chaste and delicate thoughts! There is no use in saying that she must look upon the study as she would upon that of a wooden figure! That is an utter impossibility. Living, moving flesh and blood, is not, and cannot, be studied thus. The stifling heat of the room adds to the excitement, and what might be a cool, unimpassioned study in a room at 35°, at 85° or even higher is dreadful.[24]

The equation made here, between the study of nude models and the loss of virginity, was not unique to Philadelphia. The theme of women artists and male models had provided fodder for lewd French cartoons throughout the nineteenth century, and it furnished Charles Aubert, a Parisian pulp fiction writer, with a topic for his 1883 novel *L'Aveugle*, in which an attractive, married, and modest painter is overcome with desire for her semi-nude, supposedly blind model.[25] This fundamental conflict between accepted moral values for women and an artist's need for serious training in rendering the human form is apparent throughout the literature about women artists during the late nineteenth century, and it affected the curriculum of every art school of the period (figs. 6, 7).

That women wanted such classes is illustrated again and again, for the taste for high art in the 1870s and 1880s was still for heroic, figurative compositions. Such paintings, traditionally ranked at the top of the academic hierarchy, most often included large-scale figures that made evident an artist's ability to paint the human form. Although Bostonians were among the first Americans to admire the informality of Impressionism, they still believed strongly in conventional methods of artistic training that included anatomy. Their ideals were made manifest in 1884, when a petition was circulated that called for "all persons interested in the development of the art of painting in this community" to contribute toward the purchase of Henri Regnault's majestic *Automedon with the Horses of Achilles* (fig. 8) for the Museum of Fine Arts. Of the forty-five working artists who signed it, six were women, all alumnae of Rimmer's or of his successor, William Morris Hunt.[26]

The issue of life drawing was an awkward one for William Rimmer. His biographer, the sculptor Truman Bartlett, reported that Rimmer "admired the human figure to an extravagant degree, but always kept it at arm's length; and he was absolutely unable to recognize the fact that an entirely nude male model was a necessity, and could be studied with propriety by females." A number of Rimmer's students disagreed with him, and a model was made available to them. "The doctor's delicacy was extreme in this matter," Bartlett continued. "He would never consent to be present or to give instruction at times when they insisted on such advantages."[27] Rimmer did not prevent the sessions from taking place, however, and other documents indicate that he did indeed teach during some of these meetings.[28] It is not clear whether they took place under the auspices of the Lowell Institute or in private lessons. Bartlett noted that "the wounded dignity and mental pain that Dr. Rimmer endured may be easily imagined, on being told by a gentleman, whose daughter was a pupil of the doctor's, that he was informed that a male model was allowed to go about the schoolroom without clothing. 'My daughter,' added the gentleman, 'is anxious to study with you; but, if this nude model promenading is permitted, I cannot consent to it.' The doctor retorted that he had a family of daughters of his own, and believed he was not wanting in a sense of propriety."[29] Cheney reported that "much opposition was made" to life drawing for women, and that it was proposed that "the pupils should all be veiled during the lesson."[30] That "Mohammedan solution," as Cheney characterized it, which not surprisingly did not meet with the approval of the female students, was intended to prevent any embarrassment should student and model encounter one another later, for the model would thus be unable to recognize any of the women who had been studying his naked form; their modesty would be protected.

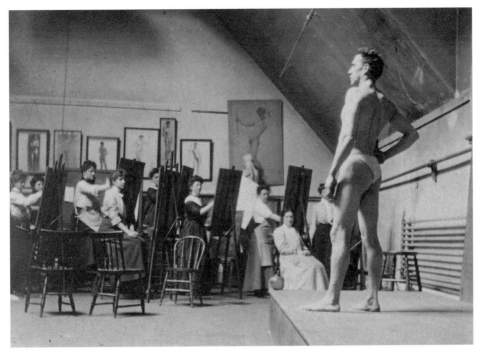

6. *Women's Life Class*, 1901–02, School of the Museum of Fine Arts, Boston. Life classes at the school were segregated by sex.

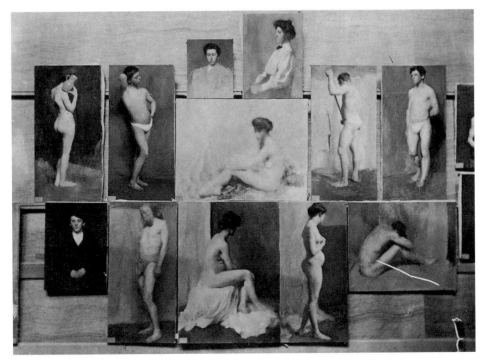

7. *Miss Roger's Work*, 1907, School of the Museum of Fine Arts, Boston. Gretchen Rogers was a talented student who went on to have a successful career (see pl. 49). Her classroom studies demonstrate that women posed entirely nude, while the male models wore loincloths.

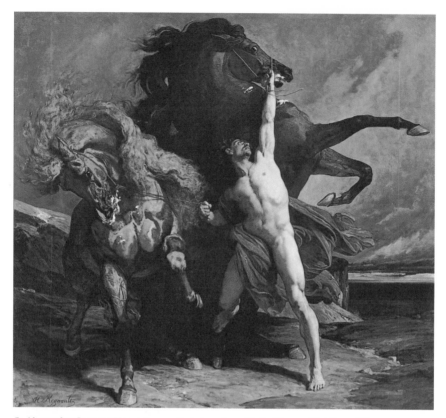

8. Alexandre-Georges-Henri Regnault, *Automedon with the Horses of Achilles,* 1868

Despite these travails, Rimmer provided women with unprecedented oppor-
tunity. In 1864, Ednah Cheney and fifty of her colleagues in the Ladies' Class in
Art Anatomy at the Lowell Institute presented the artist with a book of poetry
and an effusive letter of thanks. "Your lessons in this city form a new era in the
progress of art and education …. By offering to women the same instruction and
the same thorough training as to men, you have taken an important practical
step in opening to them wider resources of intellectual and aesthetic culture, as
well as remunerative industry. We cannot hope to repay you fully for what you
have done for us."[31] Elizabeth Bartol was more specific in her praise, crediting
Rimmer with providing "what the more earnest women cried out for ardently, a
living model, in whom the actual body could be studied in its marvelous move-
ments and mechanism. I think many of the women who are now most successful-
ly at work, must remember with an undying gratitude the impulse of that class in
the Studio Building."[32]

⤳ ⤳ ⤳

One beneficiary of Rimmer's anatomy lessons was the sculptor Anne Whitney, who studied with him from 1862 to 1864 and who had adjoining rooms in the Studio Building. At that time, she modeled a male nude, perhaps the first by an American woman sculptor. She later reworked the design into *The Lotus Eater* (fig. 9). Once extant in a life-sized marble version, which was exhibited in 1867 at De Vries's Gallery in Boston as "The Youth" (and later as "Dream of Love"), *The Lotus Eater* is known today only through a reduced copy in plaster. The figure is a sensuous fusion of the *Faun* in Rome's Capitoline Museum and Michelangelo's *Dying Slave* from the Louvre, both of which were reproduced in popular plaster casts. Whitney had not yet traveled to Italy, but the Capitoline *Faun* had also been made famous, particularly in the United States, by Nathaniel Hawthorne's novel *The Marble Faun*, often illustrated with tipped-in photographs, which had been published in Boston in 1860. As for Michelangelo, one of Rimmer's former students remarked that "Michelangelo and Dr. Rimmer are inseparable in my mind."[33] Whitney's languid male nude can hardly have assured conservative parents of the benefits of studying the live model.

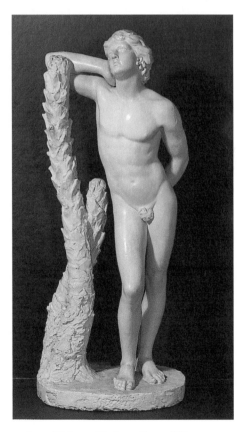

9. Anne Whitney, *The Lotus Eater,* 1868

Although older than Hosmer, Anne Whitney had a more profound effect upon the next generation of women artists, both through her art and her life. Like Hosmer, she came from Watertown, and she too enjoyed a family of liberal beliefs about women's education. An ardent feminist and abolitionist, Whitney began her professional life as a poet and teacher. By 1855, the year her work was published in *Una*, a periodical dedicated to women's rights, Whitney had also begun to work as a sculptor. She was not able to travel to Italy until after the Civil War, but in 1867, already an accomplished artist at forty-six, she went to Rome. Although she was productive during her time in Europe, she did not share Hosmer's

enchantment with Italy and spent only four years abroad, dividing her time between Rome, Paris, and Munich before returning to the United States.

Whitney opened a studio in Boston in 1871, and her work of the 1870s demonstrates both her commitment to social activism and her dedication to modern aesthetics. She began to turn away from the classically inspired productions of her early years, choosing to work instead with themes that related directly to current events. A piece entitled *Africa*, a colossal reclining figure inscribed "And Ethiopia shall soon stretch out her hands to God," was developed in plaster and exhibited in Boston in 1864–65. This was followed by two other abolitionist projects, a portrait of the Haitian emancipator Toussaint L'Ouverture (1872–73) and an image of a freed slave entitled *The Liberator* (1873).[34] In 1873, Whitney won a state competition to provide a full-length marble portrait of another liberator, the Revolutionary War hero Samuel Adams. The statue was to be placed in the United States Capitol, one of two works solicited by an 1864 act of Congress to represent Massachusetts in Statuary Hall. The Adams portrait was installed in Washington in 1876; it was only the second such monument created by a woman artist.[35] Four years later, a full-size bronze replica was placed on public view in Boston, near Faneuil Hall.

Whitney's success with the Capitol commission makes her experience with another public monument especially striking. In 1875, a competition was announced to create a memorial to be placed in Boston's Public Garden in honor of the Massachusetts senator Charles Sumner, who had died the preceding year. Whitney had known Sumner, and the statesman's strong voice in Congress on behalf of abolition—which had earned him a beating on the Senate floor—made him a natural subject for her. She completed a plaster model, depicting a seated figure holding a book, and became one of three finalists in the anonymous competition (fig. 10). Thereafter the facts become blurred, and Whitney, writing to her brother and sister from Paris, was convinced that the contest was tainted. She learned that although her own model had been judged the best of the three, Thomas Ball had been awarded the commission. The Boston Art Committee (which, twenty years later, would declare Frederick Macmonnies's *Bacchante* too licentious for the Boston Public Library), apparently upon discovering the artist's identity, declared that Whitney did not have sufficient experience to sculpt a full-scale image of a man and would be liable to fail, thus embarrassing the Committee. Four women painters—Elizabeth Greene, Ellen Hale, Elizabeth Bartol, and Sarah Whitman (all students of William Morris Hunt)—rallied around her, reported Whitney's sister, and "join[ed] their execrations to ours upon the masculine judgment." Ednah Cheney was advised to examine the

10. Anne Whitney, *Senator Charles Sumner*, 1875

models and to "give the public her opinion"; most Bostonians saw through the Committee's meager reasoning. It was said that the judges felt that a woman could not sculpt a man's legs, and the abolitionist and feminist writer Lydia Maria Child was inspired to poke fun at them in verse.[36] After considerable negotiation and a suspicious reluctance on the part of Charles Slack, secretary of the Committee, to reveal the actual proceedings (he "wriggles out of a direct reply," Whitney complained), Whitney elected to keep her $500 prize, get her model back, and drop her complaint. "Bury your grievance," she wrote to her family. "It will take more than a Boston Art Committee to quench me."[37] She took satisfaction that most art-minded Bostonians understood that she had been refused the commission because of her sex, and later was twice vindicated: in 1887, her monumental full-length sculpture of the explorer Leif Ericsson was unveiled on the Commonwealth Avenue mall, and in 1902, when she was ninety-one years old, her own *Charles Sumner* was installed in Harvard Square.

Although originally conceived in white marble, Whitney's *Adams* and *Sumner* eschew traditional neoclassicism—both figures wear contemporary

clothes, omit references to the ancient world, and are presented as life-like portraits. This interest in realism placed Whitney in the forefront of aesthetic taste in sculpture and separated her from many of her colleagues, including Hosmer, Foley, and the other women artists she met in Italy. Whitney's best-known work, *Roma* (fig. 11), is indeed an allegory originally conceived in marble, but instead of a heroic representation of the glory of Rome, it proclaims the poverty and decay of the city, a condition Whitney found shocking both in such proximity to the wealth of the Church and in comparison to the illustrious history of the ancient capital. A supporter of the republican fighter Giuseppe Garibaldi, Whitney believed that the unification of Italy under a democratic government would improve the lives of its citizens.

Whitney recalled her haggard Roman beggar in a later bronze, *Le Modèle* of 1875 (pl. 1). Based upon the features of an old peasant woman in the French artists' colony of Ecouen, *Le Modèle* was Whitney's first important work in bronze, a medium that became increasingly popular in the nineteenth century as sculptors infused their work not only with realism, but also with a physical sense of the artist's touch. Whitney's first biographer, the feminist Mary Livermore, wrote that *Le Modèle* (which she described as "delightfully ugly") epitomized France as *Roma* had represented Italy: "Whatever the idea of the artist, this bronze head fitly symbolizes France—broken by revolutions, worn out by war, overcome by domestic violence, degraded by submission to a despotism under the name of a republic—desiring only rest."[38]

Whitney had come to France in the late spring of 1875 from Italy, where she had selected the marble for her *Adams*. She joined her companion, Addy Manning, in Paris, and the two women attended the 1875 Salon exhibition, which included over six hundred works of sculpture by two hundred and forty-nine artists. "Everybody is struck with the amazing talent of the French," she wrote.[39] Whitney was inspired to stay longer in France, and in July the couple traveled to Ecouen. This small town just north of Paris was a popular summer destination for American artists, many of whom were drawn there by the presence of the French painter Edouard Frère, whose images of peasant life had become popular in the United States. Whitney's wizened subject, whom she described to her sister as a "venerable witch," was a frequent model in Ecouen, and one who had earned a reputation for sleeping as soon as she began to pose.[40]

Whitney used her model's fault to her own advantage; the aged and weary face expresses both power and exhaustion, and serves as a dramatic three-dimensional equivalent to the laboring peasants represented by Jean-François Millet. Whitney, like most Bostonians, admired Millet and Thomas Couture above

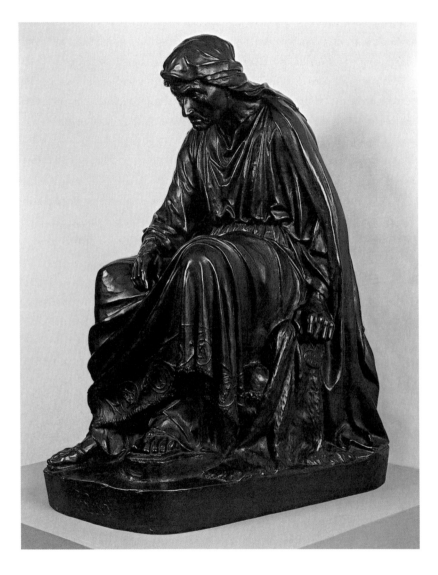

11. Anne Whitney, *Roma*, 1869

all others, and she wrote to Ednah Cheney that she found in Millet's work both a noble and simple spirit and "tenderness—the great homeliness—the humanity— the all that makes art Art."[41] The connection, both visual and spiritual, between *Le Modèle* and realist painting is particularly significant, for Whitney's work pre-dates by a number of years large-scale European examples by such sculptors as Jules Dalou, Achille d'Orsi, and Constantin Meunier that similarly glorify the laborer. Whitney selected *Le Modèle* to represent her (along with *Roma* and the *Sumner* model) in the 1876 Centennial display in Philadelphia. It was lent to the Museum of Fine Arts in 1879 and became the first of her works to enter the Museum's collection in 1885.

Whitney was not Rimmer's only student to become a successful sculptor. Rimmer's youngest surviving daughter, Caroline, also became known for her work in clay and terra cotta (sometimes cast in bronze, sometimes fired and oiled), although her accomplishments were made on a much smaller scale. Caroline Rimmer specialized in low relief, modeling figural designs on decorative plaques and later on vessels, most often large vases or urns. She seems to have had an affiliation with the art pottery called the Chelsea Keramic Art Works during the 1870s, and her work was accepted for display at the Pennsylvania Academy and other important annual exhibitions, at the 1893 World's Columbian Exposition in Chicago, and in Paris in 1900. Rimmer's most frequent subjects (nymphs, mermaids, cherubs, and the like) were popular motifs, but in her hands they gained a sensuality unusual in the work of Boston artists. Dora Morrell, a painter and writer, remarked that Rimmer's graceful figures "have that litheness and delicacy which are found among the French more often than among artists of this country." Rimmer's *Bacchante Vase* (fig. 12) is one of the few identified examples of her work; with its swirl of intertwined, long-haired women, it recalls the sinuous forms of the Art Nouveau.[42]

In addition to the art she created, Caroline Rimmer contributed to Boston's art life by teaching, continuing her father's lessons in artistic anatomy in a course of lectures she presented both in her own studio and at the Eric Pape School, an institution established in 1898 by a local illustrator and painter. In the 1890s, she published two drawing books, a guide to figure drawing for children and an instruction book for rendering animals. In both, she followed her father's method of building slowly toward the complete figure based upon a firm under-standing of anatomy and movement. Rimmer spent a large portion of her time in her later years promoting her father's sculpture, arranging for his plaster models to be cast in bronze, and ensuring that his works entered the permanent collections of public institutions.

Despite both his own and his daughter's efforts, however, William Rimmer has long been overshadowed in the history of Boston art by William Morris Hunt. The two men had similar interests, and both of them dedicated substantial resources toward the training and development of women artists. But Rimmer lacked Hunt's social standing and his calm temperament. Even Truman Bartlett's laudatory biography, *The Art Life of William Rimmer* (1882), contains frequent references to Rimmer's moodiness and quick temper. "He was stubborn and unmanageable," one contributor wrote. "In spite of the unartistic condition of things about him, he was his own worst enemy …. He was never popular with the public

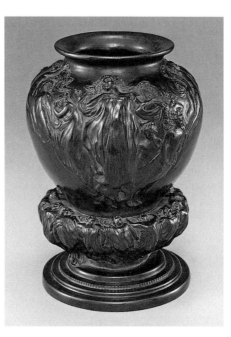

12. Caroline Hunt Rimmer, *Bacchante Vase,* 1899

or artists." "I did not care for him as a person," said another. "But I felt that as an artist he was great great great!"[43] Although Rimmer displayed remarkable talent and imagination, he was a maverick, and his stubborn independence contributed to the frequency with which he moved from one institution to another and to his lack of a strong network of support. As far as his women students were concerned, however, Rimmer had offered opportunities and expertise that had never been available to them before. Yet one essential ingredient had been neglected, for, as Elizabeth Bartol recounted, "nobody had yet taught painting."[44] That need would be filled by William Morris Hunt.

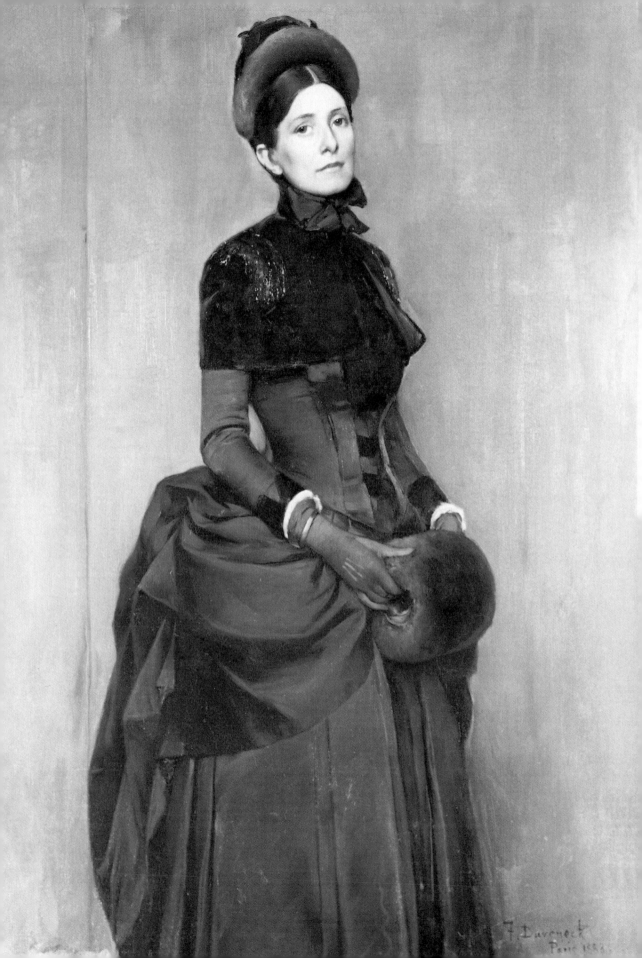

THE STUDENTS OF WILLIAM MORRIS HUNT

By the time William Morris Hunt began to offer classes to women, he was already Boston's leading artist (fig. 14). He had been educated at Harvard, trained as a painter in France, and married into one of Boston's prominent families; these three ingredients virtually assured his success.[1] In France during the early 1850s he studied with Thomas Couture and Jean-François Millet, with whom he established a lasting friendship. This friendship resulted in not only Hunt's espousal of the Barbizon style, but also his perspicacious advice to Boston collectors, who assembled the finest group of Millet's work outside of France. Hunt used a broad, painterly style, favoring tone and color rather than precise detail. Rimmer is said to have complained that Hunt was a poor draftsman, and Hunt reportedly responded that Rimmer's precisely rendered anatomical studies were not true drawings. But the two men had more in common than their paintings, writings, and public reputations might suggest; they were also colleagues and collaborators, and at one time even proposed establishing an art school together.[2]

Such a joint project never materialized, and in the winter of 1868–69, when Rimmer was teaching in New York, Hunt offered his own classes to women. The sculptor Thomas Ball remembered that Hunt had told him of his plan during a transatlantic voyage in 1868: "He thought there was a vast deal of talent among [the ladies] that only required to be directed ... he considered it his duty, and that of every artist, to do all he could to lighten the path of those groping in the dark." Hunt began with forty eager students, and as his pupil, Sarah Wyman Whitman, recalled, "his studio was filled with scholars, most of

13. Frank Duveneck, *Elizabeth Boott Duveneck* (detail), 1888

14. William Morris Hunt, *Self Portrait*, 1866

them of somewhat mature age, who had long coveted opportunity for serious study." Elizabeth Bartol remarked that the occasion "was so much more brilliant" than anything that had preceded it and "that it seemed as if all that had gone before had been but preparation for this." Others felt that Hunt's decision to instruct women and not men was a wasted opportunity. Frank Millet, a leading genre painter and a founder of the School of the Museum of Fine Arts, remarked that it was a "pity" that "more serious students, who were far enough advanced to digest and assimilate his teachings, should not have availed themselves of the great privilege of his leadership." Hunt "to school-girls gave up what was meant for mankind," griped a New York critic.[3] Hunt's school girls, however, would become a talented group of artists in a variety of media.

What Hunt gave also served to inspire his former students for years to come, for he offered them much more than lessons; he tried to teach them to see (fig. 15). "Painting is something for which you can't get a receipt," he declared, and instead of rules of drawing he lectured his pupils about the beauty of form, color, and composition, encouraging them to think of the totality of their work rather than the individual parts.[4] He suggested that they try to paint figures without faces, so that they would concentrate upon proportion and pose rather than details of likeness, and instead of promoting fastidious copying from plaster casts with a sharp pencil (the traditional academic approach), Hunt gave his students a thick stick of charcoal to render areas of broad light and shadow. It was a liberating and inspiring experience.

Hunt also offered something else to his female students; he gave them a sense of their own worth. He offered candid criticism, apparently making no concessions to contemporary theories about the fragile nature of women and the deleterious physical and mental effects of hard work and harsh words. "[We] were taught as any students in school," recalled Bartol. "[We] were criticized as roughly, made to work as strenuously, [and] praised as frankly as men …. Good work," she continued, "is neither masculine or feminine." Sarah Whitman

described Hunt's criticism as "vigorous and unsparing," but she pointed out that Hunt was able to express candid judgments without discouraging his pupils, and that his instruction "had that fine perfection which comes from equal knowledge of the lessons taught, and of the scholar who learns." Helen Knowlton, whose studio was near Hunt's in the Mercantile Building on Summer Street, put it more succinctly: "No pupil knew such a word as fail."[5]

☙ ☙ ☙

In 1871, Hunt turned his classes over to Knowlton, although he continued to offer criticism to students on a daily basis until about 1875. Knowlton taught according to Hunt's methods until the early 1900s in her Boston studio and during the summer along the North Shore, particularly in Magnolia, Massachusetts, and later in Dublin, New Hampshire. In this way, Hunt's fame as a teacher lasted for many years after his tragic death in 1879. Knowlton published two volumes of Hunt's aesthetic advice (*Talks on Art*, 1875 and 1883) and wrote the painter's biography, which appeared in 1899. She also painted Hunt's portrait (pl. 2), memorializing her mentor in a characteristic pose clutching his favorite felt hat. This affectionate likeness, dated 1880, was completed from a photograph, but

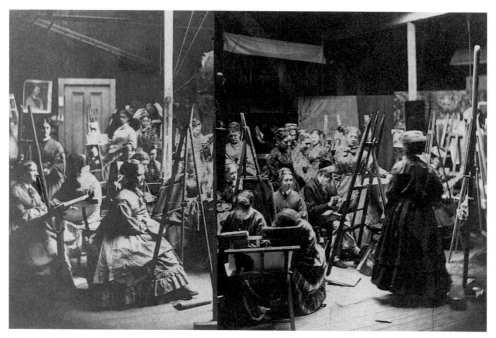

15. *The Hunt Class*, about 1873. Hunt appears at center; he held his classes for women in the Studio Building in Boston's Park Square.

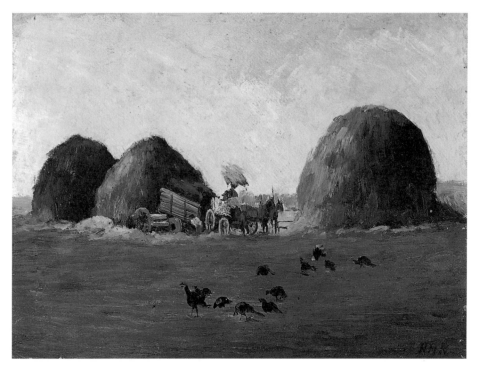

16. Helen Mary Knowlton, *Haystacks*, 1875

demonstrates nonetheless Knowlton's command of the brush.[6] She presented this painting to the newly founded Worcester Art Museum in 1896; it was the first work acquired for that collection and thus represents both Knowlton's dedication and Hunt's enduring legacy.

Knowlton devoted herself to Hunt. Her fellow student Almira Fenno-Gendrot described her as "the 'good angel' of the rather chaotic regime," but her attentive work as Hunt's studio and classroom assistant earned her the characterization "hateful" from the painter's unhappy wife.[7] Knowlton was the daughter of John S. C. Knowlton, the editor of the *Worcester Palladium*, a newspaper to which the young woman contributed and, after her father's death, also helped to edit. She came to Boston in the 1860s to study painting, and in some sources is credited with convincing Hunt to offer his classes to women and with gathering together the requisite number of students.[8] That Hunt allowed her to assume his teaching responsibilities testifies not only to their close personal relationship, but also to Knowlton's mastery of his technique. It is also evident that she needed to teach, for several letters survive to testify to her continued financial difficulties.

Both Knowlton's own work and her classes owed their substance to Hunt, but her activities as an instructor interfered with her painting. "She so generously

gave to all," recounted Fenno-Gendrot, "that she never found time to com-
plete her own life work as an artist."[9] Another writer agreed, explaining that
Knowlton's "reputation as a teacher of painting may have tended to obscure her
reputation as a painter, if, indeed, her teaching has not absorbed her time and
effort too exclusively to allow the forwarding of her art as swiftly as otherwise
would have been possible."[10] Knowlton did produce both figurative and land-
scape compositions, working in both oil and charcoal, and her broad, tonal
approach reveals her allegiance to Hunt's adaptation of the Barbizon style (fig.
16). Exhibition records show her to have favored subjects that recalled the sim-
ple, rural landscape of Millet's France, perceived through Hunt's glass. When
Knowlton described, for example, the attractions of Magnolia, Massachusetts, for
the painter, she noted not only the beach and rocky shore but also the willow-
lined road and the "simple cottage folk."[11] She established a summer studio there
in 1876, followed the next year by Hunt. She soon found her pastoral subjects
not only in Magnolia, but also in York, Maine; Newport, Rhode Island; and other
picturesque rural sites. She considered her charcoal drawings to be finished
works of art, and exhibited them several times at the Boston Art Club, where
one critic described her sketchy style and noted that her "free-hand strokes and
'smooches' of charcoal go right to the marrow of the scene."[12]

In her classes, Knowlton did expand the instruction beyond what Hunt had
offered. She invited William Rimmer to her studio to give lessons in drawing and
painting from the nude—Rimmer hired a male model—and she asked Frank
Duveneck to offer classes in figure painting.[13] Knowlton also gave to her circle
of students and friends something Hunt had been unable to impart—a sense of
community. The frequency with which Knowlton's name appears in Ellen Hale's
correspondence, Rose Lamb's letters, Susan Hale's reminiscences, Almira Fenno-
Gendrot's book, and other such material testifies to the close relationship these
aspiring artists shared, both in Boston and during their trips abroad. Fenno-
Gendrot described Knowlton as "a rare companion," a "teacher and mentor" who
started many young painters "on the road to success."[14] The willingness on the
part of Knowlton and her group to encourage others served to create a singular
environment in which women artists could, and did, begin to flourish.

In 1881, the writer William C. Brownell noted in the popular magazine
Scribner's Monthly that "it is natural to find in Boston a coterie of women artists,
whose work has already gained some distinction and is still more striking in
its promise." Brownell credited Hunt with being the "sponsor for these clever
painters,"[15] but Knowlton provided the real link that continued to hold these
aspiring women together, allowing her own work to suffer for it. The former

Hunt students traveled together, exhibited together, and supported one another both professionally and personally. Knowlton showed her oils and charcoals along with the watercolors of her friend and student Susan Hale, an acquaintance of the Hunts who had studied art in Paris and Weimar. In 1878, the two were joined in their Art Club exhibition by Susan's niece, Ellen Day Hale, who had studied with both Hunt and with Knowlton, and by Laura Coombs Hills, another Knowlton pupil. In the spring of 1881, Knowlton and Ellen Hale went to Europe together, traveling for nine months in Belgium, Holland, Italy, England, and France. Fifteen of Hunt's former pupils showed their work together at Boston's Williams and Everett Gallery in February 1888. The interconnections become too numerous to recount, but "women are helping women," as Elizabeth Bartol declared.[16]

<p style="text-align:center">⮑ ⮑ ⮑</p>

While Knowlton and Ellen Hale were exploring northern Europe during the spring of 1881, another group of Hunt students was voyaging in the south. Elizabeth Boott, Anna Dixwell, and Anna Putnam, together with another female friend, traveled throughout Spain that season, stopping in most of the major cities to sketch and to study the paintings of the Spanish masters and enjoying the companionship of a substantial number of Bostonians.[17] Boott, who was born in Boston, had been raised by her father in Italy after her mother's early death (fig. 13). She and her father returned to Boston in 1865 when Lizzie was nineteen, and Boott soon began, with her father's approval, to study with Hunt. There she not only enriched her art, but also found a supportive group of friends.

Lizzie Boott went back to Europe early in the 1870s, but she did not abandon either her art or her classmates. She returned to the Hunt circle during the summer of 1874, and continued to display her work alongside her colleagues, participating in group shows with them at several Boston dealers. There she first earned critical notice in 1876 as an accomplished member of "a small and earnest school of painters in Boston [who] are entitled to great respect"; Boott "perfectly understood what she was about."[18] In Europe, Boott studied with Thomas Couture (Hunt's former teacher) in Villiers-le-Bel during the summers of 1876, 1877, and 1878. She remained in touch with the "Huntites," describing her experiences in a remarkable series of letters that circulated among the women, each initialing the letter and passing it along. Boott recounted Couture's methods and maxims in great detail, providing specific technical information and thus giving her friends a manner of correspondence course. Couture reminded Boott of Hunt; she wrote to the class that he criticized her, as Hunt had done, for painting too quickly, and that the French painter was similar in

"his apt illustrations, and in his power of mimicry and his sense of humor." Couture was, Boott wrote, a "queer ugly little man with an artistic soul six times too large for his body," and she hoped that if her training went well, "we may all work here some day and work together as we did before in Boston town."[19] Maria Oakey, Elizabeth Bartol's cousin and another Hunt student, also worked in Villiers-le-Bel in 1876; Bartol and Sarah Wyman Whitman would travel there in 1877; Whitman returned in 1879. Boott also asked her classmates to contribute toward the purchase of a painting she had watched Couture create and she adapted his lessons to her own ambitious work in oil (fig. 17).[20]

In the summer of 1879 Boott traveled to Munich to study with Frank Duveneck, whose work she had first admired—and asked her father to purchase—in Boston. She convinced Duveneck to offer a class in Italy during the winter of 1879–80, and invited her Boston colleagues to "get a winter in Italy and the best teacher in the world."[21] Her admiration for Duveneck had become an intense romantic attachment that met with her father's disapproval; Lizzie Boott's trip to Spain with Dixwell and her second residence in Boston, from 1881 to 1885, may have been calculated to separate the two after their first engagement was cancelled. But Duveneck also came to Boston late in 1881, and it is likely that his appearance in Knowlton's art classes was due to Boott's recommendation.

Despite the distraction of Duveneck, Boott worked to establish her professional reputation, primarily in Boston but also in New York. She and Dixwell exhibited together at the J. Eastman Chase Gallery in Boston in November 1882. The work Boott showed, two dozen oils and almost an equal number of watercolors, was predominantly landscapes and floral pieces, punctuated by a view of Hunt's former studio in Magnolia and barnyard images of cows and pigs that had been painted in New Hampshire. She also participated in shows at the Boston Art Club, the American Water Color Society, the National Academy of Design, and others. Henry James, a family friend and admirer, promoted her paintings to several dealers in London, but Boott had her first solo exhibition at Doll and Richards Gallery in Boston in 1884. It was an impressive presentation of sixty-six paintings, including floral still lifes, landscapes, and figure studies. The *Boston Herald* described it as "strong and vital in its entirety, and characterized by a glow of color exceptionally rich." Fifteen of the paintings were already in the hands of private collectors (pl. 3).[22]

Boott and her father, once again accompanied by Dixwell, returned to Europe in 1885, settling this time in Paris. Boott and Dixwell enrolled at the Académie Julian, one of the most popular schools in Paris for American students and one especially important for women, who were prohibited from attending

17. Elizabeth Boott, *Woman and Children*, 1878

the prestigious Ecole des Beaux-Arts. Their Boston friend Ellen Day Hale was also studying at the Académie Julian in 1885, and may have recommended the program to them; Hale told her mother that Rodolphe Julian had offered to reduce her fees in gratitude to her for referring so many students to his school (he "regard[s] me as a kind of decoy duck," she reported).[23]

Frank Duveneck also moved to Paris in 1885; his romance with Lizzie Boott was as strong as ever, and with Francis Boott's long-awaited acquiescence the couple announced their engagement that fall. They married in Paris in March 1886, both listing their occupations in the civil register as "*artiste-peintre.*" Later that spring, Lizzie exhibited two paintings, a still life and a portrait, at the Paris Salon. Thereafter Lizzie Boott Duveneck's career reads as if it were a cautionary tale, a novel much like the one her Boston colleague Elizabeth Stuart Phelps had writ-

ten in 1877. Whether Phelps and Boott knew one another has not been established, but Phelps, who once wanted to be a painter, was associated with Annie Fields, whose literary circle virtually defined Boston and included several of Boott's particular friends, among them Henry James, Elizabeth Bartol, Rose Lamb, Helen Merriman, and Sarah Wyman Whitman (the women all students of Hunt's). In Phelps's *The Story of Avis*, the heroine, Avis Dobell, has through great effort become a painter. Despite her resolve to remain unmarried, Dobell is wooed and won by Philip Ostrander, who tells her that he would "be proud to have her paint."[24] Avis's career inevitably fails; she is overwhelmed with the domestic responsibilities of her husband, children, and the household. Significantly, Avis's daughter, whose name is revealed only at the end of the novel, is called "Wait."

After their honeymoon, the Duvenecks joined Lizzie's father at her childhood home, the Villa Castellani at Bellosguardo near Florence. Lizzie was pregnant, and occupied herself with watercolors of the Tuscan countryside. Her son was born in December 1886. Late the next year, the Duvenecks and Francis Boott returned to Paris. As was customary, Lizzie took over the administration of the household, a considerable task with a newborn baby and an aging father. She also assumed the duties of an artist's career—hiring models, arranging for exhibitions and for studio space—both for herself and her husband. Her Italian nurse returned to Florence, and Boott fretted about replacing her. She complained to her friend Henry James about the tyranny of her domestic schedule, adding that during the limited time she could find to paint, she found watercolors more manageable. She confessed to him that she was "always much occupied with the baby";[25] once again, the fictional Avis comes to mind: "She had put the new-born baby off her knee, and gone up into the hot attic studio to finish a portrait. Then came the old and commonplace story: any woman knows it. Why the children must needs select that precise time to have the whooping-cough? Why the cook must get married the week before Commencement? … such questions eternity alone can be long enough to answer to the satisfaction of some of us."[26] In March 1888, Lizzie Boott Duveneck sent a large watercolor view of the Villa Castellani to the Salon jury. On the day the jury voted to accept her painting, she caught pneumonia, and she died later the same week. Henry James, who had been displeased with Lizzie's marriage to Frank Duveneck, wrote to her father that her death may have spared her from "perpetual struggle and disappointment."[27]

～ ～ ～

18. *Anne Whitney (seated) and Adeline Manning at Shelburne, N.H.*, about 1885

Elizabeth Boott Duveneck did not live long enough to learn whether the course she had set for herself would be too difficult, whether it was possible, in the end, to combine marriage and a career as a painter. It was a constant concern for women with professional aspirations. As the Boston feminist Lucy Stone remarked in her review of *The Story of Avis*, "Miss Phelps raises the question more and more asked by women, whether marriage, in the case of a woman, is compatible with the pursuit of other strong ruling tastes."[28]

In some professions, marriage spelled the end of a career, sometimes simply by custom and sometimes by law; for example, although teaching was one of the most common occupations for women, many school boards refused to employ women who were married. Society frowned upon married women who worked; work implied that their husbands had failed to provide for them or that they were neglecting their own responsibilities to the family. And marriage almost inevitably meant family, for although birth control methods (and also abortion) were available, they were strongly discouraged as immoral (a woman's sexual activity was meant for procreation, not pleasure).[29] Women artists were just as

chary of marriage as women in other professions: Harriet Hosmer wrote that "an artist has no business to marry. For a man, it may be well enough, but for a woman, on whom matrimonial duties and cares weigh more heavily, it is a moral wrong, I think, for she must either neglect her profession or her family."[30]

There were other possibilities. Anne Whitney enjoyed the love and long-lasting partnership of Adeline Manning, a painter (fig. 18); while Ellen Day Hale lived much of her life with her companion, Gabrielle De Vaux Clements, a painter and etcher. These artists avoided many of the complications of a conventional marriage while maintaining independent households, unlike most single women, who were expected to live with their parents or their siblings. The number of women who lived together in devoted pairs was so striking that it earned its own name, the "Boston marriage," and featured prominently in Henry James's 1885–86 novel, *The Bostonians*. Whether or not all of these pre-Freudian relationships were sexual in modern terms will probably never be determined. It was an age when all women were expected to repress their sexual passion, although not their romantic sentiment. Mark A. De Wolfe Howe, editor of the *Atlantic Monthly*, described them as a "union—there is no truer word for it."[31] Many of these sororities consisted of women who worked—writers, poets, painters, sculptors, educators—and who thus understood both the desire and the demands of a career.

Of the ten students who had studied together with Boott in Hunt's class, only Sarah Wyman Whitman and Helen Bigelow Merriman had conventional marriages. Whitman had no children, independent means, and an apparently tolerant (by many accounts, completely disengaged) husband, while Merriman, the wife of a Congregational minister with whom she often worked jointly, painted relatively little and instead devoted herself to writing books and essays about art, to the classes she established, and to the institutions (including the Worcester Art Museum) that she and her husband helped to found. Aptly enough, Merriman and Whitman were close friends; the two women knew one another not only through their experiences in Hunt's class, but also through their close friendship with the writers Annie Fields and Sarah Orne Jewett. Merriman painted a portrait of Whitman for Radcliffe College (fig. 19), presenting her as a confident and competent painter, palette and brushes in hand, a lively sprig of greenery tucked into her plain tweed dress. Whitman confronts the viewer directly, standing in a jaunty hand-on-hip pose that was most often reserved for male sitters.

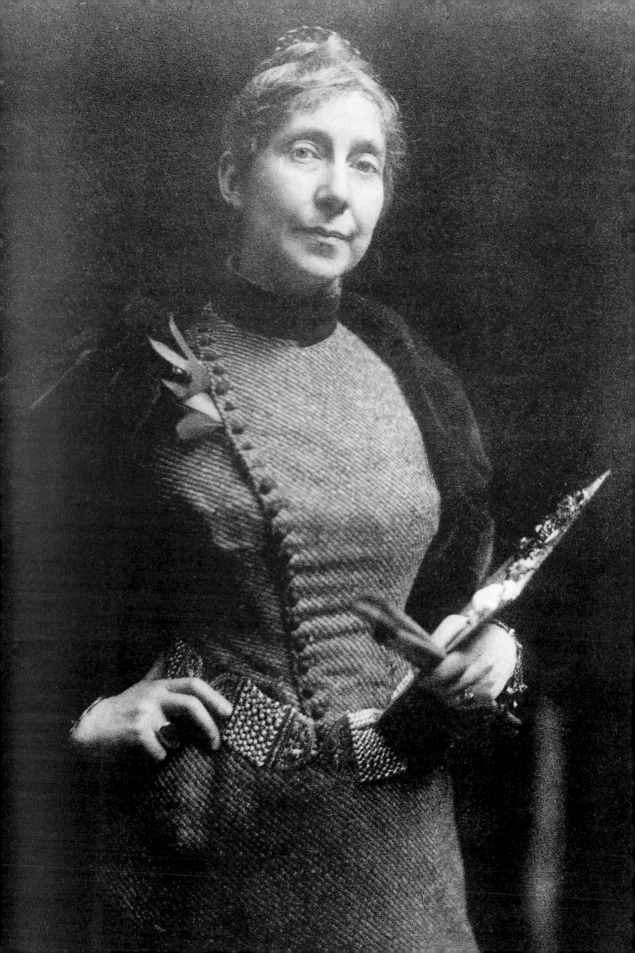

Sarah Wyman Whitman remains one of the most intriguing characters in Boston art circles. Born in Lowell, Massachusetts, Sarah Wyman spent her early years in Baltimore, returning with her family to Lowell in 1853. When she was twenty-four, she married Henry Whitman, a prosperous wool and dry goods merchant three years her senior, who provided his talented wife with a home on Beacon Hill and little interference with her artistic activities (from which he excused himself entirely, as he apparently did from much of her life). Two years later, in 1868, she enrolled in William Morris Hunt's classes, then supplemented her education with lessons from both William Rimmer (in Boston) and Thomas Couture (at Villiers-le-Bel). She traveled to Europe several times, studying architecture and the old masters in Italy, France, and England, at least once in the company of Elizabeth Bartol. From this now typical training, however, Whitman crafted a career in the arts that influenced almost every aspect of creative life in Boston. She not only made art, but collected it, wrote about it, and inspired it. As John Jay Chapman humorously recalled, "The earliest reputation that Mrs. Whitman achieved was that of being an unknown lady from some savage town,—Baltimore, perhaps,—who had appeared in Boston. It was not many years, however, before she had become a center of social influence, and of that peculiar kind of social influence in which there are strands of art, idealism,—and intellect."[1] While the self-absorbed Chapman especially admired Whitman's social skills and her ability to surround herself with "geniuses" (including himself),

19. Helen Bigelow Merriman, *Sarah Wyman Whitman*, about 1906

he might additionally have acknowledged that Whitman likewise was one of Boston's prodigies.

Early in her career, Whitman devoted herself to painting, working in both oil and in pastel. "Her paintings," declared the visiting Parisian writer S. C. de Soissons, "have all the marks of masculine art, and none of the feminine feeling we would desire to see."[2] Such gender-based commentary is common in late nineteenth-century criticism, and a woman artist was most often faulted either way. If her work was described as masculine, displaying a direct and confident painting style, the painter had denied her "true" nature; if it were described as feminine, it was often dismissed as pretty, sensitive, and ultimately unimportant.[3] In Whitman's case, the criticism is particularly interesting, for her subjects were well within the boundaries of acceptable topics for women. She did not paint the equivalent of Anne Whitney's nude youth or even of Hunt's allegorical or historical compositions. Rather, her work consisted almost entirely of portraits, pastoral landscapes, and still lifes, each infused with iridescent color effects achieved through the coarse application of paint or pastel built up in successive layers.

Whitman began to exhibit her paintings in the 1870s and held her first solo exhibition at Doll and Richards Gallery in Boston in 1882. Her work is clearly indebted to Hunt in its broad tonal manner and rural subjects, but Whitman's interest in color is more pronounced and jewel-like in its delicacy. "Mrs. Whitman['s] … decorative color effects move all observers to comment," wrote "T" in *The Art Amateur* in 1885, "whether they approve the broadness of her methods or not."[4] Her landscapes (see pls. 4–6) are suffused with light. In her images of Niagara Falls, an iconic subject Hunt had explored in 1878 and which Whitman described as her "High Altar," her rough scumbled pastel creates an opalescent richness that perfectly represents the watery rainbow effects of the thick mist surrounding the Falls.[5] Her still lifes also display this radiance of color. In *Roses—Souvenir de Villier le bel* (pl. 7), Whitman's sensitive touch and ephemeral subject add poignancy to a composition that, with its multiple layers of work, came to serve as a personal memorial to Thomas Couture, who died in 1879.

Whitman's paintings in oil and pastel won many early admirers, among them Isabella Stewart Gardner, who purchased a tonal, moonlit landscape in 1878. In 1880, the critic William C. Brownell credited Whitman with having "risen out of [Hunt's] crowd of aimless aspirants"; he had first noticed her work at the inaugural exhibition of the Society of American Artists in New York.[6] Whitman was elected a member of that organization in 1880, and her desire to be affiliated with that group clearly indicates her interest in modern art. The

Society had been established by young, European-trained painters who found the important annual exhibitions at the National Academy of Design too conservative and too nationalist to be receptive to their more cosmopolitan work. Whitman's tonal landscapes and broadly painted portraits would have been considered distinctly French in style, and although she also showed her pictures at the National Academy, she was more actively engaged with the Society of American Artists. In 1880, the *Art Journal* noted that "among the works by women" at the Society's annual exhibition, "the two best, perhaps, are by Miss Bartol and Miss Whitman of Boston"; their work was praised as "agreeable and sparkling … with charm and refinement," while the contributions by other women were dismissed as incomplete studies.[7]

While several of the artists' groups that assembled in the late 1870s and early 1880s were hospitable to women, the Society of American Artists was not quite as open to them as it claimed. Despite the fact that women were given encouragement to exhibit with the Society and that Helena DeKay Gilder, a painter and tireless worker on behalf of other artists, had been one of the founders, only eight women were among the Society's seventy-three initial exhibitors and less than five percent of the membership was female. When Whitman was listed in the roster of forty-five members published in 1881, the only other women included were Gilder and Mary Cassatt. Gilder may have blamed one of the most powerful members of the Society, John La Farge, for this predicament, noting in her diary La Farge's dismissal of her own work as "pretty" and his refusal to vote in support of the membership of her friend (and former Hunt student) Maria Oakey.[8] La Farge and Whitman, however, seem to have enjoyed an amicable relationship.

No correspondence survives between them, but late nineteenth-century Boston's art and literary community was a small, insular dominion, where each person knew everyone else, if indeed they were not related by blood or marriage. Whitman and La Farge could not have avoided one another even had they tried. In the mid-1870s, one of the most important artistic undertakings in Boston was the construction of a new home for Trinity Church, the principal Episcopal congregation, to replace the crenellated Gothic building on Summer Street that had been destroyed in the Great Fire of 1872. H. H. Richardson, the architect, worked closely with rector Phillips Brooks to create a sumptuous basilica decorated on the interior by a group headed by their friend John La Farge. La Farge had studied in France with Couture in the mid-1850s; in New York in 1858, he established his studio in the newly opened Tenth Street Studio Building, designed by William

20. John La Farge, *Agathon to Erosanthe, Votive Wreath*, 1861

Morris Hunt's brother, architect Richard Morris Hunt, who also had accommodations there. In 1858, La Farge moved to Newport, Rhode Island, to study painting with William Morris Hunt and six years later he was living temporarily in Roxbury, studying with Rimmer and crafting decorations for the Freedland House on Beacon Street. Before Whitman's election to the Society of American Artists in 1880, La Farge had exhibited extensively in Boston and sold many paintings and watercolors to local collectors; he had lectured on art at Harvard; designed stained glass windows for Memorial Hall; and become a founder of the Museum of Fine Arts, where he lectured informally on art and decoration. His Boston connections and influence soon became comprehensive, intersecting often with Whitman's.

Whitman may have become acquainted with La Farge in Newport, where she painted before 1882, or in Boston, where she is said to have been part of the army of assistants who worked on the decorations at Trinity. Her portraits came to include a number of mutual friends, including William James, Martin Brimmer (founder and president of the Museum of Fine Arts), Henry Lee Higginson (one of La Farge's important patrons), and Phillips Brooks, in whose church Whitman was an active parishioner. Whitman's portrait of Brooks (collection of Trinity Church) was complete by May 1881, when Brooks wrote to Whitman that he "had no right to be painted as nobly as this."[9] That same year, Whitman and Brimmer corresponded about La Farge's stained glass window, *Peonies in the Wind* (1879, Metropolitan Museum of Art), which was on display at the Museum of Fine Arts. Whitman admired La Farge's work and eventually owned four of his paintings, while many others were held in Boston collections, including *Agathon to Erosanthe* (fig. 20).[10] Whitman's *Roses—Souvenir de Villier le bel* (pl. 7), with its gem-like blossoms isolated against a rough wall incised with text,

recalls La Farge's composition. The two artists also shared a delight in rich, suffused color, color that manifested itself not only in paintings, but also in stained glass and architectural decoration.

~ ~ ~

Whitman's first known assignment for decorative work was to ornament the interior of the Central Congregational Church in Worcester, Massachusetts. The pastor, Daniel Merriman, was the husband of Whitman's friend and fellow painter Helen Bigelow Merriman, who played a major role in the commission. According to an unidentified newspaper clipping, La Farge had been invited to decorate the church, but was "too busy to give the matter proper attention." Helen Merriman then suggested Whitman, "who went into the work with great fervor," designing not only the stained glass windows but also the wall decorations and the gold leaf ceiling.[11] Thus began a second career for Whitman, who soon became more acclaimed for her glass than she ever had been for her easel paintings. She provided windows (and often more comprehensive interior designs) for churches in Boston, Andover, Massachusetts, and Kennebunkport, Maine; for the parish house at Trinity Church (a memorial to Phillips Brooks, pl. 8); for Berwick Academy and Bowdoin College in Maine; for Groton School in Massachusetts; and for Memorial Hall at Harvard. She also created independent compositions in glass, including decorative panels and fire screens (see fig. 21).

To complete these monumental designs, Whitman established herself in a studio, called the Lily Glass Works, at 184 Boylston Street, near Park Square, where she employed a foreman and a number of cutters and glaziers. Although several contemporary accounts describe Whitman as an acolyte of the English Pre-Raphaelites, she was adamant about the superiority of American glass-making to that of the English. Writing in *The Nation* in 1892, she explained that American glass-makers (herself included) preferred to create their motifs by exploiting modulations in the colors and thickness of the stained glass itself, rather than by depending upon paint applied to the surface of the glass and the dark outlines of the leading as the English did.[12] If her doctrine of truth to the nature of her materials suggests the principals of the Arts and Crafts movement, it will come as no surprise that Whitman was a founding member of the oldest Society of Arts and Crafts in the United States, chartered in Boston in 1897.

Whitman's stained glass is often representational, reminiscent of the work of La Farge. Using many layers of material fused together to create rich, translucent color effects, Whitman created paintings in glass, often incorporating allegorical or religious subjects. For Memorial Hall at Harvard, for example,

21. Sarah Wyman
Whitman, *Firescreen*, 1896

Whitman designed a large window to commemorate the Harvard men who had
been lost in the Civil War. The window was commissioned in 1895 by Whitman's
friend Martin Brimmer, who died the next year. Whitman thus came to memorial-
ize Brimmer as well, and in her design she combined decorative angels and his-
torical figures symbolizing the dual roles of soldier and scholar. Her rose window
was intended to communicate God's glory in color, said Whitman.[13] To achieve a
particularly striking effect, she repeated juxtapositions of complementary tones
throughout, setting close together blues and oranges, violet reds and greens, and
so forth. La Farge also made use of color theory, but the scientific examination
of color was common to many artists during the 1890s, among them the Boston-
based painter, theorist, collector, and Harvard associate Denman Ross. Yet La
Farge's influence is undeniably present in Whitman's pictorial glass.

Whitman also became well known for another, more modern style of design
in which clear panels work as windows—thus the format of the piece acknowl-
edged its function. Charles Connick, later a leading glass manufacturer in
Boston, recalled that Whitman was among the first artists to move toward designs

"more clearly related to architecture."[14] One example, dedicated by Whitman's Sunday School class at Trinity Church to its late rector, Phillips Brooks, was commissioned in 1895 (pl. 8). Whitman employed panes of clear glass decorated with small irregular chunks of colored glass at each corner, nuggets that she described as "jeweled flowers."[15] The central panel features an opalescent shield bearing a laurel wreath inscribed to Brooks. Here, Whitman's work points toward a much more modern aesthetic for stained glass, one that would be adopted early in the twentieth century by such artists as Frank Lloyd Wright.

22. *Mary Crease Sears at the bench in the finishing-room in her bindery,* about 1908

Boston, with its many publishing houses, played a leading role in the art of the book in the late nineteenth century, and during the 1890s, Sarah Whitman became one of the most celebrated book cover designers in the United States. She began creating covers in about 1884, and by 1887, she was a principal designer for Houghton Mifflin, who valued her work enough to feature it in their advertisements.[16] Whitman helped to establish the medium, long the domain of die-cutters and binders, as a suitable specialty for artists, thus ushering in a new era in American design. She worked almost exclusively for Houghton Mifflin, which (along with Copeland and Day) offered some of the most avant-garde designs available. Whitman produced about three hundred book covers, including almost all of the designs for her friend Sarah Orne Jewett's novels. Soon a number of Boston women were crafting books, including Mary Crease Sears and Amy Sacker (figs. 22, 23, and pls. 11, 12).

Whitman's cover designs are characterized by their elegant simplicity and grace (pls. 9, 10). She most often crafted stylized flowers or sinuous linear patterns on a monochromatic cloth or leather background. Her best-known book cover, an 1894 design for her friend Celia Thaxter's *An Island Garden,* employs ornamental poppies whose attenuated stems end in hearts, Whitman's signature.

23. *Amy M. Sacker*, frontispiece from *The Book Plates of Amy M. Sacker*, 1903

An Island Garden was available in two versions, a deluxe white and a leaf green cloth, both stamped with gold (pl. 9). While publishers often enjoyed the financial rewards of producing a limited, deluxe edition, Whitman also was committed to creating appropriate designs for mass-market books. In an address to the Boston Art Students' Association, Whitman advised her audience "to think how to apply elements of design to these cheaply sold books; to put the touch of art on this thing that is going to be produced at a level price."[17]

If Whitman's refrain sounds familiar, it is because its melody was drawn from the Arts and Crafts movement. As early as 1849, the English critic John Ruskin had declared in his *Seven Lamps of Architecture* that ornament should be derived from nature and be consistent with the character of the materials from which it was made. By the 1870s, in the hands of William Morris and others, these ideas were applied extensively to the decorative arts. There was a widespread movement to improve the quality of industrial design, to bring good art into everyday life, and many of the art classes that were offered in America after the Civil War were intended to train workers for practical careers in industry. When the Society of Arts and Crafts was founded in Boston in 1897, its first president was Charles Eliot Norton, the distinguished professor of fine arts at Harvard, who was a friend and devotee of Ruskin's. "The Society of Arts and Crafts," Norton wrote, "endeavors to stimulate in workmen an appreciation of the dignity and value of good design It will insist upon the necessity of sobriety and restraint, of ordered arrangement, of due regard for the relation between the form of an object and its use and of harmony and fitness in the decoration put upon it." Fifteen years earlier, in an article calling for art education in America, Sarah Whitman had declared the need for "the student who sees that in all beauty, fitness is a prime condition."[18] Whitman, a friend of Norton's, was not only a founding member of the Society of Arts and Crafts, but she also, as a craftsman member, exhibited there regularly and was a champion for its cause.

"She was an intense woman," recalled her friend Henry Lee Higginson. "She disliked ugly or unfit objects of daily use ... she was fond of jewels and fine-bookbinding and, in general, of beautifying everyday life."[19]

Three days before the opening of the inaugural exhibition of Boston's Society of Arts and Crafts, the *Springfield News* published a lengthy article entitled "Women of Talent: Their Work in Industrial Art." The author noted that women had "devoted their talent and taste to greater and more remunerative lines of art work, and they have now not only a footing, but are recognized as leaders." After a lengthy account of Whitman and her stained glass studio, the article declared that "it is the fact that such women as Mrs. Whitman are doing real, valuable work in the world to-day that gives intrinsic value to women's work everywhere and stimulates and inspires others who must and do work."[20] The article is interesting not only for its description of Whitman as an artist, but also for its enthusiasm for "women's work," here clearly defined as art, and particularly decorative art. Within the Arts and Crafts movement, women would find unprecedented opportunity to fulfill their creativity.

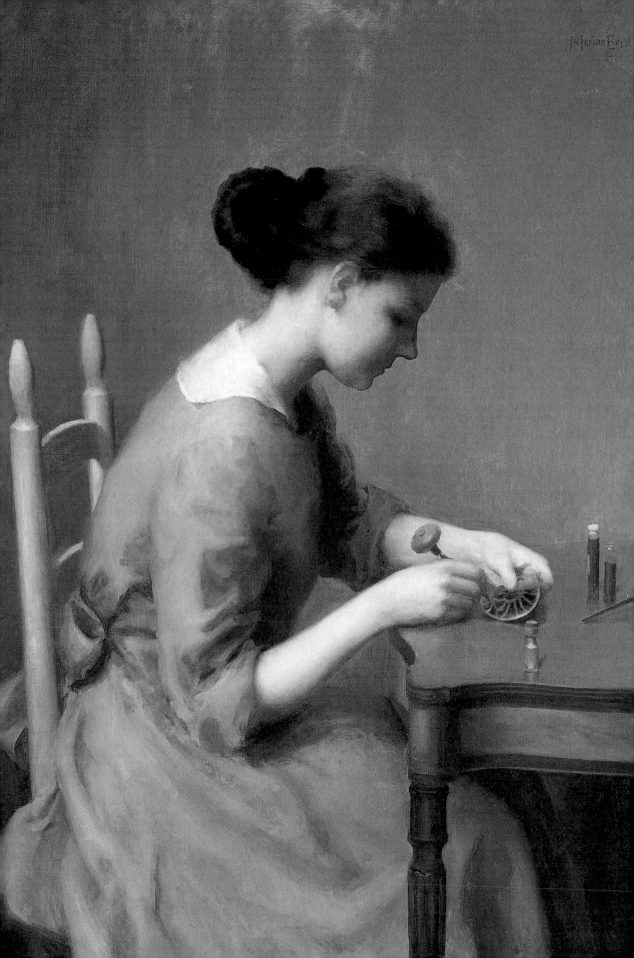

As Americans embraced the Arts and Crafts movement, placing high spiritual and ethical values upon art, creative women won an approved context for their calling. The success of women artists within the movement was related directly to its domestic nature. The world of the home was held to be a woman's realm, just as the world of work was most often defined as masculine. Within the home, a woman could cultivate any number of skills under the guise of improving the intellectual and moral standards of her family, standards for which women were responsible.

Women's artistry was often linked to moral or social causes, inspiring and enabling them to make all manner of objects in support of such goals as abolition, suffrage, education, assistance for the poor, war relief, and so on. Upon such feminine canvases as the quilt and the sampler, women could, and often did, express political beliefs in a manner that was not held to challenge the male hegemony, even if the objects they made left the privacy of the home and were sold to the public. Sarah Grimké, the sister of Angelina Grimké Weld, the first woman to address the Massachusetts Legislature, hoped that "the points of our needles [will] prick the slave owner's conscience" as she organized sales of fancywork in support of abolition.[1] Later, the painter Elizabeth Howard Bartol, who most often exhibited portraits and figure studies, created posters for the New England Hospital for Women and Children, while Laura Coombs Hills designed posters, programs, and dozens of inventive costumes for the annual pageant to benefit the Women's Educational and Industrial Union (pls. 13, 14). During the first World War, charity

24. Marion Boyd Allen, *The Enameler* (detail), 1910

exhibitions to raise money for Belgian refugees provided many women artists with venues to show their work. Here art was linked to a nobler cause than commerce.

In the 1870s and 1880s, art was given impressive power to raise American culture from base materialism to a higher plane of spiritual and moral truth. With this potency, art was not to be confined to the walls of galleries and exhibitions, instead it infused every aspect of domestic life. An artful home could restore and inspire, and it became the duty of American women to furnish such opportunities for their families. Those who needed assistance were provided with volume after volume about appropriate decoration for the household and how-to books about china painting, metalwork, and artful arrangement (written by both men and women). Bostonians, widely considered, at times almost to the point of ridicule, to be well versed in both social causes and civilization, were credited with an unconscious talent for creating an uplifting environment, as Henry James described in 1885–86 at the beginning of *The Bostonians*, when the handsome southerner Basil Ransom first comes to call on Olive Chancellor:

> The artistic sense in Basil Ransom had not been highly cultivated; neither (though he had passed his early years as the son of a rich man) was his concep-tion of comfort very definite; it consisted mainly of the vision of plenty of cigars and brandy and water and newspapers, and a cane-bottomed chair of the right inclination, from which he could stretch his legs. Nevertheless it seemed to him he had never seen an interior that was so much an interior as this queer corridor-shaped drawing room The general character of the place struck him as Bostonian; this was, in fact, very much what he had sup-posed Boston to be. He had always heard Boston was a city of culture, and now there was culture in Miss Chancellor's tables and sofas, in the books that were everywhere, on little shelves like brackets (as if a book were a statuette), in the photographs and water-colours that covered the walls, in the curtains that were festooned rather stiffly in the doorways.[2]

James went on to characterize Olive Chancellor's home as a "feminine nest," and within that domestic dominion, women were able to create both individual objects and also complete environments, assemblages that became, like Isabella Stewart Gardner's Fenway Court, works of art in and of themselves.

The fields in which women excelled were often the same areas that had tra-ditionally been recognized as female: needlework, fabric design, ceramics, and decoration. Women embraced the opportunity to create such objects, now elevat-ed to the plane of art, not only for themselves but for others. The popularity of the Arts and Crafts movement and its emphasis on the artistic home provided cre-ative women with a socially acceptable milieu in which to produce their work and sanctified their artistic expression. Certain traditionally "amateur" feminine pur-

suits—not only needlework and decoration, but also pastel and watercolor painting, which now attracted many male artists as well—were raised to a new level of distinction in the aesthetic hierarchy, muddling the definition of the professional artist and helping to bring women skilled in those media onto the public stage.[3]

The ideals that guided the women of Anglophilic Boston in the Arts and Crafts movement were naturally inspired by similar practices in England. The most direct connection came in the person of Walter Smith, a graduate of London's South Kensington School and a devoted enthusiast of the practical application of art to industry. Smith was hired by the Boston School Board in 1873 to become the first director of the new Massachusetts Normal Art School, an institution inspired by the English industrial art movement that attracted many women students (see fig. 48). In his book *Examples of Household Taste*, Smith remarked that women should "employ their leisure in refining and elevating pursuits," noting that the elaborate, monumental embroideries produced by the Royal School of Needlework, which had been exhibited at the Philadelphia Centennial Exposition, provided an appropriate model for women to follow.[4]

While Smith's call for artistic activity among women was inspirational, his further recommendation to "give American women the same art facilities as their European sisters and they will flock to the studios and let the ballot-box alone"[5] indicates that he apparently hoped artistic opportunity would keep women suitably occupied, thus preventing them from causing any serious social upheaval. The promotion of craft, or "decorative" art, for women in contrast to the "high" or "fine" arts of painting and sculpture, was a more subtle manifestation of the same politically conservative point of view. Decorative art, no matter how ambitious, was related to the home and to domesticity, while fine art required commercial interaction, either private (between artist and sitter) or public (between artist and art market). In consequence, women involved in crafts were thought to be much less likely to upset the traditional social order, and their efforts generally were encouraged and well received.[6]

In England, Arts and Crafts societies were often dominated by men, and men usually took the role of designer while women worked according to their specifications. This pattern was established both in working-class factories and in the upper-class workshops of such artisans as William Morris. The situation in New England was somewhat different. The membership of Boston's Society of Arts and Crafts was almost fifty percent women; in the 1907 show celebrating the organization's tenth anniversary, fully two-thirds of the exhibitors were female. Women produced basketry, book bindings, jewelry, leatherwork, metalwork, pottery, printing, stained glass, and textiles, and in many media they outnumbered

and overshadowed the men.[7] Nor were women restricted to the execution of designs created by men, even outside of the rarified world of artisan-crafted objects. Although such prominent firms as the Grueby and Dedham Potteries employed women as decorators, but apparently not often as designers, others were more inclusive. Sarah Whitman's designs for Houghton Mifflin were produced by male and female artisans at the Riverside Press, while women also worked as designers for Copeland and Day and the Paul Revere Pottery, among others.

<p style="text-align:center">☙ ☙ ☙</p>

The link between social reform and the Arts and Crafts movement had been formed at its inception. In New England, one of the most successful of such enterprises took place in rural Deerfield, Massachusetts, where the New York artists Margaret Whiting and Ellen Miller founded the Society of Blue and White Needlework. The project began as a historically minded attempt to collect eighteenth-century examples of the craft, but Whiting and Miller soon began to recruit local women to produce new textiles using traditional dyes and embroidery styles. In so doing, they not only preserved their colonial heritage, but, in consultation with Emily Balch, an economics professor at Wellesley College, they also revived the local economy, transforming a failing agrarian community into a productive, successful crafts center that eventually produced objects in both traditional and modern styles.[8]

There were urban equivalents to such activities, and Boston women once again took a leading role. Lace-making, a craft revived in Europe during the late nineteenth century, provided an appropriate product for Boston's Italian immigrant women to sell. Their efforts were encouraged at Denison House, a South End settlement founded in 1892 by a group of professional and upper-class women as a social and community center; classes in lace-making were offered there as early as 1908 (fig. 25). Lace made by Italian women had already been exhibited at the Society of Arts and Crafts in Boston, and the subsequent embrace of the craft by settlement houses and other such organizations is particularly interesting for its unusual acknowledgement of the benefits of individual cultural identity rather than homogenous nationalism. Many writers have explored the Arts and Crafts movement (which in New England had particularly close ties to the Colonial Revival) as an attempt to affirm upper-class Anglo-Saxon values and to impose them upon an immigrant culture that was becoming increasingly—and to some, threateningly—powerful. This interpretation of the movement, as an attempt to "Americanize" the lower classes and to preserve the political status quo, should not be disregarded. There were other points of view,

25. Denison House Lace Sample Book, about 1915. The lace samples collected here were made by several Italian women who were involved in the settlement house.

however. Writer Vida Scudder, for example, a founder of several settlement houses, president of the Circolo Italiano at Denison House, and a professor of literature at Wellesley, wrote of her hope to "guard against the 'melting-pot' melting out the best and leaving the dross to be fused into our national character—let us help save as much as possible."[9]

Scudder's sentiments were quite different from those that motivated another artistic enterprise dedicated to Boston's immigrant women, the Saturday Evening Girls. The Saturday Evening Girls began in 1899 as a club for young immigrant women, particularly Jewish and Italian girls from Boston's North End. The initial objective of the association was to educate and to Americanize them, with the intention of improving their economic potential. It was acknowledged that these were women who would need to work, and art pottery was established as an appropriate vocation for them to undertake. The sponsors of this organization were three women; Edith Guerrier, Edith Brown, and Helen Osborne Storrow. Guerrier and Brown, who both had studied at the School of the Museum of Fine Arts, provided the artistic underpinnings of the venture, while Storrow, whose family included a number of active suffragists (including her great aunt, Lucretia Mott), gave financial support. The club moved from North Bennett Street to larger quarters on Hull Street in 1908, and their new proximity

26. Paul Revere Pottery of the Saturday Evening Girls' Club, *Tortoise and Hare Motto Bowl and Plate: The Race is Not Always to the Swift* and *The Battle is Not Always to the Strong*, 1909. Instructive sayings were often painted on children's pottery.

to Old North Church inspired the name Paul Revere Pottery. Their wares were sold both at the Society of Arts and Crafts and through department stores, but the operation was largely underwritten by Mrs. Storrow, who was also one of the shop's most important patrons.

Paul Revere Pottery produced dinnerware, children's nursery sets, and some larger-scale exhibition pieces that were shown at the Society of Arts and Crafts beginning in 1916 (see pls. 15, 16). The nursery sets, an obviously appropriate undertaking for a women's association, were especially popular. Often personalized for the owner, they were most often decorated with simple animal motifs, although occasionally children's poems or instructive mottoes also appear (fig. 26). Edith Brown provided most of the designs for the shop, and when the pottery moved to Brighton, Massachusetts, Brown also planned the new quarters, creating a manufactory that looked like an English country house surrounded by gardens.[10]

Many of Boston's creative women produced their art alone, however, and they worked in many media. Boston never developed the ambitious school of women woodcarvers and furniture makers that Benn Pitman founded in Cincinnati, but woodcarving was taken seriously nevertheless. Classes were offered at various institutions, most notably the short-lived course at the School of the Museum of Fine Arts that was sponsored in 1879–80 by the Women's Educational and Industrial Union. In 1911, wood carving was added to the curriculum at the Massachusetts Normal Art School. Molly Coolidge (later Perkins),

who had studied modeling and design at the MFA School and joined the Society of Arts and Crafts before her marriage, produced and exhibited carved and decorated candlesticks, medallions, and cabinets (see pl. 17). Martha Page produced similar objects and also crafted decorative frames and screens, while Madeline Yale Wynne is known to have carved and decorated small oak chests.[11]

Many more Boston women were known for their activities as metalworkers and jewelry makers than as woodcarvers. Madeline Wynne, the daughter of the inventor of the Yale lock, credited her interest in crafts and metalwork to her early years in her father's shop (fig. 27). She studied painting at the School of the Museum of Fine Arts in 1877 and taught drawing there for a number of years. In 1885 she bought a house in Deerfield, where she became a vibrant part of that artistic community, establishing herself in two separate studios, one for painting and one for metalwork. "I consider each effort by itself as regards color and form," she wrote of her jewelry, "much as I would paint a picture."

A specialization in articles of personal adornment was considered an appropriately feminine approach to metalwork. A writer for *The Craftsman* noted that women's designs were well informed and suitable "as no man with his knowledge of the intricacies of woman's mind and gowns could ever think to make."[12] Jewelry making did not require a large studio, and its small scale was in keeping with women's dexterity, a gender difference that became especially evident in an age that witnessed the advent of the typewriter. In the tenth anniversary exhibition of the Society of Arts and Crafts, thirty-four of the forty-seven exhibitors of jewelry were women.

Madeline Wynne made jewelry of all kinds, and her work was deliberately primitive (see pls. 18, 19). Its handmade characteristics, including asymmetry and hammer marks, were emphasized, thus distinguishing and ennobling it from any base object produced by machinery. Wynne favored designs that featured the natural properties of her materials and she often used such common components as copper and unpolished pebbles. It was her design that was paramount, not the richness or rarity of precious metals and gems, and her work was characterized as "original, gorgeous, [and] barbaric."[13]

Less barbaric but equally dedicated to artistic design are the works of Josephine Shaw and Elizabeth Copeland, both of whom were fellow metalworkers of Wynne's at the Society of Arts and Crafts. Shaw studied at the Massachusetts Normal Art School in the late 1890s, and in the early 1900s turned her attention from metalwork to jewelry making. She favored rich materials, including precious stones and pearls set into delicate and intricately wrought metals like gold and platinum. She earned distinction as a contemporary artist when two of her pieces

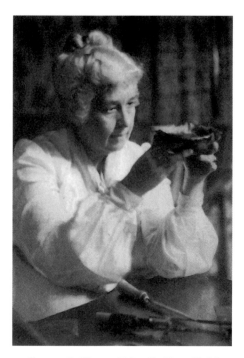

27. Frances S. Allen and Mary E. Allen, *Madeline Yale Wynne*, 1908–10

were purchased by the Museum of Fine Arts in 1913 (see pl. 20); the following year she won a medal for excellence at the Society of Arts and Crafts. That she was recognized as a serious craftsperson is reinforced not only by her prizes and honors, but also by the fact that she took on apprentices, and male ones at that—her most successful pupil was Edward E. Oakes, who also became a renowned jeweler.

Like Shaw, Elizabeth Copeland was known for her exquisite jewelry (see pl. 21). Copeland's predilection for enamel, however, was considered exceptional for her sex, as Irene Sargent reported: "The traditional figure of the enamelist … is masculine … Miss Copeland working at her furnace … possesses attractions quite other than those belonging to the woman who paints a portrait or who illustrates a book."[14] It was no doubt the furnace that brought Copeland out of the feminine realm; her art could not be achieved within the context of the home despite representations, even by women artists, which implied that enameling was a domestic and ladylike activity (see fig. 24).

Copeland had received her early training in decoration at the Cowles Art School in Boston, where she studied with Amy Sacker, one of the city's most prolific illustrators and designers and an inspiring teacher who later founded her own school (see pl. 12). Copeland supplemented her education with a course in metalwork from Laurin Martin. With the sponsorship of her fellow student, the artist and collector Sarah Sears, Copeland traveled to England in 1908. There she is thought to have studied with the famed London enameler Alexander Fisher, once Martin's own instructor. It is tempting to think that Copeland might also have met the London silversmith Edith Dawson, a watercolorist who turned her skills to enameling in the late 1890s. Dawson's inventive enameling techniques and her interest in the rich gem-like effects achieved with transparent colored enamel would doubtless have appealed to Copeland, who was already well

known for her own "color-sensations."[15] Soon after her return, Copeland was elected to master status at the Society of Arts and Crafts.

While she excelled as a jeweler, working in silver, precious stones, and enamel, Copeland is best known today for her enameled silver boxes (see pl. 22), objects that she began to undertake more and more frequently. Her richly decorated reinterpretations of medieval covered caskets often employ organic motifs of birds and flowers suffused with the dense jewel-like tones of her enamels. Like Wynne, Copeland celebrated the irregularities and asymmetries of her work, qualities that emphasized the individuality and handmade craftsmanship of her art.

Woodwork, pottery, metalwork, and textile design dominated the exhibitions at the Society of Arts and Crafts. These were traditional media that, despite the advent of machine-made goods, had a long history of hand workmanship. With the talent of a skilled maker, they could rise to the status of art. But the Society also embraced new forms of art-making, including photography, miniature painting, and poster design. Here too, women artists played leading roles.

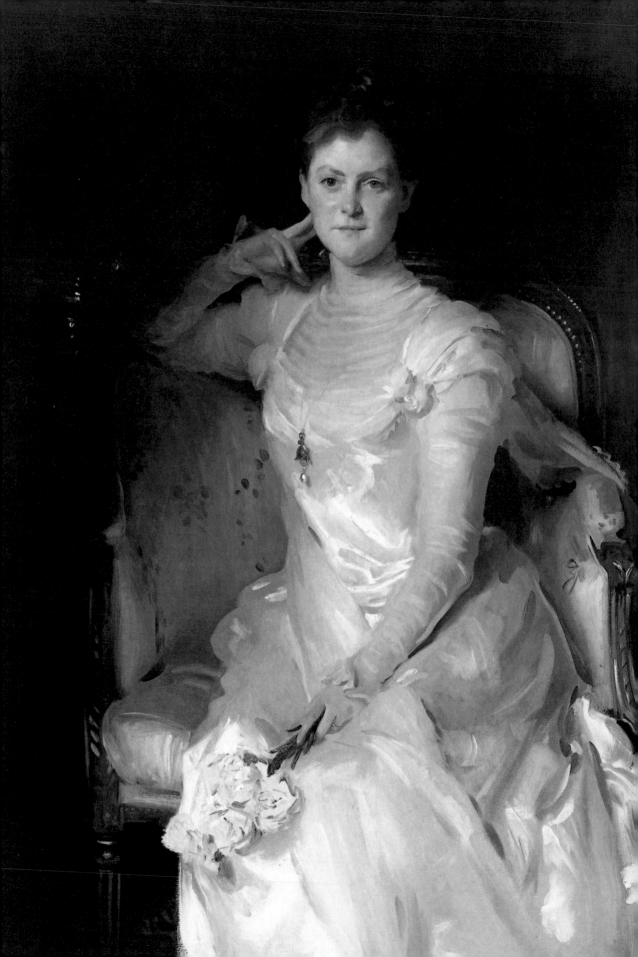

REDEFINING FINE ART: Sarah Sears, Laura Hills, and Ethel Reed

Sarah Choate Sears, who had been Elizabeth Copeland's sponsor, was a talented artist in a variety of media and an innovator in a new form of expression, photography. She was one of two women on the first board of the Society of Arts and Crafts, along with Sarah Wyman Whitman (the group's vice president). The wife of one of Boston's wealthiest real estate investors, Sears had long been interested in both making and championing art. Not only did she support Copeland, whom she had met in Martin's metalworking class, but she had also subsidized Maurice Prendergast's first trip to Italy in 1898. Sears firmly believed in allowing gifted artists an opportunity to enhance their education by traveling and studying in Europe.

Sears had studied painting with the young French-trained artist Dennis Miller Bunker at the Cowles Art School in 1885, worked informally with Abbott Thayer and George de Forest Brush, and attended the Museum School from 1889 to 1891. Her art interests were liberal in all senses of the term—she assembled a collection that was one of the most progressive in the city, which included works by Edouard Manet, Paul Cézanne, and Charles Demuth in addition to the more typical Bostonian choices of Millet, Monet, and La Farge. She embraced contemporary art and artists in a variety of media, and she befriended Mary Cassatt, Dennis Bunker, Edmund Tarbell, John Singer Sargent, Maurice Prendergast, F. Holland Day, and Gertrude Käsebier, buying examples of their work. As an artist herself, Sears first earned recognition for her watercolors, winning significant prizes for her figural work throughout the 1890s. By 1897, she was also working in pastel, embroidery, metalwork, and, perhaps most significantly, in photography.

28. John Singer Sargent, *Mrs. Joshua Montgomery Sears (Sarah Choate Sears),* 1899

Like many of the art forms featured at the Society of Arts and Crafts, photography was considered a proper medium for women, and it was actively marketed to them by film and camera manufacturers, whose advertisements frequently depicted women as photographers. With the development of dry plate negatives, celluloid roll film, and hand-held cameras in the 1880s, the cumbersome technology of early photography was eliminated and the medium became much easier and more accessible. George Eastman's "Kodak Girl" soon became the company's new symbol; her carefree presence implied not only the spirit of the wholesome, optimistic, typically American "girl" that was the emblem of a new age but also the simplicity of the camera itself—everyone could use it. Women's magazines promoted it, offering articles and helpful hints. In 1897, *The Ladies' Home Journal* espoused photography not only as a suitable hobby for women but also as a profitable business undertaking when it published photographer Frances Benjamin Johnston's suggestions for professional pursuits, "What a Woman Can Do with a Camera," in its September issue.

With this kind of marketing and endorsement, women eagerly involved themselves in photography. Some, like Molly Coolidge, took photographs purely for pleasure, creating aesthetic images that were never meant for display (Collection of Strawbery Banke Museum, Portsmouth, NH).[1] Other women worked both as studio and commercial photographers and as artists. By 1899, the journal *American Amateur Photographer* proclaimed that "photography is becoming more and more recognized as a field of endeavor particularly suited to women." The author noted women's "inborn artistic feeling," and suggested that the feminine traits of "cleanliness and patience" as well as a "delicate touch" made women "peculiarly fitted to succeed in this work."[2] Photography was further lauded as an appropriate physical activity, as the women's magazine *Cosmopolitan* remarked, photography was "an incentive to good health" and that "many a ruddy cheek there is whose hue has been won on long camera tramps, many an elastic step which would have been slow and halting, many a spirit dull and languid, but for the leading of this lens."[3]

༄ ༄ ༄

Sarah Sears led the lens as much as it led her. As a key member of the Society of Arts and Crafts, she promoted photography there, and the medium played a significant role in the early years of the group. Sears's work was included in the organization's first exhibition in 1897; she was the only woman of the four photographers represented. Along with her friend F. Holland Day, she was a firm believer in the artistic potential of the photograph, and together they promoted it as an aesthetic medium. The Society's emphasis on craftsmanship and hand-

work was well suited to photographers like Sears and Day, who sought to prove that making photographs could involve those very same properties. Like other pictorialist photographers, both felt that the medium had the potential to become fine art; their doctrine held that photographic images were not necessarily created merely by happenstance and a machine, but instead were deliberately executed by an artist.[4] The Society of Arts and Crafts was also a necessary alternative to them at a time when the medium was excluded from museum exhibitions (the first photography show at the Museum of Fine Arts was held in 1901). Photography was also promoted by the Boston Camera Club, which took as its mandate the encouragement of "the scientific study of the art," a careful semantic choice that allowed for either a mechanical or an aesthetic point of view.[5] That the club invited local painters to serve as jurors for its exhibitions, however, reveals their interest in promoting photography as a fine art. The Old Cambridge Photographic Club, across the river, provided further opportunities for community and display, and women were actively engaged in both organizations.

Sarah Sears, who joined the Boston Camera Club in 1893, began making photographs at the same time as she was painting and exhibiting regularly as a watercolorist; in both media she crafted elegant portraits and artful still lifes (pls. 23–25, 27, 28, figs. 29, 31). Her photographs seldom employ the classicizing props or atmospheric gum printing techniques favored by many of her local contemporaries, including Day and Mary Devens. Instead, Sears's approach was more straightforward and direct. She showed her work at the Boston Camera Club, the Society of Arts and Crafts, the Philadelphia Photographic Salon, and with Alfred Stieglitz's Photo-Secession group in New York. In 1900, F. Holland Day included five of Sears's photographs in his important London exhibition "The New School of American Photography"; that same year her work was seen in Frances Benjamin Johnston's display of American women photographers in Paris. Sears was also invited to become a member of the British pictorialist group, "The Linked Ring."

The ardent embrace of Sears's efforts by the leading photographers of her day was not due simply to her ability to help their cause through her own comfortable economic circumstances, but equally to the quality of her work. In her notes pertaining to the exhibition she organized in Paris, Frances Benjamin Johnston remarked that Sears was "an artist of marked ability—[a] strong conscientious amateur." The term "amateur" was often a compliment in photography circles, where it retained its original French definition, derived from the Latin "to love." "Amateur" implied that the maker was a lover of photography, an individual artisan and connoisseur, while "professional" photographers were often

29. Sarah Choate Sears, *Untitled (Young Woman with Lilies)*, about 1895

30. Mary Devens, *A Charcoal Effect (Portrait of Charles Hopkinson)*, 1900

defined as those who produced studio portraits, commercial views of famous monuments, or trade pictures for merchandising. For her own part, Sears confessed to Johnston that she took photographs "for an amusement—and have never taken any lessons. I am interested in artistic things."[6] Although Sears may not have taken classes in photography, she had studied painting, and that lent her even more credibility among those photographers who sought to have their work accepted as art. Her friendships with such accomplished photographers as F. Holland Day and Gertrude Käsebier no doubt led to informal technical and stylistic discussions, but her approach to portraiture was also honed by her association with such talented figure painters as Cassatt and Sargent.

Early in 1899, Sarah Sears was given a solo exhibition at the Boston Camera Club. The review in *Photo-Era*, the club's journal, praised Sears's display as "markedly one of the work of an artist. The subjects, almost all portraits, were treated from the artist's point of view." While stating that "the mastery of Dürer … [is] yet unassailable by the appliances of a photographer," the writer praised Sears's likenesses and her ability to capture character, and also emphasized the connection between Sears's photographs and "fine" art: "Some of the larger ones … had a peculiar and pleasing effect, as though they had been taken—not from life—

Plate 1
ANNE WHITNEY
Le Modèle, 1875, bronze

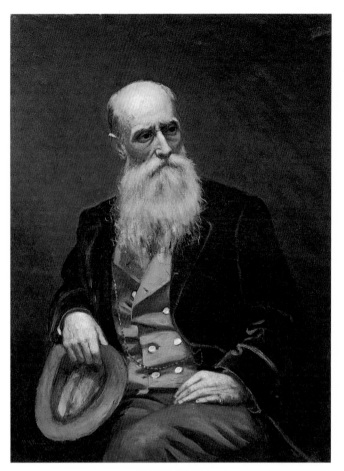

Plate 2
HELEN MARY KNOWLTON
Portrait of William Morris Hunt,
1880, oil on canvas

Plate 3
ELIZABETH OTIS LYMAN BOOTT
White Roses, 1884, oil on canvas

Plate 4
SARAH WYMAN WHITMAN
A Warm Night, about 1889, pastel on canvas

Plate 5
SARAH WYMAN WHITMAN
Niagara Falls, 1891, pastel on paper

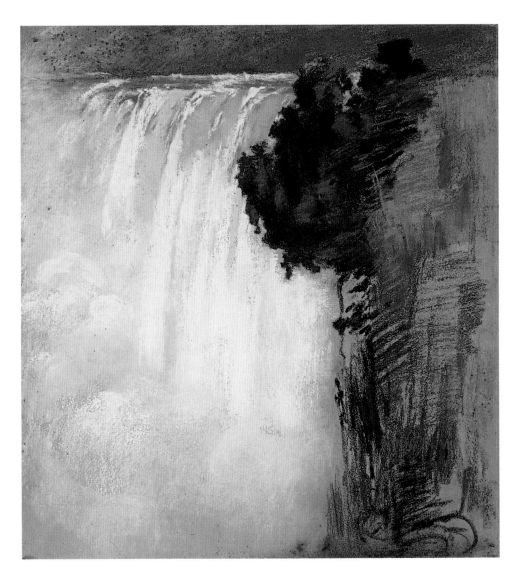

Plate 6
SARAH WYMAN WHITMAN
Niagara Falls, 1891, pastel on paper

Plate 7
SARAH WYMAN
WHITMAN
*Roses—Souvenir de Villier
le bel,* 1877–79,
oil on panel

Plate 8
SARAH WYMAN
WHITMAN
*Phillips Brooks Memorial
Window*, 1895–96,
stained glass

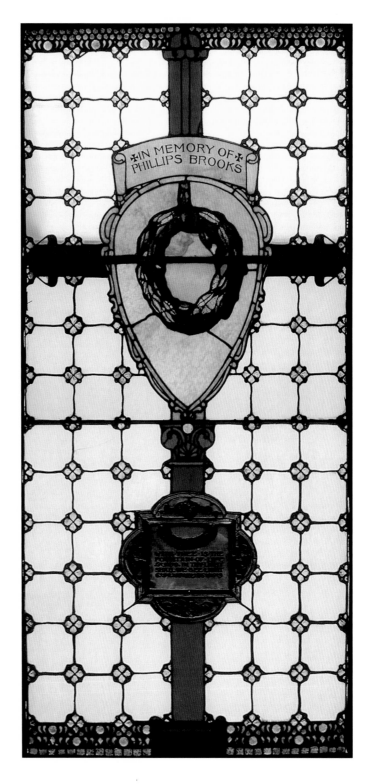

Plate 9
Sarah Wyman Whitman
Cover Design for "An Island Garden"
by Celia Thaxter, 1894

Plate 10
Sarah Wyman Whitman
Cover Design for "Cape Cod"
by Henry David Thoreau, 1896

Plate 13
ELIZABETH HOWARD BARTOL
Poster: New England Hospital for Women and Children Fair, 1896

Plate 14
LAURA COOMBS HILLS
Poster: Fairyland, An Enchantment, 1900

Plate 15
IDA GOLDSTEIN (for the Paul Revere Pottery of
the Saturday Evening Girls' Club)
Chrysanthemum Vase, about 1908, earthenware

Plate 16
Paul Revere Pottery of the Saturday Evening
Girls' Club
Rooster Bowl, about 1912, *Dancing Bunnies Pitcher*,
about 1911, *Pig Plate*, about 1910, earthenware

Plate 17
MOLLY COOLIDGE
Peacock Medallion, 1899,
carved, painted, and gilded
white pine

Plate 18
MADELINE YALE WYNNE
Belt Buckle, about 1900, hammered silver and turquoise

Plate 19
MADELINE YALE WYNNE
Watch Fob with Crystal Drop, about
1900, silver and crystal

Plate 20
JOSEPHINE HARTWELL SHAW
Brooch, about 1913, gold and
blister pearls

Plate 21
ELIZABETH ETHEL COPELAND
Brooch, about 1907, gold, turquoise,
and opal cabochons

Plate 22
ELIZABETH ETHEL COPELAND
Rectangular Box with Hinged Lid,
1912, silver, amethyst, and enamel

but from some fine painting grown dim with age … of the photographs of a young girl holding a lily, it may be said that their delicacy approaches that of a fine drawing" (fig. 29).[7]

The link so eagerly sought between "fine" art and photography was also strong in two of Boston's other most skillful women photographers, Alice Austin and Mary Devens, both of whom were included in Day's and Johnston's European shows. Austin had studied painting at both the Massachusetts Normal Art School and the School of the Museum of Fine Arts. Inspired and instructed by Käsebier, Austin specialized in portraits, noting that she hoped both to capture the personality of her sitter and to "turn out a photograph which may lay some Claim to Art."[8] Like Sears, she was affiliated with the Society of Arts and Crafts, and displayed her photographs there (pl. 26). Mary Devens, a friend of both Sears and Day and also a member of the Society, was greatly admired for her gum bichromate printing technique, a method that could be manipulated to enhance the photograph's resemblance to a traditional etching or charcoal drawing. During her 1900 exhibition at the Old Cambridge Photographic Club, her work was compared to Holbein (fig. 30), although the next year one British critic, who regarded manipulated prints with undisguised loathing, called her work "distinctly ugly."[9]

Devens crafted portraits and landscapes, while Austin was admired for her images of women and children. Of Sears, the only married member of this group, it is not surprising to note that her most frequent subject was her daughter Helen. Like many women artists who had families, she found artistic opportunities in her domestic environment, and she photographed Helen, born in 1889, from babyhood. Consciously seeking an artistic effect, she depicted Helen both nude, her slim body profiled against the light of an open door, and in elaborate costumes, isolated before a decorative backdrop. Sears's images reflect pictorialist photographs by her American peers, but they also relate closely to the romantic images of England's best known woman photographer, Julia Margaret Cameron. Sears greatly admired Cameron's work and owned at least forty-five carbon prints of her poetic photographs; her depictions of Helen entwined with flowers may have also been inspired by Cameron.[10] Some of Sears's images of Helen recall the portrait she commissioned her friend John Singer Sargent to paint in 1895, in one she even wears the same white dress and beribboned shoes (see figs. 31, 32). But to Sargent, there was no comparison. "Many thanks for sending me the photographs," he wrote to Sears in August 1895. "The new one of Helen has a wonderfully fine expression and makes me feel like returning to Boston and putting my umbrella through my portrait. But how can an unfortunate painter hope to rival a photograph by a mother? Absolute truth combined with absolute feeling," he explained.[11]

Sears's success as a photographer, combined with her energy as an organizer, her potential as a financial supporter, and her friendship with Day, eventually brought her into an ambiguous relationship with America's leading impresario of photography, Alfred Stieglitz. Stieglitz had become the vice-president of the prestigious Camera Club of New York in 1898 and edited its journal, *Camera Notes*. He sought to create an international reputation for the club and to make New York the center of the photographic world by starting a museum under its auspices. One year later, Sears challenged Stieglitz by encouraging F. Holland Day to inaugurate an important annual photographic exhibition in Boston. She approached Charles G. Loring, the director of the Museum of Fine Arts, to make arrangements for the display, and the museum agreed to sponsor it if Sears could enlist the support of an established organization. That meant mustering Stieglitz's aid, but Sears was unable to convince Stieglitz to help either his rival Day or a city outside New York. The effort was costly to Sears: in 1899, when she displayed six portraits in the second Philadelphia Photographic Salon, Stieglitz's loyal supporter Joseph Keiley denounced her work in *Camera Notes*, calling it inferior, the unprofessional product of "a $1,000,000 woman," as though Sears's money overpowered her art.[12]

Day eventually gave up his ambitions to lead a center of photography, and in 1904, Sears was elected a member of Stieglitz's new group, the Photo-Secession. Members of Stieglitz's circle came to praise her portraits; Stieglitz himself owned her likeness of Julia Ward Howe, and in 1904, the prominent critic Sadakichi Hartmann wrote of that image that Sears knew "precisely what she wanted to do and precisely what to leave undone in order to succeed …. In this art of 'omitting' Mrs. Sears is quite accomplished, and this is what gives to her prints their simplicity, their harmony, their breadth and unity of effect."[13] The following year, Sears wrote Stieglitz, "I have not been able to touch photography for many months, but I hope the time is not utterly over for me. I am going abroad for the winter—very soon—and shall be in Paris for some months, so there may be opportunity to learn something even if I do little."[14] Sears's recent inactivity as a photographer and her subsequent flight to Paris were caused by the prolonged illness of her husband, who died in June 1905. Left to manage two children and the Sears estate, she seems to have given up the serious pursuit of artistic photography, although she continued to make images of her family and friends and to support the New York group for a number of years.

During the time Sarah Sears spent in Paris, she maintained her commitment to art through her friendship with Mary Cassatt, who encouraged her to continue her activities as a collector. Cassatt also gave Sears a box of pastels (now

31. Sarah Choate Sears, *Helen Sears with Japanese Lantern*, 1895

32. John Singer Sargent, *Helen Sears*, 1895

owned by the Museum of Fine Arts, Boston), and in that medium, Sears renewed her artistic career. At one of her last solo exhibitions, held at Wellesley College in 1925, the student newspaper praised her both as artist and role model: "Let Wellesley students take note! A woman may, if she is sufficiently able, take her place in her generation as a professional, a social and civic leader, a patron of the arts, and as a wife and mother. Such is our answer to the critics of the Higher Education of women of fifty years ago."[15]

Sears's late pastels and watercolors (see pl. 28) reveal her interest in modern art, an enthusiasm her friend Cassatt did not share. Sears had introduced Cassatt to the renowned collector Gertrude Stein in Paris, and while Cassatt dismissed the experience as "dreadful," Sears went on to purchase modern still lifes by Cézanne, Braque, Matisse, and others. In her own compositions, which she dis-

played in Boston, Philadelphia, and New York, Sears created bold, cropped arrangements of flowers in glowing colors. She enhanced the vibrancy of her pictures by juxtaposing complementary shades, often using bright contours in a contrasting hue. Her still lifes frequently have no clear atmospheric setting; her bouquets explode across the sheet like fireworks.

☙ ☙ ☙

Sears's vivid and energetic pastels stand in marked contrast to the more sedate compositions of her exact contemporary, Laura Coombs Hills (fig. 33). Hills's most adventurous paintings, which include *Larkspur, Peonies, and Canterbury Bells* (pl. 29), also feature an array of flowers splayed across the surface of the composition, loosely arranged without a visible container. However Hills's delicate color harmonies and interest in botanical detail reveal a somewhat more conventional approach than Sears's. Hills, unlike Sears, was bound to the marketplace—she was a self-supporting artist who depended on sales for her livelihood. The commercial success of her floral compositions may have encouraged Hills (like many artists, both male and female) to experiment within a proven formula, keeping her work well within the boundaries of popular taste.

Hills was a year younger than Sears, but her artistic alliances were of an older generation.[16] She first studied art with Helen Knowlton and she exhibited her work as early as 1878, when she showed three paintings at the Boston Art Club along with Knowlton, Susan Hale, and Ellen Day Hale. Listed in the catalogue, these were landscapes of the area around her native Newburyport, but they cannot yet be identified with any of her extant work. The titles—"On the Merrimack," "Hillside," and "Willows"—indicate that Hills shared Knowlton's interest in the simple pastoral scenes that found their ultimate inspiration in the works of the French Barbizon School. *Sand Dunes* (pl. 30), with its curvilinear sweep of anonymous landscape and cloudy sky, belongs to this early body of work. One writer characterized such studies as "after the Sarah Orne Jewett style, which was a passion with Miss Hills once,—stretches of marsh-land and sand-dunes,—the estuaries of salt river mouths, with their peculiar weird desolateness."[17] The author may have been thinking of Jewett's novel *A Marsh Island* (serialized in the *Atlantic Monthly* in 1885), which took place in Sussex, a fictional town based upon Rowley and Essex, Massachusetts, both near Newburyport. The novel concerns a painter from the city who is improved morally and artistically by his contact with a farm family and their daughter, and it includes a nighttime passage across the forsaken marsh. What Jewett had painted in words, her good friend Sarah Whitman had rendered in pastel (see pl. 4) and it is clear that Hills

was familiar with them both. She also knew the work of Hunt and Millet, and something of the French painter's subtlety and delicate infusions of color can be seen in Hills's sensuous and deserted dunes. She showed similar landscapes, along with portraits and still lifes (all in pastel), in her first solo exhibition at J. Eastman Chase Gallery in 1889.

During the 1880s, Hills supplemented the income from her pastels, and may well have supported herself entirely, with decorative projects, all of a type considered appropriate for a woman who needed to work. She created valentines and other greeting cards for Louis Prang, made commercial patterns for needlepoint, provided designs for calendars and candy boxes, and drew pictures for the children's magazine *St. Nicholas*. She also illustrated Kate Douglas Wiggin's story *The Birds' Christmas Carol*, a book published commercially in 1887 to raise funds for Wiggin's work training kindergarten teachers. Hills's images (fig. 34), with their bright colors and foreshortened compositions, demonstrate her mastery of children's book illustration, and pioneer a style later made popular by the Philadelphia artists Jessie Wilcox Smith and Elizabeth Shippen Greene.

33. Laura Coombs Hills, *Self Portrait*, 1903

In 1890, Hills illustrated another children's book, Anna Pratt's *Flower Folk*. Her images provided her with the inspiration for the floral motifs of the posters, sets, programs, and costumes Hills designed two years later for the annual pageant held to benefit the Women's Educational and Industrial Union, an organization that provided community services to working women (see pl. 14). Hills's imagery for both of those projects has been described as an homage to Walter Crane, the popular English writer and illustrator, who had published a book entitled *Flora's Feast, A Masque of Flowers* in 1889. The Museum of Fine Arts hosted an exhibition of Crane's work two years later, and the artist spent about six weeks in Boston at that time. He later recalled that his original illustrations for *Flora's Feast* were especially admired, and that several had been sold to Boston collectors.[18] But while Hills no doubt admired Crane and may well have met him, her interest in costumes and pageantry was long established and had been made quite evi-

34. Laura Coombs Hills, *Christmas Morning,* illustration for Kate Douglas Wiggin's *The Birds' Christmas Carol,* 1889

dent some years before, when she had appeared as a gleaming, writhing snake in one of the annual festivals sponsored by the Art Students' Association.

In 1892 or 1893, Hills traveled to England, where she shared a country cottage with three other women (described in *Time and the Hour* as "girl-bachelors") in the real Sussex. Her activities in Europe are unknown, but it was in Britain that she became inspired to try her hand at miniature portraits on ivory. Upon her return, she painted her first seven likenesses, all young women of Newburyport, which she showed in the annual exhibition of the Boston Water Color Club in December 1893 (see fig. 35). She later recalled that since her childhood she had had an "obsession for small things," and that her attraction to miniatures was its natural result.[19] Her display was an unqualified success, and she immediately received orders for twenty-two miniature portraits, including one from Sarah Sears.

Hills's small paintings, like Sears's photographs, overlapped the boundaries between art and craft. Miniature portraits, so popular in the United States in the colonial and federal periods, had all but disappeared with the widespread use of

photography after 1839. Like weaving,
embroidery, and basketry, such portraiture
was perceived in the 1890s as one of the
forgotten arts of the eighteenth century
that merited reviving. The first large
group of antique portrait miniatures
entered the collection of the Museum of
Fine Arts in 1884, at about the same time
artists in both America and Britain began
to experiment once again with small-scale
work on ivory. These new miniatures were
also a reaction against the mechanization
of image-making, both by the camera and
by print-making processes. The photo-
graphic studio portrait and the illustrated
periodical allowed for the dissemination
of countless likenesses, but the Arts and
Crafts movement reestablished a taste for

35. Laura Coombs Hills, *Alice Crecy,* 1893

the precious, singular object, and Hills's delicate miniatures fulfilled that desire.

The International Studio reinforced the distinction, declaring that while "pho-
tography has undeniable value as a means of giving rapidly and effectively a more
or less literal likeness, and when it is used with intelligence and taste its results
are not wanting in artistic intent … [but] the miniature … aims at something
more."[20] Hills's miniatures were tiny paintings, distinguished by their deliberately
artistic qualities (pls. 31–34). Like many revival miniatures, they were relatively
large in scale, allowing room for more of the figure or for decorative back-
grounds. Hills used a traditional stipple technique for faces and other areas of
detail, but for sweeps of drapery she favored translucent washes of color, some-
times wiped or blotted to create additional texture and pattern. Similarly, her
contemporary Lucy Stanton allowed her paints to collect in tiny puddles, incor-
porating them into her final design (pl. 35, fig. 36).

Hills was a leader in the American miniature revival, and, along with New
York and Philadelphia, Boston soon became a center for such activity. As one
writer noted, "Boston has had much to do with the renaissance. In the studios of
this city are to be found the foremost painters of miniatures in America … the
day has passed when people cultivated in other branches of art regard miniature
painting as a trifling accomplishment to be indulged in by the young lady seeking
to satisfy a hobby or kill time with some fad. Most of the men and women now

36. Lucy May Stanton, *Self Portrait*, 1912

engaged in the art have had long training in other forms of painting."[21] Boston had supported a number of women miniaturists early in the 1800s (Sarah Goodridge [fig. 2], Clarissa Peters Russell, and Caroline Negus among them), and late in the century women were once again attracted to the delicate, portable medium. Hills, Stanton, Annie Jackson, Theodora Thayer, Evelyn Purdie, Sally Cross, and many others (see pls. 31–36) specialized in the genre and produced intimate images of many local citizens.

That Hills thought of her miniatures as small paintings is further revealed by the number of compositions she made depicting artfully arranged models rather than paying clients. In such images (including *Fire Opal* and *The Nymph*, pls. 31, 32), Hills created delicately balanced explorations of color and texture, brilliant little decorations that were intended to be displayed on tabletop easels or hung on the wall. Her work gained her election to the Society of American Artists in 1897, "an honor which few women ever attain," stated Grace Nutell in the magazine *The Puritan*, "and which had never before been conferred upon a miniaturist."[22] In 1898, Hills became a founding member of the American Society of Miniature Painters.

Hills painted 369 miniatures, each one scrupulously recorded in a note-book (collection of the Historical Society of Old Newbury, Mass.); the last entry is dated 1933. Her commissions had begun to decrease in the 1920s (she had already painted nearly everyone who desired such a likeness), but she felt the decline offered her a new opportunity: "The drop off for miniatures is refresh-ing," she wrote. "I've had enough noses and mouths. I'll kick up my heels and move to flowers in a field."[23]

Hills's new field, flower painting, was even more productive than her old one. She held exhibitions of her vibrant floral pastel still lifes almost every year from 1921 to 1947, and her new work sold very well. When questioned about her productivity, Hills credited her sister. She not only grew the exquisite blossoms Hills rendered, but "she also solves domestic problems," reported *Arts and Artists*, "giving Miss Hills the freedom so necessary to the accomplishment of artistic ideals. 'God bless a single sister.'" A. J. Philpott, critic for the *Boston Globe* (see fig. 67), dubbed Hills the "Queen of Flower Painters."[24]

Philpott commented that, at age eighty-eight, Hills painted like a woman of fifty. The remark reflected more than Hills's youthful spirit, it also recalled old conventions about appropriate roles for women in the arts. Painting like a woman had often meant painting flowers—still lifes, traditionally unimportant in the academic hierarchy of subject matter, had long been sanctioned as appropri-ate motifs for female artists. *The Art Amateur* claimed in 1880 that "few ladies are physically able to endure for any length of time the severe course of study, requir-ing daily several hours of intense application in the heated rooms of the life class," and thus chose instead to depict flowers.[25] As women were much more like-ly than men to be limited to small studios in their homes, the domestic nature of still lifes also proved convenient. A few flowers from the garden or fruits placed in a bowl could serve for models; there was no need to hire someone to pose nor was one forced to carry one's painting supplies out into the landscape. Flower painting was also a natural outcome of such feminine pursuits as embroidery, china painting, or the botanical record of a garden.

Ellen Robbins and Elizabeth Bigelow Greene were among the older genera-tion of Boston painters who had made the subject their specialty. Robbins's botanical accuracy was much admired by many, and she offered classes in "flower and autumn leaf painting"; she was a friend of Celia Thaxter's, and shared that writer's passion for the garden (pl. 37). Robbins often sold her work in albums, each containing about twenty images on a single theme—spring flowers in their succession of bloom, for example—and some of her watercolors were reproduced as lithographs by Prang and Company. She also provided floral decorations for

37. Elizabeth B. Greene, *Roses,* 1890s

furniture and a frieze for the Browning Room at Wellesley College. "The criticism of my pictures," she recalled, "was that they were too realistic ... I often said to Mr. Doll, who sold my pictures: 'I wish I could paint more in Miss Greene's style' ... and he would answer in an excited way: 'Don't you wish anything of the kind; you have your own original style—and keep to it.'"[26] Robbins admired Greene's broadly painted, colorful canvases, a legacy of her work with Hunt (fig. 37). Greene was "one of the best painters of flowers in America," claimed the critic William Howe Downes, adding that her work was "decorative in a delicate, refined, and exquisite way"; he also noted that Greene was "not less highly esteemed as a woman than as an artist."[27]

Flower painting was considered an instinctive subject for women as well, just as female metaphors had long been used to describe the natural world. "Let women occupy themselves with those kinds of art they have always preferred ... the paintings of flowers, those prodigies of grace and freshness which alone can compete with the grace and freshness of women themselves," proclaimed the French periodical *Gazette des Beaux-Arts.*[28] Women were attuned to the cycles of life, women were attracted to the ephemeral beauty of flowers, women were often equated with flowers in literary and pictorial analogies—thus women were suited to depict flowers, and many more women artists than men made floral still lifes their specialty. For some, the affinity proved to be a deception deeper than the illusions they created on canvas: for example, Elizabeth Bartol's cousin, Maria Oakey Dewing, who was widely praised for her magical flower pieces, wrote at the end of her life that she had "hardly touched any achievement ... [it] seems only a mockery," adding, "I dreamed of groups and figures in big landscapes."[29] But Dewing's sense of thwarted ambition was not shared by all women artists—Hills in particular was delighted with her success. Yet there was something about flower painting that was held to be minor and unimportant, for while Hills won several prizes and medals for her miniatures, she never achieved that honor for her still lifes.[30]

While Hills made images well within the confines of popular notions about women and art, the illustrations of her friend Ethel Reed seem to communicate a subtle subversion of those ideals. Reed was also from Newburyport, and Hills gave instruction in drawing to the young girl, described in a contemporary journal as a "picturesque deep-eyed maid … with tangled elf-locks" (fig. 38).[31] Reed also posed for one of Hills's first miniatures on ivory, and Hills may have introduced her young protégée to F. Holland Day, to whom she is known to have recommended models; Reed appears in Day's photograph *The Gainsborough Hat* (fig. 39). Reed continued her studies briefly at the Cowles Art School. Her first illustrations appear in periodicals in 1894, when she was just twenty years old. As her admirers state, Reed "streaked through Boston like a comet," disappearing from the city by May 1896 when she traveled to Europe, evading marriage with the painter Philip Hale and leaving many of her projects incomplete.[32] Best known as a poster artist, Reed exhibited landscapes with the Boston Art Students' Association in 1894, contributed several illustrations to children's magazines, and is said to have created her first mature poster design, for the *Boston Herald*, initially as a proposal for a decoration in stained glass (fig. 40).

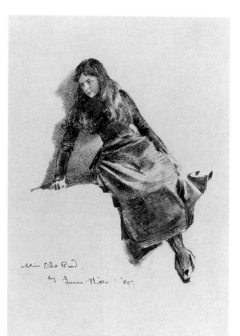

38. Laura Coombs Hills, *Miss Ethel Reed (Portrait of a Girl)*, 1880

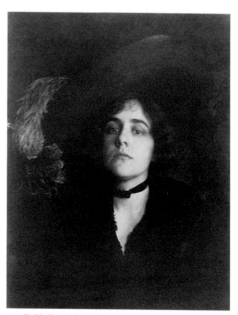

39. F. Holland Day, *The Gainsborough Hat*, 1895–98

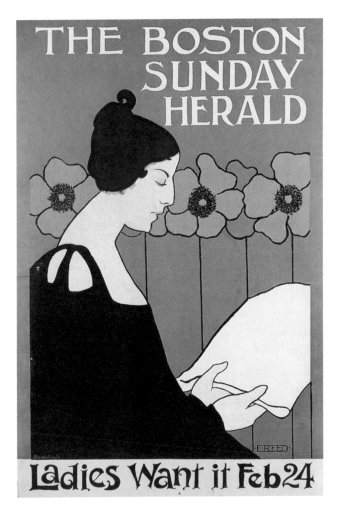

40. Ethel Reed, *"Ladies Want It," The Boston Sunday Herald,* 1895

Art posters had only recently come into fashion in the United States. The first American examples appeared in 1893, inspired by the popularity of such posters in Paris. Most were commissioned by publishers, and the field was dominated by men, among them Will Bradley, J. C. Leyendecker, Maxfield Parrish, and Edward Penfield.[33] But Reed's work was highly praised, and between February 1895 and July 1896, she produced about twenty outstanding posters that were admired and collected as art (see pls. 38–40). She worked for the *Boston Herald* and for several other Boston publishers, including Lamson Wolffe, Louis Prang, and Copeland and Day, creating images that were renowned for both their modern design and for their unsettling fin-de-siècle mood.

Reed's poster for Louise Chandler Moulton's book *In Childhood's Country,* produced for Copeland and Day, is one such example (pl. 40). The book, for which Reed also provided a cover and endpaper designs, is a collection of poetry for children, one of the many new publications aimed at young readers that

increasingly drove publishing houses in the 1890s. The assignment of women artists to projects for children was considered especially appropriate and took place frequently, but Reed's imagery is anything but juvenile. Set against a midnight blue background striped with black bars that might represent tree trunks, a young blonde girl teases the viewer: her eyes are partly closed, her lips are open, and her blouse slips from her slim bare shoulders. The composition is related to Reed's work for Gertrude Smith's *The Arabella and Araminta Stories* of 1895 (pl. 38), which included two blonde girls arranged back-to-back, but the decorative sweetness of the earlier design has been replaced with an unsettling decadence associated more with European symbolism than with American codes of morality. The "childhood's country" Reed represented here is far from innocent; her image bears more resemblance to the indolent temptresses of Gustav Klimt and Egon Schiele than to the wholesome American girls of Charles Dana Gibson and Frank Benson.

The link is not merely visual. Both *The Arabella and Araminta Stories* and *In Childhood's Country* were published by Copeland and Day, in a series dubbed "The Yellow Hair Library," a designation that could only call to mind the British illustrated magazine *The Yellow Book*, designed by the self-consciously decadent Aubrey Beardsley. *The Yellow Book* had been greeted with dismay in New York, where *Harper's* magazine described it as "yellow literature … a sign of degradation, like the phosphorescent light of decaying vegetable matter."[34] Copeland and Day were the first American publishers of *The Yellow Book* and similar publications, including Oscar Wilde's controversial *Salome*, and Reed was intimately involved in F. Holland Day's circle of poets and visionaries.[35] Of Reed's *The Arabella and Araminta Stories*, a critic for *The Book Buyer* remarked satirically that when Beardsley saw it, he would "shed tears of great joy, for [his] art principles have been applied at last to the manufacture of literature and pictures for children; and animal crackers and peg-tops and glass agates and such things will henceforward be symbols; and the children will go to bed and dream about little girls who look like glorified queens of spades."[36] When Reed abandoned Boston in 1896, leaving behind her a retinue of would-be lovers, she traveled first to London, where, ensconced in a studio in Cheyne Walk, she produced several drawings and a cover design for the seventh volume of *The Yellow Book*, succeeding Beardsley himself as the art editor of the journal.[37]

The decadent overtones of Reed's work were not apparent to everyone, however, particularly to those critics who persisted in viewing art through their preconceived ideas about masculine and feminine culture. A writer for *The International Studio* saw the work in art historical terms, comparing it to images of

the Madonna and Child and commenting that Reed's "pretty babies in quaint frocks, almost always slipping off their shoulders and showing merely a dainty bust ... recalls some of the delicious bambinos of Della Robbia." The French critic S. C. de Soissons, who had written a small book about Boston art in 1894 and who looked to women to produce art that was in keeping with their "peculiar views" and "feminine spirit," wrote an article about Ethel Reed in 1898 that appeared in the London illustrated journal, *The Poster.* Reed's *In Childhood's Country* was among the reproductions accompanying the article, but de Soissons seems to have been oblivious to the carnal undertones of Reed's image. Instead he concluded that Reed's success was due to the gentle ladylike essence with which she imbued her pictures, to the fact that she "saw with her own, and not masculine eyes." "Her work has feminine qualities; one sees in it a woman, full of sweetness and delicacy This is the greatest praise one can bestow upon a woman," he added.[38]

The idea that there were masculine and feminine qualities in art not only affected the reception of the works of an individual artist, but also was used to distinguish between media. The decorative arts were held to be feminine, the fine arts masculine. With the rise of the Aesthetic Movement in the 1880s, which called for unity among all the arts, these distinctions were minimized. Women, both as arbiters of the requisite artistic household and as creators of the decorative arrangements and accessories that made such an environment possible, were granted new status as artists and tastemakers.[39] That so many male artists involved themselves in decoration also bestowed higher stature upon the so-called minor arts, whether the men did so through their main profession, like Louis Tiffany and John La Farge (both of whom were also painters) or through their clubs, like the men of New York's Tile Club (primarily painters who experimented with producing decorative tiles). Even fashion and dress-making, long ridiculed as the preoccupation of empty-headed women, were given new status as high art with the popular new style of aesthetic dress; as the hero of William Dean Howell's 1893 novel *The Coast of Bohemia* remarked, "I don't see why a man or woman who drapes the human figure in stuffs, isn't an artist as well as the man or woman who drapes it in paint or clay."[40]

Yet even as the decorative arts were promoted for women, a woman's ability to perform in the traditionally masculine world of fine arts was questioned. E. A. Randall explained in 1901 that, "china painting and decorative art in general are the specialty of woman, who excels in the minor, personal artistic impulses, and in this way gives vent to her restricted life."[41] Even William Morris Hunt, when

confronted with a tearful student frustrated that she could not "paint like an expert" advised her to "go home and hem a handkerchief," or, in other words, to retreat to the feminine sphere.[42] As the Aesthetic Movement began to dissolve in the 1890s, a new effort was made to redefine art in masculine terms, to rescue it from an aesthetic agenda promoted by such figures as Oscar Wilde, whose opinions about art came to be associated with the "unnatural" crimes of which he was convicted in 1895. As the *Philadelphia Press* declared, "The fall of Oscar Wilde has put before the sight of men the end, fate, and fruit of Art for Art."[43] The prestige of the decorative arts, and the artistic reputation of their makers, diminished once again, despite the unquestionable aesthetic merit of the objects that continued to be produced. Some women were quick to recognize that this meant an inversion of their accomplishments, including Emily Sartain, a Philadelphia artist and the principal of the Pennsylvania School of Design for Women. "There is too loud a distinction made between Art and Industrial Art," she told the Art Club of Philadelphia in an 1890 address.[44]

For all of the significant artistic accomplishments made by Boston women in the 1880s and 1890s in glass, metalwork, photography, miniature painting, and illustration, there were others, like Anne Whitney, who wanted to achieve success in the realm of fine art: painting and sculpture. For these women, success in the decorative arts was only limited success, an achievement awarded by men that kept women in their place and away from direct competition with the male fine arts establishment. The issue erupted openly during the preparations for the 1893 World's Columbian Exposition in Chicago, when women artists in all media were invited to display their work in the Women's Building. Many protested against having their work shown in segregated quarters, away from the main art display in the Fine Arts Building; they wanted their work to be judged alongside that of their male colleagues. Others felt that their paintings or sculpture were diminished by their inclusion in a display of handicraft. Anne Whitney was among the reluctant exhibitors in the Women's Building, and she specified that her work was not to be shown in proximity to "bed quilts, needlework, and other rubbish."[45] The distinction was articulated clearly by Maria Oakey Dewing, who recalled, "ages ago I did a theatre curtain and the famous and infamous Oscar Wilde praised it exorbitantly and said, 'Why don't you go into decoration and wipe them all out?' Because I must paint pictures or die said I."[46]

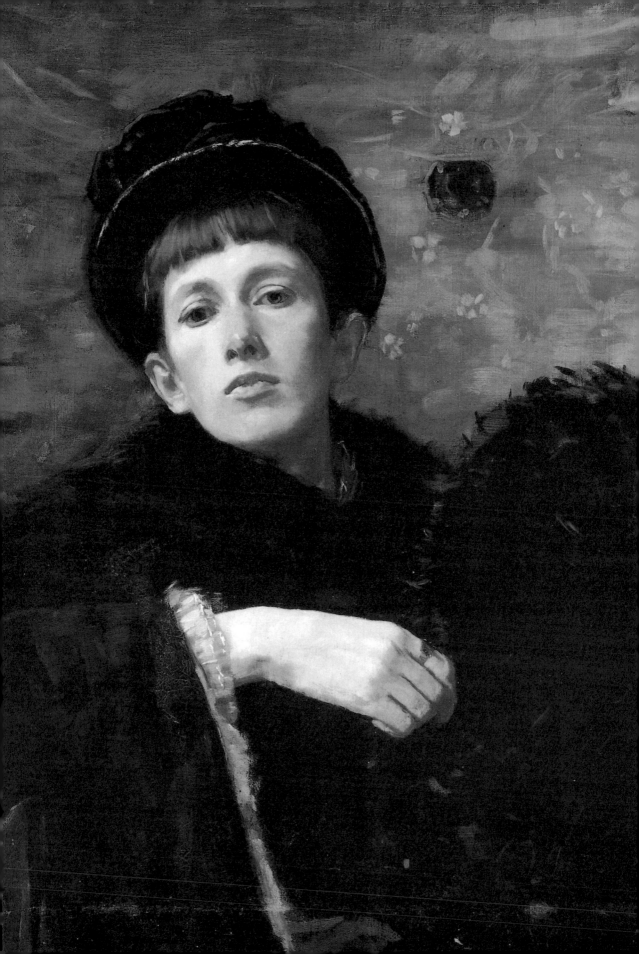

STUDYING ART ABROAD

Of the women who, like Maria Oakey Dewing, had studied with William Morris Hunt, few went on to have long and distinguished careers as professional painters. Most were dismissed as imitators of their teacher; of the others, Elizabeth Boott died young, Dewing retreated to modest still lifes, and Sarah Whitman turned her talents to other media. Ellen Day Hale continued her studies in Paris and would earn some recognition as a painter. She also played a major role as a mentor for a younger generation of aspiring women artists, cautioning them "against being too influenced by any one of [their instructors] … a fault common among artists of our sex." The charge was the one critics had leveled frequently against Hunt's students in particular, claiming that "much of the truth [Hunt] sought to impart [has] been lost sight of by his admirers … an enraptured throng of followers." But at least one writer was to remark of Ellen Day Hale that "she displays a man's strength."[1]

Ellen Hale was the daughter of the Unitarian clergyman and novelist Edward Everett Hale and his wife Emily Perkins Hale. She showed an early interest in drawing, and may have received her first instruction from her aunt, Susan Hale, with whom she exhibited landscapes and portraits in 1878. By that time, she had studied anatomy with William Rimmer and painting with Hunt and Helen Knowlton. She also attended classes at the Pennsylvania Academy and made an extended trip to Europe with Knowlton. After several months visiting museums and making copies, Knowlton traveled to England and Hale settled in Paris, where she undertook her training under a variety of Parisian masters.

41. Ellen Day Hale, *Self Portrait* (detail), 1885

Boott, Whitman, and Elizabeth Bartol had all studied in France with Thomas Couture during various summers in the 1870s, but Hale was the first of the group to enroll in a formal program. As Whitman had recalled in her article about art education under Hunt, "for young men, it is true, there was the chance of going to Europe to study, but this was less attainable for women" (see fig. 42).[2] In part, European training was less within reach because women were not admitted to the most prestigious schools; for example, the Ecole des Beaux-Arts resisted female enrollment until 1897. Instead, women were obliged to study at one of the independent academies, which charged tuition (unlike the Ecole), and women were usually charged higher fees than their male colleagues for the same (or fewer) services. They also needed more money upon which to live, for the bohemian accommodations in disreputable neighborhoods that served for many men were simply unacceptable, and often dangerous, for women.[3] For those who could afford it, however, Parisian training provided not only serious instruction, but also the prestige that accompanied those who had been tested in the art capital of the western world.

By the late 1870s, enough American women were seeking European training that the painter May Alcott Nieriker felt it worthwhile to publish a book of advice, *Studying Art Abroad and How To Do It Cheaply* (1879), which was prepared especially with female art students in mind. "I am assuming our particular artist to be no gay tourist, doing Europe according to guide-books, with perhaps a few lessons, here and there, taken only for the name of having been the pupil of some distinguished master," she wrote, "but a thoroughly earnest worker, a lady, and poor, like so many of the profession, wishing to make the most of all opportunities." While Nieriker included information on both London (recommended for those interested in watercolors, china painting, and decorative art) and Rome (best for aspiring sculptors), she gave the most attention to Paris, "the desired goal" for painters of figures and landscape, for "there is no art world like Paris, no painters like the French, and no incentive to good work equal to that found in a Parisian atelier."[4] Soon many American women were taking advantage of her advice.

Ellen Hale studied in three schools in Paris: the drawing classes offered by Emmanuel Frémiat at the Jardin des Plantes, the Académie Colarossi, and the Académie Julian. She also studied independently with Emile-Auguste Carolus-Duran and Jean-Jacques Henner, who offered private classes to women. The many articles appearing in contemporary periodicals concerning art students' life in Paris, some of them devoted particularly to the "girl-student," emphasized the rigors of the programs, where a model was available for life drawing and painting

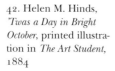
42. Helen M. Hinds, *'Twas a Day in Bright October*, printed illustration in *The Art Student*, 1884

an average of eight hours a day, divided between two or three sessions. "The trial to a modest young woman is at first great," reported an American woman in 1873, "but as soon as she is possessed of the art feeling, the first impression she receives on entering the atelier quickly wears away, and she is soon absorbed in her work like those around her. There is no sex here; the students, men and women, are simply painters."[5] Such statements were meant to reassure both nervous parents and the American public that the still-controversial life classes were not compromising women's reputations, and that their Parisian experiences were devoted to work, not play—and thus were worth the money they cost.

"The atelier for women [at the Académie Julian] is truly a fortress of the Amazons," reported M. Riccardo Nobili in *Cosmopolitan* in 1889, a few years after Ellen Hale was enrolled there. Hale spent three years studying at Julian's, preferring it to the Académie Colarossi, which she found "neither interesting nor inspiring." Like Elizabeth Boott, Hale described her Parisian experiences to friends in Boston, writing letters and newspaper articles offering advice and helpful hints, rating the various professors for their severity and seriousness (she pre-

ferred "a few rough words" from Gustave-Rodolphe Boulanger than comments "too gentle" from others) and later describing herself as a "Julianite."[6]

At the Académie Julian she found an international community of aspiring women artists who were united in their desire to receive the same comprehensive training from the same distinguished teachers as their male colleagues (albeit by 1879 in separate classes and at a higher fee). The *concours*, or class competitions, which were held to provoke constructive criticism and to mark a student's progress, took place anonymously, without account of gender, and students of both sexes competed together. It surprised Julian himself "how often women have the best of it in these trials ... especially is this true of portraiture, which is generally supposed to be a man's specialty."[7]

The program at Julian's was renowned for its commitment to anatomy and figure painting, and Hale learned her lessons well. Two of her figurative works, *Beppo*, a study of an Italian boy, and *Winter in America*, an image of an old man seated by a window (current locations unknown), had been accepted at the prestigious annual Salon. An authoritative self-portrait of 1885, the last work she completed in Paris, marks the high level of her achievement (pl. 41 and fig. 41). Hale selected an unusual horizontal format for her painting and isolated her figure against a backdrop of blue embroidery, probably a piece of Chinese or Japanese fabric. The conceit had been used by William Merritt Chase in his full-length portrait of the painter Dora Wheeler (Cleveland Museum of Art), which Hale could have seen at the Paris Salon in 1883, the first year her own work was displayed there. But Hale cropped her portrait more tightly, including only her head and hands, and this concentration upon the figure, combined with the intense gaze typical of the self-portrait, gives Hale's likeness more power than that communicated by the idle Miss Wheeler, who is surrounded and diluted by objects of luxury.

Hale learned not only from the classes she took, but also from the art she saw. She admired the customary selection of old masters—Titian, Rembrandt, Hals, Correggio, and Velásquez—as well as the work of Gustave Courbet, whom she described as "violent enough in all conscience, but ... he knows when to be astonishingly precise; in fact he knows a great deal about drawing, [even] if he was a Communist Well, he's dead now and I'm sorry for it," she added. "I should have liked some advice from him." Like her countrywoman Mary Cassatt, Hale appreciated the bold strength of Courbet's picture-making. She was also an admirer of the work of Edouard Manet, whose straightforward images of women, including the painter Berthe Morisot and the artistic hostess Nina de Callais, may have influenced Hale's self-portrait.[8] Hale was in Paris when Manet died, and

would have likely attended the enormous
retrospective exhibition of his work that
was held at the Ecole des Beaux-Arts in
January 1884.

　While such comparisons are easy to
draw, the particular curriculum of the
Académie Julian should not be forgotten.
The work that bears the closest resem-
blance to Hale's *Self Portrait* is a chalk
drawing by the Swedish artist Wilhelmina
Carlsson-Bredberg, *Woman with a Parrot
Hat* (fig. 43). Hale was no longer in Paris
when Carlsson-Bredberg made her draw-
ing, but the similarity is uncanny, and
suggests that such images grew out of
assignments at the school.[9] When Hale's
painting was exhibited in Boston, the
reviewer described it as "refreshingly

43. Wilhelmina Carlsson-Bredberg, *Woman
with a Parrot Hat,* 1888

unconventional," no doubt at least in part for its confrontational attitude.[10] In
her self-representation, Hale renounced the stereotypical role of demure lady
artist in favor of an image of great force and power.

　Despite her projection of strength, Hale's life as a painter revolved around
family exigencies. She settled in Santa Barbara, California, for two years in the
early 1890s, perhaps in an effort to improve her health. She painted a mural for
her father's church and in 1904, she moved to Washington, D.C., where she
acted as her father's hostess during his time as chaplain of the U.S. Senate. Her
niece Nancy Hale recounted that Ellen Hale's "middle years were given up to
looking after a semi-invalid mother and a famous, sought-after, impractical extro-
vert father …. Aunt Nelly was sorely needed to keep house, be hostess, and fend
the circling harpies off him and the well-intentioned parishioners off her. I used
to fly into a rage when my mother sometimes suggested that it must have been
wonderful to have such a devoted daughter."[11] But a woman of Ellen Hale's gen-
eration, unmarried, typically did not rail against her fate. She did instead what
she was expected to do, as even Mary Cassatt had done, and devoted herself to
the needs of her parents. As the Boston historian Winthrop Peirce explained in
1930, "Fifty years ago the art student girl was a fresh creation. Like the college
girl of her day, she was one of a perfectly new and very small class. As in all previ-
ous times, it was not questioned that the only place for the unmarried girl was in

the home of her parents, or as a helper to her married sister, until she should marry." Ellen Hale remained in many ways that art student girl, "with all her jauntings about the world, Aunt Nelly's essence—her original young girl's ardor—remained intact … she dashed to meet an old maid's fate with cries of consent," said her niece.[12] Despite her obligations, however, Hale never turned her back on art, and she continued to paint and make etchings for the rest of her life.

Hale's style eventually shifted permanently toward a more Impressionist aesthetic. She had first seen the work of the self-proclaimed "Independents" in Paris, and while she felt that their preference for blues, greens, and violets, used "with no values" (blacks), "all makes you feel rather sick the first minute," she discovered that she "like[d] a great many of them … especially those by a man named Monet (not Manet, he's different)." She preferred the landscapes she saw in that seventh group show, remarking that "most of the brethren I'm sorry to say drew the figure in the most evil manner you can imagine, and painted it disgustingly, as if they were little boys and girls." She found "a very striking exception to this bad drawing" in the work of Berthe Morisot.[13] She communicated her interest to her younger brother, Philip Hale, who became one of the earliest Americans to work at Monet's home in Giverny and also an important practitioner of Impressionism in the United States

❧ ❧ ❧

By the end of the century, Boston homes were full of canvases by the French Impressionists and the style had had a decisive impact upon the work of local painters. As early as 1887 the Boston correspondent for *The Art Amateur* announced that "quite an American colony has gathered … at Giverny, seventy miles from Paris on the Seine, the home of Claude Monet, including our Louis Ritter, W. L. Metcalf, Theodore Wendel, John Breck, and Theodore Robinson of New York."[14] This first group of Bostonians was all men, but women were soon to follow, and among the most influential was Lilla Cabot Perry (fig. 44).

The daughter of a well-known Boston surgeon and abolitionist, Lilla Cabot was well educated in music, art, literature, and languages when she met the scholar and linguist Thomas Sergeant Perry in 1868. They married in 1874, and had three daughters during the next ten years. By the mid-1880s, it was clear that ideas, an impressive family lineage, and Lilla Perry's small inheritance would not keep the family afloat, a condition that Alice James had predicted, remarking to a friend that "Sargy and Lilla are to be married in a month or two and to live on no one knows what." One of the socially acceptable ways for an upper-class woman to make a living was through art, as an 1899 book, *What Women Can Earn*,

44. Lilla Cabot Perry, *Self Portrait*, 1897

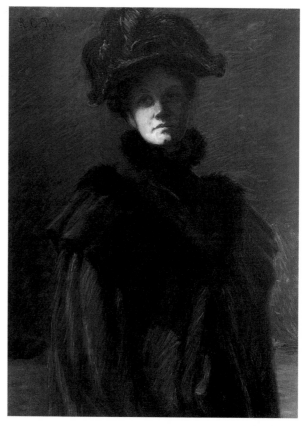

would note, "the purpose of this paper is not to dwell upon the great achieve-ments of women painters, but to point out the way in which any woman with an eye for colour and form may become an artist in oil." While pointing out that long training was a necessity and the subsequent income was "not much," anoth-er chapter of the book entitled "Society Women in Business" included the section "A Studio for Colour Study."[15]

From 1884 to 1886, Perry studied art with Alfred Collins, Robert Vonnoh, and Dennis Bunker, all young men trained in Paris who became distinguished teachers in Boston at both the Cowles Art School and at the School of the Museum of Fine Arts. Perry studied both privately and at Cowles, and when her husband announced that he was taking the family to Munich and Paris, Perry delightedly continued her education there, feeling that she had achieved success when two of her portraits were accepted for the 1889 Salon. Her art changed dramatically, however, when she saw Claude Monet's work in a large exhibition at the Galerie Georges Petit in June 1889, a show that was dominated by images of figures in the landscape.

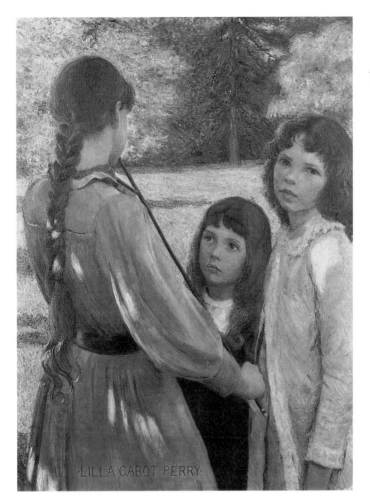

45. Lilla Cabot Perry,
Open Air Concert, 1890

The Perrys took up quarters in Giverny that summer, a sojourn they would repeat nine times, intermittently until 1909. Perry radically shifted her painting style and began to employ the bright colors and broken brushstrokes that were the hallmarks of Impressionism, although like most American painters, she modeled her figures more solidly (fig. 45). She became an important promoter of Monet and also a supporter of fellow Bostonians who used the new style. Perry's work was favorably received in the early 1890s, and she gained a number of portrait commissions that provided the family with a somewhat reliable income. "Once," she recalled, "when we were very hard up, I painted thirteen portraits in thirteen weeks." What may have meant even more to her was the compliment she earned that her work "ranks at once with the men."[16]

⤳ ⤳ ⤳

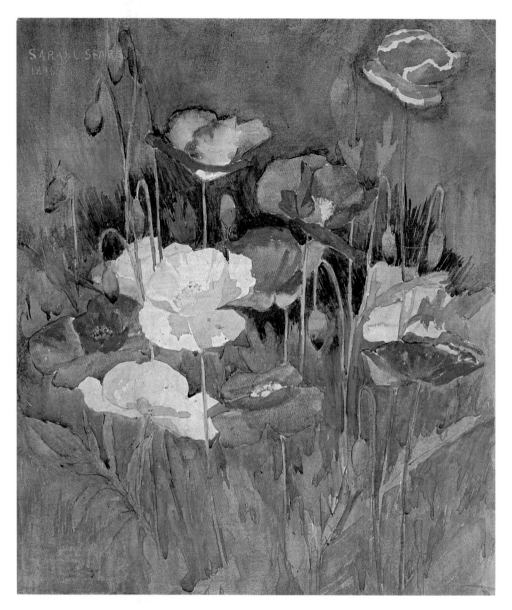

Plate 23
Sarah Choate Sears
Poppies, 1896, watercolor on paper
mounted on paperboard

Plate 24
SARAH CHOATE SEARS
Lilies, 1890s, platinum print

Plate 25
SARAH CHOATE SEARS
*Portrait of Helen Sears with Persian Ceramic Pot
and Lilies*, about 1893, platinum print

Plate 26
ALICE AUSTIN
Child by Window, 1910, platinum or
palladium print

Plate 27
SARAH CHOATE SEARS
Helen Sears with Japanese Lantern, 1895,
platinum print

Plate 28
SARAH CHOATE SEARS
Auratum Lilies, 1915, pastel on paper

Plate 29
LAURA COOMBS HILLS
Larkspur, Peonies, and Canterbury Bells,
about 1926, pastel on paperboard

Plate 30
LAURA COOMBS HILLS
Sand Dunes, 1890s, pastel on paper

Plate 31
LAURA COOMBS HILLS
Fire Opal (Grace Mutell), 1899,
watercolor on ivory

Plate 32
LAURA COOMBS HILLS
The Nymph, 1908, watercolor on ivory

Plate 33
LAURA COOMBS HILLS
Laddy Greene (John Gardner Greene), 1910,
watercolor on ivory

34
LAURA COOMBS HILLS
Clement Bernheimer, 1904, watercolor
on ivory

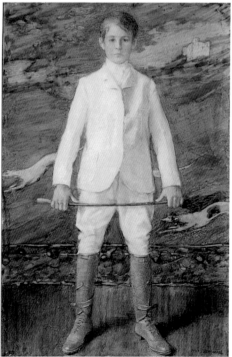

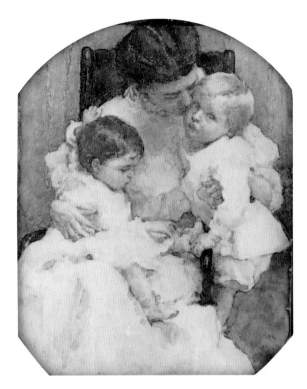

Plate 35
LUCY MAY STANTON
*Maternité (Mrs. W. T. Forbes and
Children)*, 1908, watercolor on ivory

Plate 36
ANNIE HURLBURT JACKSON
Small Boy in a Rocking Chair, about 1910,
watercolor on ivory

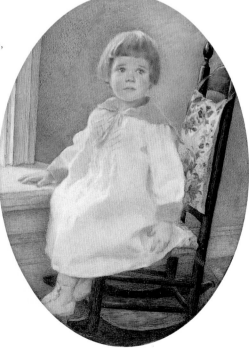

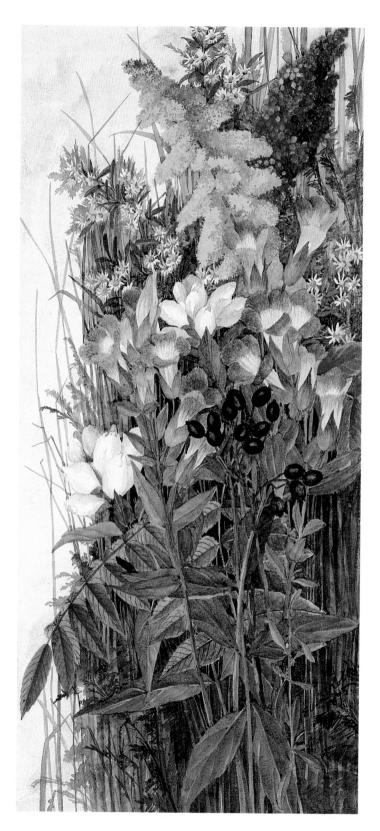

Plate 37
ELLEN ROBBINS
Wildflowers, 1875, water-
color and graphite on
paper

Plate 38
ETHEL REED
*Arabella and Araminta
Stories,* 1895, lithograph in
black, red, and yellow

Plate 39
ETHEL REED
Is Polite Society Polite?, 1895,
lithograph in black and
olive green on imported red
handmade paper

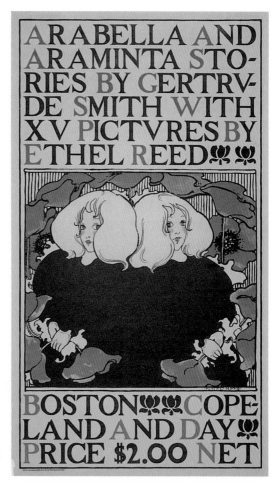

Plate 40
ETHEL REED
In Childhood's Country, 1896,
lithograph in yellow, pink,
blue, and black

There were aspects of the Impressionist style that made it particularly attractive to women, and its very anti-academic nature was inviting to those who had been left out of the academy. That Monet's work did not depend upon carefully crafted figures but upon visual sensation made years of struggle to obtain proper training in life drawing seem somewhat less critical, and the prevalence of domestic subject matter—one's own home, garden, or a local landscape—was more easily accessible to women. The relatively small scale of Impressionist paintings was helpful as well, for they were easily portable and did not require a huge studio equipped with models and assistants to move large canvases. Impressionism was also characterized as feminine by many art critics, both academics and modernists, often in an attempt to discredit it; in consequence, many of its male practitioners sought to emphasize the style's basis in optical theory (science, and therefore masculine) or to imbue their work with deeper symbolic content.[17]

In the United States, Impressionism soon became the dominant style, first of a small group of French-trained painters and then, as those artists became important teachers and academicians, a generic impressionist technique was broadly adopted nationwide. Women were quick to make the pilgrimage to Giverny. Will Hickok Low described the French town as full of young women "votar[ies] of art … [they came] in numbers so largely plural that the male contingent at Giverny was greatly in the minority."[18] Bostonians were among them, and not only Perry—Ellen Day Hale also was among the women who traveled there in the 1890s, perhaps in the company of her brother Philip.

After the turn of the century, Ellen Hale's work became increasingly lighter in tone. Like many American artists, she crafted a compromise between Impressionism and the academic training she had worked so hard to obtain. Her painting *Morning News* (pl. 42) is lighter in palette and looser in technique than her earlier work had been, but she did not give up her facility for depicting the human form. Here, within a sensuous cascade of pinks, blues, greens, and violets that represents garments, the newspaper, and an artfully arranged still life, Hale crafted a firm and carefully drawn profile, isolating her model's features against a dark background as if they were etched upon a cameo, echoing the sculpted portrait on the wall behind her. Hale's success with *Morning News*, one of her most accomplished canvases, proved that even after moving to Washington to become her father's hostess, she made time for her work.

Much of Hale's artistic activity took place in the summer, in the studio she had built for herself and Gabrielle Clements in Folly Cove, near Gloucester, Massachusetts. Here Hale surrounded herself with artist friends, almost all women except for her brother. As Nancy Hale remarked, "Here at Aunt Nelly's

46. Theresa Bernstein, *New England Ladies,* 1925

for the first time I saw art lived corporately—a shared vocation to be embarked on daily with cries of joy …. If a church decoration were underway, Miss Clements and the other old maids might all work on it … another year it might be etchings they worked on … afterward they all clustered around to examine critically the result achieved. The atmosphere [was] brisk, fresh, and precise."[19] The group was memorialized in Theresa Bernstein's 1925 composition, *New England Ladies* (fig. 46). Seated among "the old maids" to the right of her sister-in-law Ellen Hale, was another talented painter, Lilian Westcott Hale.

Lilian Hale was twenty-five years younger than Ellen Hale and despite the family, talent, and ambition they shared, the two women's experiences as painters differed tremendously. The accomplishments gained by Lilian Hale and her contemporaries would not have been possible without the work of the previous generation. They not only gained acceptance for women artists, but also were able and available to offer the younger artists concrete advice and encouragement. For example, Ellen Hale taught art classes for women, both with Helen Knowlton

in the late 1870s and also on her own a decade later. But even these formal inter-
actions may not have been as inspirational as the informal gatherings of like-
minded individuals. "Oh how good it is to be with someone who talks under-
standingly and enthusiastically about Art," wrote Emily Sartain about her
Philadelphia friend Mary Cassatt, after visiting her in Paris.[20] Ellen Hale provided
similar support for her sister-in-law. In their case, isolation was not the issue;
there were any number of people in Boston to whom they might have spoken
about art, most obviously Philip Hale. However the network of friendships among
Boston's women artists should not be overlooked as a significant source of valida-
tion and strength. Lilian Hale's letters to Ellen Hale are full of details about art,
and Ellen Hale acted as her confidante and champion. As Elizabeth Bartol had
remarked, "women are helping women."[21]

Women were helped not only by each other but also by the new schools of art that had been founded in Boston during the last quarter of the nineteenth century. These provided unprecedented opportunities for women to learn art in an organized and structured program, making it much easier for them than the independent classes or foreign travel and study had been for their older colleagues. Marion Boyd Allen, Margaret Fitzhugh Browne, Adelaide Cole Chase, Gertrude Fiske, Lilian Hale, Anna Vaughn Hyatt, Loïs Mailou Jones, Nelly Murphy, Bashka Paeff, Marie Danforth Page, Elizabeth Paxton, Lilla Cabot Perry, Marion Pooke, Margaret Richardson, Elizabeth Roberts, Gretchen Rogers, Josephine Shaw, Polly Thayer, Elizabeth Walsh, Katharine Lane Weems, and Madeline Yale Wynne all studied painting or sculpture at one of the new schools, and the availability of such programs within the city produced a tremendous boom in the numbers of active women artists.

The first of these programs to open its doors had been the Normal Art School, where Walter Smith guided the program to meet the new demand for art teachers caused by the 1870 passage of the Massachusetts Drawing Act. That legislation required that mechanical drawing be taught in the commonwealth's public schools in an effort to improve the quality of local manufacture. To train enough competent teachers, the state funded the school; it was the first government supported art school in the United States. It opened in 1873, and Massachusetts residents received free tuition if they contracted to become teachers, a fact that made art education available to anyone, no matter their income.

47. Gretchen Rogers, *Woman in a Fur Hat* (detail), about 1915

The Normal School quickly attracted a large number of women students, some sixty-five percent of its enrollment. All students, regardless of sex, were offered instruction in drawing, painting, architecture, and isometric projection. The successful program, heralded at the Centennial Exposition in Philadelphia, was soon expanded to four years, and classes were added in anatomy, antique and life drawing, and portraiture.[1]

By 1886 the Normal School had moved to an impressive Richardsonian Romanesque building at the corner of Newbury and Exeter Streets in the Back Bay (fig. 48), one block from the Boston Art Club and two blocks from the Museum of Fine Arts, then located in Copley Square. By 1898, when the school published its *Historical Sketches,* three-quarters of its alumni were female and almost a third of those women reported their profession as either teacher or artist. Many of the city's best-known painters were graduates of the Normal School. By the time the distinguished portraitist Joseph DeCamp began to teach there in 1903, the program had shifted to accommodate students who wanted to create art themselves instead of only teaching it to others. Margaret Fitzhugh Browne, highly regarded as a portraitist, particularly of men, and the author of a book on portrait painting, had been one of DeCamp's pupils. The lessons she learned there, combined with her own considerable skill at capturing the psychology of her sitters, is brilliantly demonstrated in her powerful image of a blind veteran, *Blessé de Guerre* (pl. 79). In old age, Browne reasserted her youthful ambition, recounting that she had never wanted to do anything but paint.[2]

<p style="text-align:center">⏜ ⏜ ⏜</p>

DeCamp had come to the Massachusetts Normal School from the Cowles Art School, another of the city's important institutions. The school was established in 1882 by Frank Cowles and his brother, who had been inspired and motivated by the financial success of the Art Students' League in New York. They sought to offer a French-inspired curriculum, based upon the art academies of Paris rather than the industrial schools of London. They hired impressively talented young instructors who had been trained in France, among them Robert Vonnoh, Dennis Bunker, and Ernest Major. The program was coeducational, although the life classes were segregated by sex. After two years on Tremont Street, the school joined the city's other arts institutions in the Back Bay, setting up quarters in the New Studio Building on Dartmouth Street just behind the Museum of Fine Arts. When Bunker became chief instructor in painting the next year, he complained about the quality of his students, characterizing them as "old maids" and "raw boys," and he grumbled about "Old Cowles" and his desire "to get the place full," no matter what level of aptitude a pupil displayed.[3] Nevertheless, he was highly admired as a teacher, and among his appreciative students were Sarah Choate

48. Massachusetts Normal Art School, corner of Newbury and Exeter Streets, Boston, Mass., about 1900

Sears and Lilla Cabot Perry. Some years later, *The Art Amateur* reported that enrollment at the Cowles School had surpassed two hundred students, "nearly half of whom are men," a statistic that someone, either at the school or the magazine, felt enhanced the school's reputation.[4] The Cowles Art School merged with the New England Conservatory in the mid-1890s; by 1902 instruction in the fine arts had ceased and the school turned its attention completely toward music.

☙ ☙ ☙

The majority of women who achieved success as painters and sculptors in the early twentieth century in Boston studied at the School of the Museum of Fine Arts. The school had been conceived in 1870 as part of the museum itself, and a separate committee was appointed to determine how best to achieve the goal of instruction in the fine arts. The group, which included the painters William Morris Hunt, John La Farge, and Frank Millet, first proposed a school of drawing and suggested that classes start immediately in the galleries of the Boston Art Club. The Art Club had been founded in 1855, and while it offered membership both to professional artists and to laymen, women were not included in either category (they could, however, participate in Art Club exhibitions). The Art Club felt that hosting students and teachers would inconvenience their members, and the School committee resigned itself to waiting until the Museum's Copley Square building was completed, where classrooms had been planned for the

49. Museum of Fine Arts, Boston, Copley Square, Boston, Mass., about 1895

basement level (fig. 49). Classes at last began in January 1877 with eighty students under the instruction of Otto Grundmann, a portrait and figure painter with whom Frank Millet had studied at the Academy in Antwerp.

Grundmann's own training had been traditional and rigorous; as the journal *Portfolio* explained in 1879, the student in Antwerp "must make up his mind … to conform to the rules and hours in a serious, business-like manner, for there is no trifling with study here: it is downright work."[5] Grundmann carried that professionalism into the new school in Boston. Classes began with instruction in drawing from the antique. Women students, who met in separate facilities, were given the same assignments and criticism as the men. Soon after the term began, a painting class was organized, and three women joined five men to paint from a still life "tightly packed into an alcove at the end of the corridor." A life class was not established until the following year, over the objection of some of the trustees. Many of them had expressed "horror … at the idea of a nude model in their chaste Museum of Fine Arts," although some of the male students, "enjoy[ing] the sense of being in opposition to their elders," chipped in the first year to hire a male model to pose "behind a carefully locked door." One year after models were made available (officially) to the men, separate classes were

established for women, and the program continued according to strict academic standards. Students drew from casts, then from life, and only after succeeding in these ventures were they encouraged to pick up a brush.[6]

By 1880, the School of the Museum of Fine Arts allowed women to participate not only as students, but also as teachers and administrators. There were a handful of women instructors in the early years of the school: Lilian Greene, Mary Brewster Hazelton, and Rosamond Smith Bouvé (all former students at the school) all taught drawing before 1900; Alice Hinds Stone offered classes in design and decoration. Several women also served as teaching assistants. But perhaps more significantly, women were involved in the school's governing Council. Originally comprised of twelve men, the council expanded in 1885 to include Sarah Wyman Whitman, who in addition to her prodigious activities as an artist was also a tireless proselytizer on behalf of education for women and a major supporter of Radcliffe College. May Hallowell, a painter, served on the council for thirty years, starting in 1886 when the group decided to include a past pupil among its members. During the 1890s, painter and alumna Edith Howe, Sarah Sears, and former design student and M.I.T.-trained architect Lois Howe all became council members. By the turn of the century, one-third of the council's members were female, a fact that must have helped to assure young students that it was possible for a woman to play an influential role in the arts in Boston. In addition, the executive management of the school, once the domain of the board committee secretary, was given in 1890 to a new officer with the title of Manager, whose responsibility included being at the school and acting as a liaison to the students. "As a large majority of the latter are women," noted the secretary in the annual report, "it seemed best to have a woman in this position." The School of the Museum of Fine Arts soon became renowned for the quality and seriousness of its program, and women flocked to enroll. By 1889, as the *Boston Traveller* reported, ninety-five of the school's one hundred sixteen pupils were women, almost eighty-two percent.[7]

Yet the story of women's attainment in the fine arts in Boston cannot be read by statistics alone. Simple enrollment numbers do not reveal which students became successful professionals. In his history of the Museum School, Winthrop Peirce remarked that the first women students were "mostly amateurs," adding that "the great majority never worked for professional recognition." In addition to such women of talent who chose not to pursue a career, large numbers of well-bred young women went to art school to occupy themselves before marriage. As Marian Lawrence Peabody, daughter of one of the city's most noteworthy families, readily confessed, "I went to Art School off and on from the time I was eight-

een until I was married. I even worked at it the year I came out."[8] There were, however, many for whom art was neither an amateur's activity nor a pastime, but a calling, and among the women of the first graduating class at the school were Madeline Yale Wynne (pls. 18, 19); Frances Houston, a painter active in Cornish, New Hampshire; and Evelyn Purdie, who gained recognition for her portrait miniatures. Soon the School of the Museum of Fine Arts became the city's most important training ground for women artists, and while its best-known alumnae were painters and sculptors, its students also excelled in photography (Sarah Sears and Alice Austin), metalwork (Wynne), design (Edith Brown and Loïs Mailou Jones), and architecture (Lois Lilley Howe).

Alumnae of the School of the Museum of Fine Arts were active in other ways as well. Alice Spenser Tinkham approached "the leading women of the school" in 1879 with an idea for an art students' society that would function not only as an alumni group but also as a locus for exhibitions, lectures, classes, and pageants. The organization was an enormous success; by the 1890s they had opened their membership to all interested persons, whether or not they had studied at the Museum School, and they operated a complex of artists' studios (named the Grundmann Studios in honor of Otto Grundmann, who had died in 1890). The association, which changed its name to the Copley Society in 1901, became a significant rival to the Boston Art Club and began to sponsor major exhibitions, including an annual contemporary art show, a Sargent retrospective, a display of Monet and Rodin, and the Boston venue of the Armory Show.[9] Women were also founding members and actively engaged in the Guild of Boston Artists, founded in 1914.

In addition to their efforts to foster organizational support for Boston artists, some alumnae also provided funds for individual students. Sarah Sears offered for many years an annual cash prize to the winners of each of the final *concours* of the year: one for drawing from the antique, one for drawing from life, and one for the best portrait. She also contributed funds to complete the endowment of the Paige Traveling Scholarship, which allowed students, male or female, two years' study in Europe. The annual award had been inaugurated by William Paige, who was moved by the lack of support for women at the school:

> In this school of two hundred and seventeen pupils there are only twenty seven men, and of the one hundred and ninety women are said to exist none who are not faithfully and conscientiously devoting themselves to the study of art, and yet, most strange to say, there is no provision for a foreign scholarship for women—and this in view of the fact that they are doing decidedly the best work in the school. The reason for this unfair discrimination is said to be in consequence of the liability of girls to marry.[10]

The first Paige award went to Mary Brewster Hazelton in 1899. She was an alumna of the school, a teacher of antique drawing, and already had been the first woman ever awarded the National Academy of Design's Hallgarten Prize. Further support for women came from Caroline Eddy Hamblen, who, in memory of her daughter Helen, donated a scholarship for women students in 1898 that sculptor Bashka Paeff was to win (see fig. 67); while Ellen Kelleran Gardner, one of the school's earliest students, bequeathed an endowment of $5000 in 1906 to fund a scholarship "for girls who show decided talent, and who, being without means to carry on their work, intend to make practical use of their education in art" (Elizabeth Morse Walsh was among the recipients, fig. 51, pl. 43).[11] Significant funds for a variety of awards also were bequeathed to the school by Elizabeth Bartol, perhaps in memory of her own struggle to find appropriate instruction in art.[12]

<p style="text-align:center">❧ ❧ ❧</p>

While several scholarships were designated for women, few other art ventures were segregated by gender in Boston. There were two dramatic exceptions, the Boston Art Club and the St. Botolph Club. The antebellum years of the Boston Art Club had been informal and some women, including the landscape painters Sarah Freeman Clarke and Sophia Towne Darrah, had attended the club's meetings. When the organization adopted its first formal by-laws in 1870, however, it specifically excluded female members. Women artists were always able to exhibit there, but they had to use a separate entrance. Only in the midst of the Depression—when the art world had shifted away from it and the brotherhood was in financial difficulty—did the Boston Art Club invite women to join. "I don't know why women shouldn't join," said the painter Marie Danforth Page. "But I doubt if I will … I am already a member of many organizations."[13]

The St. Botolph Club, founded in 1880, was closed to women members until 1990, although here too women artists could display their work. Among the solo exhibitions the club hosted were shows by Sarah Wyman Whitman, Anna Klumpke, Lilla Cabot Perry, Cecilia Beaux, and Mary Cassatt. In 1915, they sponsored a group show of women painters.[14] Despite these restrictions, and unlike the New Yorkers who founded the Women's Art Club in 1889 (called the National Association of Women Artists after 1917) and the Philadelphians who started the Plastic Club in 1895, Boston women seem to have organized only one art group for themselves, the Boston Water Color Club, founded in 1887 in response to the men-only Boston Water Color Society that had appeared two years before. By the mid-1890s, however, the Water Color Club was open to both

50. Winslow Homer, *Girl (Adelaide Cole, later Mrs. William Chase)*, 1879

sexes, and Boston's women artists seemed to prefer it that way. They had strong voices at the Copley Society and later at the Guild of Boston Artists, two of the city's most active arts organizations. Even in the 1910s, when the Boston Art Club, the Copley Gallery, Doll and Richards Gallery, the St. Botolph Club, and the Vose Galleries all began to host regular group shows of women artists, some of which traveled to other cities, F. W. Coburn remarked in the *Herald* that such segregated exhibitions were not ideal, and that "a woman painter ought to stand entirely on her own merits as a human being and a trained practitioner."[15] Most Boston artists agreed.

On April 25, 1895, the daily newspaper the *Boston Standard* ran an article devoted to the Museum School entitled, "Woman's Work." The title impishly conjures images of domestic chores, but these words should also be placed in the context of contemporary events—it had been just six months since the strike of the Garment Worker's Union had been settled, a labor dispute that brought women workers at last to the attention of the Boston press; it was also the year in which women's suffrage was brought to a state-wide referendum (and defeated).[16] The old adage that "man may work from sun to sun, but woman's work is never done" was used with new intensity to communicate the earnest aspiration of the Museum School's students, for the anonymous reporter noted that "while the

majority of young men students
employ their afternoons and even-
ings in some lucrative manner in
order that they may have the addi-
tional money … the young women
devote every moment of their time to
the study of art, working with inde-
fatigable zeal."[17] Among the current
students praised was Marie Danforth
(see pls. 45, 46), who already had
won a portrait commission from the
Harvard Sunday-School Society, a
Unitarian ministry.

Marie Danforth had started
studying art several years before
enrolling at the Museum School, and
she had strong ties to the older gen-
eration of women painters. Her first
lessons came in 1886 from Helen
Knowlton, who instructed her young

51. Elizabeth Morse Walsh, *Self Portrait*, 1940

pupil in the broad tonal drawing style that had originated with William Morris
Hunt. She also learned about portraiture from Frank Duveneck, who offered
criticism in Knowlton's studio classroom both before and after his wife's death.
Duveneck painted two images of Danforth at that time (private collection and
Cincinnati Museum of Art). In 1890 Danforth enrolled at the Museum School,
studying painting with Edmund Tarbell and Frank Benson, creating a number of
black and white illustrations, and winning a prize for foreign study that she was
unable to accept because of her responsibility to look after her ailing mother.
"Boston is as good a place as any in the world to learn painting," she later
remarked.[18] After finishing her courses, Marie Danforth married Calvin Gates Page,
a recent graduate of Harvard Medical School and a research bacteriologist (pl. 45).
He supported her career as a portraitist and in turn her earnings provided a sub-
stantial portion of the family income. Page specialized in portraits of women and
of children, later combining the two in a series of maternal images that would win
her much acclaim. An active participant in Boston's art scene, Page believed strong-
ly in the standards of craftsmanship and beauty that would come to define the
Boston School.

THE BOSTON SCHOOL

In April 1901, an exhibition was held at the Museum of Fine Arts that celebrated the twenty-fifth anniversary of the Museum's school. It was a time of both gratification and introspection, and it marked the emergence of a distinct local style of painting that has come to be known as the Boston School. Its leaders were the city's foremost teachers—Edmund Tarbell, Frank Benson, Joseph DeCamp, and William Paxton. The most prominent of them, Tarbell and Benson, led the painting classes at the Museum School. Their work, and that of their students, both male and female, is marked by a love of beauty and a devotion to craftsmanship. They favored portraits, impeccably arranged still lifes, and especially figure studies of elegant women or attractive children in tasteful interiors or in sun-filled landscapes. They painted few narrative genre scenes and virtually no images of people at work; city scenes are rare, and emotional expression is held in check. The New York art historian Samuel Isham explained that "the whole body of painting produced in Boston [has] a distinct character of its own, which cannot be said of another American city." He characterized it as full of a "desire for breadth, simplicity, and strong direct work ... it follows more or less the artist's standpoint and seeks artist qualities in handling and light and color, a certain breadth, a rougher texture, a quivering light." Charles Caffin, a leading American critic, praised these images for their removal from the "frippery and vulgarity" of urban life.[1]

These very qualities of beauty, elegance, and refinement have been decried by other writers, both contemporary and modern, who preferred art that incorporated emotion, social realism, or political com-

52. William McGregor Paxton, *The Green Dolman (Elizabeth Paxton)*, 1924

53. Joseph Rodefer DeCamp, *The Seamstress*, 1916

mentary. Guy Pène du Bois, a New York correspondent and a modernist painter trained under Robert Henri's creed of "art for life's sake" (as opposed to the "art for art's sake" of earlier days), described the Boston painters in 1915 as ladylike, prudish, and flawlessly barren, concluding that "there is neither a laugh nor a tear in all the Boston painting." More recently, several scholars interested in feminism have described Boston School interiors, with their silent elegant women, as going "beyond the genteel tradition's avoidance of anything harsh, ugly, or excessively emotional. They seem to contain an implicit criticism of recent political and social gains of Boston women, and suggest a deliberate denial on the part of Boston men of the real lives of Boston women."[2]

Yet "the real lives of Boston women" included an astonishing number of women artists, women who played a major role both as creators and as collectors of just this type of Boston School painting. As the *Boston Herald* noted in its story about the Museum School's twenty-fifth anniversary, "It is gratifying to see that in the work of the graduates of this school there is comprised that of a large proportion of the foremost artists in the United States," adding, "many of the most talented of the graduates have been women."[3] The writer singled out Adelaide Cole

Chase and Marie Danforth Page with praise (see pls. 44–46); they were soon to be joined by a number of women who, working within the philosophy and subject matter of the Boston School, achieved significant recognition as painters.

The subjects the women painted during the early years of the twentieth century in Boston were remarkably similar to those of the men. Some specialized in portraits, others in still life, but few demonstrate an approach substantially different from those of their male colleagues. While women were commissioned far more often to paint likenesses of women than they were of men, and many women artists were considered natural choices to create images of children, the way they crafted their paintings, the types of objects they chose to include, and the style in which they applied paint to canvas differ little from those of the men. Lilian Hale, for example, created many images of decorative women in interiors (see pls. 47, 48), Marion Boyd Allen celebrated maternity in her canvas *Motherhood* (pl. 58), Gretchen Rogers painted her self-portrait without including the tools of her trade (fig. 47, pl. 49). Only occasionally does the viewer sense a different perspective brought about by the artist's sex. One such moment occurs in Elizabeth Paxton's *The Open Window* (pl. 51), which seems to present a shy, sly comment upon the work of her husband William Paxton and his fellows. Here a woman sits sewing, momentarily pausing from her work to gaze through a window. The subject was a popular one among the members of the Boston School, but unlike the ladylike stitchery rendered by the men (fig. 53), Elizabeth Paxton's model poses as a seamstress with a sewing machine, the wall behind her is decorated not with Japanese prints and copies of old master paintings, but with dress patterns and fashion designs. Yet despite such allusions to real work and the impression of wistful yearning, Elizabeth Paxton was just as interested as her colleagues, male and female, in the other aspects of her painting: in creating a subtle rendering of light falling across a wall, a balanced and harmonious arrangement of form, a faithful depiction of a wide variety of materials and textures.

≈ ≈ ≈

It should not be a surprise that the women artists of Boston created imagery so much in keeping with those of their male colleagues. They sought to join the establishment, not to overthrow it. To prove that they were serious painters, most of Boston's women artists worked within the aesthetic and social conventions of their day. They wanted to exhibit and to sell their canvases, activities that marked them as professionals rather than amateurs and hobbyists. Nancy Hale remembered some potential clients who had trouble "bringing themselves to speak of

money to so beautiful and elegant a
person as my mother." They said they
"couldn't ask her how much she
charges … she's such a lady," she
recalled, to which Lilian Hale (fig. 54)
responded, "Good Heavens! Does she
think I do it for nothing? …. You'd
think I was some damned amateur."
"My mother never swore," Nancy Hale
continued, "but to my father amateurs
were always 'damned amateurs' …
'Never give away your work [he said].
People don't value what they don't
have to pay for.'"[4] Thus, in a city that
favored a distinctive, genteel style,
women painters sought to prove their
equality by working within the bound-

54. Lilian Westcott Hale, *Self Portrait*, 1928

aries of established taste. They were rewarded with critical and financial praise,
and in that way, achieved striking professional success.

The imagery of the Boston School was not created solely by men. Nor was
every male painter seeking consciously to create, and to venerate, an illusory con-
servative realm in which women could be denied the active roles that they were
gaining in the real world. Such scenes were not even purchased exclusively by
male patrons. Sarah Sears, for example, bought Tarbell's *Three Sisters: A Study in
June Sunlight*; Georgina Cary, a former student, acquired two Tarbells of inactive
women, *Reverie* (see fig. 56) and *The Dreamer*. Boston collector Zoë Oliver
Sherman, who was interested primarily in old master paintings, also owned
Paxton's *New Necklace* and Tarbell's *Rehearsal in the Studio*, as well as works by sev-
eral Boston women artists. The Boston School style was fabricated by men and
women alike, both artists and collectors. They were united not by a sweeping,
reactionary political attitude of antifeminism, as some scholars maintain, but by
the intense belief that the primary goal of art was to create beauty. It was a con-
servative approach, one that rejected completely the nascent modernism that had
started to appear in Europe and in New York.[5]

In the years between 1895 and 1915, when the tenets of the Boston School
crystallized, there was little indication that its aesthetic creed would ultimately
be judged a failure in the progressive reading of the history of art, that their for-
mula would come to be seen by many critics and historians as a stubborn refusal

to explore new ideas, as reactionary and antifeminist, and that Boston would come to be regarded as an artistic backwater. There were an equal number of established and prestigious artists in New York who held the same values and painted similar pictures—Thomas Dewing, Childe Hassam, and William Merritt Chase, for example—but Boston was a smaller town, unable to support the variety of artistic constituencies that could, and did, thrive in New York. While a few short-lived attempts were made to introduce new styles in Boston, the hegemony of the Boston School painters was far too strong, and after awhile, most incipient modernists simply gave up and moved away. Among those who decamped to New York was Arthur Wesley Dow, who left in 1895 to teach at the Pratt Institute, where his students included Georgia O'Keeffe and Max Weber. Marsden Hartley worked in Boston from 1907 to 1909, and although he once wrote Philip Hale a letter of effusive praise, he too soon moved to New York. Maurice Prendergast, despite the continued support of Sarah Sears, left Boston in 1914. As Lincoln Kirstein, later an exceptional patron of modern dance, wrote of his years at Harvard in the 1920s when he was deeply involved in modern art, "Boston was a combination of a prison and Friday afternoons at the Symphony."[6]

If Boston seemed like a dungeon to champions of modernism, it appeared as an oasis of beauty for artists who favored a more traditional approach. As William Paxton explained, "the best group of painters in the world today is right here in Boston."[7] The circle was firmly linked, men and women alike—all were either teachers at the Museum School (or at Massachusetts Normal) or had been students there, or both; they had quarters in the Fenway Studio Building on Ipswich Street (fig. 55) or in their homes; they had the same club affiliations (with the exception of those closed to women); they showed their work at the same galleries; they attended and praised each other's exhibitions; and in many instances, they were close personal friends, even marrying one another, as did Lilian Westcott and Philip Hale, Elizabeth Okie and William Paxton (fig. 52), Nelly Littlehale and Hermann Dudley Murphy, Marcia Oakes and Charles Woodbury, Sally Cross and Carroll Bill (see pls. 47, 48, 50–57). All of these conspicuous connections led to a remarkable stylistic unity and helped to produce the so-called Boston School.

Painters of the School were interested in realism, but not the social realism of the group of New York artists dubbed the Ashcan School, who were active during just the same period, nor the emotional realism favored by some of the modernists. In his memorial to Marie Danforth Page, Anthony Philpott noted that she had "ignored the cant that ugliness and vulgarity are necessary factors in art." Nancy Hale remarked that her mother Lilian Hale stood apart from "modern

55. Fenway Studio Building, 30 Ipswich Street, Boston. Many of Boston's best-known painters, both men and women, had studios here.

painters … [who] gazed at the ground, painted by electric light, peered into the shadow—all of which was against her artistic religion." The Boston critic F. W. Coburn articulated the distinctive local taste in 1913, after seeing the Armory Show, when he noted regretfully that the modernists "trifle and jest with such sacred things as form and color and air and sunlight and the human being's love of refined and intelligent workmanship."[8] Instead of showing the unpleasant truths of urban life or rendering a personal expressionist response to the world, the Bostonians were absorbed in a different kind of realism; they sought instead to "make it like," a credo repeated over and over again amongst the group. Once they had selected their subjects, chosen for their beauty and harmonious arrangement, they worked to portray them faithfully, not only by depicting forms perfectly, but also by enveloping them in light and atmosphere. It was a style in which the work of Johannes Vermeer, the recently rediscovered seventeenth-century Dutch master of domestic interiors, was proposed as an appropriate model for contemporary painting—not because he showed women in traditional domestic roles, but because he was a master at painting light, a subject in which the Boston painters had been interested since the 1880s when they were among the first Americans to explore the French Impressionist style.

≈ ≈ ≈

It was Vermeer's work which inspired Lilian Hale to paint *Home Lessons* (pl. 50), a large figure study of her young Dedham neighbor Margaret Foley, whom Hale's daughter Nancy described as "plain as a hedge fence."[9] The atmosphere is studious rather than decorative, set by the model's serious expression and the attributes of learning surrounding her: a book representing history, a terrestrial globe symbolizing geography, a spinet illustrating music, and a large painting denoting the fine arts. *Home Lessons* was purchased soon after its completion by Duncan Phillips, a patron celebrated today for his devotion to modernism, but who wrote of his own collecting that he held to "a definite policy of supporting many methods of seeing and painting ... [the Phillips Collection] is famous for its inclusiveness, but at the same time for its atmosphere of aesthetic integrity ... [it] must guard its doors against the intrusion of wild unbalanced radicals and of dogmatic, close-minded conservatives ... there is just as much sham and intolerance at one extreme as at the other."[10]

The genteel character, often inspired by Vermeer, that dominates the imagery of the Boston School should not be misconstrued to stand as a faithful representation of the artists themselves. Although the scenes were often set in the homes and studios of the painters, and thus reflect the artistic atmosphere and traditional New England furnishings many of them preferred, they do not necessarily reveal completely their personal political and social attitudes, which were much more complex. The male artists of the group who have been accused of manufacturing antifeminist imagery were in many cases actually staunch supporters of working women, women who were artists. Edmund Tarbell and Philip Hale are often considered the most egregious examples of painters who refused to see women as they really were, but instead used them as passive props whom they could arrange decoratively alongside the other fashionable accessories of an upper-class household (fig. 56).

While Tarbell's imagery can support such conclusions, it is difficult to reconcile these perceptions with his activity as a teacher. Tarbell was the mentor of the majority of Boston women who became successful professionals. He remained a champion even later in their careers, telling his former student Lilian Hale that the drawings she exhibited at the Rowlands Galleries in 1908 (see fig. 75) were "the finest modern drawings he had ever seen" and buying one of them for his own collection. Many years after she had left his tutelage, Tarbell congratulated Gretchen Rogers (pl. 49 and fig. 47) on one of her exhibitions at the Guild of Boston Artists. "Permit me to say," he wrote, "that as your ancient instructor, I am proud of you ... some of your pictures there seemed as beautifully painted as any

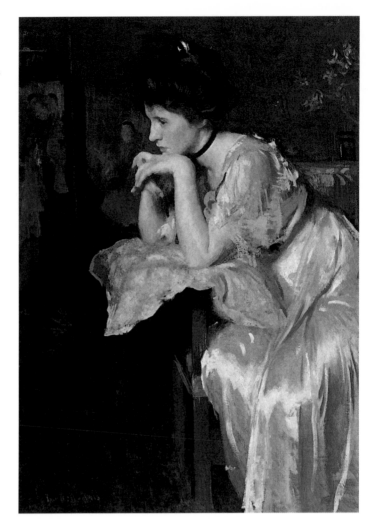

56. Edmund C. Tarbell, *Reverie (Katharine Finn)*, 1913, oil on canvas.

I have seen in years." A member of Rogers's family recalled a conversation with Tarbell about her, quoting him as saying that Rogers was "the best pupil I ever had … a genius. She's too modest, that is the trouble with her. She doesn't value herself enough."[11] Tarbell did paint inactive women, but he did not necessarily believe in them.

Tarbell's Museum School colleague Philip Hale had a more complicated relationship with Boston's women artists, no doubt because he had one for an aunt, another for a sister, and a third for a wife. In each case, however, there is evidence to suggest not only that these women supported Hale's artistic ambition, but that he also upheld theirs. Susan Hale was Philip Hale's first art teacher, and she accompanied him during his first studies in Paris. An indefatigable traveler, reader, and observer, her correspondence reveals her to have been an intellectual and informed woman of spirit and determination. While she did teach classes in

watercolor, her own art remained an avocation rather than a profession. Nevertheless, her strong presence and positive spirit must have communicated the potential of women to both her nephew Philip and to her niece Ellen. The presence of women like Susan Hale and Ellen Day Hale in Philip Hale's family predisposed him to think that women painters were a natural occurrence; that feminist Charlotte Perkins Gilman was his first cousin and writer Harriet Beecher Stowe was his great aunt may have also affected his understanding of women's capabilities. The art created by his wife, Lilian Westcott Hale, certainly made him aware of the power of a woman's talent.

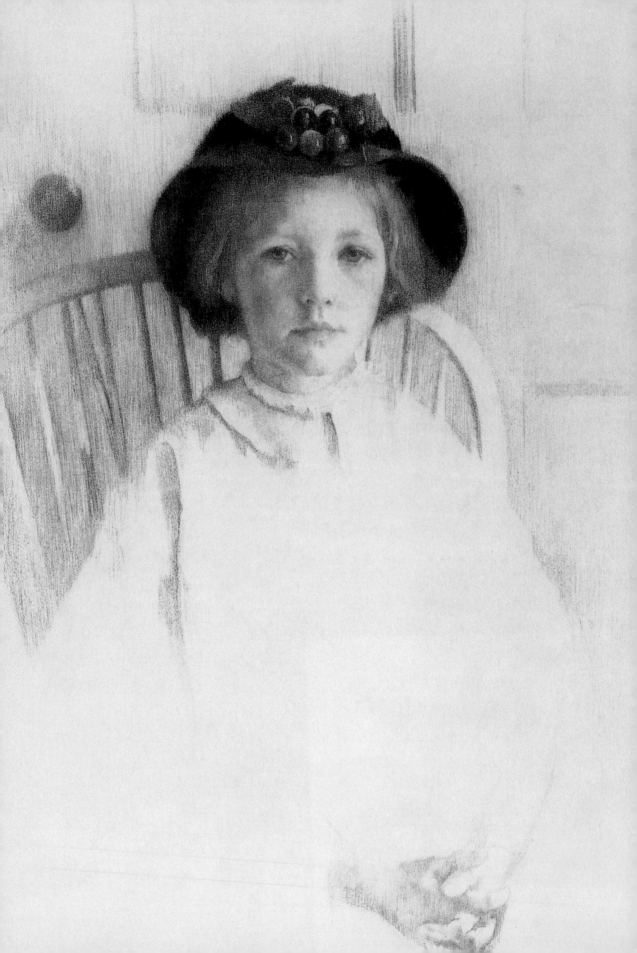

Lilian Westcott had been a talented student at the Hartford Art School in Connecticut and a summer pupil of William Merritt Chase. She had arrived at the School of the Museum of Fine Arts with high recommendations and a scholarship. She told her instructor in Hartford, Elizabeth Stevens, that her "highest ambition [is] to be a portrait painter," a specialty that she felt combined both high art and the potential to earn her own living. Her practical streak was also reflected in her youthful plan to avoid marriage, dedicating herself instead to her craft. Like the women of the preceding generation, Westcott feared that marriage would put an end to her professional aspirations, a concern that would continue to trouble aspiring women well into the twentieth century. She was not alone—in 1892, the painter Adelaide Cole wrote to a friend about her impending marriage to architect William Chase, "I already feel that I am not I anymore."[1]

Contemporary culture still reinforced the notion that marriage and art could not be combined successfully. In Eleanor Hoyt's short story "Women are Made Like That," published in *Harper's* in November 1901, a young American woman artist in Paris, Elizabeth Russell, doubtful of her own prospects, agrees to marry her suitor. Before they wed, she decides to make one last effort and, with a portrait of her fiancé, she wins acceptance to the Salon. Her work is hung "on the line" and earns enthusiastic critical acclaim. Russell immediately calls off her wedding, writing in her farewell note to her forsaken lover, "'I would hurt you more if I married you. Art was always first.'"[2]

57. Lilian Westcott Hale, *Portrait of Nancy (The Cherry Hat)*, about 1914

Marriage and a career were still as incompatible in this story as they had been for Avis Dobell in Phelps's novel *The Story of Avis,* but now the heroine could strike out on her own. The same year, the Boston biographer Caroline Ticknor discussed this new woman somewhat ambivalently in the *Atlantic Monthly,* noting that her "point of view is free from narrow influences, and quite outside of the home boundaries … [and she is] prepared to enter a profession."[3] The New Woman was independent, educated, questioned her traditional role, and might eschew marriage for a career, but she did not necessarily combine the two. As one Museum School student wondered in 1895, "What [shall we] all be doing five years from now; shall we be drawing and painting still? Shall we be successful, or shall we, after that deplorable weakness of womankind, fall in love and marry?" The two objectives seemed mutually exclusive.[4]

When Lilian Westcott met and fell in love with Philip Hale in Hartford after her first year at the Museum School, she was forced to reconsider her decision to remain unmarried. There were conflicting ideas on the subject, as Louise Cox explained in an 1895 article entitled "Should Woman Artists Marry." Cox was responding to an earlier article, "by a woman," which proclaimed that "to the vast majority of women it is impossible to practice art after marriage. Either it will be poor art, or an unkempt family. It is true, we cannot serve two masters." In Cox's view, however, "women writers marry, women musicians marry; Why should artists be in a class by themselves?":

> The woman painters who marry and go to pieces would probably do that anyway … I should never honor a woman who would give up a marriage—not marriage in general, but a marriage in particular for one exclusively devoted to art … she shirks half her duties and loses more than half the happiness of life … art after all is life and I will never yield to the pessimistic theory that the fuller development of one must kill the other in women any more than in men.

Westcott expressed her quandary to her sister, who responded that "Mr. Hale seems a man very congenial in his tastes to yours, and I do not see why [by] loving and marrying him you would break your vow of everlasting faithfulness to your work." And Philip Hale courted her not only with love but also with professional encouragement. "We shall have you a great painter one of these days," he wrote her during her studies.[5]

Lilian Westcott married Philip Hale in June 1902, and thus she entered one of the largest communities of women artists: women who were related, by blood or marriage, to male artists. The role she undertook was complex, and while it

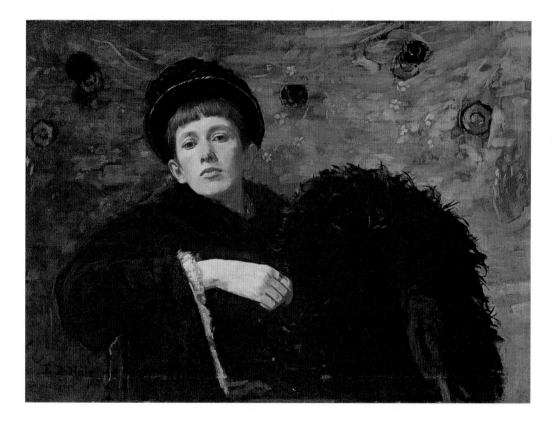

Plate 41
ELLEN DAY HALE
Self Portrait, 1885, oil on canvas

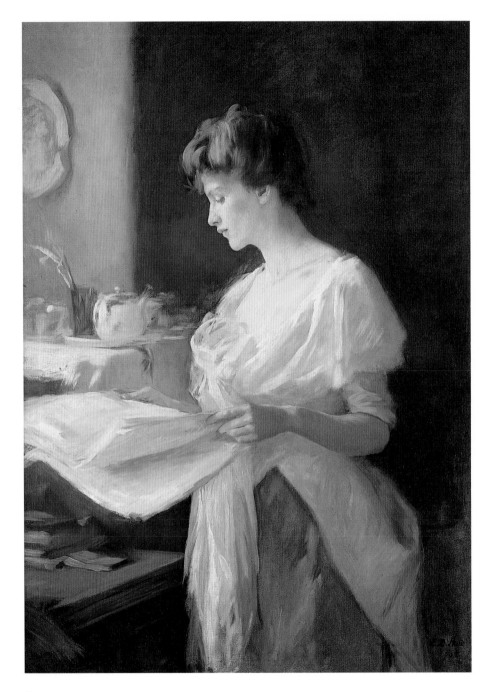

Plate 42
ELLEN DAY HALE
Morning News, 1905, oil on canvas

Plate 43
ELIZABETH MORSE WALSH
A Maid of Dundee, 1918,
oil on canvas

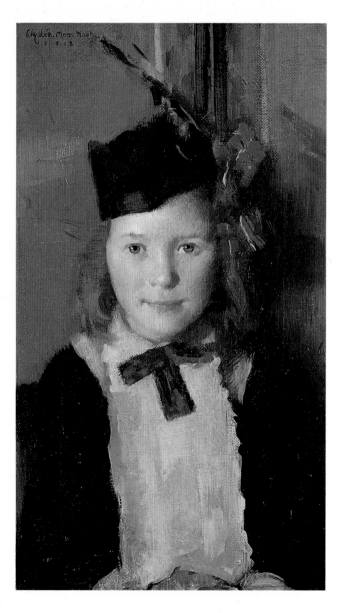

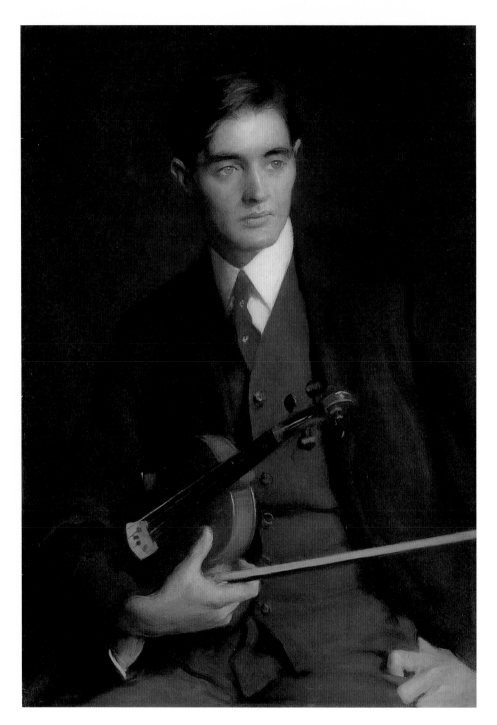

Plate 44
ADELAIDE COLE CHASE
The Violinist (John Murray), about 1915, oil on canvas

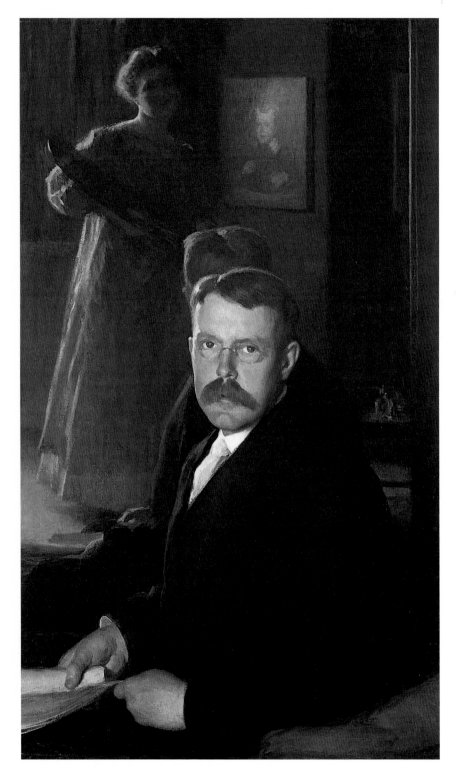

Plate 45
MARIE DANFORTH PAGE
Calvin Gates Page, 1909, oil on canvas

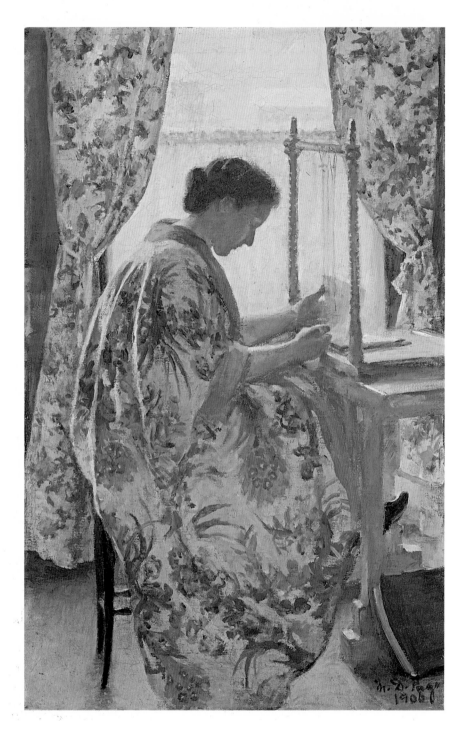

Plate 46
MARIE DANFORTH PAGE
The Book Binder, 1906, oil on canvas

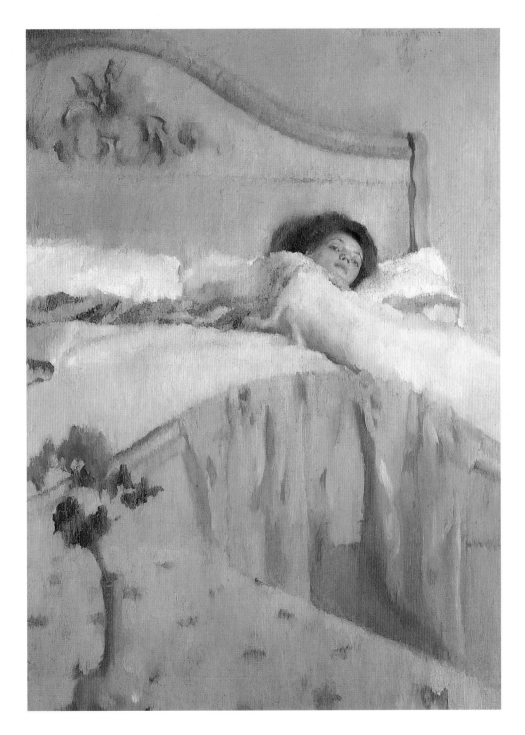

Plate 47
LILIAN WESTCOTT HALE
Zeffy in Bed (The Convalescent), 1906, oil on canvas

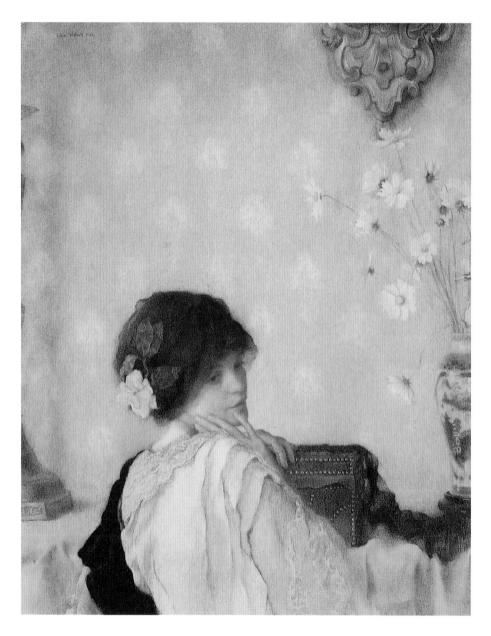

Plate 48
LILIAN WESTCOTT HALE
Gardenia Rose, 1912, charcoal on paper

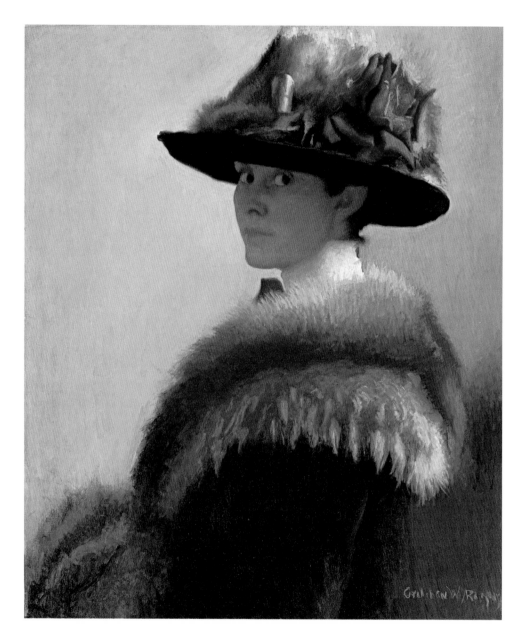

Plate 49
GRETCHEN ROGERS
Woman in a Fur Hat, about 1915, oil on canvas

Plate 50
LILIAN WESTCOTT HALE
Home Lessons, 1919, oil on canvas

Plate 51
ELIZABETH VAUGHAN OKIE PAXTON
The Open Window, 1922, oil on canvas

Plate 52
LILIAN WESTCOTT HALE
Flower (Nancy Hale, aged 6 weeks), 1908,
charcoal on white board

Plate 53
LILIAN WESTCOTT HALE
Portrait of Nancy (The Cherry Hat), about
1914, charcoal on paper

Plate 54
LILIAN WESTCOTT HALE
On Christmas Day in the Morning,
about 1924, charcoal and colored
chalk on paper

Plate 55
ELIZABETH VAUGHAN OKIE PAXTON
Breakfast Still Life, about 1923, oil on canvas

Plate 56
ELIZABETH VAUGHAN OKIE PAXTON
The Breakfast Tray, about 1910, oil on canvas

Plate 57
NELLY LITTLEHALE MURPHY
Peonies, 1937, watercolor on paper

Plate 58
MARION BOYD ALLEN
Motherhood, 1920, oil on canvas

worked for some women artists, it still proved difficult for others. The dangers had recently been pointed out by the painter Anna Lea Merritt, who wrote a letter of advice to artists, "especially women artists," that was published in *Lippincott's Monthly Magazine* in 1900, the year Lilian Westcott entered the Museum School. Merritt discussed art training and professionalism, and explained that she found women artists to be included appropriately in schools and in exhibitions. But she added a warning: "The inequality observed in women's work is more probably the result of untoward domestic accidents ... women who work must harden their hearts, and not be at the beck and call of affections or duties or trivial domestic cares ... the chief obstacle to a woman's success is that she can never have a wife."[6] Not only could a heterosexual woman not have a wife, but also when she married, she was the wife—and certain rigorous restrictions and obligations were imposed by contemporary society. Women of sufficient economic means were not expected to work for money; whatever training they had undertaken before their marriage was now meant to be put to use in the home, to benefit the children or to serve a charitable cause. To do otherwise reflected poorly on the family's finances or their ethics, for only an immoral woman would take a respectable paying job away from someone who truly needed it in order to fulfill her vanity. Wives were also expected to manage domestic affairs—arranging for child-care, cooking, house-cleaning, laundry, mending, handling social correspondence, and so on, whether they did these tasks themselves or hired servants to do them. Married women artists of Hale's generation took particular care to emphasize that their talents did not disrupt the sanctity of their homes.

Such assurances were especially important when a painter's own children entered the equation. In 1905, when the Fenway Studio Building on Ipswich Street first opened, Lilian and Philip Hale were among the first tenants. Significantly they did not share a studio, but took adjoining accommodations that gave each painter equal space. But in 1908, when their daughter Nancy was born, Lilian Hale moved her studio into her new suburban home in Dedham, ceding her rooms at the Fenway Studios to her unmarried friend Gretchen Rogers. Almost all of her subsequent work was made in her domestic studio; that fact alone reassured those who felt women should not work outside the home.

Like most new mothers, Hale was preoccupied with the needs of her baby, and she produced little work in the eighteen months after Nancy's birth. But she created opportunities for herself, combining her maternal duties and her art by drawing her daughter as she napped. In *Flower* (pl. 52), an infant Nancy lies on an elaborate floral cloth against a background of garlanded rococo wallpaper. In

a highly effective use of negative space, Hale left the center of her image com-
pletely blank, allowing the white of the paper to define the child's gowned form.
The rest of the page is given over to sinuous, luxurious pattern, against which the
baby's plump fists and delicate features almost disappear. The infant herself
becomes another of the joyous blossoms that decorate the composition. Nancy
would remain her mother's most frequent model, sometimes by choice but no
doubt also by necessity. As Hale remarked when Nancy was five, "I'm beginning
to feel very lost in anticipation of Mother's departure next week which will again
tie my hands, for it will be like having my governess advisor and housekeeper
desert me … with her help this winter I have had such good and regular hours
for painting and drawing and such freedom to go wherever I wished."[7]

Hale could both mind her child and produce her art if Nancy posed for
her, and her daughter's solemn features lend dignity to another portrait, entitled
The Cherry Hat (pl. 53 and fig. 57). In another artist's hands this image may have
become sentimental, but Lilian Hale instead captured her daughter's seriousness,
her distinct identity as an individual. Just as she is being observed, Nancy exam-
ines the viewer. She seems to hold as many secrets as she reveals. Hale created
this sense of mystery by concentrating her drawing on Nancy's head and hands
and including only a scant suggestion of the rest of the figure; the young girl
seems magically both solid and ethereal.

<p style="text-align:center">⌢ ⌢ ⌢</p>

Creating art related to children—whether illustrating books for young readers,
crafting nurseryware, or producing children's portraits—was of course held to
be appropriately feminine, whether or not a painter had offspring of her own.
Illustrator Ethel Reed, designer Edith Brown, photographer Alice Austin, and
painter Adelaide Cole Chase all produced images both for and of children,
despite the fact that they were not mothers themselves (fig. 58). Lilian Westcott
Hale, Marie Danforth Page, and Sarah Sears, who had children, did the same.
"This is the age of the child," reported the critic Sadakichi Hartmann in the July
1907 issue of *Cosmopolitan*, and "to have the children painted or photographed
has become a habit with all elders."[8] Writers agreed almost universally that por-
traying children was particularly well suited for women, for they were considered
to have an inherent understanding of their subjects. For a woman artist, whether
she liked children or not, it was both a trap and an opportunity. Children were
seldom the subject of important public commissions, but portraits of children, by
both men and women, were widely exhibited and won substantial critical atten-

58. Alice Austin, *Reading*, about 1900

tion and acclaim—one need only recall Sargent's much-admired *Daughters of Edward Darley Boit* (1883, Museum of Fine Arts, Boston). Even the old masters were admired for their images of youth; Velásquez's images of the Spanish Infanta were among his most highly praised paintings, and Gainsborough's *Blue Boy* commanded a record price when it was sold in 1921. While some women may have felt pigeonholed by the demand for children's portraits, the theme also provided them with subjects that could be painted within a domestic setting (easier for those who had studios at home) and with a consensus that their likenesses would be well received, considered both natural and appropriate.

Lilian Hale created dozens of likenesses of children and, as it was for Page, the specialty proved to be a reliable source of income. Painters who did not teach most frequently relied upon portraits for their livelihood, and such commissions were of course sales, business transactions that enhanced an artist's reputation as a professional (and not an amateur). In 1927, Hale held a joint exhibition at Manhattan's Grand Central Galleries with the New York painter Ellen Emmet Rand; the show was dedicated to children's portraits and the headline in the *New York Sun* proclaimed "Two Artists—Also Mothers—Exhibit Their Canvases. Both Admit Their Children Are Their Best Work." The newspaper emphasized not only the artistic accomplishments, but also the motherhood of the protagonists, mentioning specifically the Roman legend of Cornelia, who, when asked about her most precious jewels, replied that they were her children. The review also dealt with the difficulties of combining motherhood and a career:

'They say'— that the deadly palette and brush in the hands of woman have
scuttled more than one matrimonial bark. 'They say'—that landscape and
omelet artistry can never be combined; and 'they do say' that successful moth-
ers and successful artists—well, my dear, if you read Kipling at all, never the
twain shall beat. So a current thumbs-down opinion on motherhood and art as
a successful joint career should never permit Mrs. Ellen Emmet Rand, A. N. A.,
artist and mother, and Mrs. Lilian Westcott Hale, mother and artist, from ever
seeing the day when they would exhibit charming portrait after portrait ...
[Yet both] are successful mothers and successful artists, as their portraits on
exhibition substantiate.[9]

Hale's dress, appearance, and household were also described in detail, reassuring
the reader that her career as a painter had not destroyed the integrity of her
home or the well-being of her family.

Such press coverage is significant, for it shares the same strategy used by
writers in support of other active women. Similar tactics appear in pro-suffrage
literature; Mary Kinkaid's 1912 article for *Good Housekeeping*, entitled "The
Feminine Charms of the Woman Militant: The Personal Attractiveness and
Housewifely Attainments of the Leaders of the Equal Suffrage Movement," is
but one example. Kinkaid described Elizabeth Cady Stanton as an accomplished
homemaker, Susan B. Anthony as a woman who finished her mending while she
contemplated her speeches, and Carrie Chapman Catt as a cook who made her
pumpkin pies without resorting to canned goods. The article also included a
photograph of Inez Mulholland, a Vassar-educated suffragette, in costume as
Cornelia.[10] Even after the Nineteenth Amendment guaranteeing women's right
to vote was passed in 1920, working women still felt the need to prove that their
homes, the sacrosanct ideal of American life, had not been compromised. "As for
seeing anything rare or unusual in the successful triumvirate of wife, mother, and
artist, Mrs. Hale, on the contrary, finds it only a 'very comfortable and satisfacto-
ry' arrangement. Her household is not turned topsy-turvy, because she maintains
a studio in her home," wrote McBride in the *New York Sun*.

With so much attention paid to their domestic affairs, it is no wonder that a
woman like Lilian Hale felt compelled to produce jar after jar of homemade jelly
and preserves, a process described by her daughter in *The Life in the Studio*. The
story also reveals Philip Hale's support for his wife's career, for as Nancy Hale
related:

I knew that he [Philip Hale] was thinking it unfair she should be considered
domestically careworn, when he never wanted her to do all that cooking in the
first place. I knew he was thinking, Why must she insist on doing what the world
does? The world had its ways and my parents had theirs—a painters' life so pre-

59. Elizabeth Vaughan Okie Paxton, *The Kitchen Table*, about 1926

cious, so joyful, that only a saying of Gainsborough's that my father loved ade-
quately expresses it: 'We are all going to Heaven, and Van Dyck is of the compa-
ny.' It seemed to my father that he and she had quite enough to do with the
world as it was—attending to things that couldn't be got out of. Income tax
forms, for one thing …. If practical matters were so noxious, why can vegetables?
The only thing my father ever wanted my mother to do was paint.[11]

Even with her husband's support, Lilian Hale felt obligated to fulfill traditional
expectations, to emphasize her capability for domestic chores, to be the woman
contemporary society demanded.

Nor was such behavior limited to women artists with children. Elizabeth
Okie Paxton, a student at the Cowles Art School when she met her future hus-
band, painter William Paxton, produced art that is remarkable for its concentra-
tion on feminine, domestic subjects (see pls. 55, 56). Her still lifes, crafted with
great harmony and precision, are almost exclusively kitchen still lifes—breakfast
trays; arrangements of eggs, bowls, and milk pitchers; copper pots and spoons
(fig. 59). "The Kitchen Table," noted one newspaper account of Paxton's work,
"shows what a tasty picture may be compounded from homely objects if you have
the right recipe."[12] Her more ambitious still lifes were also within a feminine
sphere, depicting shop windows filled with bric-a-brac, such as *The Mannequin*
(fig. 60) or *At Auction* (private collection). In addition to such scenes, Paxton cre-

60. Elizabeth Vaughan Okie Paxton, *The Mannequin,* about 1920

ated a number of interiors, both with and without figures, that feature women's bedrooms, clearly identified as such by the abandoned breakfast trays, high-heeled shoes, corsets, and other feminine accoutrements they contain (pl. 56). Some of them were reproduced in women's magazines, including *House and Garden,* where they appeared in advertisements for Wamsutta sheets.

Only once, very early in her career, is there a hint that Elizabeth Paxton rivaled her husband, when the *Boston Evening Transcript* remarked in a review of a group show of Boston painters at the Rowlands Galleries that "both Mr. Hale and Mr. Paxton have talent, and it is a pity that they should not make the best of themselves. We suggest that they take a few lessons of Mrs. Hale and Mrs. Paxton."[13] But the Paxtons did not compete, and Elizabeth Paxton's career took a minor path compared to that of her husband. She produced her paintings in a studio in her Newton home, working steadily, carefully noting her exhibitions and business transactions in a small notebook and exhibiting in both local and national shows. At some point after her husband's death in 1942, she moved back into the Fenway Studio Building, sending out a change of address card with a picture showing herself happily painting at her easel.

≈ ≈ ≈

The Boston women artists whose husbands were also painters faced an additional challenge to the balance they sought to maintain between their careers and their families—the role their work took in relation to their husbands'. Just as Elizabeth Paxton developed a distinct niche, Nelly Littlehale Murphy confined herself to watercolor (pl. 57), and even when she and her husband both turned their attention to floral still lifes, there was little rivalry between them. "As ever," remarked a newspaper review entitled "H. Dudley Murphy et uxor," "Mr. Murphy confines himself to oils and his talented wife to water. But here water and oil mix well, and save for the difference in media ... it might be difficult to distinguish between the two artists and more difficult still to appraise their respective merits."[14] Yet the writer went on to spend most of the review discussing Hermann Murphy's work, for oil painting had always taken precedence over watercolors, and watercolor had been a traditional medium for women. By restricting herself to watercolor, Nelly Murphy made it easier for the press to advocate her husband's work; yet there is no evidence to suggest that she was dissatisfied with her choices.

For the Hales it was different, for they both knew that she was the better artist and her work was more favorably received than his. But Lilian Hale either allowed or depended upon her husband to take the superior role in their marriage:

> When my father got home from his Boston studio just before dinner at night, he would go at once to my mother's studio, on the north side of our house in Dedham, and see how her day's work had progressed. "I need a crit," she would cry, embracing him at the front door. The slang abbreviation, used by callow art students ... suggested the relationship of master and pupil.[15]

Throughout their marriage, Lilian Hale relied upon her husband's support, advice, and encouragement. She seems to have needed it to reinforce her strengths and to overcome her insecurities, and it presumably helped to make their marriage work. It certainly was in keeping with the dominant cultural pattern, and was a strategy that allowed her to be a professional artist within a conservative artistic environment. It no doubt helped, however, when a visitor admired Philip Hale's paintings, that he "looked over his glasses ... and said, 'Wait until you see Mrs. Hale's pictures.'"[16]

Even women painters who did not marry artists or have children were bound by the social values of contemporary culture; as historian Lisa Tickner has written, none were exempt from the accepted definitions of what women should be, what they should do, or how they should present themselves. Their accomplishments must be judged in context. In her 1901 definition of New England women, Kate Stephens noted that "a narrow fatalism, united with the conser-

61. Marion Boyd Allen, *Cannon Mt., Glacier National Park*, about 1930

vatism and aristocratic instincts common to women from their life, gives the New England woman a hedged sympathy with the proletarian struggle for freer life."[17]

Marion Boyd Allen, who entered the Museum School at age forty in 1902 and continued her studies there after her 1905 marriage to William Allen, was childless. Nevertheless at the beginning of her career, even after her husband's death in 1911, she specialized in appropriately feminine subjects. *The Enameler* (fig. 24) is one of the few known today, but contemporary descriptions of several unlocated works make Allen's emphasis clear: *Killarney Roses*, two young women opening a box of flowers; *The Challenge*, a girl dressed for a winter walk, grasping a sprig of mistletoe; *The Studio Mirror*, a young model admiring her reflection, and so forth. From 1918 to 1920, she painted two images celebrating children and parenting; *Fatherhood*, an unusual depiction of a young man with a laughing nude toddler (current location unknown) and *Motherhood* (pl. 58). Paintings such as these reinforced Allen's connection to the feminine world, even while she was doing business as an artist (arranging portrait commissions, exhibitions, and sales). Only when she was in her sixties did Allen indulge her taste for rugged travel and turn her attention to landscapes of the American West (fig. 61). One newspaper reported that Allen had wanted to be a landscape painter since her youth, when she had first seen the Swiss Alps, however "marriage, domestic cares, and attendance on an aged and invalid mother intervened." But even late in Allen's career the press maintained her femininity and she was described in the Boston papers as a "chubby, motherly little woman" whom "you wouldn't think … was capable of such a life in the Rockies."[18] Allen's strength was clearly revealed in at least one arena, however, for her painting style, especially in such works as *Anna Vaughn Hyatt* (fig. 62 and pl. 59), is particularly forceful and bold.

Allen's portrait represents the sculptor Anna Vaughn Hyatt at work in her Annisquam, Massachusetts, studio. Adamant that her portraits fulfill their purpose as faithful likenesses, Allen captured Hyatt in action, allowing the sculptor to work shaping her clay model during their session. Thus Hyatt assumed a customary pose, one foot resting on the stand that holds her model. She holds her wire loop in one hand, and manipulates the clay with her other, raptly absorbed in her creative process. Allen later remembered that Hyatt had asked her to repaint the arms in this portrait to display her actual muscular strength. Hyatt was not concerned with ideals of feminine beauty, but she cared deeply about her image as a capable sculptor, one of several active in Boston.[19]

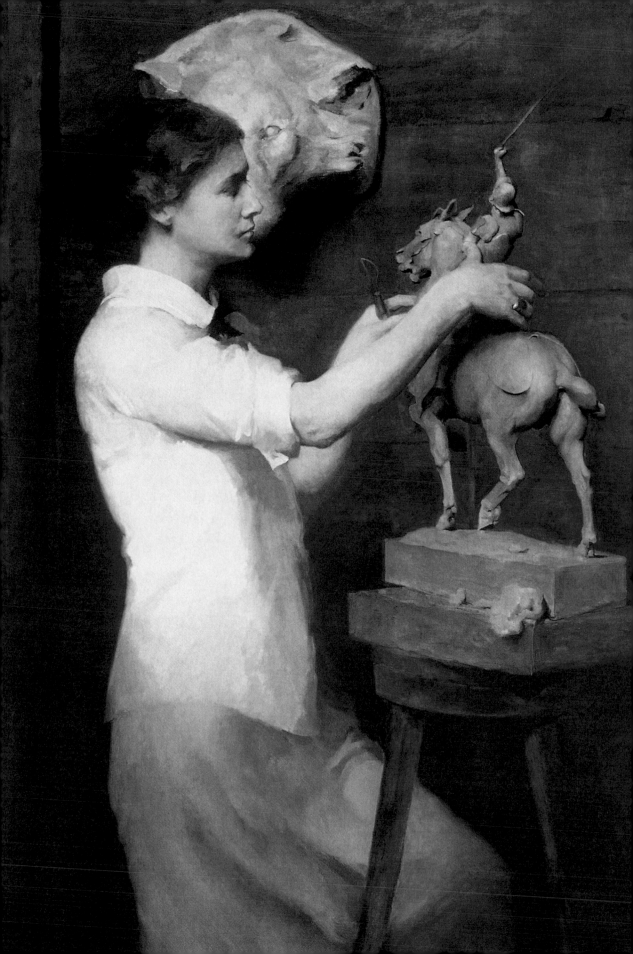

"THUMPING WET CLAY"

Sculpture had by no means disappeared from the hands of women. By the 1890s lessons in modeling and casting were offered regularly at the School of the Museum of Fine Arts, the Cowles Art School, the Massachusetts Normal School, and other institutions. Often modeling classes were intended to train students to make ornaments for mantelpieces, wall decorations, and picture frames; in consequence many of the students interested in artistic rather than commercial production favored the Museum School. That program had had an erratic start in the late 1870s and ceased altogether during the next decade, but in 1893 the Paris-trained sculptor Bela Lyon Pratt was hired and the course became firmly established. It won national acclaim in 1904, when students at the Museum School won the Grand Prize for modeling at the Louisiana Purchase Exposition in Saint Louis. In 1915, the *Boston Herald* loudly proclaimed in its headline that "Thumping Wet Clay Fascinates the Women," and reported that with the arrival of adequate instruction in the art schools, Boston had developed a considerable community of women sculptors.[1]

At the turn of the century, the strong presence of sculptor Anne Whitney reminded Boston women that such a career was possible. In the early 1890s, Whitney provided busts of four prominent campaigners on behalf of women's rights for the 1893 Exposition: Harriet Beecher Stowe, Lucy Stone, Mary Livermore, and Frances Willard (pl. 60).[2] Willard, the dynamic Chicago speaker, educator, and president of the Woman's Christian Temperance Union, had posed for Whitney in Boston in April 1892. She convinced the sculptor, whom she called

62. Marion Boyd Allen, *Anna Vaughn Hyatt* (detail), 1915

"Boston's pride," to participate in the project, despite Whitney's disdain for the segregated display in the Women's Building. "I do not want anything I have done put forward on the basis of its being the work of a woman," Whitney declared.[3] At about this same time, Whitney crafted a bronze relief portrait of Mary Hemenway, the Boston philanthropist and proponent of physical education for women (collection of the Wellesley College Archives). In 1898, in a bold statement against the increasing aggression and imperialism of American foreign policy, the seventy-seven-year-old Whitney publicly argued for her fellow citizens to remember the work for world peace undertaken by their former senator Charles Sumner. Financed by public subscription, she reworked her monumental *Sumner*, which at last was cast in bronze and installed in a place of honor in Cambridge in 1900.[4] The site was only a few blocks from the childhood home of Anna Vaughn Hyatt, who would have her own first solo exhibition of sculpture the same year.

❦ ❦ ❦

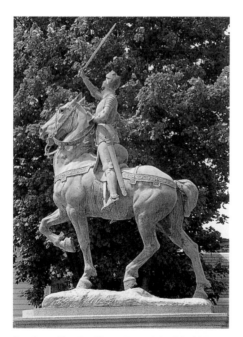

63. Anna Vaughn Hyatt, *Joan of Arc*, World War I Memorial, Gloucester, Mass., 1915–18

64. Anna Vaughn Hyatt, *Joan of Arc* (small bronze version), 1915

Like Anne Whitney, Anna Hyatt came from a liberal Massachusetts family (fig. 62). The daughter of Alpheus Hyatt, a professor of paleontology and zoology and founder of the first American marine biology laboratory, and his wife Audella Beebe Hyatt, an amateur landscape painter and illustrator, Anna and her sister Harriet were encouraged by their parents to pursue their interest in art. Both daughters studied drawing at the Cowles Art School and modeling with the prolific Boston sculptor Henry Hudson Kitson (whose wife, Theo Alice Ruggles Kitson, was also a sculptor). Harriet Hyatt, eight years older than Anna, crafted her sister's likeness in 1895; Anna soon also began to plan a career in sculpture. The two women shared a studio and imagined opening a school together, but Harriet's mar-

riage to a biology professor in 1900 occasioned a move to Princeton, New Jersey, where she worked only sporadically. The sisters, along with Harriet's friend the painter Adelaide Cole Chase, were reunited during the summers they spent together in Annisquam.

Anna Hyatt's first exhibition, held at the Boston Art Club, was devoted to small animal studies, a subject that attracted a large number of women sculptors. It might be argued that Hyatt's love of animal subjects came from her zoologist father, and the genre was her passion. It was also one considered appropriate for women, although it was by no means limited to them. The problem went back to the issue of studying anatomy from a live model, the demon that had so inflamed Victorian sensibilities. Drawing or painting from life was bad enough, but to model from life was even worse, for of course, the form would need to be touched. There was no "Mohammedan solution" of students wearing veils for that, but an animal could be appropriately studied and modeled without as much controversy, as painter Rosa Bonheur had demonstrated. Hyatt pursued her studies wholeheartedly, studying animals at special livestock shows, circuses, and the zoo.

While Hyatt did produce tabletop pieces, she is most admired for her monumental sculpture, much of it the result of important public commissions. The *Joan of Arc* that she shapes in Allen's portrait was the second version of the subject that Hyatt undertook. Her first rendition, made during the time she worked in France, was accepted for the 1910 Salon. That piece (no longer extant) helped win her the commission to create a life-size equestrian statue of the French heroine honoring the 500th anniversary of her birth for the city of New York; monumental versions were also cast for Blois, Québec City, San Francisco, and Gloucester, Massachusetts (where it serves as a World War I memorial, fig. 63). Public equestrian monuments were not the usual fare for women, but Hyatt's strong reputation as an animalier and the gender of her subject were in her favor, and *Joan of Arc* was well received. Later Hyatt was given other such commissions, including *El Cid, Don Quixote,* and *José Martí.*

As expected from the accurate anatomy and powerful modeling of the great Percheron stallion upon which Joan rides, Hyatt had been devoted to the faithful representation of animals throughout her career. She held that she had been dismissed from Kitson's studio for correcting him on a point of equine musculature, and she was scrupulous in her study and representation of all types of creatures, from bears to vultures. As her nephew later recalled, "We children learned order and concentration by watching Aunt Anna as she changed into her work clothes as soon as she came home from errands, went straight to her modeling stand,

and instantly, without error, shaped the beasts that she had been revising in her mind's eye while outwardly busy with other things."[5] Among her most successful works are those of wild cats, particularly jaguars (pl. 61).

Hyatt first studied the animals at the Bronx Zoo in 1905 during the time she spent in New York extending her education at the Art Students' League. She was discovered at her work by a reporter for the *New York Times*, who described her as "a tall, young woman in a gray tailor-made frock and a red plumed hat ... [with] a mass of clay on a high stool." The illustrated article, entitled "Woman Sculptor and Bison in the Bronx Zoo Exchange Confidences," related Hyatt's history and training as if she were in a conversation with the bison. The conceit was amusing ("no flattery, please, here's a tasty bunch of grass"), but it represented Hyatt as an eccentric rather than a professional. Hyatt was, however, intensely serious about her craft, stating to the *Times* that "one ought to be perfectly independent in one's work and above outside influence ... before going abroad."[6]

She did travel to France in 1907, where she further developed her images of jaguars, producing several different compositions of the sinuous felines sitting, crawling, and eating. Among the most remarkable things about them is their scale, for here Hyatt eschewed the table-top menageries that had been popularized in America particularly by the great French master Antoine-Louis Barye and others. Instead she depicted the creatures at full scale in unusual poses that interact with the viewer's space. Later used as gateposts and garden sculpture, the jaguars are both accurately observed and sensuously beautiful.

Hyatt made good money with her art, and was listed in 1912 as one of only twelve American women in any field to earn $50,000 a year. She was living in New York during the winter and Annisquam in the summer, but she remembered her Boston roots by exhibiting her sculpture with paintings by Adelaide Cole Chase at the Saint Botolph Club (1917) and by Marion Boyd Allen at the Copley Gallery (1918). Hyatt's work was much admired locally, and in 1923 she was commissioned to create a bronze fountain for the garden of Mr. and Mrs. John Hays Hammond in Gloucester. Hyatt had known the Hammond family since her childhood; she also sculpted portraits of the family's Great Danes that served as gateposts to the estate. Her fountain design, *Young Diana* (pl. 62), was based upon another fountain depicting a more mature goddess, *Diana of the Chase*, for which she had won the prestigious Saltus Medal at the National Academy of Design. With its intertwined dolphins and slender, windblown adolescent huntress, Hyatt's design is fanciful and lighthearted, perfectly suited to its original seaside location.

Women frequently were hired to create sculpture for gardens; for many it was their only type of commission. The specialty echoed the fortune of women architects, who most often were employed to design houses and schools, but seldom large public buildings. Such work was considered appropriately feminine, like painting children's portraits. Garden sculpture allowed women an arena in which to pursue a professional career and they produced serious work in the genre. However it had never been accorded the same importance as other forms of the art. Some sculptors found it inferior to their talents; it was largely ornamental, meant for pleasure, and therefore was felt to lack the educational or spiritual components that informed high art.

Garden sculpture occupied women and gave them opportunities, but it simultaneously deferred them from challenging their male colleagues for more public, monumental projects. However some women sculptors, like Janet Scudder, maintained that garden sculpture was not secondary, and that the joy and affirmation of life they communicated in such "informal" works were as meaningful to society as the "higher" values of glory and patriotism that were most often represented in public monuments (an attitude that gained further acceptance after World War I).[7] Anna Hyatt was also very active as a garden sculptor and designer. The field allowed her to combine the two things she loved, art and nature, and one of her most impressive legacies is the garden she would help to design and fill with both her own work and that of other figurative sculptors at Brookgreen Gardens in South Carolina.

In 1922, in connection with the commission of a medal honoring the writer William Dean Howells, Hyatt became well acquainted with the scholar, Hispanophile, and railroad heir Archer Huntington. Huntington's first wife had left him, and he and Hyatt were attracted to one another. When Huntington immediately proposed, Hyatt refused to marry him; she was forty-six years old and committed to her career, not to the demands of society. Huntington continued his suit, apparently seeing Hyatt as a path away from his state of depression, and he eventually convinced her to accept. They were married in her studio in 1923.

While her marriage afforded her the opportunity to work at any scale and to bring to her proposals the imprimatur of a significant advocate, her responsibilities for the couple's several estates diminished her capacity for work. From 1927 to 1933, exhausted by her obligations to her art, to her husband, and to her ill mother, Anna Hyatt Huntington contracted tuberculosis and ceased to sculpt altogether. She resumed her career in the mid-1930s, when she was praised in the magazine *Apollo* as "a thoroughly representative American artist and an exemplar of the strength of the weaker sex in the plastic arts."[8] By this

time, she had become a vocal antimod-
ernist, upholding the conservative tradi-
tion of figurative sculpture in an age of
increasing interest in abstraction and
new materials; her only concession to the
machine age was her use of aluminum as
a medium for her realistic work.

65. *Katharine W. Lane*, 1930

≈ ≈ ≈

Anna Hyatt Huntington's championship
of figurative sculpture, along with her
local roots, made her especially influen-
tial in Boston, where modern art had
aroused little interest. She had already befriended one young Boston sculptor,
Katharine Ward Lane (later Weems), who recalled that:

> Though I had read about her and admired her animals, I did not realize that
> she lived only half an hour away from me until mutual friends offered to take
> me to see her studio. I was nineteen at the time [1918], and succumbed
> instantly to the charm and warmth of her personality. What I could not know
> was that she would change my whole world, and be my guiding light for sixty-
> five years. She was to become my very close friend. I was to study and work
> with her, both in her studio in New York and in Annisquam, and eventually
> become an animal sculptor myself under her guidance … I was impressed by
> her simplicity and dignity, and the high standard of art in which she believed.
> She gave short shrift to some of the sculpture passing for art these days, or for
> anything affected or insincere.[9]

Lane, who grew up in the best of Boston society, attended the School of the
Museum of Fine Arts not as a pastime, as did some of her circle, but as a devoted
student (fig. 65). She worked with instructor Frederick Allen and visiting profes-
sor Charles Grafly, and sought hard to be taken seriously, devoting herself to her
studies. "I knew we would be working from live models," she recalled, and "one
was already posing in the nude. For the sake of propriety we were segregated,
women in one room and men in another, a different model for each, but curiosi-
ty was strong and there was much running back and forth." Her parents had
encouraged her love of art—her father was president of the Museum's board of
trustees for seven years until his death in 1918—but they had not expected her
to have a career. "I wouldn't talk too much about your modeling. People will
think it odd that you take it so seriously," said her mother.[10]

Lane also studied in New York with Brenda Putnam and also with Hyatt, who arranged for her to work from the animals at the Bronx Zoo as she herself had done, despite Lane's mother's insistence that she be accompanied by a chaperone. Lane soon earned recognition for a small bronze of a pygmy elephant and she resolved to continue her career. She took a studio with the painter Aimée Lamb in the Fenway Studio Building and devoted herself to sculpting animals. Among her most successful works is the delightful *Narcisse Noir* (pl. 63), a portrait of a jet-black champion racing whippet that belonged to her friend Harry Crosby. In her bronze, Lane perfectly captured the dog's nervous elegance; the whippet's tightly coiled muscles and quick curve of his tail imply his strength and speed. *Narcisse Noir* also suggests a marriage of form and fashion, for its graceful sleek beauty recalls the decorative flair of the art deco style. The piece earned Lane her first unreserved praise from Charles Grafly and a gold medal from the Pennsylvania Academy of the Fine Arts. It also reveals her close relationship with the leading decorative sculptor of the period, Paul Manship, who had invited her to his studio, offered her technical advice, and became a good friend.

"I approached thirty with increasing confidence that after twelve years of apprenticeship, I had found what I was best qualified to do," Katharine Lane recalled, adding that it "kept me absorbed and detached from matrimony My Boston contemporaries who wanted to marry me would not accept my detachment and turned elsewhere ... I needed time to prove that in sculpture I was not a flash in the pan." With no need to wed for financial support, Lane was afraid that marriage might compromise her career and she devoted herself instead to her work.

In 1930, when the Depression had already begun to take a toll on Boston, she was commissioned to decorate the façade of the new biology labs at Harvard with bronze doors and a frieze of animals worked into the brick. She also crafted a pair of monumental rhinoceroses to flank the doorway (a copy now adorns the courtyard before the School of the Museum of Fine Arts). With such commissions, Lane was consumed with projects throughout the 1930s and 1940s, and her work was praised for its decorative rhythm. It was often discussed in terms related to Lane's gender. In an interview clearly adjusted to her sex, Lane was asked to choose, from a sculptor's point of view, the ten most handsome men in the United States. When despite her list of good looking candidates she concluded that she would rather sculpt animals, she earned national attention and an insolent caption in *Look* magazine: "Sculptress Lane, 46, unmarried." She finally capitulated to societal pressure in 1947 and married her longtime admirer Carrington Weems. "We have shaken Boston to its foundation," declared her mother.[11]

Katharine Lane Weems continued her career although her new social obligations, her mother's final illness, and her husband's eventual declining health gave her the other concerns and responsibilities she had long feared. When in 1950 she had exhibited her work with Anna Hyatt Huntington under the name "Lane," her husband was infuriated; she confessed in her diary that "he really burned up over the use of my former name in this connection and said this was not to be another Malvina Hoffman situation and he did not believe in the Lucy Stone League. It makes no difference to me which name I use so I went to the studio & signed Gino's head K. Lane Weems."[12]

Lucy Stone, an ardent Boston feminist who had petitioned several legislatures in the 1850s for women to retain separate legal status after they married, had continued to use her maiden name after she wed. Women who kept their names were often called Lucy Stoners, and Malvina Hoffman, a New York sculptor, was one. In the 1930s, just as Hoffman achieved the peak of her artistic success, her marriage collapsed; she was divorced in 1937. Weems had known Hoffman since the 1920s, but it seems clear that Carrington Weems did not approve of Hoffman's independent lifestyle. In 1957 Hoffman visited Weems and criticized her for neglecting her art in favor of the demands of society and her marriage. She "read me the riot act about working," wrote Weems. "[She] said I owed it to my talent to work regularly regardless."[13]

Weems did continue to sculpt, but she never cast one particular early image into bronze until 1980, long after her husband's death. Variously titled *Striding Amazon, Rebellion,* and *Revolt* (pl. 64), she had modeled it in 1926; it is one of the few human figures she ever crafted. According to the sculptor, this muscular woman, intently poised with a rock in one hand and a look of anguish on her face, "dramatized the vexation women of her day felt toward the unfair tradition permitting only men to win honors for athletic daring and display." Described in 1926 as "a creature of nature who has no fear of sunlight, air, and hard physical labor," *Striding Amazon* might also reveal Weems's own unwavering belief in women's potential.[14]

☙ ☙ ☙

Katharine Lane Weems was hardly the only woman to encounter interference from her husband as she attempted to continue her career after marriage. It is interesting to compare her experience with that of Meta Warrick Fuller, for although the backgrounds of these two talented women are hardly similar, their careers evince interesting parallels. Fuller was not from Boston, but she settled in the area in 1909 following her marriage and lived in Framingham, Massachusetts, for the next fifty-nine years. Meta Warrick had grown up in an upper middle-class

African-American community in Philadelphia. Her parents supported her interests and she studied both industrial and fine arts in Philadelphia, continuing her training in Paris in 1899 at the Académie Colarossi and with the encouragement and advice of the renowned Auguste Rodin, who admired her work and told her, "Mademoiselle, you are a sculptor; it is in your fingers."[15] Warrick remained in the French capital for three years, becoming an important member of the city's African-American expatriate community whose members included the painter Henry O. Tanner and the writer and educator William E. B. DuBois. Her first solo exhibition was held in Paris in 1902 at the galleries of Samuel Bing. Although many of Fuller's early works were lost in a fire, such titles as *Head of the Medusa*, *The Rhine Maidens*, *Man Eating Out His Heart*, and *The Wretched* indicate a taste for emotion and the macabre that would have appealed both to Rodin and Bing, whose galleries were the Parisian headquarters of the Art Nouveau.

Seven years after her return to Philadelphia in 1902, Meta Warrick married the Liberian-born, American-educated doctor Solomon Fuller and moved north. Fuller was a prominent physician with a specialization in neurology, psychiatry, and Alzheimer's disease. The couple had met in Boston during the summer of 1906; by late 1908, the house Fuller built in Framingham was complete, including a sculpted overmantel depicting the four seasons that Warrick had created especially for her new home. After their marriage in February, 1909, a childhood friend wrote in response to Meta Fuller's account of her activities, "I hope you are not letting your studio take second place to any room in the house. You must live your highest life."[16] By the time Fuller had received her equipment from Philadelphia, however, she was pregnant with her first son and preoccupied with her domestic responsibilities.

Fuller's devotion to her family helped her through the devastating loss of most of her work in a 1910 Philadelphia warehouse fire. She had stopped sculpting altogether, telling her friends she did not have time; she had a second son and took in her young niece after her sister died in 1911. Both Fuller and her husband believed in the traditional roles of husband and wife. Fuller also served as hostess for the large numbers of notable guests who visited, often staying in her house when appropriate hotel accommodations were unavailable to African Americans.

Fuller's period of inactivity ended in 1913, when W. E. B. DuBois asked her to create a sculpture for his New York exhibition to mark the fiftieth anniversary of the Emancipation Proclamation. The success of her *Spirit of Emancipation* (pls. 65, 66) encouraged her own liberation and Fuller began to work again, producing mostly small-scale portraits and images of her children. In the spring of 1914,

she organized a solo show at the Boston Public Library; the display was apparently extended at Fuller's home. The Framingham newspaper noted that visitors came from both Boston and Worcester, and declared that "Mrs. Meta Vaux Warrick-Fuller's work is coming to be recognized in artistic circles as bearing the true stamp of genius." The reporter added, "Mrs. Fuller is very modest about her work but she is full of enthusiasm and the 'divine fire,' and not the least pleasing part of the occasion was the privilege of meeting the artist herself."[17] For an African-American artist in a white community, this was important praise.

While Fuller continued to create art, she exhibited only intermittently after her marriage. Whether her relative privacy was the result of her race, her husband's wishes, personal preference, or other circumstances remains unclear. Until the mid-1920s, most of Fuller's artistic activities revolved around African-American events, and she seems to have had little contact with the Boston art community. There were also physical and financial limitations. Public commissions were usually large—it would be impossible to complete a monumental piece in an attic studio—and the bigger the work, the more expensive the material. Fuller seems to have kept her art costs separate from those of her household; she disliked asking for money from her husband to support her work and she had few monetary resources of her own. It was a difficult cycle to break, for to make money from art one had to have exhibitions and commissions, and to hold a show and thereby to gain sponsors, one needed the resources and support to make art.

Fuller also worked to encourage an interest in art among African-American families, writing a column for *New Era Magazine* and lecturing to teachers and community groups. Her efforts were exhausting. "I am so tired out trying to keep all my 'irons in the fire,' housework nursing and sculpture and occasionally church work but they don't … mix no matter how carefully I introduce the 'ingredients,'" she wrote to a friend, just after discovering she was pregnant with her third child.[18] She kept up her efforts: she was awarded a prize for her work by the Massachusetts branch of the Women's Peace Party; she contributed to the "Making of America" festival in New York, arranged by the African-American writer James Weldon Johnson; and she exhibited in a show held in conjunction with Johnson's lecture at the Boston Public Library in memory of Maria Baldwin, Massachusetts's first African-American school principal and the president of the League of Women for Community Service. In its review of that display, the *Boston Herald* praised Fuller's "flair for symbolic sculpture delicately conceived."[19]

Fuller's mature work was always figurative, often political, and frequently religious. She responded to many of the political events of her day, crafting a por-

trait of Mary Turner after the murder of the Georgia woman and her unborn child at the hands of a lynch mob in 1918, and an allegorical piece entitled *Peace Halting the Ruthlessness of War* in the midst of World War I. She was devoted to her church, finding in it not only spiritual solace but also a socially acceptable means to work outside her home. The sculpture she produced in the teens and twenties most often addressed antislavery and antiviolence themes. In 1915, she also crafted a medallion in support of equal suffrage for women.

The designs Fuller had created for the Emancipation monument remain among her most moving (pls. 65, 66). After their exhibition in New York in 1913, Fuller's plaster models were reproduced in *The Crisis* in 1914, but *The Spirit of Emancipation*, which survived in Fuller's Framingham garage, was never cast in bronze until 1999, when it was at last erected in Boston's South End. Fuller explained her work as representing "suddenly freed children, who, beneath the gnarled fingers of Fate, step forth into the world unafraid The Negro has been emancipated from slavery but not from the curse of race hatred and prejudice."[20] The powerful figures are at once intertwined with the tree of fate and separate from it; they are linked to their past but look forward, with apprehension, firm resolve, and hope. The dignity and beauty of Fuller's male and female figures celebrate their distinctive racial heritage, and mark a new trend to depict and to honor African-American identity rather than disguise it.

Fuller also addressed African-American culture in such works as *Ethiopia Awakening* (fig. 66), which was included in her 1922 display at the Boston Public Library and illustrated in the *Herald*, and *The Talking Skull* (1939, The Museum of Afro-American History, Boston). These images share not only the subject matter, but also the spirit and creative energy that would come to define the Harlem Renaissance, whose artists knew Fuller and responded to her work. Many of Fuller's images were inspired by African songs and folk tales, stories that she invested with an emotional intensity equal to the passion she gave her Christian motifs. Whatever her narrative sources, Fuller most often addressed subjects united by their manifestation of human emotions—of sorrow, loss, need, and devotion.

Fuller began to involve herself more fully in Boston's art community in the 1920s. While several African Americans in New York, particularly DuBois, were discussing the formation of a Negro Art Association, which they felt would help make up for their exclusion from a variety of opportunities, Fuller was against it, writing that "if we must have an American art let it be made by all Americans as the country has been made." She added, "It is not difficult for a Negro of promise to obtain instruction at the most desirable art institutions ... nor for meritori-

ous Negro artists to secure admission to the leading exhibitions."[21] Her desire to avoid a segregated society for African-American artists shared the feelings held by many members of the women's movement, who, like Anne Whitney, had objected to having a separate exhibition for women at the 1893 Chicago Exposition. Fuller spoke publicly about her concerns, lecturing on "The Negro in Art" at Framingham's Grace Church in 1923; she also began to teach privately. In 1927, with money she had just inherited from her grandfather and initially without her husband's knowledge, Fuller built a studio for herself near their home. Their son later recalled that while Dr. Fuller was greatly angered, he came to recognize both his wife's conviction and her accomplishment; the studio also encouraged her to work.[22]

In the early 1930s, Fuller became a member of the Boston Art Club, which had finally allowed women to join, and she began to show her work there. She also served at least once on the club's exhibition selection jury, along with the well-known local sculptors Cyrus Dallin and Philip Sears. Her activities in Boston proved to be short-lived, however, for by 1940 she was forced into retreat by her husband's failing sight and degenerating health. By 1951, she had confessed to her diary that "he is doing his best … but sometimes he can be very hateful. I had hoped once to leave behind work that would have a meaning to the coming generation, but that is all over now … I am tired."[23] Fuller's discouraged confession marked a lapse in her work that lasted

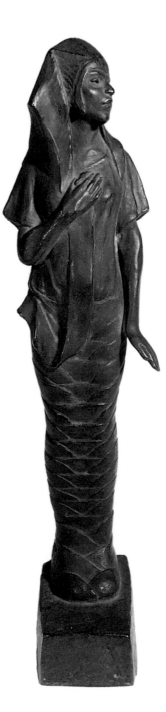

66. Meta Vaux Warrick Fuller, *Ethiopia Awakening*, 1915–21

until the 1960s, when interest in African-American culture, civil rights, and the women's movement brought her back to public attention. In 1966, despite her fragile health, she celebrated her eighty-ninth birthday at Radcliffe College, honored at long last by Boston's first families.

≈ ≈ ≈

While Meta Fuller remained on the outskirts of Boston's artistic community, Bashka Paeff was able to inject herself into its midst. Paeff, a Jewish emigrant from Russia whose family lived in the North End, was just the sort of woman at whom social improvement programs, in particular the Saturday Evening Girls, had been aimed. Ignoring her father's preference for her to be trained in music, Paeff entered the Normal School in 1907 with the intention of becoming an instructor of drawing. There she studied modeling with the sculptor Cyrus Dallin, who recommended that she pursue her talents as an artist rather than a teacher. Aided by the sponsorship of Mrs. Harry Converse of Beacon Street and her job taking tokens on the subway, Paeff entered the School of the Museum of Fine Arts in 1911. Her unusual status immediately brought her to public attention as the "subway sculptress" and she became the subject of numerous newspaper articles expressing amazement at the unlikely alliance.

Perhaps because of both her quick acceptance by the establishment and her need to earn her own living, Paeff seems to have been happy to undertake relatively conventional commissions of fountains, animals, and children's portraits. She sometimes combined those motifs, as she did in her 1914 design for the *Boy and Bird Fountain* in the Boston Public Garden, one of her most beloved compositions. Paeff allied herself with the conservative members of the local art community, joining the Guild of Boston Artists in 1916 and noting in 1921 that "futurist painting actually makes me sick when I look at it and sculpture of the same kind is even worse." By 1932 she was confident that "modernistic sculpture seems to be going out of fashion." Like many of her Boston colleagues who were painters, Paeff believed that "art should always be beautiful and ennobling," and she favored traditional craft and workmanship over experimental techniques.[24]

Yet Paeff's designs were not completely isolated from modern style; they were not, for example, the romantic variations on Rodin favored by her older colleague Nanna Matthews Bryant, who produced poetic allegorical figures in marble throughout the 1920s (see pl. 67). Like Katharine Lane, whose *Narcisse Noir* is both a masterpiece of realism and a snappy decoration, Paeff adapted the energetic spirit of the decade, regulating it to her preference for "making it like." Among her most successful works is her bronze head of Anthony Philpott, a

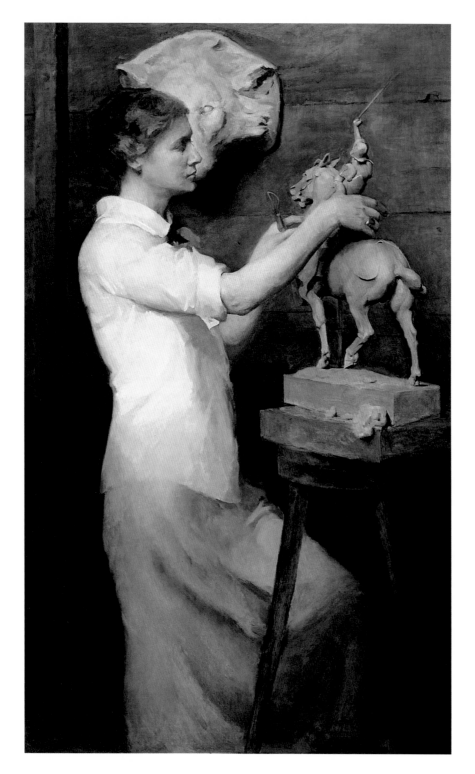

Plate 59
MARION BOYD ALLEN
Anna Vaughan Hyatt, 1915, oil on canvas

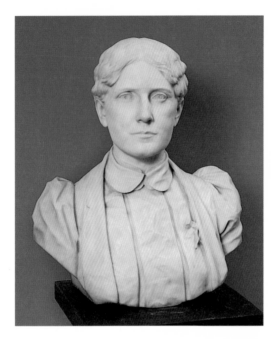

Plate 60
ANNE WHITNEY
Frances E. Willard, 1892, marble

Plate 61
ANNA VAUGHN HYATT
Reaching Jaguar, modeled 1906, bronze

Plate 62
ANNA VAUGHN HYATT
Young Diana, 1923, bronze

Plate 63
KATHARINE LANE
Narcisse Noir, 1927,
bronze and marble

Plate 64
KATHARINE LANE
Striding Amazon (or *Revolt*),
modeled 1926, bronze

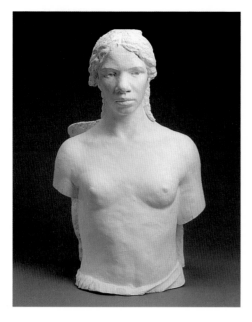

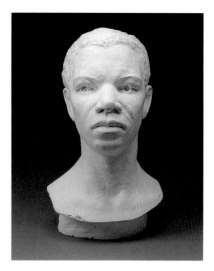

Plate 65
META VAUX WARRICK FULLER
Bust of a Woman (Partial cast of
"Emancipation"), 1913, plaster

Plate 66
META VAUX WARRICK FULLER
Head of a Man (Partial cast of
"Emancipation"), 1913, plaster

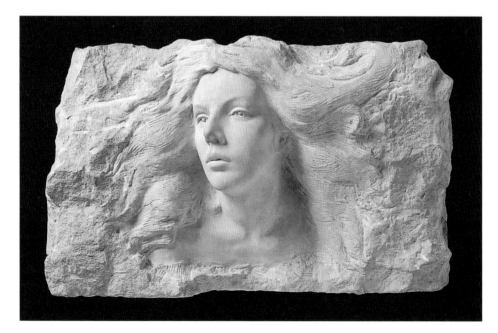

Plate 67
NANNA B. MATTHEWS BRYANT
Head of a Woman, about 1920, marble

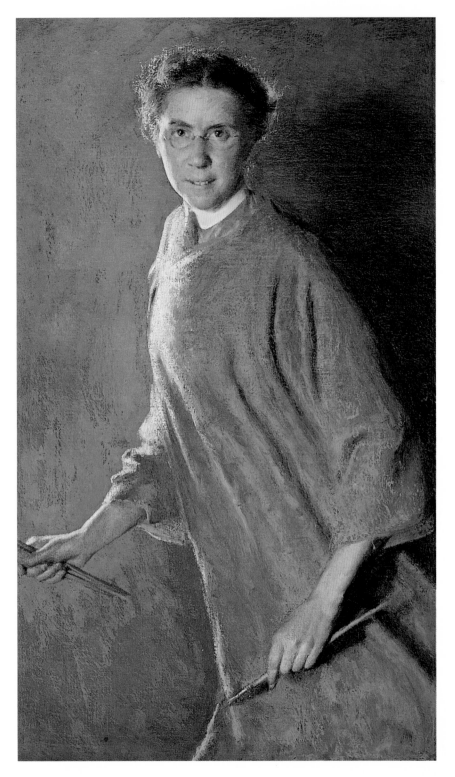

Plate 68
MARGARET FOSTER RICHARDSON
A Motion Picture, 1912, oil on canvas

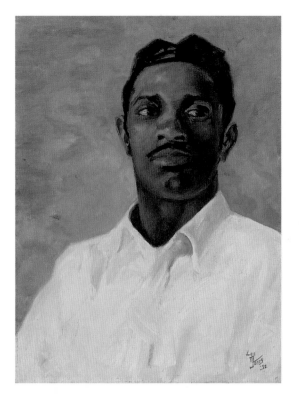

Plate 69
LOĪS MAILOU JONES
Portrait of Hudson, 1932, oil on canvas

Plate 70
MARION LOUISE POOKE
The Subway, after 1922, oil on canvas

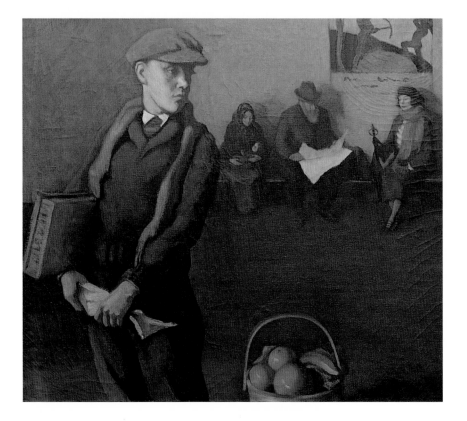

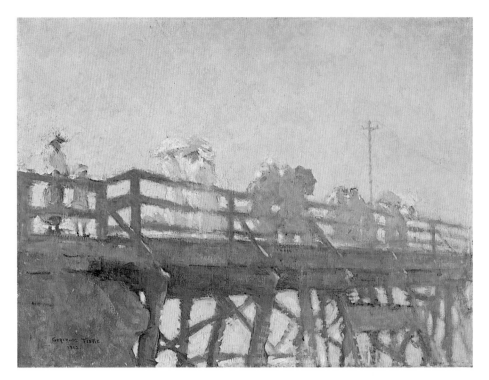

Plate 71
GERTRUDE FISKE
Saunterers (Causeway), about 1913, oil on canvas

Plate 72
GERTRUDE FISKE
Jade, about 1930, oil on canvas

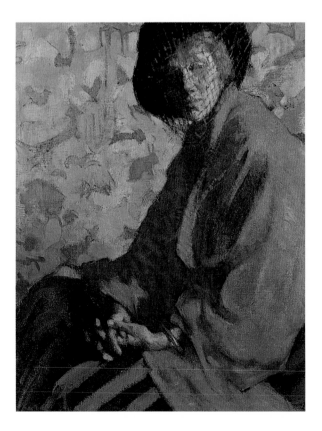

Plate 73
GERTRUDE FISKE
The Window, about 1916, oil on canvas

Plate 74
GERTRUDE FISKE
Wells, Maine, about 1920, oil on canvas

Plate 75
GERTRUDE FISKE
Revere Beach, Winter, about 1930, oil on canvas

Plate 76
ELIZABETH WENTWORTH ROBERTS
Figures on the Sand, about 1913–20, oil on canvas

Plate 77
MARGARET JORDAN PATTERSON
Trees on the Hilltop, about 1915,
color woodblock print on paper

Plate 78

MARGARETT SARGENT

Beyond Good and Evil (Self Portrait), about 1930, oil on canvas

Plate 79
MARGARET FITZHUGH BROWNE
Blessé de Guerre, 1935, oil on canvas

Plate 80
POLLY (ETHEL R.) THAYER
Self Portrait: The Algerian Tunic,
1927, oil on canvas

Plate 81
POLLY (ETHEL R.) THAYER
Circles, about 1928, oil on canvas

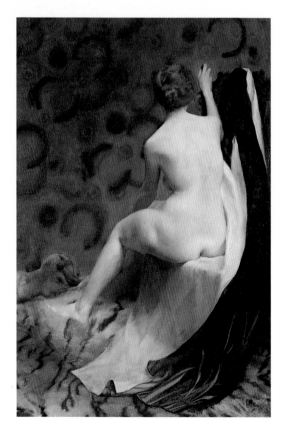

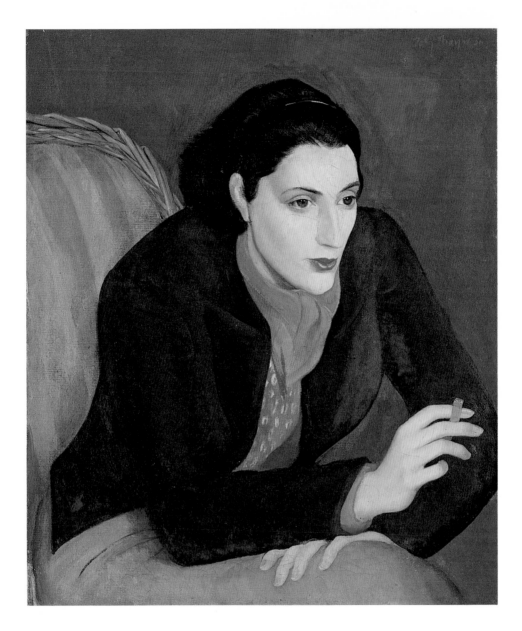

Plate 82

POLLY (ETHEL R.) THAYER

Portrait of May Sarton, 1936, oil on canvas

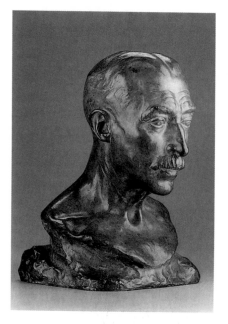

67. Bashka Paeff, *Bust of Anthony J. Philpott,* 1922

68. Thomas Hart Benton, *Thomas Craven,* 1919

writer for the *Boston Globe* (fig. 67). Erudite and thoughtful, Philpott provided a fair-minded assessment of the city's art scene for many years. Like Paeff, he was an emigrant to the United States; he first began to pay notice to her work in 1914, downplaying her unusual personal story in favor of articles about her art. His favorable commentary evidently inspired Paeff to model his portrait, for the likeness was not commissioned by Philpott or his family. Paeff worked within a traditional vocabulary, faithfully capturing her sitter's actual appearance. She also imbued Philpott's features with an intense expression that communicates intellectual energy. Here contemplation has become a physical activity; Philpott's brow is furrowed, his head muscular and taut. Paeff's bust even recalls another portrait of an art critic, regionalist painter Thomas Hart Benton's stylized image of Thomas Craven (fig. 68). Despite her claims to hold fast to tradition, the spirited energy Paeff communicates marks her work as a product of the twentieth century.

Few Boston critics responded to those artists who stood outside the strong circle of the Boston School. But newspaper columnist Anthony Philpott praised not only Bashka Paeff, but also another young artist who had no connections with the local art establishment, Loïs Mailou Jones (fig. 70). "There is little doubt in the minds of those who have seen her work," he wrote early in 1939, "that Loïs M. Jones is the leading Negro artist in the United States."[1] Jones had already moved away from Boston by the time her work was first exhibited in the city; her solo show opened in a Massachusetts Avenue society in January and continued (in a slightly smaller installation) the next month at the Vose Galleries near Copley Square. Jones had received her early training in art at Boston's High School of Practical Arts. She noted that she had been inspired to pursue an artistic career by Meta Warrick Fuller, whom she had met during the summers she spent with her family on Martha's Vineyard.

Jones attended the School of the Museum of Fine Arts from 1923 to 1927, taking courses in design, anatomy, perspective, and portraiture, and supplementing her work with classes at the Normal School. She twice won the Museum School's Thayer prize for design and the Susan Minot Lane scholarship, which had been established in 1918 (and named after a Boston woman artist who had studied with William Morris Hunt) to assist "deserving poor young women students, preferably inhabitants of Massachusetts." "I made the museum my home," Jones later recalled. Despite her attachment to the institution, Jones was unable to secure an assistant position at the Museum School after her

69. Margarett Sargent, *Beyond Good and Evil (Self Portrait)* (detail), about 1930

70. *Loïs Mailou Jones at work in her Paris studio,* 1937–38

graduation, and she was advised to "think of going south to help my people."[2] At first shocked by such a suggestion, made to someone whose family roots were firmly in Boston, Jones accepted the recommendation when it was echoed by educators within the African-American community. She worked first at the Palmer Institute in Sedalia, North Carolina, and beginning in 1930, at Howard University in Washington, D.C., where she would teach for almost fifty years, becoming one of America's most honored African-American artists.

During her time in Boston, Jones had concentrated on working as a textile designer, and she worked as a freelancer for F. A. Foster Company in Boston and the Schumacher Company in New York. Her brilliantly colored, jazzy geometric patterns were well received and were put into production by the manufacturers (fig. 71), but Jones resented the anonymity of the work and craved recognition as a serious artist. She started painting the local landscape in South Carolina and on Martha's Vineyard, and she made portraits of her students at Palmer and Howard, firmly modeled figure studies that reveal her strong academic training in Boston (pl. 69). By 1932, she had joined the celebration of African culture that came to be called the Harlem Renaissance.

In such paintings as *The Ascent of Ethiopia* (fig. 72), Jones combined her interest in color and in design to create a compelling image that depicted the elevation of African Americans from slavery to the pinnacles of achievement in the arts. In 1937, Jones left the United States for Paris, the city that had been recommended to her as an artist's paradise by advisors both black and white. Meta Fuller had advocated it for its racial cosmopolitanism, while Jones's instructors at the Museum still honored it for the strength of its academic training. Jones took advantage of both, enrolling at the Académie Julian and also experimenting with the imagery of African masks, familiar to her from her own work, but in Paris celebrated as progenitors of modern art. Her first exhibition upon her return was her solo show in Boston, which consisted almost entirely of her French work and was praised not

only by Philpott, but also by Dorothy Adlow, the critic for the *Christian Science Monitor,* who spoke out in support of new art.

Jones's career led her away from Boston, but the spirit of modernism that she represented did not disappear entirely. As Adlow remarked, "in the long run it is impossible to erect walls high enough to stem the flood of ideas."[3] While Boston cared little for abstraction, modern art did eventually have an effect upon the work of a number of younger local painters. In 1931, Philip Hale died and Edmund Tarbell and Frank Benson retired from the School of the Museum of Fine Arts, marking the end of a regime that had included all three men or their followers since 1893. Two British instructors trained at the Slade School, Rodney Burn and Robin Guthrie, were hired in their place, and as one newspaper noted, "the council hopes to meet the present-day challenge for instruction which will lead to freshened creative effort." Anthony Philpott noted that "not for many years have Boston art circles had a shock equal to that … many members of the association are now saying that this is the end of what has long been known as the Boston School of Art—a school that has been deeply respected, and which has stood for strong principles in drawing and painting, and which has carefully shunned the eccentricities of the modernists in painting and sculpture."[4]

71. Loïs Mailou Jones, *Textile Design,* about 1928

72. Loïs Mailou Jones, *The Ascent of Ethiopia,* 1932

Among those who expressed their concern about the changes at the school was the painter Margaret Richardson, who wrote to the director of the importance of sound training, adding that "always ideas are of first importance, but we must have a thorough knowledge of the use of our tools before we can express our beautiful ideas in the fullest way." She did admit, however, that "our beloved Museum School was in a 'rut'—its instructors had gotten to the place where they were all 'technique'—technique had become a god—ideas were nowhere."[5] While the obituary of the Boston School was premature, a stylistic shift did take place in the work of some local painters, among them several women.

∽ ∽ ∽

In most cases, these changes did not signal a lesser commitment to craftsmanship, but rather an expanded range of subjects and a more worldly point of view. Margaret Richardson, for example, was among the first to have presented herself as a "New Woman," actively engaged in her profession with no concession to contemporary ideals of fashion (pl. 68). Richardson had come to Boston from Illinois in 1900 at age nineteen to study art, first with Joseph DeCamp at the Normal School and then with Tarbell at the Museum School. In 1906, she published an article in the magazine *Brush and Pencil* in which she praised both Monet and Velásquez and called for "the emancipation of vision," for painters to record the natural appearance of things in a world of light and atmosphere. Richardson was best known as a portraitist of both men and women, and her work earned praise from Philip Hale for its "intensity of vision … close observation, severe workmanship, and uncompromising honesty."[6] Among her early subjects were a number of active women, including painter Laura Coombs Hills. But she presented the idea of a modern woman most successfully in her self-portrait, painted in 1912 and called *A Motion Picture*. While the title clearly refers to Richardson's active pose, striding across the canvas into the light, it also alludes to film, and particularly to the movies.

By 1912, motion pictures were firmly established as popular entertainment, an inexpensive democratic diversion that was egalitarian, just as available to the working class as to the fashionable set who frequented live theater. They were also a subject of current debate—in September 1912, *Harper's Monthly* published an article criticizing certain school committee officials in Massachusetts who had proposed censoring movies to curb their corrupt effect on the state's youth.[7] By using the title *A Motion Picture*, Richardson identifies herself not only as an active woman, but also as a working one. Dressed in a painting smock with her brushes clenched in her hands, she is both literally and figuratively a woman on the move.

Richardson's uncanny acumen at capturing a likeness was disconcerting to some critics, who felt that her work verged on caricature. In 1921, in a review of her solo exhibition at the Guild of Boston Artists, William Howe Downes wrote that her portraits were "extremely unflattering," especially those that captured facial expressions that differed from the pleasant smiles that most artists painted. Her portrayal of the Boston painter Arthur C. Goodwin, who was shown laughing, was described as "merciless" and "mephistophelian in its expression."[8] Richardson's *A Motion Picture* had also been strikingly honest in its portrayal. The hegemony of beauty in Boston art was beginning to wane.

The change was subtle, but first became apparent in a shift of subject matter. Boston's painters had largely avoided urban genre scenes through the turn of the century, but images of city life began to appear in the teens and twenties. Surprisingly, Edmund Tarbell was among the first to produce such subjects, painting the waiting room at North (Union) Station in 1915 (fig. 73). He was no doubt most taken with the strong shafts of light that illuminated the shadowy space, but his aesthetic interest was now no longer confined to the private domestic interior. Women sit idly reading or daydreaming here too, in Tarbell's familiar formula, but around them men in straw boaters dash for trains or hoist their luggage. The painting was a departure for Tarbell and he did not repeat it. The Boston painter Arthur Spear followed suit, painting the interior of a streetcar in 1916.

Women in both of these images are still the subject of the male gaze, but the streets did not belong only to men. In about 1922, Rosamond Smith, a Museum School alumna, painted a remarkable image entitled *Quick Lunch* (fig. 74), one of a number of city scenes she painted shortly before her marriage. The setting is a restaurant during the busy noon hour; white-jacketed countermen and waiters rush through their tasks while working men and women dine alone. The only personal interaction is between the viewer and the smiling waiter, who looks out as if to acknowledge another customer. Marion Pooke's *The Subway* (pl. 70) depicts another unconventional view of Boston, an underground station with an assortment of waiting passengers lost in their own thoughts. Pooke, who studied at the Normal School and with Tarbell and Benson at the Museum, applied some of the most characteristic ingredients of Boston School interiors—an atmosphere of contemplation, an interest in light falling across flat surfaces, artful arrangements—and transported them into the modern world.

꒰ ꒰ ꒰

73. Edmund C. Tarbell, *Station Waiting Room,* about 1915

74. Rosamond Smith, *Quick Lunch,* 1923

Pooke's marriage in the mid-1920s removed her from the city's art scene, but one of her friends, Gertrude Fiske, continued to experiment. Fiske, the daughter of a prominent Boston lawyer, was twenty-six when she entered the School of the Museum of Fine Arts in 1904. She studied with Tarbell, Benson, Paxton, and Hale, but her traditional education was supplemented by the classes she took during her summers in Ogunquit, Maine, under the instruction of Charles Woodbury, best known for his marine views. Woodbury's method of strong, direct painting, captured in his recommendation to "paint in verbs not in nouns," had a lasting effect on Fiske's powerful work.[9] Her early compositions combine the two aesthetics. In *The Saunterers* (pl. 71), for example, Fiske depicted elegantly dressed women, some with parasols, strolling along a wooden bridge in York, Maine. Woodbury had painted the same bridge with long fluid strokes and swirls of water passing beneath it, but Fiske's image also recalls the popular taste for sunlit scenes of seaside leisure that had been established by her teacher Frank Benson. She exhibited the painting (or its second version) at the Corcoran in 1912, the Art Institute of Chicago in 1913, and the Pennsylvania Academy in 1914, marking the end of her student days. "Miss Fiske is a brilliant and clever painter … full of life and spirit and style," remarked a local critic.[10]

Having mastered the aesthetic program of her teachers, Fiske moved in a fresh direction. She maintained her interest in the iconography of the Boston School, favoring scenes of women in decorative interiors, but she invested them with new strength and power. *Jade* (fig. 76 and pl. 72) depicts a veiled model set before a decorative backdrop, a subject that had attracted artists like Lilian Hale some years before (fig. 75). However, Fiske's model shows none of the fragile, demure gentility of Hale's, instead she confronts the viewer, seemingly at liberty to examine us directly while maintaining her own privacy and distance. In *Jade*, the veil empowers the woman who wears it. Fiske's broad application of paint and her unusual orange and green color scheme reinforce the impression of bold self-reliance.

Like many of her peers, Fiske worked in the Grundmann Studio Building on Clarendon Street, which had been described in the Providence Sunday Journal as "the haunt and home of a little colony of women artists."[11] Her studio provided the setting for *The Window*, a compelling composition of 1916 (pl. 73) in which Fiske gave herself a difficult technical assignment by placing her three models against the glare of a bright window. The placement of the figures seems random; they are isolated from one another and inhabit individual worlds, linked neither by pose nor gaze. She included the painting in her solo exhibition at the Guild of Boston Artists in 1920, where it captured the attention of critic William

75. Lilian Westcott Hale,
The Old Ring Box, 1907

Howe Downes. Downes admired Fiske's originality, "adventurous spirit," and
"indifference to all current aesthetic fads"; he wrote in praise of Fiske's handling
of composition, color, and especially the enveloping light in *The Window,* compar-
ing the strength of her work favorably to that of Edouard Manet. "Miss Fiske is
decidedly of her time," he suggested.[12]

While Fiske remained interested in the aesthetic issues of the Boston
School, she, like Pooke, transferred them to different subjects. Her interior fig-
ure studies include as many men as women, and she particularly enjoyed depict-
ing older models, including a gentleman with a long white beard who posed vari-
ously as a ship-model maker (in *The Captain,* 1920, current location unknown),
a carpenter (fig. 77), and a pious ruminator (with an elderly companion, in
Sunday Afternoon, about 1925, current location unknown). Fiske's models were
considered in the press to portray distinctive New England types, an interest that
was increasing among image-makers of all kinds in the 1920s and 1930s. Fiske,

Browne, Thayer, and several other
painters depicted such representative
workers as florists, craftsmen, postmen,
fishermen, clerics, and others, although
an interest in regionalism has rarely
been credited to artists associated with
the Boston School, whose works in this
genre are little known.

Fiske was best known as a figure
painter, but she also produced a number
of innovative landscapes, a fact noted by
the press when she was appointed the
first woman member of the State Art
Commission in 1930. "There is a note of
personal distinction in all of her work,"
continued the report, "a virile note."[13] As
many critics did during the 1920s, the
writer equated virility with modernity, for
Fiske's later landscape paintings are no
longer the sparkling seaside views of
ladies with which she began her career,
nor do they avoid the intrusions of
man's hand in nature. In *Wells, Maine*
(pl. 74), for example, Fiske employed
the elevated horizon line advocated by
her friend Woodbury, thus allowing the
rhythmic passages of tidal marsh and
distant sea to become patterns of com-
plementary blues and oranges that
vibrate across the surface of her compo-
sition. The scene is interrupted at regu-
lar intervals by the strong verticals of
telephone poles. It is clearly a contem-
porary view and not a japonesque medi-
tation of the type favored by Arthur
Wesley Dow and his followers.

Fiske embraced other aspects of
the modern world in her landscapes as

76. Gertrude Fiske, *Jade*, about 1930

77. Gertrude Fiske, *The Carpenter*, about 1922

well; like Woodbury, she produced a number of landscapes from the vantage point of an airplane and several scenes of the bathhouses and bathers at Ogunquit's popular beach. She also painted the Navy yard in Portsmouth, New Hampshire, and a stone quarry in Weston, Massachusetts. Among her most unusual images are the views she painted of Revere Beach, in which the roller coaster and giant wooden figures at the amusement park, abandoned for the winter, take on a disconcerting and surreal aspect (pl. 75).

Fiske's work also marks the increasing importance of landscape subjects to women painters in the teens and twenties, for not since the time of Hunt had so many Boston women artists set forth to render pastoral motifs. In part, the increasing number of landscapes painted by women reflects a significant shift in conventional wisdom about women and physical fitness that took hold in the early twentieth century. The "new woman" of the progressive era believed in exercise and vigorous activity. "Most happily," wrote the Boston physical education teacher Helen McKinstry in 1917, "actual facts and statistics are absolutely disproving previous theories of women's physical and mental inferiority and particularly this antiquated shelving of women for the menstrual period and permanent retirement to caps and knitting at 50."[14] Carrying painting supplies into the countryside was well within the new woman's power; it also was no longer considered hopelessly eccentric to travel alone (by foot, bicycle, or automobile), unaccompanied by the family and friends who had obligingly and picturesquely arranged themselves in the domesticated landscapes of earlier years. "Ideals change," wrote Caroline Hazard, president of Wellesley College, in 1900. "The days of the 'elegant female' … are happily gone by. Raven tresses and tears and frequent faintings are no longer in fashion …. Our modern young woman, with her good physique, corresponds much more closely to the old Greek conception." "To be an interpreter of beauty," Hazard added, "one must certainly have a knowledge of what is beautiful … in the old time, when women were shut closely in the house, very little opportunity was given for the out-of-door training which is now thrown open to them."[15]

Fiske and her landscape colleagues—including Elizabeth Wentworth Roberts, who painted lush beach scenes (pl. 76) and whose partner Grace Keyes was a champion golfer and avid outdoorswoman; Marion Boyd Allen, who shifted her subject matter from genteel interiors to the Rocky Mountains (fig. 61); Mary Bradish Titcomb, who favored views of Marblehead (fig. 78), and Margaret Jordan Patterson, whose bold and vibrant color prints of trees and hillsides are as modern as Fiske's own (pl. 77)—took advantage of women's changing roles to

78. Mary Bradish Titcomb, *View Looking Towards Gloucester, Mass.*, 1915

explore the world beyond the walls of their studios. Eventually, some local women artists also began to seek the world beyond the Boston School.

<p style="text-align:center">◈ ◈ ◈</p>

Interest in modern art had been slow to develop in Boston, but by the 1920s there were hints of an attraction to a different kind of art than that produced by the Boston School. The painters Marion Monks Chase, Carl Gordon Cutler, Charles Hopkinson, Charles Hovey Pepper, and Harley Perkins, for example, all of whom had received a traditional artistic education, embraced modern ideas in art and exhibited their innovative watercolors together beginning in 1924; they soon became known as the "Boston Five." "Let us look at all these pictures with an open mind," a letter to the editor had begged about Hopkinson's watercolors, "[with] a will to put ourselves in the artist's place and a desire for free speech in painting as well as in … other human activities. We have had one kind of painting in Boston for so long that many of these pictures seem strange and acid and rude; but are not these traits preferable to prettiness which is the besetting sin of American art and which is so often mistaken for beauty?"[16]

Hopkinson's successful and prolific career as a traditional portraitist made his venture into modern art even more remarkable, and the contrast was discussed repeatedly in the press. Chase, a former Museum School student, favored bold and imaginative color juxtapositions in her carefully composed landscapes (fig. 79). Harley Perkins not only painted, but also, and perhaps more significant-

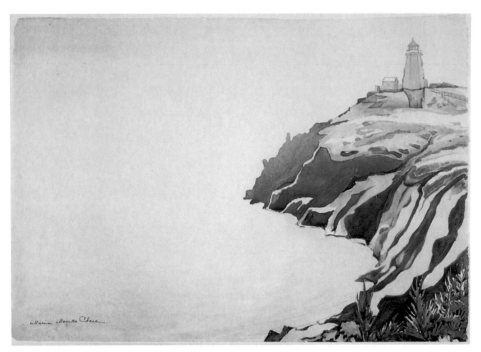

79. Marion Monks Chase, *The Sun and Coastline*, about 1930

ly, wrote reviews for the *Boston Evening Transcript*, becoming its art editor in 1922. He thus was positioned to promote modernism to the Boston public through his favorable commentary on artists who worked in that style.

Surprisingly, it was the venerable Boston Art Club, founded in 1855, that briefly became a pioneer in opening itself up to modern art. Although the club still prohibited women from becoming members, it was less exclusionary toward modern artists (at least for a few years), and in 1917, Charles Hovey Pepper became chairman of its art committee. He adopted modern display techniques, favoring light gray walls instead of dark colors, and he included works by some nonresidents in the annual exhibition, among them George Bellows, Rockwell Kent, George Luks, and Eugene Speicher. Pepper was succeeded on the art committee by Perkins, and in December 1925 the club mounted an exhibition of Post-Impressionist painting that included works by Seurat and Matisse. Perkins wrote a lengthy and laudatory review of the show in the *Transcript*; it was the first time a significant public exhibition of such art had been seen in Boston since the Armory show. The very next year, the Boston Society of Independent Artists was organized, an association committed to providing an annual open exhibition for

artists who preferred modernism to the conservative styles favored by the juries of most of the important American art annuals. Their first show was held in January 1927, in a renovated stable on Beacon Hill.

The original Society of Independent Artists had been founded in New York in 1917 by Walter Pach, one of the organizers of the Armory Show, and the group's first exhibition had included Marcel Duchamp's infamous *Fountain,* a urinal exhibited as a "ready-made" sculpture. Harley Perkins proudly announced in the *Transcript,* however, that "in keeping with Boston seriousness," the 1927 inaugural show included "none of the practical joke exhibits, like the cake of soap nailed to a board, which have sometimes appeared in shows held under similar conditions in New York."[17]

The remarkable aspect of the Boston group was that it was dominated by women, "one of the most striking points of the whole undertaking," as Perkins commented, "testifying once more to the moving power which women really exert over the arts, though academies are proverbially man-made."[18] Jane Houston Kilham, a painter who came to Boston from California, was the president of the group. She received funds from an anonymous Boston woman to renovate the stable and she solicited the support of two New York women interested in modernism, Juliana Force and Gertrude Vanderbilt Whitney. Kilham promoted her efforts in the press, stating that it was "impossible for a Boston artist to have a picture hung in any other gallery here without its fitness first being passed on by the critics, and they absolutely refuse to deal with the new school." There were a number of women exhibitors at the Society, among them Kilham herself, Marion Monks Chase, Lilla Cabot Perry, and Margarett Sargent. "The spokes of the wheel are rattling against the Hub," claimed Perkins.[19]

The group survived until the late 1950s, maintaining a rule of no juries and no awards, in contrast to the traditional procedures employed by the Guild of Boston Artists. In 1928, two years after Kilham's formation of the Boston Society of Independent Artists, Hopkinson, Pepper, and Cutler started the New England Society of Contemporary Art, which began to mount annual exhibitions of modern art that included many important painters from New York, some of them summer residents in New England. That same year, a group of Harvard students inaugurated the Harvard Society for Contemporary Art. Their goal was to provide a forum for the exhibition of modern art (especially European) of the type that the Fogg Art Museum refused to display, and their first show opened in February 1929 in rented rooms above the Harvard Cooperative Society. The Harvard group was wealthy, male, and well connected, and despite the activities of the

other coalitions, has come to be regarded as the progenitor of all efforts to support modern art in Boston. Its student founders, Lincoln Kirstein, Edward Warburg, and John Walker, were supported by Paul Sachs, the dynamic teacher and assistant director of the Fogg, as well as a group of influential trustees, among them A. Conger Goodyear, president of the newly founded Museum of Modern Art in New York. The connections between Harvard and New York were strong, and one of its results was the formation in 1936 of a Boston affiliate to New York's Museum of Modern Art, called The Institute of Modern Art in Boston (the organization declared its independence from MOMA in 1939; in 1948 it became the Institute of Contemporary Art). With the advocacy of its energetic trustee Nathaniel Saltonstall and the considerable achievements of its first director, James Plaut, the emergence of modern art in Boston, as in many cities, has been recorded as a narrative of male achievement.[20]

Many Boston artists of both sexes and all specialties upheld and proclaimed conservative values in the face of modernism, but a number of conservative women were among the most active and outspoken, including Margaret Fitzhugh Browne (fig. 80), Lilian Hale, Anna Hyatt Huntington, Katharine Lane, Lilla Cabot Perry, and Bashka Paeff. Even William Morris Hunt's former students, now in their eighties, rallied to the cause: Almira Fenno-Gendrot claimed that "the 'Cubists' and 'Radicals' … are following a false and baneful standard of hideousness and distortion. Would [that] they might learn that real art is 'truth and beauty,'" she wrote in 1923.[21] Browne, whose own *Blessé de Guerre* (pl. 79) seemed direct and innovative for its day, became one of the most fervid anti-modernists, and the founder in 1939 of the Boston branch of the Society for Sanity in Art.

The group had started in Chicago in 1936, under the leadership of philanthropist Josephine Logan, who proselytized against modernism and in favor of what she called "rationally beautiful" paintings; she presented the group as the champion of the common man in a struggle against excessively high-brow, non-representational art. It was a perfect fit for many Bostonians, who continued to value above all the traditions of art, particularly those shaped at the Ecole des Beaux-Arts. The Boston chapter of Sanity in Art published a pamphlet entitled "How the Disease of Modern Art Spread" and announced its own annual exhibitions, with both Browne and Paeff on the jury, in an issue of *Art Digest* that, on the page opposite, described Katharine Dreier's gift of the Société Anonyme collection of abstract art to Yale. The attitudes of many of the city's conservative artists and critics were ridiculed in *Time* magazine, which noted in June 1940 that "Boston's Brahmins have firm opinions. On no subject are their opinions firmer than on Modern Art … from the black-upholstered fastness of her Victorian

apartment, the Society's old-maid presi-
dent, Margaret Fitzhugh Browne, said
[the recent Picasso show] is an exhibi-
tion of crazy stuff."[22] What *Time* did not
know, or chose to ignore, was that the
advocates of modernism in Boston were
often Brahmins too—not only Nathaniel
Saltonstall, but also Margarett Sargent
and Ethel (Polly) Thayer, among
others. In fact, the Harvard Society of
Contemporary Art closed its first season
in February 1930 with a show of
Margarett Sargent's paintings. As the
Boston Sunday Herald had proclaimed
in 1914, in an article subtitled "Hub
Society Boasts of Many Women Who
Are Ranked as High as Their Bohemian
Sisters in the World of Artistic Endea-
vor," upper-class women in Boston were
no longer dilettantes, but professionals,
and "the butterfly debutante has discov-
ered that she has a brain and the privi-
lege of indulging it."[23]

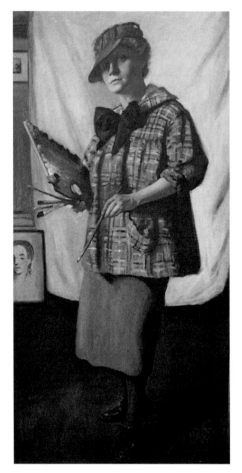

80. Margaret Fitzhugh Browne, *Self Portrait,*
about 1935

Margarett Sargent, whose ancestor Epes
Sargent had been painted by Copley and who was a cousin of John Singer
Sargent, was a child of privilege (fig. 81). She was educated at Miss Winsor's
School in Boston, and then attended Miss Porter's in Farmington, Connecticut.
She took drawing classes there, spent a year in Italy, and came home, according
to her brother Dan, "crazy about Donatello, and she started to talk about becom-
ing a sculptor."[24] After her debutante ball at the Somerset Club, she became
engaged, but broke it off, announcing that she was returning to Italy to sculpt.
The outbreak of the war prevented her from doing so; instead, she took private
lessons from Bashka Paeff, who had just completed her *Boy and Bird Fountain.*
Sargent arranged several portrait commissions for Paeff, and the sculptor offered
Sargent advice on a double portrait of her nephews, Sargent and Zeke Cheever.
Paeff was not the only Boston woman artist Margarett Sargent knew. Paeff's

81. *Margarett Sargent McKean,* 1932

friend Gertrude Fiske painted her portrait, and the two likely met again in Ogunquit, when Sargent studied there with Fiske's former teacher Charles Woodbury during the summers of 1915 and 1916.

Sargent's first public exhibition was as a sculptor in October 1916, when she participated in the annual exhibition at the Art Institute of Chicago. She was faring well, crafting portraits of children and animals, when in 1917 Sargent decided to enhance her skills by working with Gutzon Borglum, the dynamic figurative sculptor who had also taught Anna Vaughn Hyatt. Through Borglum, Sargent met the painter George Luks, who would become her new artistic mentor. She sculpted Luks's portrait and exhibited it at the Pennsylvania Academy annual (fig. 82), where critics praised it for its strength and vitality. Sargent soon became Luks's painting student. She was fascinated by him, for he represented the opposite of everything most Bostonians cared about—he painted the streets, he drank, he rebelled against authority, and he introduced Margarett Sargent to modern art.

The vitality of Sargent's art world and her life in New York was tempered by the domestic concerns that had always haunted women artists. After the death of her father in 1920, Sargent was expected to return to Boston and, like any unmarried daughter, to look after her widowed mother. She married to avoid it, believing that she would be able to continue her career; she persisted in signing her work "Margarett Sargent," despite her new responsibilities as Mrs. Quincy Adams Shaw McKean and, beginning a year later, as a mother. She maintained her friendship with Luks, lending him her St. Botolph Street studio during his extended stay in Boston in 1922–23 and organizing a show of his work in her home in Pride's Crossing. The effort was praised in the *Transcript* by Harley Perkins, but it resulted in only one sale, to sugar heir John Taylor Spaulding, a friend of Perkins's and Charles Hovey Pepper's who was, along with Sarah Sears and Sargent herself, one of Boston's few collectors of modern art.

Through Luks, Sargent met the New York dealer John Kraushaar, and her first solo exhibition opened at his Fifth Avenue galley in March 1926. She displayed sculpture, large plaster reliefs, and watercolors. The show was well received in the New York press, and was followed by four more, in 1927, 1928, 1929, and 1931. Sargent made her second Boston debut—her artistic one—at the Art Club in December 1927. Her friend Perkins wrote in the *Transcript* that she had succeeded in "saying the essential things with the fewest of means."[25] Soon Sargent began to work increasingly in oils, still concentrating upon portraits and figure studies.

82. Margarett Sargent, *George Luks,* 1918

Sargent's paintings are intense, bold, and expressive. They are unlike the work of any other painter active in Boston during this period, for they shun the strict representation of natural form in favor of emotional intensity. "She is an out-and-out modernist in style as well as spirit," reported the *Boston Evening Transcript* on her 1930 Harvard show. "Her style is slap-dash, but … [her] line will betray a whole trend of emotion or indeed an entire personality with the lift of an eyelid."[26] While her portraits of her friends seem forceful and bold, the image she painted of herself during the summer of 1930 is strikingly vulnerable (fig. 69 and pl. 78). She is weightless, floating in a silvery sky with a cat, a dog, and a dove; her skin is ashen and insubstantial, her eyes vacant and elusive. Sargent called the painting *Beyond Good and Evil,* and the title seems to refer to a place of escape beyond the daily judgements of right and wrong. Sargent had increasingly sought that place in alcohol, in sexual liaisons, in designing her home, in gardening. She showed her work at an antique dealer's shop in Gloucester during the summer of 1931 and at Doll and Richards Galleries in Boston in the spring of 1932. The *Transcript* called her "the most direct link between this city and Paris" and "the leading figure in our non-conservative art movement," but by 1936 she had stopped painting. "It got too intense," she later told her granddaughter.[27]

∽ ∽ ∽

Sargent's younger colleague Ethel (Polly) Thayer had better luck (fig. 83). Thayer's family roots were as strongly Bostonian and upper class as Margarett Sargent's or Katharine Lane's ("she is one of the Back Bay's foremost society girls," noted the *Boston Post*), but her art, like Sargent's, took her in a direction different from that expected of her. She began in a conventional fashion, enrolling at the School of the Museum of Fine Arts and studying both there and privately with Philip Hale. She mastered the lessons he taught, learning to "make it like" and demonstrating her achievements to public acclaim in 1929, when she won the Hallgarten Prize at the National Academy of Design for her painting *Circles* (pl. 81); it was only her third public exhibition. "Miss Thayer paints legitimately," claimed the *Boston Post*, "she is not one of the extremists of the day—and indulges in no modernisms."[28] Thayer's picture, a full-size female nude seen from the back, was a dramatic presentation of her accomplishments and communicated clearly her academic training. A nude was not, by this time, an unusual subject for a woman artist to undertake—Gertrude Fiske had won the Shaw prize at the National Academy for her image of a nude model in the studio in 1922—but the subject signaled Thayer's emergence as a serious painter and not an upper-class amateur. While her figure is tightly painted and deliberately evocative of the academic tradition, Thayer also played with more modern design, setting her model before a lively background of circles—fabric or wallpaper that recalls the stylized geometric patterns of art deco ornament.

At the National Academy, Thayer also showed a self-portrait, *The Algerian Tunic* (pl. 80), in which she depicted herself against a backdrop of gold fabric. She wears an elegant embroidered robe from an exotic land, and with the artistically composed bowl of fruit and spray of daisies that stand beside her, Thayer might be one of the carefully arranged, decoratively garbed women in interiors who appear so frequently in Boston painting. The artist herself had poked mild fun at the ubiquity of such images in one of her own works of this type, which, rather than "Daydreams" or "Reflections," she eventually entitled simply *Boston Arrangement* (private collection).[29] But in her own self-portrait in the guise of a Boston lady, Thayer does not seem passive but instead positive. Her hair is bobbed in the new style, she gazes at the viewer directly, and she holds her brush in mid-air, just about to use it.

Thayer revealed her systematic plan to advance in the world of art and to challenge the status quo to a reporter from the *Boston Herald* in 1932. "Miss Thayer was at first all for the classic school of form and line and contour, the school of rules and traditions, and technique and history," the article noted; these ideals were clearly evident and successfully achieved in *Circles*. She planned

to continue her education in New York and in France, the article continued, "and then, having learned everything—or much that schools can teach—she is going to look into this thing called modernism." "I hope someday to paint imaginative things, interpretations of traffic jams, subway crowds, and night club life," she commented to another writer.[30] Thayer's simple wish to "look into" modernism was already a shift from the principles of her teachers, and one that would lead her away from the Boston School tradition.

Thayer had been interested in modern art for some time. She had studied with Charles Hawthorne in Provincetown in the late 1920s and had admired Eugene Speicher in New York. Neither artist had abandoned repre-

83. *Ethel (Polly) Thayer*, 1932

sentation, but both had urged Thayer to free herself from the strict academic standards of painters like Hale. It was only after she had proved herself competent in traditional painting, however, that Thayer pursued her interest in modern art. She studied briefly in Provincetown with Hans Hofmann, a vibrant colorist who would become a renowned teacher. Thayer's later portraits are striking for their flattened pictorial space and brilliant color. They are clearly modern, marked by what Philip Hale told his former student was "the slime of the serpent,"[31] a comment reflecting Hale's belief that Boston art was soon to be cast from Eden.

Thayer's *May Sarton* (pl. 82), completed in 1936, fully demonstrates her enthusiasm for a new way of painting. Thayer and Sarton met one another through their mutual interest in theater. Sarton had left Cambridge after graduating from high school, exploring creative writing and theater direction in New York and New Haven before returning to Boston. Her first book, *Encounter in April*, was published in 1937 with a Thayer portrait drawing as its frontispiece; it included a poem dedicated to the painter. Thayer depicted Sarton as a woman of the world, vital and intense, with a cigarette dangling from her fingers. "A step-up in color is prevalent in her later endeavors," wrote a critic for the *Harrisburg Patriot*, "[it is] a forceful example of modern painting." Dorothy Adlow, the art critic for the

84. John Steuart Curry, *Storm over Lake Otsego,* 1929

85. Polly (Ethel R.) Thayer, *My Childhood Trees,* 1938–39

Christian Science Monitor, would be forced to conclude that "at present it is difficult to trace [Thayer's] artistic genealogy to the Museum School, for in the last few years she has made a decided departure from accustomed methods."[32]

Thayer married Donald Starr in 1933, and while she continued to paint and to remain active in the Boston art world, the scope of her activities did diminish after her children were born. She did not retreat into conservatism, however, but rather served as a member of the board of the Institute of Modern Art in Boston and exhibited her work there. She owned several paintings, both by Bostonians and by such artists as Charles Burchfield and John Steuart Curry, whose *Storm over Lake Otsego* (fig. 84), with its agitated trees and animate landscape, seems to have influenced Thayer's own views of New England. In 1940, the Board of Trustees of the Museum of Fine Arts voted to accept one of them as a gift from the Boston Society of Independent Artists (fig. 85). Thayer's landscape became one of fewer than ten paintings in the Museum's American collection at that time that could be characterized as modern (even including the Ashcan School) and it was the first one to have been painted by a Boston artist.

Polly Thayer, Gertrude Fiske, Aimée Lamb, and Margarett Sargent, along with several other younger painters, had joined with their peers in an attempt to widen the sphere of art in Boston to include new methods of painting and new ways of seeing. "They have generally been made to feel like barbarians and intruders by the patrician arbiters of taste," commented Dorothy Adlow, who, along with Perkins, was one of the few public voices to support a modernist point of view.[33] It was not a battle that could be won, at least not before the outbreak of another world war. There were also many female voices on the other side of the argument, dedicated professional painters who decried the loss of artistic standards and spoke eloquently in favor of traditional art.

The argument proved at least one thing—that by 1940 women artists in Boston were numerous enough, confident enough, and strong enough to disagree with each other. There was no longer a need for women to band together, subverting their own artistic expression in favor of a single aesthetic that would win attention for all. They could now support one another as professionals while maintaining their individual voices, for each had found a studio of her own. Through the efforts of three generations of women, Boston had become a center for women's achievements in the arts. "Painting Wasn't Ladylike," the headline in the *Boston Post* blared when H. Winthrop Peirce published his history of the Museum School, "But What of It?"[34]

86. Gertrude Fiske, *Self Portrait,* 1922

Appendices

ENDNOTES

Introduction

1. E. H. B. [Elizabeth Howard Bartol], "Some Women Artists of Massachusetts," unidentified clipping, Richard Morris Hunt Archive, American Institute of Architects, Washington, D.C.

2. William Howe Downes, "Boston Art and Artists," in F. Hopkinson Smith et al., *Essays on Art and Artists* (Boston: American Art League, 1896), p. 280.

3. Philip Hale, "Painting and Etching," in *Fifty Years of Boston*, ed. Elisabeth M. Herlihy (Boston: Tercentenary Committee, 1932), p. 362.

4. Lisa Tickner, *The Spectacle of Women: Imagery of the Suffrage Campaign, 1907–14* (Chicago: University of Chicago Press, 1988), p. 13.

5. Hosmer to Phebe Hanaford, quoted in Hanaford, *Daughters of America* (1883), pp. 321–22, as excerpted in Charlotte Streifer Rubinstein, *American Women Artists* (New York: Avon Books, 1982), pp. 44–45.

Opening Steps

1. Cecilia Beaux, address given at Barnard College, 1915, Cecilia Beaux Papers, Archives of American Art, Smithsonian Institution, Washington, D.C., quoted in Laura Prieto Chesterton, "A Cultural History of Professional Women Artists in the United States, 1830–1930," Ph.D. dissertation, Brown University, 1998, p. 254.

2. Louise Rogers Jewett to her family, September 17, 1893, Louise Rogers Jewett Papers, Mount Holyoke College Library Archives, quoted in Betsy Fahlman, "Women Art Students at Yale, 1869–1913, Never True Sons of the University," *Woman's Art Journal* 12 (Spring/Summer 1991), p. 18; William Howe Downes, "Boston Art and Artists," in F. Hopkinson Smith et al., *Essays on Art and Artists* (Boston: American Art League, 1896), p. 280.

3. Philip Hale, "Painting and Etching," in *Fifty Years of Boston*, ed. Elisabeth M. Herlihy (Boston: Tercentenary Committee, 1932), p. 362.

4. Greta [pseud.], "Art in Boston," *The Art Amateur* 20 (January 1889), p. 28.

5. Ednah D. Cheney, "The Women of Boston," in *The Memorial History of Boston*, ed. Justin Winsor (Boston: Ticknor and Company, 1880–81), vol. 4, p. 356.

6. Ednah Dow Cheney, "Margaret Fuller," in *Reminiscences of Ednah Dow Cheney* (Boston: Lee and Shepard, Publishers, 1902), p. 205.

7. Cheney, "Women of Boston," p. 351.

8. Quoted in ibid., p. 340.

9. Charlotte Streifer Rubinstein, *American Women Artists* (New York: Avon Books, 1982), p. 75.

10. See, for example, Jan Seidler Ramirez, "Harriet Hosmer," in Kathryn Greenthal et al., *American Figurative Sculpture in the Museum of Fine Arts, Boston* (Boston: Museum of Fine Arts, 1986), pp. 159–60.

11. Hosmer to Cornelia Crow Carr, April 22, 1853, in *Voicing Our Visions: Writings by Women Artists,* Mara R. Witzling, ed. (New York: Universe, 1991), p. 47.

12. Henry James, *William Wetmore Story and His Friends* (London: Blackwood, 1903), vol. 1, p. 257.

13. Dolly Sherwood, *Harriet Hosmer: American Sculptor 1830–1908* (Columbia: University of Missouri Press, 1991), p. 230. Charlotte Rubinstein credits 30,000 people with attending (Charlotte Streifer Rubinstein, *American Women Sculptors* [Boston: G. K. Hall and Co., 1990], p. 40).

14. Whitney's friend Elizabeth Bartol also depicted Lady Godiva; she wrote to Whitney in 1867, "Picture selling is very dull … I haven't had an opportunity to sell my Lady Godiva yet." Elizabeth Bartol to Anne Whitney, July 6, 1867, Anne Whitney Papers, Wellesley College Archives, Wellesley, Mass.

15. Hosmer, "The Process of Sculpture," *Atlantic Monthly* (December 1864), as excerpted in Rubenstein, *American Women Sculptors*, pp. 41–42.

16. Hosmer to Phebe Hanaford, quoted in Hanaford, *Daughters of America* (1883), pp. 321–22, as excerpted in Rubenstein, *American Women Sculptors*, pp. 44–45.

17. England's Government School of Design was founded in 1837 at Somerset House; it was incorporated as part of a museum under the direction of Henry Cole in 1852 and opened as the South Kensington Museum (now the Victoria and Albert) in 1857. A separate course for women was established in 1841; by 1857 most of its classes had been absorbed into the men's school. See Malcolm Baker et al., *A Grand Design: The Art of the Victoria and Albert*

Museum (New York: Harry N. Abrams, Inc., 1997), pp. 26–27, 76; and F. Graeme Chalmers, "Fanny McIan and London's Female School of Design, 1842–57," *Women's Art Journal* 16 (Fall 1995/Winter 1996), pp. 3–9. The Philadelphia School of Design for Women, founded in 1844, survives today as the Moore College of Art.

18. Cheney, *Reminiscences*, pp. 144–45.

19. Cheney tactfully identifies him only as "Mr. Wh—." Cheney, *Reminiscences*, pp. 74–75.

20. Ellen Robbins, "Reminiscences of a Flower Painter," *New England Magazine* 14 (June 1896), p. 443; May Alcott Nieriker, *Studying Art Abroad and How to Do It Cheaply* (Boston: Roberts Brothers, 1879), p. 28; E. H. B. [Elizabeth Howard Bartol], "Some Women Artists of Massachusetts," unidentified clipping, Richard Morris Hunt Archive, American Institute of Architects, Washington, D.C.; Cheney, *Reminiscences*, pp. 75–76. I am grateful to Martha Hoppin and William H. Gerdts for making the Bartol clipping available to me.

21. For the Lowell Institute, see Charles K. Dillaway, "Education, Past and Present," in *The Memorial History of Boston*, vol. 4, p. 265 and Edward Weeks, *The Lowells and Their Institute* (Boston: Little, Brown, and Company, 1966).

22. Cheney, *Reminiscences*, p. 142; Bartol, "Some Women Artists of Massachusetts."

23. William Rimmer to Ednah Cheney, March 28, 1864, quoted in Truman H. Bartlett, *The Art Life of William Rimmer* (Boston: James R. Osgood and Company, 1882), pp. 42–43. For Rimmer, see also Jeffrey Weidman et al., *William Rimmer: A Yankee Michelangelo* (Hanover, N.H.: University Press of New England, 1985), this book includes an essay by Neil Harris about Rimmer as a teacher; and Jeffrey Weidman, "William Rimmer: Critical Catalogue Raisonné," 7 vols., Ph.D. dissertation, Indiana University, 1981.

24. R. S. to James Claghorn, 1882, quoted in Christine Jones Huber, *The Pennsylvania Academy and Its Women* (Philadelphia: Pennsylvania Academy of the Fine Arts, 1973), p. 21.

25. For French examples, see Tamar Garb, "The Forbidden Gaze," *Art in America* 79 (May 1991), pp. 147–51, 186.

26. The women were: Elizabeth Boott, Anna Dixwell, Alice Curtis, Helen Knowlton, Susan Minot Lane, and Lucy Ellis. Another petition was signed by 180 art students. Curatorial files, Museum of Fine Arts, Boston.

27. Bartlett, p. 118.

28. See Jeffrey Weidman, "William Rimmer: Critical Catalogue Raisonné," vol. 1, pp. 48–53 and accompanying notes.

29. Bartlett, p. 118.

30. Cheney, *Reminiscences*, p. 142.

31. Quoted in Bartlett, p. 42.

32. Elizabeth Bartol, "Some Women Artists of Massachusetts."

33. Unidentified author, quoted in Bartlett, p. 141.

34. Whitney destroyed the plaster model of *Africa* after her return from Italy; the current locations of both *Toussaint L'Ouverture* and *The Liberator* remain unknown. See Elizabeth Rogers Payne, "Anne Whitney, Sculptor," *The Art Quarterly* 25 (Autumn 1962), pp. 244–61. Elizabeth Bartol posed for the figure of *Africa;* see Chesterton, "A Cultural History of Professional Women Artists," p. 172.

35. Vinnie Ream Hoxie's full-length *Lincoln* had been installed in the Capitol rotunda in 1871. A full list of the sculpture in Statuary Hall, its makers, and dates of presentation can be found at www.aoc.gov.

36. Sarah Whitney to Anne Whitney, February 4, 1876, Anne Whitney Papers, Wellesley College Archives, Wellesley, Mass. Lydia Child's poem, which directly assaulted the committee for believing that a woman was unable to sculpt a man, is quoted in Eleanor Tufts, "An American Victorian Dilemma, 1875," *Art Journal* 51 (Spring 1992), p. 54.

37. Anne Whitney to Adeline Manning, February 27, 1876, Anne Whitney Papers, Wellesley College Archives, Wellesley, Mass.; Elizabeth Rogers Payne, "Anne Whitney: Art and Social Justice," *The Massachusetts Review* 12 (Spring 1971), p. 251.

38. Mary A. Livermore, "Anne Whitney," *Our Famous Women* (Hartford: A. D. Worthington and Co., Publishers, 1884), pp. 687–88.

39. Anne Whitney to Sarah Whitney, September 19, 1875, Anne Whitney Papers, Wellesley College Archives, Wellesley, Mass.

40. Ibid., p. 135. See also Livermore, "Anne Whitney," p. 687.

41. Anne Whitney to Marianne Dwight Orvis and Ednah Dow Cheney, July 25, [1875], from Ecouen, quoted in Elizabeth Rogers Payne, "Biography of Anne Whitney," unpublished manuscript, pp. 1029–30, Anne Whitney Papers, Wellesley College Archives, Wellesley,

Mass. The original letter is in the Sophia Smith Collection at Smith College, Northampton, Mass.

42. Dora M. Morrell, "Workers at Work: Miss Rimmer in Her Studio," *The Arena* 21 (January 1899), p. 74. It must be stated, however, that the sensuality of Caroline Rimmer's sculpted women never achieved the luxurious seductiveness of the contemporary figurative work of, for example, the Rookwood Pottery in Cincinnati. See Wendy Kaplan, *"The Art That Is Life": The Arts and Crafts Movement in America, 1875–1920* (Boston: Museum of Fine Arts, 1987). For Rimmer, see also Rachel J. Monfredo, "Caroline H. Rimmer, Sculptor," unpublished manuscript, 1996, curatorial files, Museum of Fine Arts, Boston.

43. Bartlett, pp. 137, 139.

44. Bartol, "Some Women Artists of Massachusetts."

The Students of William Morris Hunt

1. For Hunt, see Helen M. Knowlton, *Art-Life of William Morris Hunt* (Boston: Little, Brown, and Company, 1899); Martha J. Hoppin and Henry Adams, *William Morris Hunt: A Memorial Exhibition* (Boston: Museum of Fine Arts, 1979); and Sally Webster, *William Morris Hunt* (Cambridge: Cambridge University Press, 1991).

2. See Weidman, "William Rimmer: Critical Catalogue Raisonné," vol. 1, p. 95.

3. Thomas Ball, *My Threescore Years and Ten* (Boston: Roberts Brothers, 1892), p. 304; Sarah Wyman Whitman, "William Morris Hunt," *International Review* 8 (April 1880), p. 396; Bartol, "Some Women Artists of Massachusetts"; Francis D. Millet, "Mr. Hunt's Teaching," *Atlantic Monthly* 46 (August 1880), p. 191; C. C. [Clarence Cook], "A Tribute to the Dead Artist," *New York Daily Tribune*, September 10, 1879, p. 5. For a complete account of Hunt's classes and his students, see Martha Hoppin's excellent article, "Women Artists in Boston, 1870–1900: The Pupils of William Morris Hunt," *The American Art Journal* 13 (Winter 1981), pp. 17–46. Among the women who studied with Hunt were Miss Baker, Elizabeth Howard Bartol, Miss Becket, Elizabeth Boott [Duveneck], Lilian Clarke, Caroline A. Cranch, Alice Marion Curtis, Anna P. Dixwell, Lucy Ellis, Almira Fenno-Gendrot, Elizabeth Bigelow Greene, Ellen Day Hale, Sarah J. F. Johnston, Helen Mary Knowlton, Rose Lamb, Susan Minot Lane, Helen Bigelow Merriman, Emily

Danforth Norcross, Maria Oakey [Dewing], Elizabeth Welles Perkins, Anna Putnam, Annette Perkins Rogers, Mrs. Josephine Tryon, Adelaide E. Wadsworth, Susan M. L. Wales, Sarah Wyman Whitman, and Mary Hubbard Whitwell. Laura Coombs Hills studied with Knowlton.

4. Hunt, quoted in Martha A. S. Shannon, *Boston Days of William Morris Hunt* (Boston: Marshall Jones Company, 1923), p. 108.

5. Bartol, "Some Women Artists of Massachusetts"; Whitman, "William Morris Hunt," p. 397; Helen Knowlton, *The Art-Life of William Morris Hunt* (Boston: Little, Brown, and Company, 1899), p. 85.

6. Hunt's student Rose Lamb also painted a portrait of Hunt, illustrated in Shannon, *Boston Days of William Morris Hunt*, facing page 108. The photograph upon which Knowlton based her portrait also served as a model for William Willard, who painted a head from it, and for C. H. Walker, who used it as the basis for an etching.

7. Both women quoted in Hoppin, "Pupils of William Morris Hunt," p. 25. Hunt separated from his wife in 1873. Sally Webster, quoting Hunt's sister Jane's diary, suggests that Hunt and Knowlton had an affair (among other hints, Jane Hunt reported that Mrs. Hunt accused her husband of "leading an immoral life"); see Webster, *William Morris Hunt*, pp. 105–07.

8. See, for example, Frederic A. Sharf and John H. Wright, *William Morris Hunt and the Summer Art Colony at Magnolia, Massachusetts, 1876–1879* (Salem, Mass.: Essex Institute, 1981), p. 16. In addition to her contributions to the *Worcester Palladium*, Knowlton also wrote art criticism for the Boston *Post*. See Frederic A. Sharf, "Helen Knowlton," *Notable American Women* (Cambridge: Harvard University Press, 1971), vol. 2, pp. 342–43.

9. Almira B. Fenno-Gendrot, *Artists I Have Known* (Boston: The Warren Press, 1923), p. 36.

10. William C. Brownell, "The Younger Painters of America, Part III," *Scribner's Monthly* 22 (July 1881), p. 332.

11. Helen Knowlton, *The Art-Life of William Morris Hunt*, p. 116.

12. *The Art Amateur*, January 1881, p. 27.

13. These classes are described in Fenno-Gendrot, *Artists I Have Known*, pp. 36–39; see also Bartlett, p. 65.

14. Fenno-Gendrot, p. 35.

15. Brownell, "The Younger Painters of America, Part III," p. 327.

16. Bartol, "Some Women Artists of Massachusetts."

17. For a detailed account of Boott's and Dixwell's journey to Spain, see Carol M. Osborne, "Yankee Painters at the Prado," in *Spain, Espagne, Spanien: Foreign Artists Discover Spain, 1800–1900* (New York: The Equitable Gallery, 1993).

18. "Some New Paintings by Women Artists," unidentified clipping, January 15, 1876, pp. 90–91, courtesy of William H. Gerdts.

19. Carol M. Osborne, "The Picture Season at Villiers-le-Bel, 1876–78: Elizabeth Boott, Thomas Couture, and Henry James," *Apollo* 149 (May 1999), pp. 46, 47–48; Lizzie Boott to "Dear friends," June 14, 1876, Frank Duveneck Papers, Archives of American Art, Smithsonian Institution, Washington, D.C., Roll 1097, frames 238–39. Boott's letters are held by the Cincinnati Historical Society. For the term "Huntite," see Fenno-Gendrot, p. 13. Couture had many American pupils; a number of them would become well-known artists in Boston. Besides Hunt, they included William Babcock, John La Farge, and Ernest Wadsworth Longfellow, with whom the Bootts shared a house in 1876. See Marchal E. Landgren, *American Pupils of Thomas Couture* (College Park: University of Maryland Art Gallery, 1970), and Osborne, "The Picture Season at Villiers-le-Bel, 1876–78," pp. 40–51.

20. Osborne, "The Picture Season at Villiers-le-Bel, 1876–78," p. 47. The initial selection failed when Couture apparently sold the painting to someone else; in 1877, with the assistance of Sarah Wyman Whitman, Couture's *Two Soldiers* was purchased for the newly opened Museum of Fine Arts. Although the Couture credit line indicates a subscription was raised for the purchase, Whitman's correspondence indicates that the funds were provided anonymously by Mrs. Quincy Adams Shaw and that Whitman paid for shipping and restretching the painting (curatorial files, Museum of Fine Arts, Boston).

21. Boott to the Hunt class, September 13, 1879, quoted in Carol M. Osborne, "Lizzie Boott at Bellosguardo," in Irma B. Jaffe, ed., *The Italian Presence in American Art, 1860–1920* (New York: Fordham University Press, 1992), p. 193. For further biographical information on Boott, see also Carol Osborne's essay "Frank

Duveneck and Elizabeth Boott: An American Romance," written for the Owen Gallery, New York, February, 1996. For Duveneck's travels, see Michael Quick, *An American Painter Abroad: Frank Duveneck's European Years* (Cincinnati: Cincinnati Art Museum, 1987).

22. *Boston Herald*, February 3, 1884, p. 14; see also the *Boston Evening Transcript*, February 5, 1884, p. 3.

23. Ellen Day Hale to Emily Perkins Hale, April 26 and May 24, 1885, Box 45a, Folder 1064, Hale Papers, Sophia Smith Collection, Smith College, Northampton, Mass. (hereafter referred to as Hale Papers, SSC). See also Hoppin, p. 44, and the discussion in Kirsten N. Swinth, "Painting Professionals: Women Artists and the Development of a Professional Ideal in American Art, 1870–1920," Ph.D. dissertation, Yale University, 1995, pp. 123–24.

24. Elizabeth Stuart Phelps, *The Story of Avis* (1877), ed. Carol Farley Kessler (New Brunswick, N.J.: Rutgers University Press, 1985), p. 69. For Phelps, see also Elizabeth Spring, "Elizabeth Stuart Phelps," in *Our Famous Women*, pp. 560–80.

25. These events are recounted in detail in Carol M. Osborne, "Lizzie Boott at Bellosguardo," pp. 197–98 and the quotations appear in the same author's 1996 essay for the Owen Gallery.

26. Phelps, *The Story of Avis*, pp. 179–80.

27. Quoted in Osborne, "Lizzie Boott at Bellosguardo," p. 198.

28. Lucy Stone, "Literary Notices," *The Woman's Journal* 8 (December 15, 1877), p. 400, reprinted in Phelps, *The Story of Avis*, ed. Carol Farley Kessler, p. 274.

29. Harvey Green, *The Light of the Home: An Intimate View of the Lives of Women in Victorian America* (New York: Pantheon Books, 1983), pp. 29–33.

30. Harriet Hosmer to Wayman Crow, August 1854, in Cornelia Carr, ed., *Harriet Hosmer: Letters and Memories* (New York: Moffat, Yard, and Co., 1912), p. 24.

31. Helen Howe, *The Gentle Americans* (New York: Harper and Row, Publishers, 1965), p. 83. The category "lesbian" only came to be defined by behaviorists in the 1870s; it was not part of the public consciousness or generally perceived as "abnormal" until the 1910s; see also Lillian Faderman, "Nineteenth-Century Boston

Marriage as a Possible Lesson for Today," in Esther D. Rothblum and Karen A. Brehony, eds., *Boston Marriages* (Amherst: University of Massachusetts Press, 1993), pp. 33–34; Lillian Faderman, *Surpassing the Love of Men* (New York: Quality Paperback, 1981), pp. 190–203; and Carroll Smith-Rosenberg, *Disorderly Conduct: Visions of Gender in Victorian America* (New York: Oxford University Press, 1985), pp. 266–96.

Beautifying Everyday Life: Sarah Wyman Whitman

1. John Jay Chapman, *Memories and Milestones* (New York: Moffat, Yard, and Company, 1915), pp. 103, 106. For Whitman see also *Letters of Sarah Wyman Whitman* (Cambridge: The Riverside Press, 1907); Virginia C. Raguin et al. "Sarah Wyman Whitman, 1842–1904: The Cultural Climate in Boston," typescript, Art History Department, College of the Holy Cross, 1993; and Betty S. Smith, "Sarah de St. Prix Wyman Whitman," *Old-Time New England* 77 (Spring/Summer 1999), pp. 46–64. I am especially grateful to Betty Smith, who has generously shared information from her own work on Whitman and who has been a tireless champion of Whitman's career.

2. S. C. de Soissons, *Boston Artists: A Parisian Critic's Notes* (Boston: Carl Schoenhof, 1894), p. 37.

3. See the related discussion in Sarah Burns, "The 'Earnest, Untiring Worker' and the Magician of the Brush: Gender Politics in the Criticism of Cecilia Beaux and John Singer Sargent," *The Oxford Art Journal* 15 (1992), pp. 36–53 and her chapter "Outselling the Feminine" in Sarah Burns, *Inventing the Modern Artist: Art and Culture in Gilded Age America* (New Haven: Yale University Press, 1996), pp. 159–86.

4. T., "The Disciples of William Morris Hunt," *The Art Amateur* 13 (July 1885), p. 41.

5. For Niagara Falls, see Whitman to Sarah Orne Jewett, July 17, 1898, *Letters of Sarah Wyman Whitman*, p. 101. While the correct spelling of Couture's hometown is Villiers-le-bel, Whitman's composition of roses is clearly inscribed "Villier-le-bel," hence the variant spelling in the title of her painting.

6. Brownell, "The Younger Painters of America, Part III," p. 329. Whitman showed an unlocated painting, *Girl and Cat;* Boott, Bartol,

and Oakey were also included in the 1878 exhibition (as was Hunt). Hunt and his students Boott, Bartol, Curtis, Greene, Hunt, Knowlton, Lane, Oakey, and Wadsworth had all participated in the 1875 exhibition at Daniel Cottier's New York gallery that precipitated the founding of the Society. See Jennifer A. Martin Bienenstock, "The Formation and Early Years of the Society of American Artists: 1877–1884," Ph.D. dissertation, City University of New York, 1983.

7. S. N. Carter, "The Society of American Artists," the *Art Journal* 6 (1880), p. 156.

8. See Bienenstock, "The Formation and Early Years of the Society of American Artists"; the Society's catalogues; and the discussion in Swinth, "Painting Professionals," pp. 143–44. La Farge's extramarital affair with Maria Oakey, which ended in the late 1870s, may have had more to do with his reluctance to support her than did consistent antifeminism on his part. I am grateful to James L. Yarnall for his insights and information on La Farge. Oakey became engaged to the painter Thomas Dewing in December 1880.

9. Phillips Brooks to Sarah Wyman Whitman, May 24, 1881, Archives of American Art, Smithsonian Institution, Washington, D.C., Roll D32.

10. James L. Yarnall, *Nature Vivante: The Still Lifes of John La Farge* (New York: The Jordan-Volpe Gallery, 1995), p. 116. *Agathon to Erosanthe* had been in the collection of Ellen Hooper (later Mrs. Ephraim Gurney) since 1864. Ellen Hooper's sister Marian (called Clover) married Henry Adams, one of La Farge's closest friends; her brother Edward was also a friend and patron of La Farge's; and Ellen's niece Mabel Hooper (Edward Hooper's daughter) married La Farge's son Bancel.

11. This clipping is cited by Betty Smith in her "Biographical Outline: Sarah Wyman Whitman (1842–1904)," typescript, curatorial files, Museum of Fine Arts, Boston. Whitman added a mural to the chancel of Worcester's Central Congregational Church in 1889; most of her work has since been renovated out of existence.

12. S. W. W., "Stained Glass Windows," *The Nation* 55 (December 8, 1892), p. 431. Whitman's studio is described in "Women of Talent: Their Work in Industrial Art," *Springfield* [Mass.] *News*, April 2, 1897. See also Orin E. Skinner, "Women in Stained Glass," *Stained Glass* 35 (Winter 1940), pp. 113–15. Despite

Whitman's words, some of her windows do employ painted details.

13. Whitman is quoted in Mason Hammond, "The Stained Glass Windows in Memorial Hall, Harvard University," typescript, 1978, Harvard University Archives, p. 282. See also Virginia Raguin, "Memorial Hall Windows Designed by Sarah Wyman Whitman," typescript, Harvard University. I am most grateful to Virginia Raguin for sharing her work with me.

14. Charles J. Connick, *Adventures in Light and Color* (New York: Random House, 1937), p. 401.

15. Sarah Whitman to Mrs. Bigelow Lawrence, in *The Letters of Sarah Wyman Whitman*, p. 40.

16. For Whitman's work as a book cover designer, see Sue Allen and Charles Gullans, *Decorated Cloth in America* (Los Angeles: University of California, 1994) and Nancy Finlay, *Artists of the Book in Boston* (Cambridge, Mass.: The Houghton Library, 1985). I am also indebted to Sue Allen's lecture, "The Book Cover Art of Sarah Wyman Whitman," presented at the Houghton Library, Harvard University, May 6, 1999.

17. Sarah Wyman Whitman, *Notes of an Informal Talk on Book Illustration, Inside and Out, Given before the Boston Art Students' Association, February 14, 1894* (Boston: Boston Art Students' Association, 1894), p. 5.

18. Norton, quoted in Nancy Finlay, "A Millenium in Book-Making: The Book Arts in Boston," in Marilee Meyer et al., *Inspiring Reform: Boston's Arts and Crafts Movement* (Wellesley, Mass.: Davis Museum and Cultural Center, 1997), p. 129; Whitman, "The Pursuit of Art in America," *The International Review* 12 (January 1882), p.15.

19. Bliss Perry, *Life and Letters of Henry Lee Higginson* (Boston: The Atlantic Monthly Press, 1921), p. 372. Whitman's decorative interests also included metalwork, and she created an elegant silver pitcher, manufactured by Shreve, Crump and Low, for the Phi Beta Kappa Society at Harvard (I am grateful to Jeannine Falino for providing this information). Whitman also devised the college seal for Radcliffe in 1894, upon its incorporation, and she designed the crest for Isabella Stewart Gardner's Fenway Court.

20. "Women of Talent: Their Work in Industrial Art," *Springfield* [Mass.] *News*, April 2, 1897, Society of Arts and Crafts Papers, Archives of American Art, Smithsonian Institution, Washington, D.C., Roll 322, frame 198.

Boston Women and the Arts and Crafts Movement

1. Sarah Grimké, quoted in Whitney Chadwick, *Women, Art, and Society* (London: Thames and Hudson, 1990), p. 193.

2. Henry James, *The Bostonians*, 1885–86 (New York: New American Library, 1979), p. 11.

3. See also Sylvia L. Yount, "'Give the People What They Want': The American Aesthetic Movement, Art Worlds, and Consumer Culture, 1876–1890," Ph.D. dissertation, University of Pennsylvania, 1995, pp. 125–26, 150–164, 219–47.

4. Smith quoted in Catherine Lynn, "Surface Ornament: Wallpapers, Carpets, Textiles, and Embroidery," in Doreen Burke et al., *In Pursuit of Beauty: Americans and the Aesthetic Movement* (New York: The Metropolitan Museum of Art, 1986), p. 98.

5. Ibid.

6. See the discussion of these issues in "Woman's Position in Art," *The Crayon* 8 (February 1861), pp. 25–28; Anthea Callen, *Women Artists of the Arts and Crafts Movement, 1870–1914* (New York: Pantheon Books, 1979); Rozsika Parker and Griselda Pollock, *Old Mistresses: Women, Art, and Ideology* (New York: Pantheon Books, 1980); and Anthea Callen, "Sexual Division of Labor in the Arts and Crafts Movement," *Woman's Art Journal* 5 (Fall 1984/Winter 1985), pp. 1–6.

7. See Beverly K. Brandt, "'All Workmen, Artists, and Lovers of Art': The Organizational Structure of the Society of Arts and Crafts, Boston," in Meyer et al., *Inspiring Reform*, p. 36.

8. Anne Digan Lanning and Marla R. Miller, "A Virtuous Sweatshop? Craftwork and Community in Deerfield," paper presented at the symposium "Aspects of the Arts and Crafts Movement in New England," Historic Deerfield, Inc., November 8, 1996.

9. Quoted in Nicola J. Shilliam, "Boston and the Society of Arts and Crafts: Textiles," in Meyer et al., *Inspiring Reform*, pp. 104, 113.

10. See Kaplan, *"The Art That Is Life,"* pp. 312–13; Susan J. Montgomery, "The Potter's Art in Boston: Individuality and Expression," in Meyer et al., *Inspiring Reform*, pp. 64, 227; and Kate Larson, "The Saturday Evening Girls: A Social Experiment in Class Bridging and Cross Cultural Female Dominion Building in Turn of the Century Boston," Master's thesis, Simmons

College, 1995. I would like to thank Susan Montgomery for her invaluable help and advice.

11. See Edward S. Cooke, Jr., "The Aesthetics of Craftsmanship and the Prestige of the Past: Boston Furniture-Making and Wood-Carving," in Meyer et al., *Inspiring Reform*, pp. 47–48, 54–56, 227.

12. Quoted in Meyer, "Historic Interpretations," p. 95.

13. Wynne, quoted in Kaplan, *The Art That Is Life*, p. 265; review from *House Beautiful* quoted in Marilee Boyd Meyer, "Historic Interpretations: Boston's Arts and Crafts Jewelry," in Meyer et al., *Inspiring Reform*, p. 93. See also *In Memory of Madeline Yale Wynne*, printed pamphlet, publication details unknown, Harvard University Library, n.d. (about 1918).

14. Irene Sargent, "The Worker in Enamel, With Special Reference to Miss Elizabeth Copeland," *The Keystone* 27 (February 1906), p. 193. I would like to thank Jeannine Falino for providing this reference.

15. Sargent, "The Worker in Enamel," p. 196. Edith Dawson worked with her husband Nelson, another former student of Fisher's; the couple operated a small firm in Chelsea that was known for its decorative silver and enamelwork. For Dawson, see Callen, *Women Artists of the Arts and Crafts Movement*, pp. 155–56.

Redefining Fine Art: Sarah Sears, Laura Hills, and Ethel Reed

1. When a Boston Kodak dealer put Coolidge's photographs in his shop window, her mother purchased all of them. She told her daughter that it was "better not to be in the public eye in shop windows" although she admitted that it was "a great compliment ... to have the professional admire them so much." Mary Coolidge Perkins, *Once I Was Very Young* (Milton, Mass.: privately printed, 1960), p. 52.

2. Richard Hines, Jr., "Women and Photography," *American Amateur Photographer* 11 (March 1899), p. 118.

3. W. S. Harwood, "Amateur Photography of To-day," *Cosmopolitan* 20 (January 1896), quoted in Anne E. Havinga, "Pictorialism and Naturalism in New England Photography," in Meyer et al., *Inspiring Reform*, pp. 135–36.

4. See the discussion in Havinga, "Pictorialism and Naturalism," pp. 135–36; Anne E. Havinga,

"F. Holland Day and the Boston Arts and Crafts Movement," in *New Perspectives on F. Holland Day*, edited by Patricia J. Fanning (North Easton, Mass.: Stonehill College, 1998), pp. 64–67; and Laura Elise Meister, "Missing from the Picture: Boston Women Photographers 1880–1920," Master's thesis, Tufts University, 1998.

5. Quoted in Meister, p. 36.

6. Sarah Sears to Frances Johnston, May/June 1900, quoted in Toby Quitslund, *Her Feminine Colleagues: Photographs and Letters Collected by Frances Benjamin Johnston in 1900* (College Park, Maryland: University of Maryland Art Gallery, 1979), p. 139.

7. "Among the Clubs: Recent Exhibitions," *Photo-Era* 2 (March 1899), pp. 260–61.

8. Austin to Johnston, quoted in Quitslund, p. 113.

9. See Meister, pp. 63–72; E. J. Wall reviewed the eighth annual Photographic Salon for the London *Photographic News* and his commentary (on Devens and others) was reprinted in *Camera Notes* 4 (January 1901), pp. 164–66.

10. Sarah Sears's 45 carbon prints were given to the Museum of Fine Arts by her daughter Helen Sears Bradley in 1942. The carbon prints were not made by Cameron, but were produced from her negatives by both her dealer, Colnaghi, and possibly by her son, Herschel Cameron. I am grateful to Anne Havinga for her assistance. Sears's art collection will be the subject of a forthcoming article by the present author.

11. John Singer Sargent to Sarah Choate Sears, August 7, 1895, private collection.

12. Joseph T. Keiley, "The Salon: Its Purpose, Character, and Lesson," *Camera Notes* 3 (January 1900), p. 169. The rivalry between Day and Stieglitz, and Sears's role within it, is studied in wonderful detail in Jane Van Nimmen, "F. Holland Day and the Display of a New Art: 'Behold, It Is I,'" *History of Photography* 18 (Winter 1994), pp. 368–82.

13. Sadakichi Hartmann, "Pictorial Criticism: Constructive, not Destructive," *The Photographer* 1 (June 11, 1904), quoted in Stephanie Mary Buck, "Sarah Choate Sears: Artist, Photographer, and Art Patron," M.F.A. thesis, Syracuse University, 1985, p. 58. See also Sadakichi Hartmann, "Women in Photography," *Photographic Progress* 1 (October 1909), p. 140, for similar praise.

14. Sarah Choate Sears to Alfred Stieglitz, September 19, [1905], Alfred Stieglitz Papers, Beinecke Library, Yale University, New Haven, Conn.

15. "Sarah C. Sears Paintings Exhibition at Art Building," *Wellesley College News*, June 1925, clipping, private collection. Sears did not attend the college.

16. For Hills, see *Laura Coombs Hills: A Retrospective* (Newburyport, Mass.: Historical Society of Old Newbury, 1996).

17. "Famous People at Home. XIV. Miss Laura Coombs Hills," *Time and the Hour* 5 (May 22, 1897), p. 8.

18. See Finlay, *Artists of the Book in Boston*, p. 87. Crane's *Flora's Feast* continued to inspire Bostonians as a subject for masques and pageants for years to come. The Women's Educational and Industrial Union was founded in 1877; it continues to operate today.

19. M. J. Curl, "Boston Artists and Sculptors Talk of Their Work and Ideals, IV, Laura Coombs Hills," *Boston Evening Transcript*, January 2, 1921.

20. A. Lys Baldry, "Modern Miniature Painting," *The International Studio* 35 (September 1908), p. 171.

21. "Miniature Painting Coming into Its Own Again Here After Many Years," unidentified clipping, Fine Arts Department, Boston Public Library.

22. Grace Alexander Nutell, "A Painter of Miniatures," *The Puritan* 5 (April 1899), p. 387.

23. Quoted in *Laura Coombs Hills: A Retrospective*, p. 35.

24. Florence Spaulding, "Laura Coombs Hills," *Arts and Artists* 1 (December 1936), p. 1; A. J. Philpott, "Flower Painting Exhibit Attracts Boston Enthusiasts," *Boston Globe*, November 23, 1947, clipping, curatorial files, Museum of Fine Arts, Boston.

25. "Some Lady Artists of New York," *The Art Amateur* 3 (July 1880), p. 27. See also the discussion and charts of types of subject matter exhibited by men and women in Swinth, "Painting Professionals," pp. 162–68, 338–41 and her discussion of artistic hierarchies, pp. 200–01.

26. Robbins, "Reminiscences of a Flower Painter," pp. 446–47.

27. William Howe Downes, "Painter of Flowers," *Boston Evening Transcript*, 1916, clipping

included with the Greene correspondence, Anne Whitney Papers, Wellesley College Archives, Wellesley, Mass. Greene painted her friend Whitney's portrait (unfinished, Wellesley College Archives); she and Robbins also were friends with the sculptor Margaret Foley, the painter Elizabeth Bartol, and the writer Annie Fields.

28. Quoted in Parker and Pollock, *Old Mistresses*, p. 54. See also the discussion in Annette Stott, "Floral Femininity," *American Art* 6 (Spring 1992), pp. 72–76.

29. Maria Oakey Dewing to Nelson C. White, August 30, 1927, quoted in Jennifer Martin, "Portraits of Flowers: The Out-of-Door Still-Life Paintings of Maria Oakey Dewing," *American Art Review* 4 (December 1977), p. 116.

30. During the 1920s, no prizes were awarded to still lifes at the Corcoran's annual exhibitions, while at the Pennsylvania Academy, the prize for "best painting by a woman resident of Philadelphia" produced three still life winners.

31. "Famous People at Home. XIV. Miss Laura Coombs Hills," *Time and the Hour* 5 (May 22, 1897), p. 8.

32. Sinclair Hitchings to the author, April 11, 2000; see also Finlay, *Artists of the Book in Boston*, pp. 100–01, and Jessica Todd Smith, "Ethel Reed: The Girl in the Poster," senior thesis, Harvard University, 1991.

33. A useful history of American art posters can be found in David W. Kiehl et al., *American Art Posters of the 1890s in the Metropolitan Museum of Art* (New York: Metropolitan Museum of Art, 1987).

34. Charles Dudley Warner, "Editor's Study," *Harper's New Monthly Magazine* 90 (February 1895), quoted in Burns, *Inventing the Modern Artist*, p. 98.

35. These relationships are discussed at length in Douglass Shand-Tucci, *Boston Bohemia, 1881–1900* (Amherst: University of Massachusetts Press, 1995), pp. 345–48, 355–61.

36. *The Book Buyer*, 12 (1895), p. 716.

37. Reed's work succeeding Beardsley at *The Yellow Book* was greeted in one review as a "passage from strong drink to tea" (see "The Decadent's Progress, The Yellow Book, A Quarterly," *The Chap Book* 6 [March 15, 1897], p. 370), although other critics were much less caustic. See Smith, "Ethel Reed: The Girl in the Poster," pp. 99–111.

38. "The Work of Miss Ethel Reed," *The International Studio* 1 (June 1897), p. 236; S. C. de Soissons, "Ethel Reed and Her Art," *The Poster* 5 (November 1898), pp. 199, 202.

39. See the discussion in Mary Warner Blanchard, *Oscar Wilde's America: Counterculture in the Gilded Age* (New Haven: Yale University Press, 1998), pp. 33–34.

40. William Dean Howells, *The Coast of Bohemia* (New York: Harper and Brothers, 1893), p. 30.

41. E. A. Randall, "The Artistic Impulse in Man and Woman," *The Arena* 24 (October 1900), p. 420.

42. Knowlton, *Art-Life of William Morris Hunt*, p. 99, quoted in Kathleen D. McCarthy, *Women's Culture, American Philanthropy and Art, 1830–1930* (Chicago: University of Chicago Press, 1991), p. 87.

43. *Philadelphia Press*, 1895, quoted in Burns, *Inventing the Modern Artist*, p. 99. Burns provides a fascinating discussion of the emphasis upon masculinity in the art world in the 1890s; see also Swinth, "Painting Professionals," pp. 263–79.

44. Emily Sartain, *The Pioneer in Industrial Art Education* (Philadelphia: Art Club of Philadelphia, 1890), n.p. See also the discussion in Swinth, "Painting Professionals," pp. 11–15.

45. Anne Whitney, quoted in Jeanne Madeline Weimann, *The Fair Women* (Chicago: Academy, 1981), p. 285.

46. Maria Oakey Dewing to Royal Cortissoz, February 20, 1921, Royal Cortissoz Papers, The Beinecke Rare Book and Manuscript Library, Yale University, quoted in Yount, "'Give the People What They Want,'" p. 158.

Studying Art Abroad

1. Ellen Day Hale to Miss Curtis, May 14, 1887, Hale Papers, SSC; Lyman H. Weeks, "Pictures by Women Painters," *Boston Post*, February 3, 1888, p. 8; Greta [pseud.], "Art in Boston," *The Art Amateur* 16 (January 1887), p. 28.

2. Whitman, "William Morris Hunt," p. 396. Boott and Anna Dixwell would later also enroll at the Académie Julian.

3. See Jo Ann Wein, "The Parisian Training of American Women Artists," *Woman's Art Journal* 2 (Spring/Summer 1981), pp. 41–44; see also "The American Art Student at the Beaux-Arts," *The Century Illustrated Monthly Magazine* 23

(November 1881), pp. 259–72, which noted that the Latin Quarter had "extended to the girl students, who once gave no small scandal here by trying to ignore the difference in manners and customs between Paris and Poughkeepsie. They thought that what a blameless Una might do there, she surely might do here, and so they sometimes went into the studios among the men,—French in the main, be it understood,—with very disagreeable results The Daisy Millers of our time have learned that, if you want to live in Europe with comfort, you had better conform in some respects to European ways," (pp. 259–60).

4. Nieriker, *Studying Art Abroad*, pp. 6–7.

5. A. Rhodes, "Views Abroad," *The Galaxy* 16 (1873), p. 13.

6. M. Riccardo Nobili, "The Académie Julian," *Cosmopolitan Magazine* 8 (November 1889), p. 751; Ellen Hale to her family, November 7, 1881, Hale Papers, SSC; Ellen Day Hale to Miss Curtis, May 14, 1887, Hale Papers, SSC.

7. Rodolphe Julian, in "Julian's Studios, An Interview with Their Creator," *The Sketch* (June 1893), quoted in Catherine Fehrer, "Women at the Académie Julian in Paris," *The Burlington Magazine* 136 (November 1994), p. 754. For further information on the Académie Julian and the opportunities it offered to women, see also Gabriel Weisberg and Jane R. Becker, eds., *Overcoming All Obstacles: The Women of the Académie Julian* (New York: Dahesh Museum, 1999).

8. Ellen Hale to her family, November 24, 1881, Hale Papers, SSC. In May 1902, Ellen Day Hale attended the student art show at the Museum of Fine Arts and saw there a figural composition by her future sister-in-law Lilian Westcott. Philip Hale reported Ellen's comments to Lilian: "[she said] it looked like a Manet—and we think that's about the highest praise,"(Philip Hale to Lilian Westcott, June 7, 1902, Hale Papers, SSC).

9. While Carlsson-Bredberg is said to have worked at Julian's in 1888, her drawing is clearly inscribed "concours de 11 decembre 1885." See Weisberg and Becker, eds., *Overcoming All Obstacles*, pp. 33–36.

10. Greta, "Art in Boston," *The Art Amateur* 16 (January 1887), p. 28. It is not clear where in Boston this exhibition took place. The reviewer describes three pictures, the self-portrait, "a sturdy old man in shirtsleeves," and a landscape

(perhaps more than one). In 1886, Hale showed three pictures fitting that description in the Spring Exhibition at the St. Botolph Club (nos. 37–39), but the gap between exhibition and critique seems much too long. Tracy Schpero concludes that Hale's exhibition took place at the Museum of Fine Arts, but this cannot be confirmed (Tracy Schpero, "American Impressionist Ellen Day Hale," Master's thesis, George Washington University, 1994, p. 37).

11. Nancy Hale, *The Life in the Studio* (Boston: Little, Brown, and Company, 1969), p. 105.

12. H. Winthrop Peirce, *The History of the School of the Museum of Fine Arts* (Boston: Museum of Fine Arts, 1930), p. 105; Hale, *The Life in the Studio*, p. 114.

13. Ellen Hale to her family, March 16, 1882, Hale Papers, SSC.

14. Greta [pseud.], "Boston Art and Artists," *The Art Amateur* 17 (October 1887), p. 93. See also William H. Gerdts, *Monet's Giverny: An Impressionist Colony* (New York: Abbeville Press, 1993) for a complete overview of Americans at Giverny.

15. Alice James to Sara Sedgwick, 1874, quoted in Betha LeAnne Whitlow, "Lilla Cabot Perry and Lilian Westcott Hale: Women Artists in the Boston School," M.A. thesis, Washington University, 1995, p. 28; Grace Dodge et al., *What Women Can Earn: Occupations of Women and Their Compensation* (New York: Frederick A. Stokes, Company, 1899), pp. 218–21. For Perry, see also Meredith Martindale, *Lilla Cabot Perry: An American Impressionist* (Washington, D.C.: National Museum of Women in the Arts, 1990).

16. Lilla Perry to Bernard Berenson, August 23, 1929; unidentified clipping, 1891; both quoted in Martindale, *Lilla Cabot Perry*, pp. 25, 84.

17. Many of these issues have been discussed in detail in a number of books and articles by such scholars as Tamar Garb and Norma Broude.

18. Quoted in Gerdts, *Monet's Giverny*, p. 122.

19. Hale, *The Life in the Studio*, pp. 105, 111–12.

20. Emily Sartain to John Sartain, May 8, 1873, quoted in Swinth, "Painting Professionals," p. 120.

21. Bartol, "Some Women Artists of Massachusetts."

New Opportunities in Boston

1. Diana Korzenik has worked extensively on the history of the school and my synopsis is indebted to her work. See Diana Korzenik, *Drawn to Art: A Nineteenth-Century American Dream* (Hanover: University Press of New England, 1985); and her "Art Education of Working Women," in Alicia Faxon and Sylvia Moore, *Pilgrims and Pioneers: New England Women in the Arts* (New York: Midmarch Arts Press, 1987), pp. 33–41; see also *Historical Sketches of the Massachusetts Normal Art School Alumni Association and of The Massachusetts Normal Art School* (Boston, 1898) and Arthur D. Efland, *A History of Art Education* (New York: Teachers College Press, 1990).

2. Obituary, *Boston Globe*, January 13, 1972, p. 35.

3. Dennis Bunker to Joe Evans, October 3 and November 24–25, 1885, Dennis Miller Bunker Papers, 1882–1943, Archives of American Art, Smithsonian Institution, Washington, D.C.

4. "Notes from the Arts Schools," *The Art Amateur* (January 1893), p. 69.

5. Thomas John Lucas, "Art Life in Belgium," *Portfolio* 10 (1879), p. 179, quoted in Marc Simpson, "Reconstructing the Golden Age: American Artists in Broadway, Worcestershire, 1885 to 1889," Ph.D. dissertation, Yale University, 1993, p. 94; for the Museum School, see also H. Winthrop Peirce, *The History of the School of the Museum of Fine Arts*, and the annual reports of the school.

6. Peirce, *The History of the School of the Museum of Fine Arts*, pp. 12, 29–30, 35, 37.

7. The first manager of the school was Sarah Morton. She was succeeded in 1891 by Elizabeth Lombard, who held the post for ten years (*School of Drawing and Painting at the Museum of Fine Arts Twenty-fifth Annual Report* [Boston, 1901], p. 12). *Boston Traveller*, September 3, 1889, clipping from the Scrapbook Collection, School of the Museum of Fine Arts, Boston, hereafter cited as SMFA scrapbooks.

8. Peirce, *The History of the School of the Museum of Fine Arts*, pp. 30–31; Marian Lawrence Peabody, *To Be Young Was Very Heaven* (Boston: Houghton Mifflin Company, 1967), p. 73.

9. The Boston Art Club dissolved in 1950; the Copley Society remains active. For the Copley Society, see H. Winthrop Peirce, *Early Days of the*

Copley Society (Boston: Rockwell and Churchill Press, 1903) and the organization's annual reports.

10. "Woman's Work," *Boston Standard*, April 25, 1895, SMFA scrapbooks. In 1889, the Longfellow Traveling Fellowship had been established to send "a young man to Europe every three years for three years' study," (*School of the Museum of Fine Arts, Twenty-fifth Annual Report*, 1901, p. 13). Paige left the museum $30,000 with the stipulation that an additional $10,000 be raised within five years; he specified that the prize was to benefit both sexes (*School of the Museum of Fine Arts, Twenty-second Annual Report*, 1898, p. 9). Sarah Sears was one of twenty-five individual contributors of the additional funds; the Women's Educational and Industrial Union also donated $1,450 (*School of the Museum of Fine Arts, Twenty-third Annual Report*, 1899, pp. 8–9).

11. *School of the Museum of Fine Arts, Thirtieth Annual Report*, 1906, p. 9.

12. The School also sponsored a self-supporting organization called the Stuart Club, founded in 1907, which provided communal living arrangements for women students. The Club constructed a home, designed by architect C. Howard Walker, with a dining hall, library, two parlors, and accommodations for fifty women on the Fenway in 1910 (SMFA scrapbooks).

13. "Women Coy of Art Club Move to Woo Them," unidentified clipping, Vose Galleries Artist Files, quoted in Nancy Allyn Jarzombek, *"A Taste for High Art": Boston and the Boston Art Club, 1855–1950* (Boston: Vose Galleries, 2000). I would like to thank Nancy Jarzombek for sharing her prepublication manuscript with me.

14. For the St. Botolph Club, see Doris A. Birmingham, "Boston's St. Botolph Club: Home of the Impressionists," *Archives of American Art Journal* 31 (1991), pp. 26–34; and the Club's own pamphlet, "The Golden Years, St. Botolph Club Exhibitions 1881–1921" (2000).

15. F. W. Coburn, "Feminine Artists of the City Are Making a Brave Display," *Boston Sunday Herald*, May 6, 1917. When asked to join the Woman's Professional Club, an interdisciplinary association, Marie Danforth Page remarked, "I have always maintained that women should not encourage a separate point of view toward their professional work," and declined to enroll. See Chesterton, "A Cultural History of Professional Women Artists," p. 358–59.

16. For political and historical context, see Sarah Deutsch, *Women and the City: Gender, Space, and Power in Boston, 1870–1940* (New York: Oxford University Press, 2000); and Jack Tager and John W. Ifkovic, eds., *Massachusetts in the Gilded Age: Selected Essays* (Amherst: University of Massachusetts Press, 1985).

17. "Woman's Work," *Boston Standard*, April 25, 1895, SMFA scrapbooks.

18. M. J. Curl, "Boston Artists and Sculptors in Intimate Talks, XI, Marie Danforth Page," *Boston Evening Transcript*, undated clipping (1920–21), Marie Danforth Page Papers, Archives of American Art. See also Martha J. Hoppin, *Marie Danforth Page: Back Bay Portraitist* (Springfield, Mass.: George Walter Vincent Smith Art Museum, 1979).

The Boston School

1. Samuel Isham, *The History of American Painting*, 1905 (New York, Macmillan Company, 1942), p. 475; Charles H. Caffin, "The Art of Frank W. Benson," *Harper's Monthly Magazine* 119 (June 1909), p. 105. The best examination of the Boston School is Trevor J. Fairbrother et al., *The Bostonians: Painters of an Elegant Age* (Boston: Museum of Fine Arts, 1986).

2. Guy Pène du Bois, "The Boston Group of Painters," *Arts and Decoration* 5 (October 1915), p. 460; Bernice Kramer Leader, "Antifeminism in the Paintings of the Boston School," *Arts* 56 (January 1982), p. 113. The general sentiments of both Pène du Bois and Leader appear repeatedly in the works of numerous other writers and are used here to characterize much more widely held viewpoints.

3. "An Art Anniversary," *Boston Herald*, April 1901, SMFA scrapbooks.

4. Hale, *The Life in the Studio*, p. 25.

5. See Leader, "Antifeminism," and Bailey van Hook, *Angels of Art: Women and Art in American Society, 1876–1914* (University Park: Pennsylvania State University Press, 1996). Tarbell's *Three Sisters* (1890) is in the collection of the Milwaukee Art Museum; his *Reverie* (1913) and Paxton's *New Necklace* (1910) are in the collection of the Museum of Fine Arts, Boston. Tarbell's *The Dreamer* (1903) is in a private collection, and his *Rehearsal in the Studio* (about 1904) is in the Worcester Art Museum.

6. Lincoln Kirstein to Trevor Fairbrother, December 21, 1985, quoted in Fairbrother, *The Bostonians*, p. 92.

7. M. J. Curl, "Boston Artists and Sculptors Talk of Their Work and Their Ideals, III, William M. Paxton," *Boston Evening Transcript*, December 26, 1921.

8. Anthony J. Philpott, "Memorial Exhibition by Marie Danforth Page at Guild," *Boston Globe*, December 11, 1940; Hale, *The Life in the Studio*, p. 27; F. W. Coburn, "Boston Sees Cubist Show," *Boston Herald*, April 28, 1913, p. 1.

9. Author in conversation with Nancy Hale Bowers, June 9, 1988 and July 20, 1988.

10. Duncan Phillips, *A Collection in the Making* (Washington, D.C.: Phillips Memorial Gallery, 1926), pp. 6–8.

11. Edmund Tarbell to Lilian Hale, January 24, 1908, Hale Papers, SSC; Edmund Tarbell to Gretchen Rogers, quoted in Robert F. Brown, "New England," *Archives of American Art Journal* 34 (1994), p. 37; Tarbell on Rogers, quoted by her cousin in an undated letter, photocopy, curatorial files, Museum of Fine Arts, Boston.

Balancing Acts

1. Lilian Westcott to Harriet Westcott, n.d. (about 1897–98); Adelaide Cole to Harriet Randolph Hyatt, n.d. (spring 1892), Thomas J. Watson Library, Metropolitan Museum of Art, New York.

2. Eleanor Hoyt, "Women are Made Like That," *Harper's Monthly Magazine* 103 (November 1901), p. 860.

3. Ticknor's article regretfully concludes, "Hail the new woman,—behold she comes apace! Woman, once man's superior, now his equal!" Caroline Ticknor, "The Steel-Engraving Lady and the Gibson Girl," *Atlantic Monthly* 88 (July 1901), p. 106, 108; see also the discussion in Ellen Wiley Todd, *The "New Woman" Revised* (Berkeley: University of California Press, 1993), pp. 1–38.

4. Elizabeth Shaw Oliver, "Boston Art School," unidentified clipping, April 1895, SMFA scrapbooks.

5. J. E. C., "Women's Sphere in Art," *The Limner* 1 (March 1895), p. 8; Louise Cox, "Should Woman Artists Marry," *The Limner* 1 (May 1895), pp. 6–7; Anna Westcott to Lilian Westcott, October 17, 1901; Philip Hale to Lilian Westcott, October 27, 1901; Hale Papers, SSC.

6. Anna Lea Merritt, "A Letter to Artists: Especially Women Artists," *Lippincott's Monthly Magazine* 65 (March 1900), p. 467.

7. Lilian Hale to Emily Perkins Hale, March 26, 1913, Hale Papers, SSC.

8. Sadakichi Hartmann [writing as Sydney Allen], "Children as They Are Pictured," *Cosmopolitan* 43 (July 1907), p. 235. See the discussion of these issues in Naomi Rosenblum, *A History of Women Photographers* (New York: Abbeville Press, 1994), pp. 82–84.

9. Maxine McBride, "Two Artists—Also Mothers—Exhibit Their Canvases," *New York Sun*, January 10, 1927.

10. Mary Holland Kinkaid, "The Feminine Charms of the Woman Militant: The Personal Attractiveness and Housewifely Attainments of the Leaders of the Equal Suffrage Movement," *Good Housekeeping* 54 (February 1912), pp. 147, 148. This subject is discussed in detail in Martha Banta, *Imaging American Women: Idea and Ideals in Cultural History* (New York: Columbia University Press, 1987), pp. 45–91; see also Lisa Tickner, *The Spectacle of Women: Imagery of the Suffrage Campaign, 1907–1914* (Chicago: University of Chicago Press, 1988) and Elisabeth Israels Perry, "Introduction," in Alice Sheppard, *Cartooning for Suffrage* (Albuquerque: University of New Mexico Press, 1994), pp. 9–12.

11. Hale, *The Life in the Studio*, p. 92.

12. Unidentified newspaper clipping, March 2, 1930, curatorial files, Museum of Fine Arts, Boston.

13. *Boston Evening Transcript*, May 16, 1907, SMFA scrapbooks.

14. "H. Dudley Murphy et uxor," unidentified clipping, 1934, Artists' Files, Fine Arts Reference Department, Boston Public Library.

15. Hale, *The Life in the Studio*, p. 13.

16. George Walter Dawson to Gertrude Hanna, 1932, Hale Family Papers, Archives of American Art, Smithsonian Institution, Washington, D.C. For a discussion of antimodernism and women artists, see Whitlow, "Lilla Cabot Perry and Lilian Westcott Hale."

17. Lisa Tickner, *The Spectacle of Women*, pp. 13–15; Kate Stephens, "The New England Woman," *Atlantic Monthly* 88 (July 1901), p. 64.

18. "Marion Boyd Allen and Her Mountains," unidentified clipping, March 14, 1931, curatorial files, Museum of Fine Arts, Boston; "A Boston Painter in the Canadian Rockies," *Boston Evening Transcript*, September 23, 1931. Marion Boyd Allen's maiden name was also Allen.

19. M. J. Curl, "Boston Artists and Sculptors Talk of Their Work and Ideals, XXV, Marion Boyd Allen," *Boston Evening Transcript*, May 29, 1921. Allen painted a second portrait of Anna Hyatt Huntington in 1929–30, in which the sculptor is shown in a relaxed pose with a large mallet in her hand (Hispanic Society of America, New York).

"Thumping Wet Clay"

1. "F. W. Coburn, "Thumping Wet Clay Fascinates the Women," *Boston Herald*, October 3, 1915, SMFA scrapbooks; see also Catlin C. Rockman, "Breaking Ground: Art Education in Boston and Institutional Training for Women Sculptors, 1870–1920," Seminar Paper, 1997, curatorial files, Museum of Fine Arts, Boston.

2. Whitney modeled her busts in clay, then cast them in plaster and sent them to Italy to be carved in marble. The Stowe bust is in the collection of the Stowe-Day house in Hartford, Conn.; *Lucy Stone* belongs to the Boston Public Library; the plaster version of *Mary Livermore* is owned by the Melrose, Mass., Public Library and the marble is held privately.

3. Frances E. Willard, "Extempore Address Before the Federation of Women's Clubs, Chicago," *The Union Signal* (May 19, 1892), p. 4. I am grateful to William Beatty, archivist of the Frances E. Willard Memorial Library in Evanston, Ill., for providing me with this information.

4. Tufts, "An American Victorian Dilemma, 1875," pp. 55–56.

5. The incident concerning Kitson is recounted in Rubinstein, *American Women Sculptors*, p. 163; A. Hyatt Mayor, *A Century of American Sculpture: Treasures from Brookgreen Gardens* (New York: Abbeville Press, [1981]), p. 25.

6. "Woman Sculptor and Bison in the Bronx Zoo Exchange Confidences," *New York Times*, December 31, 1905, section 3, p. 6.

7. For these issues, see Michelle H. Bogart, "American Garden Sculpture: A New Perspective," *Fauns and Fountains: American Garden Statuary, 1880–1930* (Southampton, N.Y.: The Parrish Art Museum, 1985).

8. Kineton Parkes, "An American Sculptress of Animals, Anna Hyatt Huntington," *Apollo* 16 (August 1932), p. 66. For the details of Hyatt's marriage to Huntington, see Mayor, pp. 23–24 and Katharine Lane Weems, *Odds Were Against Me* (New York: Vantage Press, 1985), pp. 53–54.

9. Katharine Lane Weems, "Anna Hyatt Huntington," *National Sculpture Review* 22 (Winter 1973–74), pp. 8–9.

10. Weems, *Odds Were Against Me*, pp. 22, 42.

11. Weems, *Odds Were Against Me*, pp. 72–73; 120–28, 130.

12. Katharine Lane Weems, diary entry, February 10, 1950, quoted in Louise Todd Ambler, *Katharine Lane Weems* (Boston: Boston Athenaeum, 1987), p. 73.

13. Katharine Lane Weems, diary entry, August 31, 1957, quoted in Ambler, *Katharine Lane Weems*, p. 81.

14. Interview, Jan Seidler Ramirez and Katharine Lane Weems, January 13, 1982, recounted in Greenthal et al., *American Figurative Sculpture in the Museum of Fine Arts, Boston*, p. 463; "Boston Sculptress Is Gaining Renown at Home and Abroad," *Boston Evening Transcript*, May 8, 1926, SMFA scrapbooks. When Weems cast *Striding Amazon* in bronze, she changed a rock in the figure's hand to a lump of clay. I am grateful to Rebecca Reynolds for her assistance with sculpture.

15. Rodin is quoted in Benjamin Brawley, "Meta Warrick Fuller," *The Southern Workman* 47 (January 1918), p. 26; and also in variant forms in Tritobia Hayes Benjamin, *Three Generations of African American Women Sculptors: A Study in Paradox* (Philadelphia: The Afro-American Historical and Cultural Museum, 1996), p. 21 and Harriet Forte Kennedy, "Meta Vaux Warrick Fuller," in *An Independent Woman: The Life and Art of Meta Warrick Fuller* (Framingham, Mass.: Danforth Museum of Art, 1985), p. 7.

16. Elizabeth Dunbar to Meta Fuller, May 9, 1909, quoted in Judith Nina Kerr, "God-Given Work: The Life and Times of Sculptor Meta Vaux Warrick Fuller, 1877–1968," Ph.D. dissertation, University of Massachusetts, 1986, p. 193.

17. The Framingham *Evening News* is excerpted in "Along the Color Line: Music and Art," *The Crisis* 8 (July 1914), p. 111.

18. Meta Fuller to Freeman Murray, January 31, 1916, quoted in Kerr, "God-Given Work," p. 243.

19. *Boston Sunday Herald*, October 8, 1922, section C, p. 5.

20. Quoted from a 1916 statement in Rubinstein, *American Women Sculptors*, p. 202.

21. Meta Fuller to Mrs. W. P. Heddon, October 5, 1921 quoted in Kerr, "God-Given Work," p. 263; see also Benjamin, *Three Generations*, p. 20.

22. Kennedy, "Meta Vaux Warrick Fuller," pp. 9–10; Kerr, "God-Given Work," pp. 268–75.

23. Quoted in Kerr, "God-Given Work," p. 330.

24. M. J. Curl, "Boston Artists and Sculptors Talk of Their Work and Ideals, IX, Bashka Paeff," *Boston Evening Transcript*, February 6, 1921; "Finds Sculpture Veering from Modernism," *The Art Digest* 6 (June 1, 1932), p. 6.

Modern Women, Modern Art

1. Anthony Philpott, "Lois Jones Exhibits Paintings in Boston," *Boston Globe*, undated clipping [1939], SMFA scrapbooks.

2. Records of the Museum of Fine Arts, Boston; Jones, quoted in Tritobia Benjamin, *The World of Loïs Mailou Jones* (Washington, D.C.: Meridian House International, 1990), pp. 2, 3.

3. Dorothy Adlow, "Young New England Paintings," *Magazine of Art* 31 (May 1938), p. 293.

4. "Museum School Faculty Changes," unidentified clipping, probably March 1931, SMFA scrapbooks; A. J. Philpott, "Art School Stirred by Appointments," *Boston Globe*, March 10, 1931. Tarbell taught at the MFA School from 1889–1913, and served as director from 1928–1931. Benson taught from 1889–1917, and also served as director from 1928–1931. Hale taught from 1893–1931. During Tarbell's absence from the school (and until 1931), painting classes were led by his pupil and follower, Frederick Bosley.

5. Margaret Richardson to George Harold Edgell, September 23, 1935, Archives, Museum of Fine Arts, Boston.

6. Margaret F. Richardson, "The Emancipation of Vision," *Brush and Pencil* 7 (February 1906), pp. 62–67; Philip Hale, "Exhibition of Portraits at the Copley Gallery," *Boston Evening Transcript*, November 2, 1909, SMFA scrapbooks.

7. Lawrence Levine, *Highbrow/Lowbrow: The Emergence of Cultural Hierarchy in America* (Cambridge, Mass.: Harvard University Press, 1988), p. 231.

8. William Howe Downes, "Work of Miss Richardson," unidentified clipping, March 15, 1921, SMFA scrapbooks.

9. "Disreputable Remarks by Charles H. Woodbury," unpublished manuscript compiled by Elizabeth Ward Perkins, Woodbury Papers, Boston Public Library.

10. "A Trio of Women Painters," unidentified clipping, April 11, 1914, SMFA scrapbooks.

11. *Providence Sunday Journal*, December 11, 1898, quoted in Nancy Allyn Jarzombek, *Mary Bradish Titcomb and Her Contemporaries* (Boston: Vose Galleries, Inc., 1998), p. 8.

12. William Howe Downes, "Miss Fiske's Pictures," unidentified clipping, December 14, 1920, SMFA scrapbooks.

13. "Gertrude Fiske Appointed to State Art Commission," unidentified clipping (possibly *Boston Globe*), January 9, 1930, SMFA scrapbooks. See the discussion of such issues in other cities in Chesterton, "A Cultural History of Professional Women Artists," pp. 308–28.

14. McKinstry was a 1900 graduate of the Boston Normal School of Gymnastics (founded in 1889 to teach women to be physical educators); quoted in Martha H. Verbrugge, *Able-Bodied Womanhood: Personal Health and Social Change in Nineteenth-Century Boston* (New York: Oxford University Press, 1988), p. 187. The Boston Normal School of Gymnastics, founded by Mary Hemenway, merged with Wellesley College in 1909.

15. Caroline Hazard, *Some Ideals in the Education of Women* (New York: Thomas Y. Crowell and Co., 1900), pp. 6–7, 15. See also Smith-Rosenberg, *Disorderly Conduct*, pp. 245–65.

16. "Letter to the Editor," unidentified clipping, February 22, 1920, quoted in Anne W. Schmoll, *Charles Hopkinson, N.A., Moods and Moments* (Boston, Vose Galleries, 1991), pp. 10–11. See also Leah Lipton, "The Boston Five," *American Art Review* 6 (August/September 1994), pp. 132–39, 157, 159.

17. Harley Perkins, excerpted in "Boston Has a Very Superior Sort of Independent Show," *The Art Digest* 1 (February 15, 1927), p. 7.

18. Harley Perkins, "Independent Artists Now Hang High on Beacon Hill," *Boston Evening Transcript*, January 15, 1927, p. 10. See the discussion of these events in Honor Moore, *The White Blackbird* (New York: Viking, 1996), pp. 162–67.

19. *Boston Evening Transcript*, January 14, 1928, quoted in Lipton, "The Boston Five," p. 138; Harley Perkins, "Boston Notes," *The Arts* 9 (April 1926), p. 211. The scrapbook of the Society is held by the Boston Public Library.

20. See, for example, Elisabeth Sussman et al., *Dissent: The Issue of Modern Art in Boston* (Boston: Institute of Contemporary Art, 1985) and Edith A. Tonelli, "The Avant-Garde in Boston: The Experiment of the WPA Federal Art Project," *Archives of American Art Journal* 20 (1980), pp. 18–24.

21. Fenno-Gendrot, p. 43, quoted in Chesterton, "A Cultural History of Professional Women Artists," p. 316.

22. "Sane Boston," *Time Magazine* 35 (June 3, 1940), p. 43. For the Society for Sanity in Art, see "Sanity in Art," *The Art Digest* 10 (April 1, 1936), p. 12; "Josephine Logan, Militant Leader of the Right, Presents 'Sane' Art," *The Art Digest* 13 (October 1, 1938), p. 7; "Sanity Defined," *The Art Digest* 15 (October 15, 1940), p. 13; "Sanity in Art Jurors," *The Art Digest* 16 (November 15, 1941), p. 16.

23. Mrs. Barbee-Babson, "Fair Devotees to Art in Boston's '400'," *Sunday Herald*, May 31, 1914, SMFA scrapbooks.

24. Quoted in Moore, *The White Blackbird*, p. 54. All the information about Sargent presented here is drawn from Moore's fascinating biography.

25. Harley Perkins, *Boston Evening Transcript*, December 10, 1927, p. 10, quoted in Moore, *The White Blackbird*, p. 163.

26. G.K., *Boston Evening Transcript*, February 12, 1930, quoted in Moore, *The White Blackbird*, pp. 200–01.

27. Alfred Franz Coburn, "Margarett Sargent's Paintings," *Boston Evening Transcript*, March 26, 1932; Margarett Sargent to Honor Moore, 1975, both quoted in Moore, *The White Blackbird*, pp. 216, 247.

28. "Honor to Hub Girl Painter," *Boston Post*, March 14, 1929, SMFA scrapbooks.

29. The painting (private collection) was first displayed in 1929 with the title *The Book of Dreams*. I am grateful to Wendy Swanton for allowing me access to her unpublished chronology of Thayer's career, and to both Ms. Swanton and Polly Thayer for their gracious assistance.

30. Hazel Canning, "Paintings of Miss Ethel Thayer Win Honors at Wildenstein Galleries, New York," *Boston Herald*, February 14, 1932, SMFA scrapbooks; "Ethel Thayer, Artist, First Longed for Stage," unidentified clipping (New York newspaper), 1932, curatorial files, Museum of Fine Arts, Boston.

31. Hale's remarks were recalled by Thayer in a conversation with the author on October 4, 2000.

32. Earl S. Johnston, "Lauds Exhibit of Two Artists Here," *Harrisburg* [Penn.] *Patriot*, December 9, 1936; Dorothy Adlow, "At Grace Horne Galleries," unidentified clipping, January 30, 1940; both curatorial files, Museum of Fine Arts, Boston.

33. Dorothy Adlow, "Young New England Paintings," *Magazine of Art* 31 (May 1938), p. 293.

34. *Boston Sunday Post*, April 27, 1930, SMFA scrapbooks.

ARTISTS' BIOGRAPHIES

AUTHORS

JLC Janet L. Comey
EER Ellen E. Roberts

NOTE TO THE READER:

Artists' studios, including those in the home, are given where known.

Many of the women included here studied at the School of the Museum of Fine Arts, Boston (referred to here as MFA School, and still in operation today). The leading instructors were Edmund C. Tarbell, who taught painting from 1889 to 1913 and from 1928 to 1931; Frank W. Benson, who taught from 1889 to 1917 and from 1928 to 1931; Philip Hale, who taught from 1893 to 1901 and from 1902 to 1931; and William Paxton, who taught from 1906 to 1913. Only their last names are given in these biographies.

The Massachusetts Normal Art School is referred to as Mass. Normal School. The school exists today as the Massachusetts College of Art.

Selected references are listed for each artist. Extensive use has been made of the following sources, for which shortened references appear:

Falk
Falk, Peter Hastings, Editor in Chief. *Who Was Who in American Art, 1564–1975*. Madison, Conn.: Sound View Press, 1999.

Greenthal
Greenthal, Kathryn, Paula M. Kozol, and Jan Seidler Ramirez. *American Figurative Sculpture in the Museum of Fine Arts*. Boston: Museum of Fine Arts, 1986.

Heller
Heller, Jules and Nancy G. Heller. *North American Women Artists of the Twentieth Century: A Biographical Dictionary*. New York and London: Garland Publishing, Inc., 1995.

Hirshler
Hirshler, Erica E. "Artists' Biographies," in Trevor J. Fairbrother, et al. *The Bostonians: Painters of an Elegant Age, 1870–1930*. Boston: Museum of Fine Arts, 1986.

Hoppin
Hoppin, Martha J. "Women Artists in Boston, 1870–1900: The Pupils of William Morris Hunt." *The American Art Journal*. 13 (Winter 1981), pp. 17–46.

Kaplan
Kaplan, Wendy. *"The Art That Is Life": The Arts & Crafts Movement in America, 1875–1920*. Boston: Museum of Fine Arts, 1987.

Meyer
Meyer, Marilee Boyd, ed. *Inspiring Reform: Boston's Arts and Crafts Movement*. New York: Harry N. Abrams, Inc., 1997.

Rubinstein
Rubinstein, Charlotte Streifer. *American Women Sculptors*. Boston: G. K. Hall & Co., 1990.

SMFA Scrapbooks
Scrapbook Collection of the School of the Museum of Fine Arts, Boston.

Tufts
Tufts, Eleanor. *American Women Artists, 1830–1930*. Washington, D.C.: International Exhibitions Foundation for the National Museum of Women in the Arts, 1987.

Ulehla
Ulehla, Karen Evans, ed. *The Society of Arts and Crafts, Boston Exhibition Record*. Boston: Boston Public Library, 1981.

MARION BOYD ALLEN

Born 1862, Boston; died 1941, Boston

Painter of portraits, figures, and landscapes. As a young girl Allen was taken to Europe by her parents, where she sketched the Alps and decided to become a painter. Care for her invalid mother intervened, and in consequence, her formal art education did not begin until she entered the MFA School in December 1902 at the age of forty. She won prizes in her early classes and studied painting with both Benson and Tarbell. In 1905, she married William Augustus Allen, who died in 1911; she received her diploma in May 1909.

Allen's solo show of portraits and figure studies at the Copley Gallery in 1910 was the first in a series of successful solo and group exhibitions in Boston and New York, which continued until 1936. She displayed her work at the Paris Salon (1914), the Panama-Pacific International Exposition in San Francisco (1915), the National Academy of Design, and in other prestigious exhibitions. She won several prizes, including the Hudson prize from the Connecticut Academy of Fine Arts and a medal from the French Institute in the United States, both in 1920. Her life-size portrait of Anna Vaughn

Hyatt (pl. 59) was awarded the People's Prize as the most popular picture at the Newport Art Association in 1919. Her half-length figure study *A Girl of the Orient* was displayed on the cover of *The Literary Digest* on March 8, 1924. Allen's figure studies display a softness and grace that in one case prompted a young man to reacquaint himself with the model, whom he had once known, and marry her.

In her sixties, perhaps inspired by her brother Willis Boyd Allen, author of *The Mountaineers*, Allen began to travel and camp in the West annually, producing a series of decorative landscapes of the northwestern United States and the Canadian Rockies (fig. 61). She also spent ten summers painting desert landscapes in the Southwest, where she made portraits of Native Americans, which she exhibited in frames carved by indigenous craftsmen.

Residences: 477 Commonwealth Avenue, Boston [1905–14]; 60 The Fenway, Boston [1941].

Studios: Commonwealth Avenue [1912]; 561 Boylston Street, Boston [1913–15]; 303 Fenway Studios [1920–37].

Member: Copley Society; Connecticut Academy of Fine Arts; National Association of Women Painters and Sculptors; New Haven Paint and Clay Club; Boston Art Club; National Art Club, New York; Pen and Brush Club, New York; Buffalo Society of Artists.

References:
SMFA Scrapbooks.
Tufts, cat. 21.
Ellen M. Schall, et al., *American Art: American Vision* (Lynchburg, Va.: Maier Museum of Art, 1990), p. 46.
Hirshler, p. 198.

JLC

ALICE AUSTIN

Born after 1859, Maine; died 1933, Boston

Photographer and sculptor. Early in her life, Austin's family moved from Maine to Minnesota where her father, Horace Austin, later became governor in the 1870s. Austin studied painting at the Mass. Normal School, the MFA School, and the Pratt Institute in New York under Arthur Wesley Dow. After graduation she became the supervisor of drawing in the Brooklyn public schools. She soon developed an interest in photography. In Brooklyn, she worked as a darkroom assistant for Gertrude Käsebier, who opened her eyes "to the possibilities of art in photography."

By 1900 Austin had moved to Boston, opened a studio, and was elected a Craftsman member of the Society of Arts and Crafts, Boston; she was promoted to Master in 1910. One of her portraits was exhibited at the Second Philadelphia Photographic Salon in 1899 and the following year at the Boston Camera Club. Seven of her prints were included in the famous exhibition of American women photographers that Frances Benjamin Johnston organized for display in St. Petersburg, Moscow, and Paris in 1900–01. She was also represented in the Chicago Salon in 1900 and at the Royal Photographic Society exhibition of the "New School of American Photography" in London, organized in 1901 by F. Holland Day. She exhibited four works in the 1907 exhibition and one portrait at the 1927 Tricennial Exhibition of the Society of Arts and Crafts in Boston. Austin primarily produced pictorialist portraits, although she also did landscapes. Her sitters included sculptor Cyrus Dallin, artist James A. S. Monks, as well as her father. She wrote that she endeavored to "obtain the personality of my sitter and at the same time turn out a photograph which may lay some Claim to Art."

In 1915, Austin, already widely known as a photographer, took sculpture classes at the Copley Society; the next year her *Mother and Child* was produced in bronze by the Gorham Company.

Residences: 360 Boylston St., Boston [1900]; 61 Anderson St., Boston [1913–14].

Studios: 360 Boylston St., Boston (in her home) [1900–01]; 364 Boylston St., Boston [1902–05]; 73 Newbury St., Boston [1906]; 246 Boylston St., Boston [1907–08]; 248 Boylston St., Boston [1908–10]; 296 Boylston St., Boston [1911–12]; 384 Boylston St., Boston [1913–22]; 99 Russell Avenue, Watertown, Mass. [1923]; 105 Charles St., Boston [1924]; 384A Boylston St., Boston [1925–27].

Member: Copley Society; Woman's City Club; Society of Arts and Crafts, Boston.

References:
Obituary, *New York Times*, February 4, 1933.
Ulehla, p. 22.
C. Jane Gover, *The Positive Image* (Albany: State University of New York Press, 1988).
Judith Fryer Davidov, *Women's Camera Work* (Durham: Duke University Press, 1998).
Laura Ilise Meister, *Missing from the Picture: Boston Women Photographers 1880–1920* (M.A. thesis, Tufts University, 1998).

JLC

ELIZABETH HOWARD BARTOL

Born 1842, Boston; died 1927, Boston

Painter of portraits, still lifes, and landscapes; sculptor, metalworker, and poster designer. A descendant of the prominent Swan family of Boston, Bartol was the only child of Cyrus Bartol, the Unitarian minister of West Church in Boston and a follower of Ralph Waldo Emerson, whose home was a meeting place for transcendental thinkers. After some early training with marine painter Stephen Salisbury Tuckerman and William Rimmer, she studied with William Morris Hunt. In 1875 she traveled to France, Italy, and England with Sarah Wyman Whitman, and worked with Thomas Couture at Villiers-le-Bel (1877). The strong contours, loose brushwork, and subordination of detail in Bartol's paintings reflect the teaching of Hunt and Couture.

Bartol exhibited portraits (including charcoals), still lifes, a landscape, and a terra cotta sculpture at the Boston Art Club between 1874 and 1886. She also showed her work in New York, exhibiting portraits at the National Academy of Design in 1876 and 1877, and *Mother and Child*, which a critic for the *Art Journal* described as among the best of the women's contributions, at the Society of American Artists in 1880. Samuel G. W. Benjamin also mentioned Bartol favorably in *Art in America* (1880) and *Our American Artists* (1881), and William Brownell, writing for *Scribner's Monthly* in 1881, especially admired her landscape painting. Along with fifteen other former Hunt students, she showed her work at Williams and Everett Gallery in 1888, and also exhibited at the St. Botolph Club in 1886 and 1894. After about 1895 she seems to have given up painting, although she did design a poster for the New England Hospital for Women and Children in 1896 (pl. 13) and was elected a Craftsman in metalwork at the Society of Arts and Crafts, Boston, where she exhibited in 1899. Apparently, frail health prevented her from working in her later years. She continued to support the arts financially and gave furniture, prints, and paintings to the Museum of Fine Arts, Boston.

Residences: 17 Chestnut St., Boston [1842–1927]; 60 Mt. Vernon St., Boston [1886]; Pigeon Cove, Rockport, Mass. [summers].

Studios: in her home in Boston.

Member: Boston Society of Arts and Crafts [Craftsman, 1899; Associate Member, 1912–27]; Guild of Boston Artists [Associate Member, 1914].

References:
Hoppin, pp. 311–33.
William Brownell, "The Younger Painters of America," *Scribner's Monthly* 22 (July 1881), pp. 329–31.
Ulehla, pp. 26, 241.
Letters of Sarah Wyman Whitman (Cambridge: Riverside Press, 1907).

JLC

ELIZABETH OTIS LYMAN BOOTT (DUVENECK)

Born 1846, Boston; died 1888, Paris, France

Painter of figure studies, floral still lifes, landscapes, and portraits in oil and watercolor. Born to a prominent Boston family, Boott was raised amid the Anglo-American community in Italy by her widowed father. Her background and education in languages, literature, music, and drawing prompted Henry James to describe her as "the infinitely civilized and sympathetic, the markedly produced Lizzie." Father and daughter returned to Boston in 1865, where Boott entered the William Morris Hunt class in 1869, forming life-long bonds with the other women students. She also studied with Thomas Couture for three summers (1876–78), sending a series of letters to her Hunt classmates detailing Couture's methods. The following summer she trained in Munich with Frank Duveneck and persuaded him to teach a class in Bellosguardo, Italy. Boott and two other women artists toured Spain in 1881, she then returned to Boston where she remained until 1885.

In Boston, Boott, in a flurry of activity, exhibited her work at the Pennsylvania Academy of the Fine Arts, the National Academy of Design, the Boston Art Club, the American Water Color Society, and the Society of American Artists. In 1883 she took a trip to Aiken, South Carolina, where she painted portraits of five African-American farmworkers. She exhibited with Anna Dixwell at J. Eastman Chase's Gallery (1882) and held a well-received solo show at Doll and Richards of sixty-six paintings (1884), which the critic for the *Boston Evening Transcript* praised for the remarkable "variety of subject," admiring especially her floral pieces and her abilities as a colorist.

Returning to Europe in 1885, Boott worked at the Académie Julian, where she painted from the nude model. In March 1886, Boott finally married Frank Duveneck, to whom she had been engaged on and off since 1881; their son was born in December 1886. Although constricted by the demands of motherhood, she

painted in watercolor and showed at the Salon in 1888. Tragically however, in March, she succumbed to pneumonia, ending the career of one of the most accomplished of Hunt's students.

Residences: Villa Castellani, Bellosguardo, Italy [1855+]; Rome, Italy [1872–73]; 47 Mt. Vernon St., Boston [1881–85]; 18 rue Tilsit, Paris, France [1886].

Studios: Palazzo Barberini, Rome, Italy [winter 1872–73]; Villa Castellani, Bellosguardo, Italy.

References:
"Art and Artists," *Boston Evening Transcript*, February 5, 1884, p. 3.
Hoppin, pp. 32–36.
Carol M. Osborne, "Lizzie Boott at Bellosguardo," *The Italian Presence in American Art, 1860–1920*, ed. Irma B. Jaffe (New York: Fordham University Press, 1992).
Carol Osborne, "The Picture Season at Villiers-le-Bel, 1876–78: Elizabeth Boott, Thomas Couture, and Henry James," *Apollo* 149 (May 1999), pp. 40–51.

JLC

MARGARET FITZHUGH BROWNE

Born 1884, West Roxbury, Mass.; died 1972, Beverly, Mass.

Best known for her portraits, Browne also painted genre scenes and floral still lifes. After graduating from the Boston Latin School in 1903, she attended the Mass. Normal School from 1904 to 1909, studying with Joseph DeCamp, Richard Andrew, and color theorist Albert H. Munsell. In 1911, she studied painting with Benson at the MFA School.

Browne's portraits were prized in the 1930s and 1940s for their life-like, natural qualities. Her subjects were often seated, animated by a characteristic accessory or distinctive dress. In 1927, Browne's career received a boost when she was commissioned by the New York Yacht Club to paint King Alphonso XIII of Spain. Henry Ford; golf champion Bobby Jones; legendary Gloucester fisherman Captain Howard Blackburn; and Arthur D. Little, pioneer in industrial research, were other prominent sitters.

From 1911 until the mid-1960s, Browne maintained a vigorous exhibition schedule, participating in numerous group shows and holding solo shows at many galleries, beginning in 1922 at Doll and Richards and continuing until 1957 at the Guild of Boston Artists. She won several prizes, including the Popular Prize from the North Shore Art Association in 1925, and in 1941, a Special Award from the Society for Sanity in Art, Chicago, a conservative group

founded in the 1930s to combat modernism in art. Browne's paintings are found in the collections of many educational institutions including the Massachusetts Institute of Technology, which owns thirteen of her portraits.

Browne also wrote *Portrait Painting*, a book in which she discussed her methods and philosophy. She taught art classes well into her eighties, and actively participated in several art associations. She was the art editor for the *Boston Evening Transcript* in the early 1920s, and contributed to *The Boston Traveller* as late as 1941. At her summer home in Annisquam, Massachusetts, Browne organized the annual wax works for nearly twenty-five years. She left numerous paintings to the village in memory of her patron, Henry Wise Wood.

Residences: 32 Peterboro St., Boston [1911]; 407 Marlborough St., Boston [1914]; 259 Beacon St., Boston [1931]; "Cove House," Annisquam, Mass. [summers].

Studios: 384A Boylston St., Boston [1910+]; 194 Clarendon St., Boston [1916+]; 105 Fenway Studios, Boston [1925+].

Member: North Shore Arts Association [President, 1934–36]; Connecticut Academy of Fine Arts; National Association of Women Artists; Springfield (Illinois) Art Association; Springfield (Mass.) Art League; Newport (Rhode Island) Art Association; Boston Art Club; Copley Society; Allied Artists of America; Society for Sanity in Art, New England branch [President, 1939+]; Guild of Boston Artists; Grand Central Art Galleries; Audubon Artists, New York City; Academic Artists, Springfield, Mass.; Rockport Art Association; Duxbury Art Association; Gloucester Society of Artists; American Artists Professional League; Art Commission, City of Boston [1937–42, 1954–57].

References:
SMFA Scrapbooks.
Tufts, cat. 60.
Falk, p. 476.

JLC

NANNA B. MATTHEWS BRYANT

Born 1871, probably Boston; died 1933, Boston

Sculptor in marble and bronze, primarily of mythological subjects but also of portraits; painter; miniature artist; stained-glass designer. Annie B. Matthews, called Nanna, spent her early years in Rome where she was impressed by the Vatican collections. She studied painting in Boston with Anna Klumpke, in Paris at the Académie Julian with William Adolphe Bouguereau, and then again in Boston at the MFA School from 1895 to 1896 and from 1903

to 1906. She exhibited her paintings and miniatures, none of which are known today, at the National Academy of Design, the Boston Art Club, and the Art Institute of Chicago. By 1900, she was married to the painter Wallace Bryant.

About 1912, at the age of forty-one, Bryant took up sculpture, a medium that had always appealed to her but which she had not explored because of her longstanding fascination with color. However, she evolved a style of "painting in marble," as she called it, in which she used a lively surface texture to evoke her subject's movement, emotion, and vitality. Although she produced some sculpted portraits, the bulk of her work depicts mythological figures of the Beaux-Arts type that she would have seen as a student in Boston and Paris. She also made stained glass, which, like her marbles, is dominated by the flowing, organic curves of Art Nouveau design.

Bryant exhibited her sculpture regularly at the annual exhibitions of the Pennsylvania Academy of the Fine Arts, the National Academy of Design, and the Copley Society in Boston; her first of several solo shows was held at the Sculptors' Gallery in New York in 1920. She also continued to exhibit her paintings, although less frequently than her sculpture. She received a great deal of favorable criticism in her lifetime and was awarded the Sterling Memorial Sculpture Prize by the New Haven Paint and Clay Club in 1923.

Residences: Fay House, Beacon Street, Boston [by 1923–33]; Angleside, Waltham, Mass. [summers, by 1933].
Studios: in her home.
Member: National Association of Women Artists; Newport Art Association; Copley Society [1893+].
References:
SMFA Scrapbooks.
"Pictures Painted in Marble," *International Studio*, 76, 308 (January 1923), pp. 339–40.
D. G., "Two Women of Talent," *Christian Science Monitor*, January 25, 1923.
Greenthal, pp. 336–39.
Falk, pp. 487, 2219.

EER

ADELAIDE COLE CHASE

Born 1868, Boston; died 1944, Gloucester, Mass.

Painter of portraits and floral still lifes. The daughter of American landscape painter J. Foxcroft Cole and his wife, Belgian pianist Irma De Pelgrom, Adelaide Cole Chase first studied painting with her father. She traveled in Europe and California with her family and knew many of her father's artist friends, among them Winslow Homer, who used her as a model when she was about ten years old (fig. 50). She also studied with Frederic Porter Vinton, an important Boston portraitist, before marrying Boston architect William Chester Chase in 1892. During the 1890s she worked with Tarbell and Benson at the MFA School and with Carolus-Duran and Jean-Paul Laurens in Paris.

Chase had great success painting women and children, singly and in groups. One sitter remembered as a child enjoying the process so much that she was desolate when Chase, who had a "great gift with children," had completed her portrait. Critics admired her graceful and decorative compositions, her suave and fluent brushwork, and her tasteful use of accessories. Her portraits, ranging from full to bust-length, brought her from $300 to $1000 each in 1913.

Chase began exhibiting her work in 1894 at the Boston Art Club, had her first solo show at Doll and Richards in 1901, and continued exhibiting in Boston, Chicago, Washington, New York, and Philadelphia until 1927. In 1917 she had a joint show with Anna Vaughn Hyatt at the St. Botolph Club in Boston. She was awarded silver medals for her portraits at the St. Louis World's Fair in 1904 and at the Panama-Pacific International Exposition in San Francisco in 1915; she was elected an associate member of the National Academy of Design in 1906. Her work can be found in both museums and educational institutions, including Harvard, Dartmouth, and the United States Naval Academy.

Residences: 304 Boylston St., Boston [1894–99]; 95 Beacon St., Boston [1899–1909]; 8 Marlborough St., Boston [1910–31]; Adams Hill Road, Annisquam, Mass. [summers].

Studios: in her homes on Marlborough St. and in Annisquam.

Member: Guild of Boston Artists [Charter Member]; Society of American Artists [1903+]; National Academy of Design [Associate, 1906+]; Copley Society.

References:
SMFA Scrapbooks.
Mary Orne Bowditch, *Mary Orne Bowditch Memoir*, 1950, typescript, Massachusetts Historical Society, p. 29.
Hirshler, p. 204.
Falk, p. 622.

JLC

MOLLY COOLIDGE (PERKINS)

Born 1881, Paris, France; died 1962, Milton, Mass.

Woodcarver, furniture-maker, photographer, ceramicist, and painter. Mary Coolidge, called Molly, was the daughter of J. Templeman Coolidge III, an amateur painter, antique collector, and trustee of the Museum of Fine Arts, Boston, and the granddaughter of Francis Parkman, the first president of the St. Botolph Club. As an adolescent, she became an accomplished Colonial Revival photographer, portraying the old-fashioned surroundings of her family's New Hampshire summer home.

After graduating from the Winsor School, Coolidge turned her attention primarily to three-dimensional media. She studied sculpture at the MFA School with Bela Pratt in 1899 and design with Joseph Lindon Smith, while also taking academic classes at Radcliffe. She worked in wood, producing small-scale, carved decorative objects and furniture. Her smaller pieces are characterized by the stylized, elegant designs of the Arts and Crafts movement, while her furniture, with its symmetrical, simplified ornament in low-relief, demonstrates her continuing interest in the Colonial Revival.

Coolidge showed her work at the Society of Arts and Crafts, Boston, in 1897 and 1899 but ceased exhibiting after her marriage in 1905 to Boston lawyer John Forbes Perkins (she did, however, send three photographs to the 1907 exhibition of the Society). She continued woodcarving at least into the 1920s, remaining a member of the Society of Arts and Crafts until 1927, but mainly produced objects for her close family and friends. Among other projects, she carved and decorated much of the interior woodwork for the house she and her husband built in Milton, Massachusetts, in 1912.

Residences: Paris, France [1881–86]; 114 Beacon St., Boston [by 1886–1905]; Wentworth Mansion, Little Harbor Road, Portsmouth, New Hampshire [summers, 1886–1905]; Milton, Mass. [1906–62].

Studios: Boston [1881–96]; in her home [1897–1962].

Member: Society of Arts and Crafts, Boston [Craftsman, 1899–1914; Master, 1915–27].

References:
Mary Coolidge Perkins, *Once When I Was Very Young* (Milton, Mass.: [s.n.], 1960).
Mary Coolidge Perkins and John Forbes Perkins, *Stories* (Milton, Mass.: [s.n.], 1963).
Sarah L. Giffen and Kevin D. Murphy, eds., *"A Noble and Dignified Stream": The Piscataqua Region in the Colonial Revival, 1860–1930* (York, Maine: Old York Historical Society, 1992), pp. 113–14, 129–31.
Meyer, pp. 50, 55–56, 168–69, 227.

EER

ELIZABETH ETHEL COPELAND

Born 1866, Revere, Mass.; died 1957, Boston

Silversmith and enameler. Copeland began her artistic studies relatively late, at age thirty, at the Cowles Art School in Boston, where she worked primarily with Amy Sacker. In 1900, her last year at the school, she took her first course in metalworking with Laurin Martin. At Cowles, Copeland met Sarah Choate Sears who became her friend and patron. Sears sponsored Copeland's 1908 trip to Europe, where she was able to study museum collections throughout the continent. In London, Copeland may have worked with the foremost enamelist of her age, Alexander Fisher.

Copeland quickly became one of the most well-known and sought-after Arts and Crafts silversmiths in Boston. She was a jeweler and also created a series of silver boxes decorated in richly colored enamel, in emulation of jeweled reliquaries of the medieval period (pl. 22). Her intricate designs have an organic, irregular quality, testifying to the hand work that went into producing them.

Copeland began exhibiting her work nationally in the exhibitions of Arts and Crafts societies as early as 1901. That year, she was elected a Craftsman of the Society of Arts and Crafts, Boston; in 1910 she achieved the rank of Master and in 1916 received a bronze medal, the group's highest distinction. Copeland won a bronze medal at the Panama-Pacific Exposition in San Francisco in 1915 and the Mrs. Albert H. Loch prize for original design at the thirteenth annual Arts and Crafts exhibition at the Art Institute of Chicago the same year. She retired in 1937 for unknown reasons. Her work is represented in the collections of the Cincinnati Art Museum, Detroit Institute of Arts, and the Museum of Fine Arts, Boston.

Residences: Revere, Mass.; Bedford, Mass. [1901–04]; Boston [1905–27+].

Studios: in her home [1901–04]; 296 Boylston St., Boston [1905–12]; 294 Boylston St., Boston [1913–27].

Member: Society of Arts and Crafts, Boston [1901–27]; Detroit Society of Arts and Crafts.

References:
Irene Sargent, "The Worker in Enamel, with Special Reference to Miss Elizabeth Copeland," *The Keystone*, 27 (February 1906), pp. 193–96.
Ulehla, p. 59.
Kaplan, pp. 26, 268.
Meyer, pp. 24, 27, 72, 75–77, 81–82, 95, 174–75, 178–79, 210.
Falk, p. 730.

EER

MARY DEVENS

Born 1857, Cambridge, Mass.; died 1920,
Cambridge, Mass.

Photographer of portraits, landscapes, and interior or architectural views. Mary Devens grew up in Cambridge, Massachusetts, but little is known about her youth. She began experimenting with photography in the 1880s, meeting the prominent Boston Pictorialist photographer F. Holland Day, who became a friend and advocate.

Devens traveled in Europe in the 1890s, where she learned the new gum bichromate printing process. She was one of the first photographers in New England to experiment with this type of manipulated printmaking; she also used a related technique called ozotype. These methods allowed Devens to blur her subjects and to create an effect reminiscent of a charcoal drawing, with a high degree of abstraction. One British critic, hostile to manipulated prints, described her work on display in London for the British journal *Photography*, in 1900: "Her 'portrait' . . . is a great thing in brick red, of which the clothes might as well be shapes of red paper stuck on, and the face cut out of a section of a nice spongy brick. It is nearly pushed out of the frame on the right hand side, in accordance with the latest Yankee fad, leaving a preponderance of empty space; and in execution is coarse—even brutal."

Devens's work was highly regarded in America, however. She exhibited widely, in the annual exhibitions of the Old Cambridge Photographic Club and the Society of Arts and Crafts, Boston, and in major photographic shows in Philadelphia, New York, Chicago, London, Paris, and Berlin. She held at least two solo shows, at the Boston Camera Club in 1903 and at Boston's Harcourt Studio Building in 1904. Devens was a member of the Brotherhood of the Linked Ring (the major group of Pictorialist photographers in London) and a fellow of Alfred Stieglitz's Photo-Secession in New York. Stieglitz reproduced her work in his journals *Camera Notes* in 1902 and *Camera Work* in 1904. Devens's career ended prematurely sometime after 1905, when she was forced to retire due to a degenerative eye disease. The Society of Arts and Crafts held a memorial exhibition of her work in 1920.

Residences: 155 Brattle St., Cambridge, Mass. [about 1890–1920].

Studios: in her home.

Member: Old Cambridge Photographic Club [1895+]; Society of Arts and Crafts, Boston [Craftsman, 1899–1920]; Photo-Secession [Fellow, 1902+]; Brotherhood of the Linked Ring [1902+].

References:
Obituary: *Boston Evening Transcript*, March 15, 1920.
W. H. D. [William Howe Downes], "Artistic Photography," *Boston Evening Transcript*, January 18, 1921.
Peterson, Christian A. *Alfred Stieglitz's Camera Notes*, (New York: W. W. Norton & Co., 1993), pp. 95, 163–64.
Laura Ilise Meister, "Missing from the Picture: Boston Women Photographers, 1880–1920" (M.A. thesis, Tufts University, 1998).

EER

GERTRUDE FISKE

Born 1878, Boston; died 1961, Weston, Mass.

Portrait, figure, still life, and landscape painter; etcher. Born to a distinguished Massachusetts family, Fiske was an accomplished golfer until she decided to take up art. She entered the MFA School in 1904 at the age of twenty-six, and fulfilled the complete seven-year curriculum. During the summers, she attended Charles H. Woodbury's classes in Ogunquit, Maine, and his bold, painterly style had a lasting effect on her work.

From 1912, when she received her diploma, until World War II, Fiske exhibited regularly at the Pennsylvania Academy of the Fine Arts, the Art Institute of Chicago, the National Academy of Design, and the Corcoran Gallery. She also had twelve solo shows at such institutions as the Cleveland Museum of Art, the Farnsworth Museum, the Rhode Island School of Design, and the Guild of Boston Artists. Fiske won major prizes for her paintings including the Clark prize for the best figure composition (twice), the Shaw prize for women artists (twice), and the Proctor prize for portraiture from the National Academy of Design, to which she was elected an associate member in 1922 and a full member in 1930. In 1925 alone she was awarded five prestigious prizes for five different works at various exhibitions. Fiske was also the first woman appointed to the Massachusetts State Art Commission in 1930.

Fiske's work is notable for its variety of subject matter (portraits, townscapes, landscapes, park views, beach scenes, still lifes, and figure studies—especially of tradesmen and the elderly), inclusion of modern technology (telephone poles, construction vehicles, and automobiles), and use of intense colors and lively brushwork. Critics thought her paintings original in composition and technically accomplished and found her portraits to be startling likenesses; those of men were especially admired.

Residences: 216 Commonwealth Ave., Boston [1878–1961]; "Stadhaugh" (studio in barn on property), Weston, Mass. [1878–1961]; Pine Hill (or Ridge) Road North, Ogunquit, Maine [summers, about 1909–61].

Studios: Copley Hall Studios, 198 Clarendon St., Boston [1913–16]; 194 Clarendon Street, Boston [1916–17]; 126 Dartmouth St., Boston [1917–20]; 120 Riverway, Boston [1921–23]; 132 Riverway, Boston [1924–44]; Fenway Studios, #208 [1947–60].

Member: Guild of Boston Artists [Founding Member]; Grand Central Gallery, N.Y.; Connecticut Academy of Fine Arts; New Haven Paint and Clay Club; National Academy of Design [Associate Member, 1922–30; Member, 1930+]; National Association of Women Painters and Sculptors; Boston Society of Etchers [Founding Member]; Concord Art Association [Founding Member]; American Federation of the Arts; Ogunquit Art Association [Founding Director]; Chicago Society of Etchers; National Arts Club; Cosmopolitan Club, N.Y.; Copley Society.

References:

SMFA Scrapbooks.
Gertrude Fiske: Oil Paintings 1910–1928 (New York: Robert Schoelkopf Gallery, 1969).
Gertrude Fiske (1878–1961) (Boston: Vose Galleries, 1987).
Carol Walker Aten, *Gertrude Fiske (1878–1961), Images of Women: 1904–1935* (M.A. thesis, Boston University, 1990).
Falk, p. 1132.

JLC

META VAUX WARRICK FULLER

Born 1877, Philadelphia, Pennsylvania; died 1968, Framingham, Mass.

Sculptor. Born to middle-class African-American parents, Meta Warrick's first art teacher was her older sister Blanche. In 1894 and 1897, Warrick won scholarships to the Pennsylvania Museum and School for Industrial Arts, and in 1898 she received the school's Crozier Prize for modeling. The next year, she moved to Paris, studying drawing at the Ecole des Beaux-Arts and sculpture at the Académie Colarossi; she was also advised by African-American painter Henry Ossawa Tanner and French sculptor Auguste Rodin.

Rodin became Warrick's greatest influence—like the French sculptor, she used surface texture to convey movement and emotion. Warrick was quite successful in Paris, holding her first solo exhibition there in 1902, but upon her return to America that year, Philadelphia galleries refused to show her work because of her race. She persevered, exhibiting at the 1903

Paris Salon and frequently at the Pennsylvania Academy's annual exhibitions. In 1907, she was commissioned by the federal government to depict the "Negro's progress" for the Jamestown Tercentennial Exposition and won a gold medal for her multi-figured composition there.

In 1909, Warrick married Solomon Fuller, the first African-American psychiatrist, and moved to Framingham, Massachusetts. They had three children. Dr. Fuller expected his wife to devote herself to domestic duties, but she nevertheless used her own money to build a studio where she continued to sculpt and teach. Fuller produced work advocating women's suffrage and world peace; after 1910 her major subject became African-American life, a theme first suggested to her by her friend W. E. B. DuBois. In the 1920s and 1930s, she began to involve herself more with the Boston art community, becoming a member of the Boston Art Club in 1934 and showing her work locally. She also worked with the Harmon Foundation in New York, and the Harlem Renaissance artists who exhibited with her there saw her interest in African-American subjects as an important precursor to their work. After 1940, Fuller produced little sculpture, dedicating herself instead to the care of her increasingly infirm husband.

Residences: Philadelphia, Pennsylvania [1877–99]; Atlantic City, New Jersey [summers, 1877–99]; Paris, France [1899–1902]; Philadelphia, Pennsylvania [1903–09]; 31 Warren Road, Framingham, Mass. [1909–68].

Studios: Philadelphia, Pennsylvania; Paris, France [1899–1902]; 210 South Camac Street, Philadelphia, Pennsylvania [1903–09]; near 31 Warren Road, Framingham, Mass. [1909–68].

Member: Boston Art Club [1934+]; Wellesley Society of Artists.

References:

Harriet Forte Kennedy, *An Independent Woman: The Life and Art of Meta Warrick Fuller (1877–1968)* (Framingham, Mass.: Danforth Museum of Art, 1985).
Judith Nina-Kerr, "God-Given Work: The Life and Times of Sculptor Meta Vaux Warrick Fuller, 1877–1968" (Ph.D diss., University of Massachusetts, Amherst, 1986).
Mary Schmidt Campbell, et al., *Harlem Renaissance: Art of Black America* (New York: The Studio Museum in Harlem and Harry N. Abrams, Inc., 1987).
Rubinstein, pp. 201–04, 252–53.
Tritobia Hayes Benjamin, "May Howard Jackson and Meta Warrick Fuller: Philadelphia Trailblazers," in *3 Generations of African American Women Sculptors: A Study in Paradox* (Philadelphia: The Afro-American Historical and Cultural Museum, 1996).

EER

ELLEN DAY HALE

Born 1855, Worcester, Mass.; died 1940, Brookline, Mass.

Creator of portraits, figural subjects, and landscape in a variety of media; etcher; muralist. Ellen Day Hale was the daughter of the well-known minister Edward Everett Hale and the niece of watercolorist Susan Hale, who most likely was her first teacher. She studied in Boston with William Rimmer in 1873 and with William Morris Hunt and Helen Knowlton from 1874 to 1877. She continued her training at the Pennsylvania Academy of the Fine Arts in the springs of 1878 and 1879. In 1881, she traveled to Europe for nine months with Knowlton and then worked in Paris, primarily at the *atelier* of Carolus Duran and at the Académie Julian from 1881 to 1883; she returned to the Académie Julian in 1885.

In Paris, Hale formulated a bold style characterized by assymetrical, radically cropped compositions and dark, strong colors. Her style grew lighter and more impressionistic as her career progressed, and she often painted beautiful young women in interiors, a favorite subject of the Boston School. Hale also became an accomplished etcher, a technique she had learned from her friend and life-long companion, the Philadelphia artist Gabrielle de Vaux Clements. In that medium, she worked on a more intimate scale, using it to document her extensive travels through the U.S., Europe, and the Middle East.

Hale was devoted to her family—both her parents and her seven younger brothers—and moved to Washington in 1904 to be hostess in her father's house. However, she took her career extremely seriously, supporting herself by painting portraits, decorating church interiors, and teaching art. She exhibited widely: at the Paris Salon, the National Academy of Design, the Pennsylvania Academy, and elsewhere. While in Paris she was a correspondent for the *Boston Traveller*, regularly providing them with commentary on the Paris art scene, and in 1888 she published a treatise, "History of Art," about the great artists of the Renaissance.

Residences: Worcester, Mass. [1855–about 1873]; Boston [about 1873–81]; Europe, mostly Paris, France [1881–83]; Boston [1883–92]; Santa Barbara, California [1892–93]; Boston [1893–1904]; The Thickets, Folly Cove, Rockport, Mass. [summers, 1893+]; Charleston, South Carolina [winters, 1893+]; Washington, D.C. [1904–09]; Brookline, Mass. [1909–40].

Studios: in her home.

Member: Boston Art Club; North Shore Art Association; Charleston Etching Club; Society of Washington Artists; Washington Watercolor Club; Washington Art Club; Chicago Society of Etchers; National Association of Women Artists [1893+].

References:
Obituary, *New York Times*, February 12, 1940, p. 17.
Hoppin, pp. 37–42.
Alanna Chesebro, *Ellen Day Hale* (New York: Richard York Gallery, 1981).
Hale Papers, Sophia Smith Collection, Smith College.
Hirshler, pp. 209–10.
Tufts, cats. 14, 52.
Tracy B. Schpero, "American Impressionist Ellen Day Hale" (M.A. thesis, George Washington University, 1994).

EER

LILIAN WESTCOTT HALE

Born 1880, Hartford, Connecticut; died 1963, St. Paul, Minnesota

Painter of portraits, figure studies, landscapes, and still lifes; also finished charcoal drawings. Lilian Westcott grew up in Hartford, Connecticut, and took her first art classes at the Hartford Art School. She studied briefly at William Merritt Chase's summer art school at Shinnecock, New York, in 1897, and then, in 1900, she received a scholarship from the Hartford Art Society to continue her studies at the MFA School. Westcott met Philip Hale, a painter and teacher at the MFA School, in Hartford; they married in 1902 and had a daughter, Nancy, in 1908.

Lilian Hale worked in an ethereal style, especially in her charcoal drawings, employing subtly modulated, parallel, vertical lines contrasted with highlights created through selective use of reserve paper. She exhibited her large drawings alongside her paintings, and considered them equally significant. Her paintings have a similar delicacy—she often used pastel colors while defining her forms carefully. Hale's subjects are typical of the Boston School—beautiful, light-filled interiors with women and children harmoniously arranged within.

Despite her concerns that marriage and motherhood would prevent a serious professional career, Lilian Hale managed to balance her family responsibilities with her dedication to her art and achieved a remarkable degree of success. She was greatly in demand as a portraitist, and her work sold well in Boston and

beyond throughout the 1930s. Family responsibilities occupied her time in the 1940s, and she moved to Virginia in 1955. She exhibited frequently at the Pennsylvania Academy of the Fine Arts, the Copley Society, and the National Academy of Design; her first solo show was at Boston's Rowlands Galleries in 1908. Among her early prizes were a bronze medal at the Buenos Aires International Exposition in 1910 and a medal of honor for drawing and gold medal for painting at the Panama-Pacific International Exposition in San Francisco in 1915.

Residences: Sigourney St., Hartford, Connecticut [1881–99]; Boston [1899–1905]; Fenway Studios, 30 Ipswich Street, Boston [1905–09]; Sandy Valley Road, Dedham, Mass. [1909–12]; Folly Cove, Rockport, Mass. [summers]; 213 Highland St., Dedham, Mass. [1912–55]; Charlottesville, Virginia [1955+].

Studios: in her home.

Member: Copley Society; Guild of Boston Artists [Founding Member]; Concord Art Association; National Association of Portrait Painters; AFA; National Academy of Design [Associate Member, 1927–31; Member, 1931+]; Connecticut Academy of Fine Arts.

References:
Rose V. S. Berry, "Lilian Westcott Hale—Her Art," *American Magazine of Art*, 18, 2 (February 1927), pp. 59–70.
Nancy Hale, *The Life in the Studio* (Boston: Little, Brown, 1969).
Hale Papers, Sophia Smith Collection, Smith College.
Hirshler, p. 210.
Tufts, cat. 53.
Erica Eve Hirshler, *Lilian Westcott Hale (1880–1963): A Woman Painter of the Boston School* (Ph.D. dissertation, Boston University, 1992).
Betha LeAnne Whitlow, "Lilla Cabot Perry and Lilian Westcott Hale: Women Artists of the Boston School" (M.A. thesis, Washington University, St. Louis, 1995).
Erica E. Hirshler, *"Drawn with Butterfly's Wings": The Art of Lilian Westcott Hale* (Weston, Mass.: Regis College, 1999).

EER

LAURA COOMBS HILLS

Born 1859, Newburyport, Mass.; died 1952, Newburyport, Mass.

Specialist in miniatures and floral pastels; watercolor still lifes, landscapes in pastels and oils; poster and costume designer. Hills studied formally with Helen Knowlton for three winters, then briefly at the Cowles Art School, and finally at the New York Art Students' League in 1882. She first exhibited at the Boston Art Club in 1878 with Knowlton and Ellen Day Hale, and had her earliest solo show, of pastels, in 1889. In the 1880s she designed cards for Prang and illustrated children's books; at the turn of the century, she produced pageants to benefit the Women's Educational and Industrial Union, creating costumes, posters (pl. 14), and programs.

Hills began painting miniatures on ivory in 1893, after seeing examples in England. Her miniatures were instantly popular, and she produced 369 of them over the next forty years. Hills received between $300 and $1000 for her small portraits and by 1900 she was able to design and build a house in Newburyport, Massachusetts. Hills painted in both oval (which she preferred) and rectangular formats, using a magnifying glass to finish the portraits with fine strokes and stippling. Her miniatures are admired for their vibrant color schemes and decorative backgrounds. A preeminent figure in the miniature revival, Hills exhibited widely and won major awards for her work, including a gold medal at the 1904 St. Louis Exposition and the first Medal of Honor conferred by the Pennsylvania Society of Miniature Painters in 1916.

As her eyesight began to fail and the demand for miniatures declined in the 1920s, Hills turned increasingly to floral pastels, displaying them regularly at popular solo shows beginning in 1921. Using imported pastels and the freshest flowers from her garden, Hills drew the flowers in bright colors, either in vases against a fabric backdrop or in more natural arrangements. She exhibited for the last time in 1947, in her eighty-eighth year.

Residences: Washington St., Newburyport, Mass.; 13 Louisburg Square, Boston [winters, 1894–1902]; 66 Chestnut St., Boston [1903–27]; 22 Essex St., Newburyport, Mass. [1945–52]; "The Goldfish," Sawyer's Hill, Newburyport, Mass. [summers, 1900+].

Studios: in her Newburyport homes; 320 Boylston St. [1894–1902]; in her Chestnut St. home [1903–27].

Member: Society of American Artists [1897, first miniaturist elected]; Society of Arts and Crafts, Boston

[Craftsman, 1913; Master, 1914, 1917–27]; Guild of Boston Artists [Charter Member, 1914]; Boston Water Color Club; National Academy of Design [Associate Member, 1906+]; American Society of Miniature Painters [Founding Member, 1898+]; Pennsylvania Society of Miniature Painters; American Federation of Arts; New York Woman's Art Club.

References:

Grace A. Nutell, "A Painter of Miniatures," *The Puritan*, 3 (April 1899), pp. 385–89.
M. J. Curl, "Boston Artists and Sculptors Talk of Their Work and Ideals, IV, Laura Coombs Hills," *Boston Transcript*, January 2, 1921.
Sandy Lepore et al., *Laura Coombs Hills: A Retrospective* (Newburyport, Mass.: Historical Society of Old Newbury, 1996).

JLC

ANNA VAUGHN HYATT (HUNTINGTON)

Born 1876, Cambridge, Mass.; died 1973, Bethel, Connecticut

Sculptor of animals, equestrian monuments, figures, portraits, and medals. The daughter of Audella, an amateur landscape painter, and Alpheus Hyatt, a zoologist and paleontologist, Hyatt began sculpting under the influence of her sister Harriet. She was largely self-taught, though she studied drawing at the Cowles Art School and trained briefly with Henry Hudson Kitson. Always prolific, her first solo show of fifty pieces was held in 1901 at the Boston Art Club. In 1902 she moved to New York where she worked for a short time with Hermon MacNeil at the Art Students' League and received criticism from Gutzon Borglum. She maintained a summer studio in Annisquam, Massachusetts.

Best known for her animal sculptures, Hyatt modeled *Reaching Jaguar* in 1906 (pl. 61) based on sketches made at the Bronx Zoo and a bronze lion for a Dayton, Ohio, high school, her first public commission. Her life-size plaster model of Joan of Arc on horseback won an honorable mention at the Salon in 1910 and led to the commission of an equestrian statue for New York City (see figs. 63, 64). In addition to her animal and equestrian sculptures, Hyatt created fountains, including *Young Diana* (pl. 62). She was elected a full member of the National Academy of Design in 1923. That same year she married scholar and philanthropist Archer Huntington, heir to a railroad fortune.

In 1930, the Huntingtons bought three plantations in South Carolina which became Brook-green Gardens, the largest outdoor exhibition of figurative sculpture in the United States. The American Academy of Arts and Letters, to which Huntington had been elected the first woman member in 1932, gave her a retrospective in 1936. Blessed with great stamina despite a diagnosis of tuberculosis in 1927, Huntington worked into her nineties. In recognition for her achievements, she was made a *chevalier* of the French Legion of Honor (1922), and received numerous national and international prizes. She brought a keen sense of anatomy, movement, and characteristic behavior as well as inventive design to her animal sculpture. Equally accomplished in both large- and small-scale work, Huntington was one of the first sculptors to cast her work in light-weight aluminum. Her energetic sculptures are found in over 200 museums and parks worldwide.

Residences: Norton Woods, Cambridge, Mass. [1898–1902]; 1723 Euclid St., Washington, D.C. [1909]; 17 Livingston Pl., New York [1911]; 126 East 80th St., New York [1911–12]; Fifth Avenue & 36th St., New York [1912]; 126 East 18th St., New York [1912]; 124 East 80th St., New York [1913]; 158 East 62nd St., New York [1916]; 44 Gramercy Park, New York [1919–20]; 1083 Fifth Avenue, New York (later given to the National Academy of Design) [1923–40]; "Atalaya," Murrells Inlet, South Carolina [1930–47]; "Rocas," Haverstraw, New York [1933–40]; "Stanerigg," Redding Ridge, Connecticut [1940–73]; "Seven Acres," Annisquam, Mass. [summers, until 1923]; "Arbutus," the Adirondacks, New York [1923–32].

Studios: Annisquam, Mass. [summers, until 1923]; 11 East 33rd St., New York [1905–06]; former studio of Charles-François Daubigny, Auvers-sur-Oise, France [1907]; former studio of Jules Dalou, Left Bank, Paris, France [1909]; 49 West 12th Street, New York [1921–23]; her estates in South Carolina, Haverstraw, New York, and Redding Ridge, Connecticut.

Member: Copley Society; National Academy of Design [Associate Member, 1916; Member, 1923]; National Association of Women Artists; National Sculpture Society; American Federation of the Arts; Institute of Arts and Letters; American Academy of Arts and Letters, Society of Animal Artists.

References:

Rubinstein, pp. 162–68.
David B. Dearinger, "Huntington, Anna Vaughn Hyatt," *American National Biography*, vol. 11 (New York: Oxford University Press, 1999).
Tufts, cat. 120.
Greenthal, pp. 352–59.
Falk, p. 1665.

JLC

ANNIE HURLBURT JACKSON

Born 1877, Minneapolis, Minnesota; died 1959, Boston

Specialist in miniatures, chalk drawings, and floral pastels. Jackson settled in Brookline, Mass., in about 1896, and studied with Eric Pape, Hermann Dudley Murphy, Charles H. Woodbury, Charles W. Hawthorne, and Eliot O'Hara. Never married, she lived with her brother Robert Fuller Jackson (born 1875), a Harvard graduate, who was a painter, architect, designer, and teacher.

Jackson was a regular contributor to the annual exhibitions of the Pennsylvania Society of Miniature Painters from 1906 until 1939, when she was made an honorary life member. She received the Society's Medal of Honor in 1925. In 1911 Jackson had a joint exhibition with Harriet Bennett Newhall at Copley Hall, where she showed some twenty miniatures, which a critic described as "delicate and distinguished," and twenty-five portrait drawings ("serious and expressive"). She displayed her miniatures locally in Boston, Concord, Brookline, Brockton, and nationally in Chicago (1911 and 1916) and at the National Academy of Design (1914–18). William Howe Downes praised her portrait in the 1919 Guild of Boston Artists' exhibition as "one of the most successful miniatures of children in the entire group." She was awarded a gold medal at the Sesquicentennial Exposition in Philadelphia and the Charlotte Ritchie Smith prize in Baltimore, both in 1926, and a medal in the 1930 Boston Tercentenary Exhibition.

Jackson painted her miniatures in bust, three-quarter, or full-length formats in rectangular or oval frames, frequently five inches in height, using watercolors on ivory. She often included pets or accessories, or placed her sitter in a light-filled room, as in *Small Boy in a Rocking Chair* (pl. 36). Among her sitters was Olive Higgins Prouty, author of the novel *Stella Dallas*. Jackson's finely painted miniatures are in the collections of the Baltimore Museum of Art, Worcester Art Museum, Museum of Fine Arts, Boston, and the Philadelphia Museum of Art.

Residences: 119 Park St., Brookline, Mass. [1906]; 20 Littell St., Brookline, Mass. [1907–14]; 329 Tappan St., Brookline, Mass. [1915–53]; 224 Rawson Road, Brookline, Mass. [1956–59].

Member: American Society of Miniature Painters; Copley Society; Guild of Boston Artists; Pennsylvania Society of Miniature Painters; American Federation of Arts.

References:
Falk, p. 1699.
Susan E. Strickler, *American Portrait Miniatures: The Worcester Art Museum Collection* (Worcester, Mass.: Worcester Art Museum, 1989).

JLC

LOÏS MAILOU JONES (PIERRE-NOEL)

Born 1905, Boston; died 1998, Washington, D.C.

Painter in oils, watercolor, and acrylic of figural works, landscapes, and still lifes; textile designer. Loïs Mailou Jones grew up in Boston and summered in Martha's Vineyard, where she met sculptor Meta Warrick Fuller and was inspired to pursue an artistic career. Jones studied design at the MFA School from 1923 to 1927, the Mass. Normal School from 1926 to 1927, and the Designers Art School of Boston from 1927 to 1928. Her early work included costumes for the Ted Shawn Dance Company and textiles for F. A. Foster in Boston and Schumacher in New York. Frustrated by the lack of artistic recognition in that field, Jones turned to traditional fine art. Her early training is apparent, however, in the strong sense of two-dimensional design in many of her paintings.

Jones's early painting style—expressive and light-filled—came to fruition in Paris, where she studied at the Académie Julian from 1937 to 1938. With the encouragement of prominent African-American thinker Alain Locke, Jones concentrated on African-American themes, producing sensitive renditions of individuals engaged in everyday activities. In 1953, Jones married the Haitian graphic designer Louis Vergniaud Pierre-Noel and began spending part of each year in Haiti. Influenced by native Haitian and African art, Jones's pictures grew more abstract, often relying purely on graphic arrangements of flat, bright shapes to convey the vitality of African cultures on both sides of the Atlantic.

Jones enjoyed great success, holding the first of many solo shows at the Vose Galleries in Boston in 1939. She won a great number of prizes for her work, beginning with the Robert Woods Bliss Prize for Landscape at the Corcoran Gallery in 1941. In 1973, she became the first African-American woman to have a solo show at the Museum of Fine Arts, Boston. A professor of watercolor painting and design at Howard University in Washington, D.C., from 1930 to 1977, Jones inspired several generations of African-American artists and critics.

Residences: Boston [1905–28]; Martha's Vineyard, Mass. [summers, 1905–98]; Sedalia, North Carolina [1928–30]; Quincy Street, Washington, D.C. [1930–37]; Paris, France [1937–38]; Quincy Street, Washington, D.C. [1938+]; Haiti [intermittently, 1953–98]; traveling in Africa [1970–71]; 4706 17th Street, N.W., Washington, D.C. [by 1997–98].

Member: Vineyard Haven Art Guild; American Artists Congress; Society of Independent Artists, France; American Water Color Society; Washington Art Guild; Washington Water Color Club; Society of Washington Artists; Royal Society of Arts, London (Fellow, 1962); Artists Equity Association; Art Directors Club Metropolitan Washington; National Confederation of Artists (first Vice-President).

References:
Reflective Moments: Loïs Mailou Jones (Boston: The Museum of the National Center of Afro-American Artists and the Museum of Fine Arts, 1973).
The World of Loïs Mailou Jones (Washington, D.C.: Meridian House International, 1990).
Tritobia Hayes Benjamin, *The Life and Art of Loïs Mailou Jones* (San Francisco: Pomegranate Art Books, 1994).
Obituary, "Lois Mailou Jones, 92; Painter and Leading Black Woman in Art," *The Boston Globe*, June 11, 1998.
Falk, p. 1760.

EER

HELEN MARY KNOWLTON

Born 1832, Littleton, Mass.; died 1918, Needham, Mass.

Landscape, portrait, figure, and still life painter; artist in charcoal and pastel; teacher; writer. Raised in Worcester, Mass., Knowlton, whose father was mayor (1855–56) and editor of the *Worcester Palladium*, opened a studio in Boston in 1867. From 1868 until 1871, she studied with William Morris Hunt, who turned over his classes to her to run from 1871 until 1875, although he made frequent visits. In 1875, Knowlton published *Talks on Art*, a compilation of notes she had taken of Hunt's comments and teaching methods. She continued to teach through the end of the century, inviting William Rimmer and Frank Duveneck to give lectures; her students included Marie Danforth Page and Laura Coombs Hills.

Although Knowlton lost much of her work in an 1870s studio fire, she joined Ellen Day Hale in an exhibition at the Boston Art Club in 1878, where she showed thirty-eight landscapes in oil. In 1879 she became art critic for the *Boston Post*, and she published *Hints for Pupils in Drawing and Painting*, restating Hunt's principles in an instructional form and illustrating them with his charcoal drawings. After Hunt

died in 1879, Knowlton commemorated her close friend with a dramatic portrait (pl. 2). In 1881, she traveled through Europe with Ellen Day Hale for nine months.

In addition to teaching and writing, Knowlton continued to paint; her style, subject matter, and medium showed the influence of Hunt and the Barbizon school. She exhibited her work regularly at the Pennsylvania Academy of the Fine Arts and the Boston Art Club, and less frequently at the National Academy of Design (1881), St. Botolph Club (1886), and Art Institute of Chicago (1896). She had solo exhibitions at J. Eastman Chase's Gallery in Boston in 1881, where she showed eighty-seven charcoal drawings, and at the Katz Gallery in New York in 1892. Knowlton published the *Art Life of William Morris Hunt*, his first biography, in 1899, and her final paean to Hunt, a ten-page illustrated essay, published by Curtis and Cameron in 1913.

Residences: her studio in Boston [about 1878]; 4 Oxford Terrace, Boston [1890s]; Pickering Place, Needham, Mass. [1898–1918].

Studios: Studio Building, Boston [1867–72]; 153 Tremont St., Boston [1879]; 169 Tremont St., Boston [1882–85]; 120 Tremont St., Boston [1888]; 17 Harcourt Building, Irvington St., Boston [1891]; 23 Irvington St., Boston [1892–96]; 2 Winter St., Boston [1902].

Member: Copley Society [1896].

References:
Frederic A. Sharf, "Helen Mary Knowlton," *Notable American Women, 1607–1956* (Cambridge: Harvard University Press, 1971), pp. 342–43.
Hoppin, pp. 19–27.

JLC

KATHARINE LANE (WEEMS)

Born 1899, Boston; died 1989, Boston

Sculptor primarily of animals, also medals and portrait medallions. Lane, whose father served as president of the Museum of Fine Arts, Boston, was the only child of a wealthy Boston family. She studied with Charles Grafly at the MFA School in 1918–19, and with Anna Vaughn Hyatt informally in Boston and later, in 1921, in the studio Hyatt shared with sculptor Brenda Putnam in New York City. There she flourished under the encouragement of Hyatt and with anatomy lessons from Putnam; she improved her knowledge of animal forms by sketching at the Bronx Zoo.

Lane's animal sculptures were successful as early as 1927 when her graceful *Narcisse Noir*

(pl. 63) won the Widener Gold Medal at the Pennsylvania Academy of the Fine Arts and was purchased by the Museum of Fine Arts, Boston. By 1930 she received the commission for a carved brick frieze, two bronze rhinoceroses, and three bronze doors for the Harvard University Biological Laboratories, an ambitious project, which she finished in 1932, the same year she had a one-woman show at the Guild of Boston Artists. Lane went on to win many prestigious awards, including the Speyer Prize (1931) and the Saltus Gold Medal (1960) from the National Academy of Design, where she was elected a full member; she was also named *chevalier* of the French Legion of Honor. Lane's animals are most often domesticated and tame rather than wild or ferocious, and at their best are simplified, taut, and elegant. She also designed the Legion of Merit medal for the United States military. Occasionally Lane produced figural work including *Striding Amazon* (pl. 64), which expressed her anger at the restrictions society placed on women.

In 1947, Lane married banker F. Carrington Weems and moved to New York. Family matters curtailed her career for a time, but at the age of eighty she completed a huge bronze fountain of six dolphins in the waves for the New England Aquarium plaza in Boston.

Residences: 53 Marlborough St., Boston; The Chimneys, Manchester, Mass. [summers]; New York, New York [1947+].

Studios: Barn on the grounds of The Chimneys, Manchester, Mass.; Fenway Studios, Boston [1922+].

Member: National Association of Women Painters and Sculptors; National Sculpture Society; Guild of Boston Artists; National Academy of Design; National Institute of Arts and Letters [1952+]; Massachusetts State Art Commission [1941–47]; Grand Central Art Galleries; New York Architectural League; American Artists Professional League; North Shore Arts Association; Pen and Brush Club, New York.

References:
Greenthal, pp. 454–64.
Rubinstein, pp. 168–70.
Louise Todd Ambler, *Katharine Lane Weems: Sculpture and Drawings* (Boston: Boston Athenaeum, 1987).
Charlotte Streifer Rubinstein, review of *Katharine Lane Weems*, *Woman's Art Journal* 12 (Spring/Summer 1991), pp. 52–53.
Katharine Lane Weems, *Odds Were Against Me* (New York: Vantage Press, 1985).

JLC

NELLY LITTLEHALE MURPHY

Born 1867, Stockton, California; died 1941, Lexington, Mass.

Painter of decorative floral still lifes and landscapes in watercolor, illustrator of children's literature, etcher. Littlehale studied drawing with Joseph DeCamp and decorative design with C. Howard Walker at the MFA School from 1885–87. In 1893 she married Herman Daniel Umbstaetter, an editor, publisher, and short story writer. After his death in 1913, she became the second wife in 1916 of the painter Hermann Dudley Murphy, who had courted Nelly during their student days in Boston.

Early in her career, the artist illustrated children's stories and poems in such publications as *Chicken Licken* by Anne Haven Thwing (1899) and *St. Nicholas Magazine* (1910). Although she turned increasingly to landscape and flower painting, she continued to display whimsical and fanciful watercolors throughout her life. Murphy had many solo exhibitions in Boston and New York beginning in 1905, when she showed eighty-three watercolor landscapes of Nassau and New England at the C. E. Cobb Galleries in Boston. Her work was also shown at the Boston Water Color Club, the Boston Society of Water Color Painters, the American Watercolor Society, and the Art Institute of Chicago.

In the 1920s and 30s she often exhibited with her husband Hermann Dudley Murphy, who also painted landscapes and floral still lifes, primarily in oil. Her delicately painted landscapes reflect their travels to Puerto Rico, Mexico, England, and California. Murphy is best known for her meticulous still lifes of flowers, often from her garden, either arranged in a bowl against a plain, pearly gray background or presented simply and in profusion, omitting the vase.

Murphy received the Purchase prize for watercolor from the Boston Art Club in 1929. Her works are found in the Museum of Fine Arts, Boston, Fine Arts Museums of San Francisco, Stockton Museum of Arts, Phillips Academy, Andover, Mass., and the New Britain Museum of American Art.

Residences: 180 Huntington Avenue, Boston, [1915]; Follen Road, Lexington, Mass. [1918–22]; 12 Summit Road, Lexington, Mass. [1924–38].

Studios: in her Lexington homes [1918–38].

Member: American Watercolor Society; New York Water Color Club; Copley Society; Boston Society of Watercolor Painters; Guild of Boston Artists; Grand Central Art Galleries.

References:
SMFA Scrapbooks.
Falk, p. 2372.

JLC

BASHKA PAEFF (WAXMAN)

Born 1893, Minsk, Russia; died 1979, Cambridge, Mass.

Sculptor in bronze, marble, plaster, and clay of portraits, war memorials, garden statuary, and animals. Bashka Paeff, sometimes called Bessie, was born to Russian Jewish parents who emigrated to the United States when she was one year old. She grew up in Boston's North End and showed such an aptitude for art that her parents, although they had wanted her to become a musician, sent her to the Mass. Normal School in 1907, hoping that she would become a drawing teacher. She studied modeling there with Cyrus Dallin, who advised her to continue her studies in sculpture at the MFA School. Paeff enrolled in the MFA School in 1911, working with Bela Pratt. She won many prizes and scholarships at the School, including the Helen Hamblen Scholarship in 1913 and the First Prize for Sculpture and Modeling in 1914. She supported herself by working as a token-seller in Boston's Park Street subway station. Because she often took advantage of lulls in her work to model clay, the *Boston Herald* dubbed her the "subway sculptress." After graduating in 1914, she intended to go to Paris to study with Rodin but was prevented by the outbreak of World War I—it was only much later in her career, in 1930, that she was able to make her long-anticipated trip to Europe.

Paeff's sensitive, realistic style soon became sought-after in Boston and beyond. She became best known for her portraits of such notables as Chicago's Jane Addams and Boston's Oliver Wendell Holmes. She also designed garden statuary—including the immensely popular *Boy and Bird Fountain* in the Boston Public Garden and the *Julius Rosenwald Memorial Fountain* in Illinois—and war memorials, among them *Memorial to Massachusetts Chaplains* for the State House in Boston. She exhibited steadily in the Northeast, most frequently at the Guild of Boston Artists, where in 1919 she held the first of many solo shows. In 1940, she married Samuel Waxman, a professor of Romance Languages at Boston University.

Residences: Minsk, Russia [1893–94]; North End, Boston [1894+]; 43 Portland St., Boston [by 1911+]; 6 Pinckney St., Boston [by 1914–30]; MacDowell Colony, Peterborough, Mass. [summers, 1918–21]; Paris, France [1930–32]; Boston [1932–40]; Cambridge, Mass. [1940–79].

Studios: in her home [1914–about 1919]; 45 River St. Boston [1919–30]; in her home [1930–32]; 45 River Street, Boston [1932–40]; in her home [1940–79]; Greenbush, Mass. [until 1979].

Member: Society of Arts and Crafts, Boston [Craftsman, 1915–1922; Master, 1923–1927]; Guild of Boston Artists [1916+]; National Sculpture Society [Fellow]; Cambridge Art Association.

References:
SMFA Scrapbooks.
Obituary, "Bashka Paeff, Sculptor of 'Boy and Bird,' 85," *New York Times,* January 26, 1979, p. A23.
Ulehla, p. 165.
Greenthal, pp. 431–34.
Rubinstein, pp. 199–200.

EER

MARIE DANFORTH PAGE

Born 1869, Boston; died 1940, Boston

Painter of portraits, figures, and occasionally landscapes; charcoal portraits. Danforth studied drawing with Helen Knowlton from 1886–89, and with Tarbell and Benson at the MFA School from 1890–96. She began exhibiting at the Boston Art Club in 1892. In 1896, she illustrated *Short Stories for Short People* with pen and ink drawings. Also that year, she married Dr. Calvin Gates Page (pl. 45). After a 1903 trip to Europe, where she copied works by Velázquez, she worked with Denman Ross at Harvard's summer school.

Page was chiefly devoted to portraiture in oils, and by the 1920s, she was receiving seven or eight commissions annually and was able to charge $1000 for a full-length likeness. Best known for her representations of children, she was selected to paint "the typical American girl" for the *Boston American* in 1913. Starting in about 1914, she turned increasingly to mother and child compositions, sometimes hiring women and children from local charitable institutions to act as models. In 1919, at the age of fifty, she adopted two young girls who often became the subjects of her paintings. During the Depression when portrait commissions declined, Page painted cityscapes and rehearsals of the Boston Symphony Orchestra.

Page showed her work almost yearly at the Pennsylvania Academy of the Fine Arts (1903–40), National Academy of Design (1916–40), Art Institute of Chicago (1911–32), and Corcoran Gallery (1907–37). She also had a series of solo shows beginning in 1898. Her first major award was a bronze medal at the Panama-Pacific International Exposition in 1915 in San Francisco, to which she traveled through the Panama Canal. She also won prestigious awards at the National Academy of Design (Shaw Prize, 1916; Isidor Medal, 1923; and Proctor Prize, 1928), and was elected an associate member of

the National Academy in 1927. Tufts College conferred an honorary degree upon her in 1933.

Residences: 128 Marlborough St., Boston (studio on top floor) [1896–1940].

Member: Guild of Boston Artists [Charter Member]; Union Internationale des Beaux-Arts et des Lettres; National Academy of Design [Associate Member, 1927]; Connecticut Academy of Fine Arts; Copley Society; National Society of Portrait Painters; Grand Central Galleries; Board of Visitors, Museum of Fine Arts, Boston; Newport Artists' Association.

References:
Martha J. Hoppin, *Marie Danforth Page: Back Bay Portraitist* (Springfield, Mass.: George Walter Vincent Smith Art Museum, 1979).

JLC

MARGARET JORDAN PATTERSON

Born 1867, Surabaya, Java; died 1950, Boston

Woodblock printmaker and painter in oils, watercolors, gouache, and pastels of landscapes and floral still lifes. Patterson, the daughter of a Maine sea captain, was born on shipboard near Surabaya, Java. She grew up in Boston and Maine, obtaining her first artistic instruction in a correspondence course given by the publisher Louis Prang. She attended the Pratt Institute in Brooklyn in 1895 and studied with Claudio Castellucho in Florence and Ermengildo Anglada-Camrasa in Paris a few years later but seems to have learned more about art-making from her friendships with artists, especially Arthur Wesley Dow and Charles Woodbury.

Like both Dow and Woodbury, Patterson was deeply inspired by Japanese art. Although she began as a painter, around 1910 she learned the art of color woodblock printing from Ethel Mars, an Illinois native who was active in Paris. Patterson made regular trips to Europe between 1899 and 1929. Her early work consists mostly of landscapes of Italy and of the New England coast. These feature high horizon lines which lend her work a sense of abstraction and two-dimensional design, uniting it with both Dow's work and the Japanese woodblock prints that she so admired. In the 1920s, Patterson began to concentrate on floral still life. Her flower paintings and prints are even more abstract than her landscapes, for she depicted flowers using flat shapes of bold color against contrasting, plain grounds, giving her work a distinctly modernist flair.

Patterson had a successful career, exhibiting her paintings and prints frequently at venues throughout the U.S. and holding many solo shows at the Copley Society in Boston, beginning in 1910. Critics admired her work, and she won several prizes, including an honorable mention at the 1915 Panama-Pacific Exposition in San Francisco. Patterson supported herself by teaching art, first in the Boston Public Schools, where she taught drawing, and then, after 1915, at the Dana Hall School in Wellesley, Mass., where she served as Director of the Art Department until she retired in 1940.

Residences: Trinity Court, Boston.

Member: Boston Society of Water Color Painters [secretary]; American Federation of the Arts; Copley Society [1900+]; Guild of Boston Artists; Philadelphia Water Color Club; California Printmakers; Providence Water Color Club; Color Block Printmakers; The Group (Boston) [1920s]; National Association of Women Artists.

References:
SMFA Scrapbooks.
James R. Bakker and Feay Shellman Coleman, *Margaret J. Patterson: Retrospective Exhibition* (Cambridge, Mass.: James R. Bakker Antiques, Incorporated, 1988).
James R. Bakker, *Margaret Jordan Patterson 1867–1950 Exhibition & Sale* (Cambridge, Mass.: James R. Bakker Antiques, Incorporated, 1990).
Meyer, pp. 10, 156, 162, 202–03, 226–27.
Nancy E. Green, et al., *Arthur Wesley Dow (1857–1922): His Art and His Influence* (New York: Spanierman Gallery, 1999).

EER

PAUL REVERE POTTERY OF THE SATURDAY EVENING GIRLS' CLUB

Founded, 1908; Closed, 1942

The Paul Revere Pottery was founded in 1908 by Edith Brown (1870–1958), an artist and illustrator of children's books, and Edith Guerrier (1870–1958), the librarian of the North End Branch of the Boston Public Library. The two had met when both were students at the MFA School in 1891 (Brown also worked with Denman Ross at the Harvard Extension School while Guerrier studied at the Mass. Normal School). The Pottery was based at the Saturday Evening Girls' Club, a cultural group for Italian and Jewish immigrant girls in the North End. Brown, Guerrier, and the Pottery's patron, Helen Osborne Storrow (1864–1944), intended the operation to be a means for the girls to earn a living wage in good working conditions. In the

spirit of the Arts and Crafts ideal of handwork, the immigrants thus would be socially and aesthetically improved and more quickly assimilated into American society.

Brown was the Pottery's director and designer. She employed simple, elegant shapes; using matte glazes, she outlined her motifs in black and filled them with delicate, pastel colors. She taught the young women of the club all aspects of the pottery-making process. The girls were allowed to alter the designs slightly, producing identifiably individual styles, and they often signed their own work. The pottery produced large-scale vases (see pl. 15), tiles, and dinner services, but was most famous for its nursery sets, consisting of a child's mug, bowl, and plate (see pl. 16). These were usually decorated with animals and could be customized with a child's initials or name. Brown's designs also sometimes included inspirational sayings, meant to educate both the children who used them and the immigrant girls who made them.

The Pottery's work became very popular and was sold through such large retail merchants as Filene's and Marshall Field's. However, the operation continued to lose money, since Brown was committed to paying a living wage for labor-intensive work. When Brown died in 1932, the pottery began to decline; it closed in 1942. By that time, some two hundred young women had been employed there.

Locations: 18 Hull St., Boston [1908–15]; 80 Nottingham Rd., Brighton, Mass. [1915–42].

References:
Ulehla, pp. 37, 169.
Kaplan, pp. 33, 312–13.
Marilee Boyd Meyer, "Saturday Evening Girls and the Children's Movement," *New England Antiques Journal*, 9, 7 (January 1991), pp. 14–15, 34.
Kate Larson, "The Saturday Evening Girls: A Social Experiment in Class Bridging and Cross Cultural Female Dominion Building in Turn of the Century Boston," M.A. thesis, Simmons College, 1995.
Meyer, 23, 59, 64, 66, 68–69, 172–73, 227.

EER

ELIZABETH VAUGHAN OKIE PAXTON

Born 1877, Providence, Rhode Island; died 1971, Newton, Mass.

Painter of still lifes and interiors. Elizabeth Vaughan Okie studied at the Cowles Art School with Ernest L. Major and Joseph DeCamp in the early 1890s. DeCamp introduced her to her future husband, the painter William McGregor

Paxton, a fellow student at Cowles. The two were engaged in 1896 and married in 1899. They traveled to Europe several times together, beginning in 1901.

Elizabeth Okie Paxton and her husband shared the typical Boston School concern for depicting the subtle effects of light on surfaces, although she painted more still lifes while her husband produced more figural works. Elizabeth Paxton favored careful arrangements of ordinary, domestic objects, perfectly balanced to create harmonious compositions. These were much admired and received a great deal of critical commendation during her career. In 1907, for instance, a critic for the *Boston Transcript*, after describing the objects included in one of her paintings, concluded: "All these things are painted with so much delicacy and loving care, they are so pretty in themselves, and they are so well related together, that it is a pleasure to look at them. It is a long time since we have seen a better piece of still-life work." Paxton also produced a number of small interiors featuring women engaged in domestic pursuits (see pls. 51, 55–56).

Elizabeth Paxton exhibited her works almost annually in the Boston area and also farther afield: at the National Academy of Design, the Corcoran Gallery of Art, and the Pennsylvania Academy of the Fine Arts, among other places. She also won many prizes for her work, including a medal at the International Exposition in Buenos Aires in 1910, a silver medal at the Panama-Pacific Exposition in San Francisco in 1915, and the Alice Worthington Ball Prize at the North Shore Art Association in 1927.

Residences: Providence, Rhode Island; 43 Elmwood Street, Newton, Mass. [1899–1917]; 19 Montvale Road, Newton, Mass. [1917–after 1942]; East Gloucester, and Cape Cod, Mass. [summers, 1899–1971]; Fenway Studios, Boston [after 1942+].

Studios: in her home.

Member: Guild of Boston Artists; North Shore Art Association; Copley Society; American Artists Professional League.

References:
SMFA Scrapbooks.
AAA, reels 862, 640, 974, 530.
Hirshler, pp. 220–21.

EER

LILLA CABOT PERRY

Born 1848, Boston; died 1933, Hancock, New Hampshire

Painter of figure studies, landscapes, portraits; pastelist; writer. Born to an upper-class Boston family, Perry did not begin to paint until after her 1874 marriage to Thomas Sergeant Perry, a brilliant scholar and linguist, and the birth of three daughters, who later served as her models. Perry studied first with Alfred Quinton Collins in 1884, then with Robert Vonnoh and Dennis Miller Bunker at the Cowles Art School. In 1887 the family traveled in Europe for two years, where Perry worked in Munich with Fritz von Uhde, and in Paris with Alfred Stevens and at the Académies Colarossi and Julian. She also discovered Monet's landscapes and spent the first of nine summers (1889–1909) at Giverny, where she formed a friendship with Monet and began to paint with impressionist techniques. When Thomas Perry was offered a professorship in Japan in 1898, the family spent three years in Tokyo, where the Japanese watched in amazement as Perry painted landscapes in the open air.

Perry had begun exhibiting in 1889 at national and international exhibitions; she showed her work at twenty-one annuals at the Pennsylvania Academy between 1892 and 1930. Her first solo show was held at the St. Botolph Club in 1897; later she had several one-person exhibitions at the Guild of Boston Artists, where she was a founding member. She won a silver medal at the Massachusetts Charitable Mechanics Association Exhibition in 1892 and bronze medals at the 1904 St. Louis Exposition and the 1915 Panama-Pacific Exposition in San Francisco.

In addition to her bright impressionist landscapes, Perry frequently painted figures of women in subdued interiors, often in profile, and portraits of such luminaries as William Dean Howells and Edwin Arlington Robinson. Perry also published three volumes of poetry and promoted Monet's work in Boston through her writing and lecturing. After 1910, she spent several months each year in Hancock, New Hampshire, where she painted landscapes for the rest of her life.

Residences: Park Square, Boston [1848–65]; "Cherry Hill," Canton, Mass. [1865+]; 312 Marlborough St., Boston [1889+]; Giverny, France [nine summers, 1889–1909]; 14 rue de Tilsitt, Paris, France [1894–95]; Azabu district, Tokyo, Japan [1898–1901]; Hancock, New Hampshire [summers, 1910+].

Studios: 38 rue Galilée, Paris, France [1895]; 42 rue Galilée, Paris, France [1896–97]; 13 Harcourt Studios, Boston [1899]; 252 Boylston St., Boston [1902]; 59 rue de Provence, Paris, France [1907]; Fenway Studios, Boston [1911–33]; and in her homes.

Member: Guild of Boston Artists [Charter Member, 1914]; Société des Artistes Indépendants, Paris; International Society of Arts and Letters; Women's International Art Club, Paris, London; Nippon Bijitsu-in, Tokyo; Concord Art Association; Connecticut Academy of Fine Arts; American Federation of Arts.

References:
National Cyclopedia of American Biography, Ann Arbor, Michigan: University Microfilms, 1967, vol. 26, p. 272.
Tufts, cat. 50.
Meredith Martindale, et al., *Lilla Cabot Perry: An American Impressionist* (Washington, D.C.: National Museum of Women in the Arts, 1990).
Falk, p. 2581.
Lilla Cabot Perry Papers, Colby College.

JLC

MARION LOUISE POOKE (DUITS)

Born 1883, Natick, Mass.; died 1975, Paris, France

Painter of figure studies, portraits, landscapes, and still lifes; illustrator; teacher. After graduating from Smith College in 1905, Pooke studied with Joseph DeCamp at the Mass. Normal School, earning a certificate in 1908. From 1908–12 she trained with Benson and Tarbell at the MFA School. She also worked with Charles H. Woodbury in his Ogunquit summer school. Pooke taught art at the Abbott Academy in Andover, Massachusetts in 1915–16 and at the Walnut Hill School in Natick, Massachusetts for seven years between 1914 and 1923.

Pooke's joint exhibition with Beatrice Whitney and Gertrude Fiske at the Stuart Club and her solo exhibitions in the MFA School's Post-Graduate Studio in 1914 and at Abbot Academy in 1916 were all well received. In addition, Pooke submitted paintings to the Pennsylvania Academy of the Fine Arts, the Art Institute of Chicago, the Carnegie International, the Corcoran Biennial, and the National Academy of Design. In 1915 she was awarded a silver medal at the Panama-Pacific Exposition in San Francisco for *Silhouettes*, which also won the Hudson prize at the Connecticut Academy of Fine Arts Exhibition in 1917. Pooke traveled to Paris for several months in 1921 and upon her return held a solo show in her Fenway Studio quarters, where a critic praised her portraits as "excellent characterizations." Her elegant paintings frequently include graceful profiles of women in interior settings. She often used dra-

matic light effects to emphasize the sinuous contours of her figures set against shallow backgrounds.

In August 1923 Pooke married Bernard S. Duits, an art dealer and connoisseur from Amsterdam whom she had met in France in 1921. They settled in Paris and had one child. Pooke painted at least one more portrait, that of Miss Conant, one of the founders of the Walnut Hill School, which is signed "M. P. Duits" and dated 1926. She also remembered the Walnut Hill School in her will, bequeathing all her major works to them.

Residences: 22 Winnemay St., Natick, Mass. [1913–14]; 5 rue Lyautey, Paris, France [1929].

Studios: 194 Clarendon Avenue, Boston [1914]; 198 Clarendon Avenue, Boston [1916]; Grundmann Studios, Boston [1915–17]; Fenway Studios, Boston [1918–24]; 11 rue Chateaubriand, Paris, France [1929].

Member: Connecticut Academy of Fine Arts; National Association of Women Painters and Sculptors.

References:
SMFA Scrapbooks.
Leah Lipton and Robert J. Evans, *Three New England Painters: Hosmer, Pooke, Woodward* (Framingham, Mass.: Danforth Museum of Art, 1991).

JLC

ETHEL REED

Born 1874, Newburyport, Mass.; died before 1920, location unknown

Illustrator and poster designer; painter in watercolors of landscapes and figure studies. Ethel Reed was virtually self-taught, although she studied briefly with her fellow Newburyporter Laura Hills around 1886 and with Paxton at the Cowles Art School in Boston around 1893.

In the mid 1890s, Reed exhibited watercolors at both the Boston Art Students' Association and the Boston Art Club, but soon concentrated her efforts on the graphic arts. Her first poster designs were accepted by the *Boston Herald* in early 1895, launching her brief but brilliant career. In 1895 alone, she designed sixteen posters, most of which advertised books published by the Boston firms Copeland and Day or Lamson, Wolffe, and Co. She often designed the publications' covers, illustrations, and decorative endpapers as well.

Reed's boldly simplified designs reflect the influence of Japanese prints and the Art Nouveau; they received a great deal of positive criticism, both nationally and internationally.

She often depicted young girls surrounded by poppies or lilies—both erotically charged flowers in the 1890s—giving her subjects a decadent air of precocious sexuality. Reed also fascinated Boston from a personal standpoint: she was renowned for her beauty, and many of her images were said to be self-portraits. In 1895, her engagement to the painter Philip Hale (later the husband of Lilian Westcott Hale) was announced, but in May 1896 Reed left for Europe. After traveling on the continent, she settled in England in the fall of 1896 and there completed her final designs, one of them a cover for British aestheticism's leading periodical, *The Yellow Book.* She exhibited at the Society of Arts and Crafts, Boston, in 1897, but later that year was in Ireland, recuperating from an illness. There is one further reference to her having lost her sight, but otherwise she disappears from the record in 1898, at the age of twenty-four.

Residences: Newburyport, Mass. [1874–90]; Boston [1890–96]; Rossetti Mansions, Cheyne Walk, Chelsea, London, England [1896–97]; Crosshaven, Ireland [1897–98+].

Studios: 367 Boylston Street, Boston [until 1896]; in her home [1896–about 1898+].

Member: Boston Art Students' Association [1894+].

References:
Nancy Finlay, *Artists of the Book in Boston, 1890–1910* (Cambridge, Mass.: Department of Printing and Graphic Arts, The Houghton Library, Harvard College Library, 1985), pp. 7, 21, 22–23, 23–25, 26–27, 44–45, 45–47, 53, 65, 89–90, 94, 98, 100–02.
David W. Kiehl, *American Art Posters of the 1890s* (New York: The Metropolitan Museum of Art and Harry N. Abrams, Inc., 1987).
Jessica Todd Smith, "Ethel Reed: The Girl in the Poster," (B.A. thesis, Harvard College, 1991).
Frederick R. Brandt, *Designed to Sell: Turn-of-the-Century American Posters in the Virginia Museum of Fine Arts* (Richmond: Virginia Museum of Fine Arts, 1995). Meyer, pp. 118, 123, 188–89, 229.

EER

MARGARET FOSTER RICHARDSON

Born 1881, Winnetka, Illinois; died about 1947, probably Boston

Best known for her portraits in oil, Richardson also drew portraits in silverpoint and exhibited landscape sketches and genre scenes. Richardson first studied with Joseph DeCamp and Ernest L. Major at the Mass. Normal School from 1900 to 1905. She then attended the MFA School from 1905 to 1908, where she took

Tarbell's class in portraiture and from 1906 to 1907 assisted Anson Cross in his perspective class.

Richardson achieved tremendous early success. Her work was selected for numerous national exhibitions beginning in 1908 with the Corcoran Gallery Biennial, and she was given her first solo show at the Copley Gallery in 1910. For her portrait *Asa H. Paige* she won both the Norman Wait Harris Bronze Medal ($300) at the Art Institute of Chicago in 1911 and the Isaac N. Maynard Prize ($100) at the National Academy of Design in 1913. That same year, her self-portrait *A Motion Picture* (pl. 68) was purchased by the Pennsylvania Academy of the Fine Arts for their collection of artists' portraits. After these early accomplishments, Richardson took a five-month study tour of Europe in 1913. She also traveled to the American West in 1923, returning to Boston in 1926.

Among her subjects were several fellow artists (Laura Coombs Hills, Arthur C. Goodwin, Henry Hammond Ahl); Mary Baker Eddy, founder of the Christian Science Church; university presidents and faculty members; and other leading citizens of Massachusetts. Known for her uncanny ability to obtain an almost photographic likeness, Richardson was also praised for her capacity to express individual character and for her strong draftsmanship. Critics also noted the complete lack of flattery in her portraiture. In 1927, her prices were $150 for a bust and $200 for a half-length.

Richardson continued to receive commissions and exhibit widely until 1930. However, the demand for portraits was greatly diminished by the Depression and World War II, and Richardson was forced in 1943 to close her studio in the Fenway, put her painting supplies in storage, and apply unsuccessfully for a job at the Museum of Fine Arts, Boston.

Residences: 319 Marlborough St., Boston [1908–10]; 247 Newbury St., Boston [1919–20]; 120 Riverway, Boston [1923]; 274 Commonwealth Ave., Boston [1928–30]; 25 Concord Square, Boston [1947].

Studios: 14 St. Botolph Studios, Boston [1905+]; 739 Boylston St., Boston [1910–18]; 410 Fenway Studios, Boston [1920–22, 1935].

Member: Guild of Boston Artists [1921+]; Union Internationale des Beaux-Arts et des Lettres; American Federation of Arts.

References:
SMFA Scrapbooks.
Tufts, cat. 16.
MFA Archives, Director's Files.

JLC

ELLEN ROBBINS

Born 1828, Watertown, Mass.; died 1905, Boston

Painter, primarily of still life in watercolor, but also of murals and furniture decoration. Although Robbins studied briefly at the New England School of Design and Merrimac Printworks, she was essentially self-taught. She traveled quite widely in the United States and Europe, despite a lame foot, and was frequently in contact with her life-long friend, the sculptor Harriet Hosmer.

Robbins specialized in brilliant watercolors of the natural world. She drew particular inspiration from her summer visits to Celia Thaxter in the Isles of Shoals, where she depicted flowers from her hostess's famous garden. Robbins's early work demonstrates a Ruskinian interest in depicting detail; however, as her style matured, her images became more abstract. Her compressed compositions resemble the art of the flower-presser (an art in which she may have engaged), but also, in their spareness and decorative quality, reflect the influence of the Aesthetic Movement. Robbins also experimented with flower painting on wood, selling a set of furniture for one thousand dollars to one of her most loyal patrons, the well-known minister Henry Ward Beecher. Although she never attempted such large-scale work again, Robbins continued to paint on black panels, enjoying the effect of her bright flowers against the dark background. She painted a floral frieze in this style for the Browning Room at Wellesley College.

Robbins's works sold well in Boston and across the nation, both individually and bound into albums. She exhibited frequently at Doll and Richards and the Boston Art Club, as well as at the American Society of Painters in Water Colors, the St. Louis Agricultural and Mechanical Association, and the 1876 Philadelphia Centennial Exposition. Many of her watercolors were reproduced as chromolithographs by Louis Prang, which made her work well-known in England. Robbins also taught flower and leaf painting in Boston for many years.

Residences: Pleasant Street, Watertown, Mass.; Boston; Bar Harbor, Maine [summers, before 1850]; Isles of Shoals, Appledore, Maine [summers, 1850+]; Magnolia, Mass. [summers]; St. Augustine, Florida [winters].

Studios: three different studios in the Lawrence building, corner of West and Tremont Streets, Boston; 6 Beacon Street, Boston.

References:
Ellen Robbins, "Reminiscences of a Flower Painter," *New England Magazine*, 14, 4 (June 1896), pp. 440–51.
Ellen Robbins, "Reminiscences of a Flower Painter (concluded)," *New England Magazine*, 14, 5 (July 1896), pp. 532–45.
Tufts cats. 90, 91.
KJA [Kevin J. Avery], entry on Ellen Robbins's *Wildflowers, The Metropolitan Museum of Art Bulletin*, 56, 2 (Fall 1998), p. 57.
Falk, p. 2783.

EER

ELIZABETH WENTWORTH ROBERTS

Born 1871, Philadelphia, Pennsylvania; died 1927, Concord, Mass.

Painter, primarily of landscapes and seascapes, but also of portraits, subject pictures, and religious works. The only child of wealthy Philadelphia parents, Roberts began her artistic education in 1888 with Henry Rankin Poore and Elisabeth Fern Bonsall at the Pennsylvania Academy of the Fine Arts, where she won the Mary Smith Prize in 1889. That year she moved to Paris where she studied at the Académie Julian, principally under Jules Lefebvre. She remained in Europe for ten years, primarily in Paris.

Returning to the United States in 1898, Roberts divided her time between New York and New England, finally settling in Concord, Massachusetts, with her companion, Grace Keyes, in 1908. The two typically summered in the Cape Ann village of Annisquam, Massachusetts, where Roberts produced her most characteristic works: serene, sunlit beach scenes in which the colors of sand, water, and sky interweave harmoniously (pl. 76). She exhibited widely in these years—at the Pennsylvania Academy of the Fine Arts, the Art Institute of Chicago, Society of American Artists, and Seattle Fine Arts Society, among others, holding solo shows at the Detroit museum in 1909 and almost annually in Boston at Doll and Richards.

In 1916, Roberts and fellow Concord artists Daniel Chester French and Mary Abbott founded the Concord Art Association. Roberts organized their contemporary art exhibitions, and in 1922, she hired the woman architect Lois Howe to renovate the Jonathan Ball House in Concord to give the Association a permanent gallery. For the first exhibition in the new quarters in 1923, Roberts gathered the work of some of the best-known contemporary American and European painters, including John Singer Sargent, Robert Henri, and Claude Monet. Roberts had suffered from depression periodically for most of her adult life, and the disease worsened in 1925. Hospitalized, she was told she should give up painting. In despair at having to stop doing what meant most to her, she hanged herself in 1927, at the age of fifty-six.

Residences: 1805 Walnut St., Philadelphia, Pennsylvania [1887–89]; 45 Ave. de Villiers, Paris, France [1894+, 1897–98]; 106 W. 55th St., New York [1900–01+]; 489 Fifth Ave., New York [1903]; Hopkinton, New Hampshire [intermittently 1900–27]; Concord, Mass. [1908–27]; Coffin's Beach, West Gloucester, Mass. [summers, 1903–27].

Studios: in her home.

Member: The Philadelphia Ten [1922]; National Association of Women Painters and Sculptors [1922+]; Pennsylvania Academy of the Fine Arts [Associate Fellow]; La Société Internationale des Arts et des Lettres; Provincetown Art Association; Concord Art Association (Founder, 1916; Secretary, 1922]; North Shore Arts Association [1923–27]; Allied Artists of America; National Arts Club; Plastic Club [PAFA Fellowship]; The Group (Boston) [1920s].

References:
SMFA Scrapbooks.
"Forbidden Life Work, Hangs Self," *Boston Sunday Post*, March 13, 1927.
Patsy McVity, "Elizabeth Wentworth Roberts and the Concord Art Association," *Massachusetts Painters Project* (Boston: Vose Archive, Inc., 1993).
Page Talbott and Patricia Tanis Sydney, *The Philadelphia Ten: A Women's Artist Group, 1917–1945* (Kansas City, Missouri: Galleries at Moore and American Art Review Press, 1998), pp. 161–62.
Falk, p. 2786.

EER

GRETCHEN WOODMAN ROGERS

Born 1881, Boston; died 1967, New Haven, Connecticut

Painter and pastelist, primarily of portraits and figure studies, but also of still lifes, landscapes, and interiors. Margaret Rogers, called Gretchen, was the daughter of Harry Ashton Rogers, a Boston banker, and Mary Thomas Rogers. She attended private school in Boston and studied with Tarbell at the MFA School from 1900 to 1907. She was one of the school's most successful pupils and was frequently recognized for her work, winning honorable mention in the Sears prize competition in 1901 and placing first in advanced painting in 1905.

Rogers's works are sensitively and carefully painted; she favored subtle gradations in light and dark rather than dramatic juxtapositions of

color. She quickly became a popular portraitist and figure painter and received critical acclaim for her work. As early as 1911, she exhibited at the Museum of Fine Arts, Boston, and she became a frequent contributor to annual exhibitions at the Pennsylvania Academy of the Fine Arts, the Art Institute of Chicago, and the Corcoran Gallery. She was a charter member of the Guild of Boston Artists and held solo shows there in 1917 and 1928. At the Panama-Pacific International Exposition in San Francisco in 1915, she won a silver medal for her painting *Woman in a Fur Hat* (pl. 49). In the 1930s, for unknown reasons, she gave up her studio and never painted again.

Residences: 126 Newbury St. [1918+]; 250 Beacon St. (with her mother) [until about 1937]; The Lenox, Boylston St., Boston; New Haven, Conn. [1957–67].

Studios: 210 Fenway Studios, Boston [1909–32].

Member: Guild of Boston Artists [Charter member]; American Federation of Artists.

References:
SMFA Scrapbooks.
Hirshler, pp. 103, 169, 224.
Heller, p. 474.
Nancy Allyn Jarzombek, *Mary Bradish Titcomb and her Contemporaries: The Artists of the Fenway Studios, 1905–1939* (Boston: Vose Galleries, 1998), p. 49.
Falk, pp. 2807–08.

EER

AMY M. SACKER

Born 1876, Boston; died 1965, probably Boston

Designer; illustrator; teacher; lecturer; leather worker. Sacker studied under Joseph DeCamp, Joseph Lindon Smith, and C. Howard Walker at the MFA School from 1889 to 1894, receiving a diploma in decoration. An excellent student, she received a scholarship in 1892 and won a prize for the highest average in 1893. Sacker began teaching decorative design at the Cowles Art School in Boston after her graduation. A gifted and inspirational instructor, Sacker founded her own school in 1901. Later called the Sacker School of Design and Interior Decoration, she taught there for more than forty years. She also lectured at schools and clubs throughout New England and worked at Simmons College in 1914.

Sacker is perhaps best known as a children's book illustrator (for Ginn and Co., Houghton Mifflin Co., and L. C. Page Co.) and a designer of book covers and plates. Her book cover designs range from decorative patterns (pl. 12) to poster-style figurative compositions. She won

a bronze medal for book covers at the 1901 Pan-American Exposition in Buffalo and a medal for her book plates at the Boston Tercentenary Fine Arts and Crafts Exhibition in 1930. Sacker was elected a master craftsman (as a designer, illustrator, and leather worker) in the Society of Arts and Crafts, Boston, in 1899 and remained a member until 1927, exhibiting in 1897, 1899, 1907, 1911, and 1927.

In 1911 Sacker traveled to Europe for a year, visiting Greece and Spain and studying in Rome. Upon her return she exhibited her "Italian Romances," drawn in ink with "great delicacy and charm," according to one reviewer. Little is known about her sojourn in Hollywood, where she was art director for motion pictures in 1919. In the 1940s and 1950s, she donated textiles, jewelry, and books to the Museum of Fine Arts, Boston; after her death, the Amy M. Sacker Memorial Lectureship was inaugurated at Mount Holyoke College.

Residences: Newton, Mass. [1889–93]; Brookline, Mass. [1914]; Fenmore Apts., 60 Charlesgate East, Boston [1917–18, 1920–27]; 1718 N. Vine St., Hollywood, California [1919]; 64 Charlesgate East, Boston [1929–59].

Studios: 780 Beacon St., Boston [1897]; 1479 Beacon St., Brookline, Mass. [1899–1902]; 673 Boylston St., Boston [1903–04]; 8 Beacon St., Boston [1905–08]; Trinity Ct., Boston [1909–11]; 739 Boylston St., Boston [Amy M. Sacker School] [1912–37].

Member: Society of Arts and Crafts, Boston [Master Craftsman, 1899–1927]; Copley Society; American Federation of Arts.

References:
SMFA Scrapbooks.
Ulehla, p. 189.
Meyer, pp. 190–91, 231.
MFA Archives, Director's Files.
Nancy Finlay, *Artists of the Book in Boston, 1890–1910* (Cambridge, Mass.: Department of Printing and Graphic Arts, The Houghton Library, Harvard College Library, 1985), pp. 51, 59, 103–04.

JLC

MARGARETT SARGENT (MCKEAN)

Born 1892, Wellesley, Mass.; died 1978, Prides Crossing, Mass.

Painter of figure studies and portraits; sculptor. Born to a wealthy Boston family, Sargent was the fourth cousin of John Singer Sargent. After studying at Miss Porter's School in Farmington, Connecticut, she attended finishing school in Florence in 1910 and returned home "crazy about Donatello." Sargent studied sculpture with Bashka Paeff in 1914 and painting with

Charles H. Woodbury in Ogunquit in 1915 and 1916 (although for ten years she did not paint regularly). Encouraged by her exhibition of two sculptures at the Art Institute of Chicago in 1916, Sargent apprenticed with Gutzon Borglum. Through Borglum, she met George Luks (fig. 82) who introduced her to avant-garde New York, where she moved in 1917. She exhibited her bust of Luks at the Pennsylvania Academy of the Fine Arts, and other sculptures at the National Academy of Design in 1917 and 1918 and in Brookline and Boston in 1920.

In July 1920, Sargent married Quincy Adams Shaw McKean, a private banker, and bore four children between 1921 and 1924. During the 1920s she made frequent trips to Paris and collected modern paintings. Sargent held her first solo show, of watercolors and sculpture, at Kraushaar Galleries, New York in 1926. In 1927, she exhibited with the progressive Boston Society of Independent Artists and began to paint strikingly modernist oils, exhibiting twenty-four at her 1929 Kraushaar show. Sargent had her first Boston area retrospective at the Harvard Society for Contemporary Art in 1930, and another at the innovative Arts Club of Chicago, followed in 1931 by another Kraushaar show; a reviewer noted her "admiration for Matisse." Finally, in 1932, her work was shown at Doll and Richards in Boston, and the *Transcript* called her "the leading figure in our non-conservative art movement."

Sargent exhibited for the last time at the 1936 Boston Society of Independent Artists. Plagued by alcoholism and depression, Sargent gave up painting in her mid-forties, turning instead to landscape design.

Residences: 40 Hereford Street, Boston [1892+]; Wellesley, Mass. [1892+]; Wareham, Mass. [summers, 1892]; 49th Street, New York [1917]; 10 West 58th Street, New York [1919]; "Prides," Prides Crossing, Mass. [1920+]; Agassiz Hotel, Boston [1920+]; Dorset, Vermont [summers, 1927+].

Studios: Copley Hall, Boston [1916]; 198 Clarendon St., Boston [1917]; Stamford, Connecticut [1918]; 166 East 38th St., New York [1918]; 30 St. Botolph St., Boston [1920–30]; "Prides," Prides Crossing, Mass. [1922+].

Member: National Association of Women Painters and Sculptors; Society of Independent Artists [1927].

References:
Honor Moore, *The White Blackbird* (New York: Viking, 1996).
Linda Nochlin, *Margarett Sargent* (New York: Berry-Hill Galleries, Inc., 1996).

JLC

MARY CREASE SEARS

Born before 1880, Boston; died 1938, probably Boston

Bookbinder and cover designer. The young Mary Crease Sears first wanted to be an architect, but instead she studied art at the MFA School. There, Sears became interested in the art of the book, and, after her graduation, she went to Paris to study traditional book-making. In France, she met Agnes St. John, who became her long-time friend and collaborator on many projects. Sears continued her training in London and then returned to Boston, where she set up her own studio in the Back Bay.

Sears rapidly became the most influential Arts and Crafts bookbinder in Boston. She engaged in all stages of the book-making process: sewing together the leaves; attaching the cover, endpapers, and boards; and decorating the cover. Her book cover designs range from sumptuous, intricately pieced arrangements of leather for hand-made special editions (see pl. 11) to simpler designs in gold for books that were commercially produced.

Sears received many commissions in Boston and exhibited regularly. She was an extremely active member of the Society of Arts and Crafts, Boston, where she was elected a Craftsman in 1899 and Master in 1904. She served on many of that organization's committees and was included in the 1899, 1907, and 1927 exhibitions. The Society awarded her a bronze medal in 1914 and held an individual exhibition of her bookbindings in 1918. Sears also won other prizes for her work, including a gold medal at the 1904 Louisiana Purchase Exposition in St. Louis and a medal at the 1930 Tercentenary Fine Arts and Crafts Exhibition in Boston. She had great influence as a teacher, running the Sears School of Bookbinding in Boston. There she introduced several generations of women to the art of book making.

Residences: Boston; Paris; London; Boston.

Studios: Hotel Hunnewell, Newton, Mass. [1899]; 278 Boylston St., Boston [1901–03]; 657 Boylston St., Boston [1904–05]; 79 Newbury St., Boston [1907–27].

Member: Copley Society; Society of Arts and Crafts, Boston [Craftsman, 1899–1903; Master, 1904–27].

References:
SMFA Scrapbooks.
Ulehla, pp. 193, 281.
Kaplan, pp. 31, 287.
Meyer, pp. 120, 131–32, 190–91, 221, 231–32.
Falk, p. 2962.

EER

SARAH CHOATE SEARS

Born 1858, Cambridge, Mass.; died 1935, West Gouldsboro, Maine

Photographer, watercolorist, pastelist, and metalworker. Sarah Choate grew up in a prominent Boston family and in 1877 married Joshua Montgomery Sears, heir to a sizeable fortune. She studied painting at the Cowles Art School with Dennis Bunker in 1885 and worked at the MFA School with Tarbell from 1889 to 1891.

As a painter, Sears preferred watercolor, winning prizes for her portraits at the 1893 World's Columbian Exposition in Chicago, the 1900 Paris Exposition Universelle, and the 1901 Pan-American Exposition, among other places. She also produced exquisite outdoor views of flowers, which evoke sunlight flickering across the landscape (see pl. 23). As Sears's career progressed, her compositions in watercolor and pastel grew bolder and more modernist, with large, forcefully articulated, vibrant flowers against a contrasting ground (see pl. 28).

In the 1890s, Sears took up photography, encouraged by her friend, the prominent Boston Pictorialist photographer F. Holland Day. She produced floral still lifes in this medium too, and her photographs of flowers are similar to her paintings in their concentration on the effects of light on several, well-defined blossoms (see pl. 24). As a photographer, she also did portraits of some of the most prominent people in Boston, including the painter John Singer Sargent and the connoisseur Bernard Berenson, as well as a lengthy series of images of her young daughter, Helen, which demonstrate an intriguing mixture of sweetness and intensity (see pls. 25, 27).

Sears helped to found the Society of Arts and Crafts, Boston, in 1897, exhibiting her photographs there in 1897 and 1899 and serving on the jury for the 1899 exhibition. She joined the Boston Camera Club in 1897, where she held the first solo show of her photographs in 1899. She was a member of the major Pictorialist circle of photographers in London, the Brotherhood of the Linked Ring; she also knew the modernist photographers Alfred Stieglitz and Edward Steichen and became a fellow of their Photo-Secession group in 1904.

Residences: Cambridge, Mass. [1858+]; 12 Arlington St., Boston [about 1900–24+]; Wolfpen Farm, Southboro, Mass. [summers]; Bar Harbor, Maine [summers]; West Gouldsboro, Maine [summers].

Studios: in her home.

Member: Copley Society [1891+]; Boston Water Color Club; Society of Arts and Crafts, Boston [Founder, Life Member, 1897+]; New York Water Color Club; National Art Club; Philadelphia Water Color Club; Boston Camera Club [1897+]; Brotherhood of the Linked Ring [1904+]; Photo-Secession [Fellow, 1904+].

References:
Ulehla, pp. 193, 261.
Stephanie Mary Buck, "Sarah Choate Sears: Artist, Photographer, and Art Patron" (Master's Thesis, Syracuse University, 1985).
Hirshler, p. 225.
Meyer, pp. 27, 95, 136–37, 147, 149, 194–97, 232.
Falk, p. 2962.

EER

JOSEPHINE HARTWELL SHAW

Born 1865, location unknown; died 1941, probably Duxbury, Mass.

Jeweler, metalworker, and teacher. After attending Mass. Normal School in the late 1890s and studying with Arthur Wesley Dow at the progressive Pratt Institute in Brooklyn, Hartwell taught drawing in Providence and Philadelphia. During the summers of 1901 and 1902, she took courses at Harvard in design theory with Denman Ross and his protégé Henry Hunt Clark.

In 1905, Hartwell was elected a Craftsman in metalwork in the Society of Arts and Crafts, Boston, and shortly thereafter, married Frederick A. Shaw, a sculptor and silversmith. By 1910 she was promoted to Master and in 1914 given the Society's Medal of Excellence for her superior work. Shaw also exhibited jewelry and tea sets at the National Arts Club in 1907, the Cleveland Decorative Arts Club (about 1908), and the Art Institute of Chicago's arts and crafts exhibitions regularly, receiving prizes in 1911 and 1918. Her expertise was greatly admired, and Edward E. Oakes, later a renowned Arts and Crafts jeweler, apprenticed with her for three years. The Museum of Fine Arts, Boston, recognized her in 1913 with the purchase of a brooch (pl. 20) and ring. Widowed in 1912, Shaw left Brookline two years later for Duxbury. There she operated a summer tea room in her historic house and continued to make jewelry for wealthy patrons, including Atherton Loring, a Duxbury neighbor, and actress Julia Marlowe. In 1930 Shaw won a medal for a silver and gold necklace with Indian sapphires at the Boston Tercentenary Exhibition. The Depression adversely affected her business, and in 1939 she resigned from the Society of Arts and Crafts.

Shaw's jewelry is sophisticated and skillfully worked with precious and semiprecious stones and metals. She occasionally incorporated Asian motifs and carved jade into her designs. Shaw's desire to harmonize her settings with gems was described in an article in *House Beautiful* (1915): "She works in several colors of [gold], and has her own method for producing variations of tone as a given setting requires."

Residences: 19 Exeter Street, Boston [1905–06]; 9 Devotion Street, Brookline, Mass. [1908–13]; Bay Road, Duxbury, Mass. [1914–30s].

Studios: Fenway Studios [1907]; in her home [1914–30s].

Member: Society of Arts and Crafts, Boston [Craftsman, 1905; Master, 1910].

References:
Ralph Bergengren, "Some Jewels and a Landscape," *House Beautiful* 37 (April 1915), pp. 147–49.
Kaplan, pp. 267–68.
Meyer, pp. 232–33.

JLC

LUCY MAY STANTON

Born 1876, Atlanta, Georgia; died 1931, Athens, Georgia

Miniature and oil painter, watercolorist, and pastelist. Lucy May Stanton began studying art at age seven with a French artist, Sally Seago, while wintering with her family in New Orleans. In 1888, she enrolled at the Southern Female Seminary in La Grange, Georgia, where she worked with another French artist, Ada Autrie. She attended the Southern Baptist College for Women from 1890 to 1895, studying painting there with James Field. She continued her training in Paris from 1896 to 1899, where she worked at the Ecole de la Grande Chaumière, and with the artists Augustus Koopman, James McNeill Whistler, and Virginia Reynolds.

Although she had experimented with watercolor painting in miniature on ivory before going to France, study with Reynolds, a miniaturist, encouraged Stanton to develop her talents, and she became one of the most prominent figures of the turn-of-the-century miniature revival. About 1906, she developed a technique which she called puddling, involving an extremely wet application of watercolor. As a result, her mature miniatures, usually portraits, are suggestive rather than strictly descriptive, evoking the mood and personality of the sitter and calling attention to her handcrafted technique (see pl. 35).

Stanton spent ten years, from 1916 to 1926, in Boston, and exhibited at many of the city's prime venues, including the Copley Society, the Guild of Boston Artists, and Doll and Richards Gallery, where she held her first solo show in 1919. She exhibited widely, often at the Pennsylvania Society of Miniature Painters, winning a medal of honor there in 1917. She also won a blue ribbon at the Paris Salon of 1906 and a medal of honor at the Concord Art Association in 1923. She taught art and art history in high schools in the Boston area and in Baltimore, as well as intermittently at the University of Georgia in Athens.

Residences: Gordon Street, West End, Atlanta, Georgia [1876+]; Walnut Ridge, Arkansas [by 1895–96]; Paris, France [1896–99]; Grand Opera House, Atlanta, Georgia [1899–1901]; Bryant Park Studios, New York [1901–02]; Los Angeles, California [1904+]; 70 rue Notre-Dame des Champs, Paris [1905+]; 552 Cobb Street, Athens, Georgia [1906–31]; Valley Town, North Carolina [1914+]; 96 Fifth Ave., New York [1915+]; 82 Chestnut St., Boston [1916–18]; 105 Pinckney St., Boston [1918–19]; Ogunquit, Maine [summers, 1916–26]; The Green Door, Charles St., Baltimore, Maryland [1919–20]; 926 N. Charles St., Baltimore, Maryland [1920]; 57 Mt. Vernon St., Boston [1920–21]; 82 Chestnut St., Boston [1921–23]; 98 Chestnut St., Boston [1923–26]; YMCA Camp, Tallulah Falls, Georgia [summer 1924]; 86 Mt. Vernon, St., Boston [1926], Nantucket [summers 1927–30].

Studios: in her home.

Member: Pennsylvania Society of Miniature Painters [1904+; Life Member, 1929+]; American Society of Miniature Painters [1910+]; National Association of Women Painters and Sculptors [1915+]; Washington Water Color Club; Guild of Boston Artists; Copley Society [Life Member]; Concord Art Association; Baltimore Water Color Club [Associate, 1930+].

References:
Obituary, "Lucy Stanton is Dead," *The Art Digest*, 5, 13 (April 1, 1931), p. 18.
Obituary, "Lucy Stanton," *The Art News*, 29, 27 (April 4, 1931), p. 14.
W. Stanton Forbes, *Lucy M. Stanton: Artist* (Atlanta, Ga.: Special Collections Department, Robert W. Woodruff Library, Emory University, 1975).
Heller, pp. 523–24.
Falk, p. 3142.

EER

POLLY (ETHEL R.) THAYER (STARR)

Born 1904, Boston, Mass.

Painter of portraits, landscapes, and still lifes; active also in watercolor, pastel, and lithography. Thayer, the daughter of Prof. Ezra Thayer,

Dean of Harvard Law School, studied life drawing at the MFA School for eighteen months, then privately with Hale, with Charles W. Hawthorne in the late 1920s, and with Hans Hofmann in the summer of 1933 in Provincetown. She also trained at Le Grand Chaumière in Paris in 1928, with lithographer Harry Wickey at the Art Students' League in 1931, at the Ecole des Beaux-Arts in Fontainebleau in 1932, and with Carl Nelson of Boston in the 1940s.

In 1929 Thayer won the National Academy of Design's coveted Julius Hallgarten Prize, given to an American artist under the age of 35, for her large painting of a nude, *Circles* (pl. 81). The next year, a self-portrait, *Interlude*, won a gold medal at the Boston Tercentenary Art Exhibition. Her first solo shows in 1930 at Doll and Richards in Boston and Wildenstein in New York won her much praise and eighteen portrait commissions. Subsequent solo shows in New York, Pennsylvania, and Boston were well received. In 1933 Donald C. Starr, a Boston lawyer and yachtsman, interrupted his circumnavigation of the globe to marry Thayer in Genoa, resuming his trip after a three-month honeymoon in Europe. Thereafter, the demands of her social life and of raising two children curtailed Thayer's artistic output. She traveled extensively in Europe, North Africa, and the Far East, but found many of her landscape subjects closer to home.

Thayer's portraits and figure paintings progressed from an academic, Boston School style to a more colorful, simplified modern approach. Critics compared the deliberately naïve look of her landscapes to those of Henri Rousseau and praised her draftsmanship and technical ability. Thayer's work is in numerous museums, as well as the Boston Public Library, Brown University, Williams College, and the Boston Athenaeum.

Residences: 77 Bay State Road, Boston [1904–31]; 323 Beacon Street, Boston [1935]; 198 Beacon Street, Boston [1942–96]; Lexington, Mass. [1996+]; Hingham, Mass. [summers]

Studios: 307 Fenway Studios, Boston [1932–36].

Member: Guild of Boston Artists; Boston Art Club; National Association of Women Painters and Sculptors; Copley Society of Boston; Institute of Modern Art, Boston.

References:
Clippings from Polly Thayer's personal scrapbook. Robert F. Brown, "Regional Report: New England," *Archives of American Art Journal*, 36, 2 (1996), pp. 30–31. Archives of American Art, Washington, D.C.

JLC

ELIZABETH MORSE WALSH (HUNKING)

Born 1886, Lowell, Mass.; died 1983, Lowell, Mass.

Painter of portraits, figures, and landscapes. In 1906, Walsh entered the MFA School and worked under Benson, Tarbell, Paxton, and Hale. A talented student, Walsh was awarded the Sears prize for advanced painting in 1915, and the following year she won the Paige Traveling Scholarship. Walsh delayed her trip abroad because of World War I; during the intervening years, she painted portraits and exhibited her work locally and at the Corcoran Gallery of Art, the Pennsylvania Academy of the Fine Arts, and the St. Louis Art Museum. She also had a solo show at the Whistler House in Lowell in 1918. When Walsh finally went to Europe in 1922, she spent most of the two years in Paris studying with academic artist Louis Biloul and exhibiting at the Salon; she also visited England, Holland, Spain, Switzerland, and Italy. Upon her return, she displayed her European work at the Museum of Fine Arts, Boston, and the Whistler House, resumed her portrait painting, made covers for a *Reader's Digest* series, and drew silhouettes for Filene's Department Store.

Walsh painted over 150 portraits, which today are primarily in public and private collections in the Lowell area. Several early pictures show the influence of Whistler or of Frans Hals, especially in their compositions. Critics praised Walsh's feeling for color, her technical excellence, and her unusual gift for the faithful reproduction of other artists' masterpieces.

In 1950 at the age of sixty-four, Walsh married Sidney Hewes Hunking, a construction engineer. She continued painting into her nineties, concentrating in her later years on miniatures, watercolors, and drawings. She also wrote and privately published three books in her last decade, a collection of quotations of Henry James, sketches and commentary on Whistler's work, and a biography of Samuel F. B. Morse, an ancestor on her mother's side.

Residences: 419 Andover Street, Lowell, Mass. [1918–25]; 42 Holbrook Avenue, Lowell, Mass. [by 1978].

Studios: Newbury Studio, 176 Federal, Room 321, Boston [1913–14]; in her homes in Lowell [1918+].

Member: Concord Art Association; Brush and Chisel Club, Boston.

References:
SMFA Scrapbooks. Palmer Hill, "A Lifelong Passion for Art," *The Lowell Sun*, December 8, 1980. Obituary, *The Lowell Sun*, September 11, 1983.

JLC

SARAH WYMAN WHITMAN

Born 1842, Lowell, Mass.; died 1904, Boston.

Artist in oil, pastel, and watercolor of land-scapes, still lifes, and portraits; designer of book covers, and stained glass.

Married to a Boston merchant, Henry Whitman, in 1866, Sarah Whitman studied art with William Morris Hunt in Boston from 1868 to 1871 and with Thomas Couture in France in 1877 and 1879. Whitman's paintings show Hunt's influence, particularly her portraits, but she also adopted a style more in tune with the Aesthetic Movement, concentrating on harmonious arrangements and delicate color. She exhibited quite widely, holding frequent solo shows at Doll and Richards beginning in 1882 and at the St. Botolph Club in 1889. She was elected to the Society of American Artists in New York in 1880 and participated frequently in their shows. Among other awards for her pictorial works, Whitman received honorable mentions at the Paris Expositions of 1889 and 1900 and a bronze medal at the 1901 Pan-American Exposition in Buffalo.

Whitman's belief in the unity of the arts led her to expand her repertoire beyond traditional pictorial media. She operated her own stained glass studio, the Lily Glass Works, and produced major decorations for several churches and schools in Massachusetts and Maine, including Boston's Trinity Church (pl. 8) and Memorial Hall at Harvard. While some of her stained glass is pictorial, she also employed a more architectonic style characterized by clear panes of glass, highlighted with color. She designed book covers and by the 1890s became the favored artist of the Houghton Mifflin Company in Boston. Her spare, sinuous decorations are important manifestations of the Art Nouveau in America.

In addition to her artistic activities, Whitman supported many philanthropic efforts in Boston. Among other causes, she was an enthusiastic campaigner for improved educational opportunities for women and was involved with Radcliffe College.

Residences: Lowell, Mass. [1842+]; Baltimore, Maryland [by 1845–53]; Lowell, Mass. [1853–66]; Cambridge, Mass. [1866–67]; 7 Chestnut Street, Boston [1867–79]; 77 Mount Vernon Street, Boston [1880–1904]; The Old Place, Beverly Farms, Mass. [summers, 1880–1904].

Studios: in her home [1868–80]; 77 Boylston Street, Boston [1880–87]; 184 Boylston Street, Boston [about 1887–1904]; William Sullivan Stable, 45–46 Mt. Vernon Street, Boston [1890–1904].

Member: National Academy of Design [1877+]; Society of American Artists [1880+]; Council of the School of the Museum of Fine Arts, Boston [1885–1904]; Honorary Member, Art Students' Association (later the Copley Society) [1885–1904]; Boston Water Color Club [1887+]; Society of Arts and Crafts, Boston [1897–1904; founder and first Vice President, 1897]; U.S. Public Art League [1897].

References:
Hoppin, pp. 22–31, 37, 44–45.
Virginia Raguin, et al., *Sarah Wyman Whitman, 1842–1904: The Cultural Climate in Boston* (Worcester, Mass.: College of the Holy Cross, 1993).
Sue Allen and Charles Gullans, *Decorated Cloth in America: Publishers' Bindings, 1840–1910* (Los Angeles: UCLA Center for Seventeenth and Eighteenth Century Studies, 1994).
Meyer, pp. 16, 27, 117, 120, 190, 191, 211, 231, 236.
Betty S. Smith, "Sarah de St. Prix Wyman Whitman," *Old-Time New England*, Spring/Summer 1999, pp. 46–64.

EER

ANNE WHITNEY

Born 1821, Watertown, Mass.; died 1915, Boston

Sculptor in bronze and marble of portraits and ideal subjects. Anne Whitney was born to upper middle class parents who raised her in a liberal, Unitarian environment. She was first a teacher and a writer, publishing a book of her poems in 1859, before turning to sculpture in the late 1850s. Faced with the lack of formal instruction available to aspiring women sculptors at that time, Whitney went to study anatomy at a Brooklyn hospital. In 1860, she enrolled at the Pennsylvania Academy of the Fine Arts but soon realized her skills were too advanced for that program. When the outbreak of the Civil War interfered with her plans to go abroad, Whitney moved back to Boston, studying with sculptor William Rimmer from 1862 to 1864.

In 1867, accompanied by her life-long companion, Adeline Manning, Whitney finally went to Rome, but although she spent four years there, she never fully adopted the idealized, neoclassical style espoused by the city's other American expatriate sculptors. Whitney found realism more useful for sensitively depicting the subjects that most moved her, those that dealt with instances of social injustice. A fervent abolitionist and women's rights advocate, she was a passionate advocate for social equality throughout her life, and her choice of subjects—radical statesmen, suffragettes, and freedom fighters—reflected her political concerns.

In 1871, Whitney returned to Boston, where she enjoyed a long and productive career. She

received important public commissions, including one from the state of Massachusetts for a life-size Samuel Adams to be placed in the U.S. Capitol (1873). She exhibited frequently at the National Academy of Design and showed at the 1871 International Exposition in London, the 1876 Philadelphia Centennial Exposition, and the 1893 Chicago World's Columbian Exposition. She remained a vocal presence in Boston into her nineties and was a great inspiration to the generation of sculptors who came after her.

Residences: Watertown, Mass. [1821+]; East Cambridge, Mass. [by 1833–50]; Belmont, Mass. [1850–67]; Rome, Italy [1867–72]; Boston [1872–76]; 92 Mt. Vernon St., Boston [1876–93]; Shelburne, New Hampshire [summers, 1882+]; Charlesgate Hotel, Beacon St., Boston [1893–1915].

Studios: Tremont St., Boston [1862–67]; Rome, Italy [1867–72]; Boston [1872–76]; in her home [1876–1915].

References:
Elizabeth Rogers Payne, "Anne Whitney, Sculptor," *The Art Quarterly*, 25, 3 (Autumn 1962), pp. 244–61.
Elizabeth Rogers Payne, "Anne Whitney: Art and Social Justice," *The Massachusetts Review*, Spring 1971, pp. 245–55.
Greenthal, pp. 131–35.
Eleanor Tufts, "An American Victorian Dilemma, 1875: Should a Woman Be Allowed to Sculpt a Man?" *Art Journal*, 51, 1 (Spring 1992), pp. 51–56.
Lisa B. Reitzes, "The Political Voice of the Artist: Anne Whitney's *Roma* and *Harriet Martineau*," *American Art*, 8, 2 (Spring 1994), pp. 45–65.
Anne Whitney Papers, Wellesley College.

EER

MADELINE YALE WYNNE

Born 1847, Newport, New York; died 1918, Asheville, North Carolina

Metalworker; painter in oils and watercolors of portraits, landscapes, and figural subjects. Madeline Yale Wynne grew up in a household in which both creativity and metalworking were prized; her father was a miniature-painter and invented the Yale lock. She studied painting at the MFA School in 1877, and then taught drawing at the School for several years. She continued her training first in New York at the Art Students' League with Walter Shirlaw and later in Europe.

Wynne became one of the pioneers of Arts and Crafts movement metalwork, applying what she had learned about color harmonies in painting to her designs in metal, stone, and

enamel. She preferred to use her materials in their natural states, believing jewelry to be a vehicle for artistry instead of for the display of wealth. The consciously unrefined, simplified designs of her boldly hammered pieces excited her contemporaries with their originality—and earned her work the characterization "barbaric." Wynne was best known for her jewelry, but she made metal bowls, boxes, and shoe buckles as well; she also worked in wood, textiles, and leather.

Wynne exhibited her work widely in museums and arts and crafts societies across the country, including those in Deerfield and Springfield, Mass., Chicago, and Minneapolis. She helped to found the Deerfield Society of Blue-and-White Needlework in 1896, the Deerfield Society of Arts and Crafts in 1899, the Society of Deerfield Industries in 1901 (of which she served as president until her death), and the Chicago Arts and Crafts Society in 1897. In addition to her work in the visual arts, she wrote numerous short stories and poems, publishing a collection of short stories about New England entitled *Si Briggs Talks* in 1917.

Residences: Newport, New York [1847+]; Boston [1877–89+]; New York; Europe; Old Manse, Deerfield St., Deerfield, Mass. [summers, 1885–1918]; 9 Ritchie Pl., Chicago, Illinois [winters, 1893–98+]; Tryon and Asheville, North Carolina [winters, until 1918].

Studios: Branch Street, Boston; New York; Europe; barn adjoining the Old Manse, Deerfield St., Deerfield, Mass. (separate painting studio, somewhere in Deerfield) [summers, 1885–1918]; in her home in Chicago [1893–96]; Tree Building, Chicago, Illinois [1896+].

Member: Boston Art Students' Association (later the Copley Society) [1879+]; Deerfield Society of Blue-and-White Needlework [Founding Member, 1896+]; Chicago Arts and Crafts Society [Founding Member, 1897+]; Deerfield Society of Arts and Crafts [Founding Member, 1899]; Society of Deerfield Industries [Founding Member and President, 1901–18]; League of Handicraft [Founding Member, 1907+].

References:
"A Gifted Chicago Woman: Versatile Madeline Yale Wynne," *The Chicago Tribune*, January 26, 1896, p. 41.
In Memory of Madeline Yale Wynne (printed pamphlet, publication details unknown, Harvard University Library, n.d. [1918]).
Kaplan, pp. 264–65.
Meyer, pp. 29–30, 55–56, 72, 75, 93, 114, 180–81, 236–37.
Falk, p. 3655.

EER

LIST OF ILLUSTRATIONS

Black and White Figure Illustrations

(Works included in the exhibition are marked with an asterisk)

1. Edwin White, American (1817–1877), *Studio Interior* (detail), 1872, oil on canvas, 43.8 x 56.2 cm (17¼ x 22⅛ in.). Museum of Fine Arts, Boston. Bequest of Maxim Karolik 64.464

2. Sarah Goodridge, American (1788–1853), *Self Portrait* (detail), 1830, watercolor on ivory, 9.5 x 6.7 cm (3¾ x 2⅜ in.). Museum of Fine Arts, Boston. Gift of Miss Harriet Sarah Walker 95.1424

3. Sarah F. Clarke, American (1808–1888), *Kentucky Beech Forest*, about 1840, oil on canvas, 35.5 x 50.4 cm (14 x 19¹³⁄₁₆ in.). Boston Athenaeum

4. Harriet Hosmer, American (1830–1908), *Sleeping Faun*, after 1865, marble, 87.6 x 104.1 x 41.9 cm (34½ x 41 x 16½ in.). Museum of Fine Arts, Boston. Gift of Mrs. Lucien Carr 12.709

5. William Rimmer, American (born England) (1816–1879), *The Neck Muscles in Use — Illustration from Art Anatomy*, 1876, pencil on paper, 27.2 x 38 cm (10¹¹⁄₁₆ x 14¹⁵⁄₁₆ in.). Museum of Fine Arts, Boston. Bequest of Miss Caroline Hunt Rimmer 19.1501

6. *Women's Life Class*, 1901–02, photograph. Scrapbooks, Archives of the School of the Museum of Fine Arts, Boston

7. *Miss Rogers's Work*, 1907, photograph. Scrapbooks, Archives of the School of the Museum of Fine Arts, Boston

8. Alexandre-Georges-Henri Regnault, French (1843–1871), *Automedon with the Horses of Achilles*, 1868, oil on canvas, 315 x 329 cm (124 x 129½ in.). Museum of Fine Arts, Boston. Gift by Subscription 90.152

9. Anne Whitney, American (1821–1915), *The Lotus Eater*, 1868, plaster, 89.5 x 38.4 x 31.1 cm (35¼ x 15⅛ x 12¼ in.). The Collection of the Newark Museum, Gift of Mr. and Mrs. Hugh S. Hince, 1963

10. Anne Whitney, American (1821–1915), *Senator Charles Sumner*, 1875, plaster, 74.9 x 35.6 x 51.4 cm (29½ x 14 x 20¼ in.). The Watertown Free Public Library

11. Anne Whitney, American (1821–1915), *Roma*, 1869, bronze, 68.6 x 39.4 x 50.8 cm (27 x 15½ x 20 in.). Davis Museum and Cultural Center, Wellesley College, Wellesley, Massachusetts, Gift of the Class of 1886

12. Caroline Hunt Rimmer, American (1851–1918), *Bacchante Vase*, 1899, bronze, 26.03 x 17.78 x 20.32 cm (10¼ x 7 x 8 in.). Museum of Fine Arts, Boston. Frank E. Bemis Fund 1993.610

13. Frank Duveneck, American (1848–1919), *Elizabeth Boott Duveneck* (detail), 1888, oil on canvas, 165.5 x 88.3 cm (65⅛ x 34¾ in.). Cincinnati Art Museum, Gift of Frank Duveneck

14. William Morris Hunt, American (1824–1879), *Self Portrait*, 1866, oil on canvas, 77.15 x 64.77 cm (30⅜ x 25½ in.). Museum of Fine Arts, Boston. Warren Collection 97.63

15. *The Hunt Class*, about 1873. Private Collection.

16. Helen Mary Knowlton, American (1832–1918), *Haystacks*, 1875, oil on canvas mounted on paperboard, 28.26 x 39.05 cm (11⅛ x 15⅜ in.). Museum of Fine Arts, Boston. Gift from the Isaac Fenno Collection 18.403

17. Elizabeth Boott, American (1846–1888), *Woman and Children*, 1878, oil on canvas, 127 x 137 cm (50 x 53 in.). Cincinnati Art Museum, Gift of Frank Duveneck

18. *Anne Whitney (seated) and Adeline Manning at Shelburne, N.H.*, about 1885, photograph from *The Art Quarterly*, 25, 3 (Autumn 1962), p. 245

19. Helen Bigelow Merriman, American (1844–1933), *Sarah Wyman Whitman*, about 1906, oil on canvas, 70.5 x 100.3 cm (27¾ x 39½ in.). Schlesinger Library, Radcliffe Institute, Harvard University

20. John La Farge, American (1835–1910), *Agathon to Erosanthe, Votive Wreath*, 1861, oil on canvas, 58.4 x 33 cm (23 x 13 in.). Private Collection

21. Sarah Wyman Whitman, American (1842–1904), *Firescreen*, 1896, three panels of stained glass, middle panel 80 x 42.5 cm (31½ x 16¾ in.), two side panels each 80 x 39.4 cm (31½ x 15½ in.). Courtesy of the Society for the Preservation of New England Antiquities

22. *Mary Crease Sears at the bench in the finishing-room in her bindery (79 Newbury Street, Boston)*, about 1908, photograph from *The Outlook*, 90 (1908), p. 438

23. *Amy M. Sacker*, frontispiece from *The Book Plates of Amy M. Sacker*, 1903

24. Marion Boyd Allen, American (1862–1941), *The Enameler* (detail), 1910, oil on canvas, 91.4 x 76.8 cm (36 x 30¼ in.). Mr. and Mrs. Thomas A. Rosse

*69. Margarett Sargent, American (1892–1978), *Beyond Good and Evil (Self Portrait)* (detail), about 1930, oil on canvas, 101.6 x 58.4 cm (40 x 23 in.). Gift of Honor Moore, Davis Museum and Cultural Center, Wellesley College, Wellesley, Massachusetts

70. *Loïs Mailou Jones at work in her Paris Studio,* 1937–38, photograph from Tritobia Hayes Benjamin, *The Life and Art of Loïs Mailou Jones,* 1994

71. Loïs Mailou Jones, American (1905–1998), *Textile Design,* about 1928, tempera on paper, 64.8 x 45.4 cm (25 ½ x 17 ⅞ in.). The Museum of Fine Arts, Houston; Museum purchase with funds provided by the African American Art Advisory Association

72. Loïs Mailou Jones, American (1905–1998), *The Ascent of Ethiopia,* 1932, oil on canvas, 59.7 x 43.8 cm (23 ½ x 17 ¼ in.). Milwaukee Art Museum, Purchase, African-American Art Acquisition Fund, matching funds from Suzanne and Richard Pieper, with additional support from Arthur and Dorothy Nelle Sanders

73. Edmund C. Tarbell, American (1862–1938), *Station Waiting Room,* about 1915, oil on canvas, 63.5 x 81.3 cm (25 x 32 in.). E. B. Crocker Art Gallery, Sacramento, California

74. Rosamond Smith, American (1876–1949), *Quick Lunch,* 1923, oil on canvas, dimensions unknown. Location unknown

75. Lilian Westcott Hale, American (1881–1963), *The Old Ring Box,* 1907, charcoal and black chalk on paper, 57.2 x 35.9 cm (22 ½ x 14 ⅛ in.). Museum of Fine Arts, Boston. Gift of Miss Mary C. Wheelwright 36.84

*76. Gertrude Fiske, American (1878–1961), *Jade,* about 1930, oil on canvas, 75.6 x 60.3 cm (29 ¾ x 23 ¾ in.). National Academy of Design, New York

77. Gertrude Fiske, American (1878–1961), *The Carpenter,* about 1922, oil on canvas, 137.8 x 101.9 cm (54 ¼ x 40 ⅛ in.). Collection of the Farnsworth Art Museum: Gift of the Estate of Miss Gertrude Fiske

78. Mary Bradish Titcomb, American (1856–1927), *View Looking Towards Gloucester, Mass.,* 1915, oil on canvas, 45.7 x 55.9 cm (18 x 22 in.). Vose Galleries of Boston

79. Marion Monks Chase, American (1874–1957), *The Sun and Coastline,* about 1930, watercolor, 39.1 x 74.9 cm (15 ⅜ x 29 ½ in.). Collection Danforth Museum of Art

80. Margaret Fitzhugh Browne, American (1884–1972), *Self Portrait,* about 1935, oil on canvas, 76.2 x 142.2 cm (30 x 56 in.). Collection of Dr. and Mrs. Gordon F. Lupien

81. *Margarett Sargent McKean,* 1932, photograph by Emlen Etting. Private Collection

82. Margarett Sargent, American (1892–1978), *George Luks,* 1918, bronze, 38.1 x 31.1 x 18.4 cm (15 x 12 ¼ x 7 ¼ in.). The Art Institute of Chicago. Gift of Frederic C. Bartlett, 1928.707

83. *Ethel (Polly) Thayer,* 1932, photograph from unidentified newspaper clipping. Scrapbooks, Archives of the School of the Museum of Fine Arts, Boston

84. John Steuart Curry, American (1897–1946), *Storm over Lake Otsego,* 1929, oil on canvas, 101.92 x 127.63 cm (40 ⅛ x 50 ¼ in.). Museum of Fine Arts, Boston. Gift of Mr. and Mrs. Donald C. Starr 55.369

85. Polly (Ethel R.) Thayer (Mrs. Donald C. Starr), American (b. 1904), *My Childhood Trees,* 1938–39, oil on canvas, 43.18 x 53.34 cm (17 x 21 in.). Museum of Fine Arts, Boston. Gift of the Boston Society of Independent Artists 40.212

86. Gertrude Fiske, American (1878–1961), *Self Portrait,* 1922, oil on canvas, 76.8 x 64.8 cm (30 ¼ x 25 ½ in.). National Academy of Design, New York

Color Plates

(All works are included in the exhibition unless otherwise indicated)

1. Anne Whitney, American (1821–1915), *Le Modèle*, 1875, bronze, 48.26 x 29.21 x 33.02 cm (19 x 11½ x 13 in.). Museum of Fine Arts, Boston. Gift of Mrs. Maria Weston Chapman 85.423

2. Helen Mary Knowlton, American (1832–1918), *Portrait of William Morris Hunt*, 1880, oil on canvas, 103.5 x 79.4 cm (40¾ x 31¼ in.). Worcester Art Museum, Worcester, Massachusetts, Gift of Helen M. Knowlton, 1896.1

3. Elizabeth Otis Lyman Boott, American (1846–1888), *White Roses*, 1884, oil on canvas, 61 x 76.2 cm (24 x 30 in.). Private Collection of Christine Volbrecht

4. Sarah Wyman Whitman, American (1842–1904), *A Warm Night*, about 1889, pastel on canvas, 43.81 x 46.99 cm (17¼ x 18½ in.). Museum of Fine Arts, Boston. Bequest of the Artist 04.1722

5. Sarah Wyman Whitman, American (1842–1904), *Niagara Falls*, 1891, pastel on paper, 45.7 x 42.3 cm (18 x 16⅝ in.). Courtesy of the Fogg Art Museum, Harvard University Art Museums, Gift of Miss Mary C. Wheelwright

6. Sarah Wyman Whitman, American (1842–1904), *Niagara Falls*, 1891, pastel on paper, 46 x 42.3 cm (18⅛ x 16⅝ in.). Courtesy of the Fogg Art Museum, Harvard University Art Museums, Gift of Miss Mary C. Wheelwright

7. Sarah Wyman Whitman, American (1842–1904), *Roses—Souvenir de Villier le bel*, 1877–79, oil on panel, 18 x 8⅞ cm (45.72 x 22.54 in.). Museum of Fine Arts, Boston. Bequest of the Artist 04.1719

8. Sarah Wyman Whitman, American (1842–1904), *Phillips Brooks Memorial Window*, 1895–96, stained glass, 276.2 x 125.7 cm (108¾ x 49½ in.). From the Ferris Library, Parish House, Trinity Church in the City of Boston

†9. Sarah Wyman Whitman, American (1842–1904), *Cover Design for "An Island Garden" by Celia Thaxter*, 1894, 23.5 x 17.1 cm (9¼ x 6¾ in.). By permission of the Houghton Library, Harvard University

10. Sarah Wyman Whitman, American (1842–1904), *Cover Design for "Cape Cod" by Henry David Thoreau*, 1896, 19.4 x 13.3 cm (7⅜ x 5¼ in.). By permission of the Houghton Library, Harvard University

11. Mary Crease Sears, American (before 1880–1938), *Cover Design for "Flowers of Song from Many Lands" by Frederick Rowland Marvin*, 1902, 24.4 x 17.8 cm (9⅝ x 7 in.). By permission of the Houghton Library, Harvard University

12. Amy M. Sacker, American (1876–1965), *Cover Design for "Captain Fracasse" by Théophile Gautier*, 1900, 21.0 x 14.6 cm (8¼ x 5¾ in.). Arts of the Book Collection, Yale University Library

13. Elizabeth Howard Bartol, American (1842–1927), *Poster: New England Hospital for Women and Children Fair*, 1896, 69.5 x 53 cm (27⅜ x 20⅞ in.). Museum of Fine Arts, Boston. Anonymous Gift M11848

14. Laura Coombs Hills, American (1859–1952), *Poster: Fairyland, An Enchantment*, 1900, 50.8 x 33 cm (20 x 13 in.). Collection of the Historical Society of Old Newbury, Gift of Mrs. Morton P. Prince

15. Ida Goldstein (for the Paul Revere Pottery of the Saturday Evening Girls' Club), *Chrysanthemum Vase*, about 1908, earthenware, 22.2 x 19.1 x 19.1 cm (8¾ x 7½ x 7½ in.). R. A. Ellison

16. Paul Revere Pottery of the Saturday Evening Girls' Club, *Rooster Bowl* (about 1912, 4.4 x 15.9 x 15.9 cm [1¾ x 6¼ x 6¼ in.]), *Dancing Bunnies Pitcher* (about 1911, 12.1 x 12.7 x 12.1 cm [4¾ x 5 x 4¾ in.]), *Pig Plate (made for Helen Osborne Storrow)* (about 1910, 1.9 x 22.2 x 22.2 cm [¾ x 8¾ x 8¾ in.]), earthenware. Collection of Marilee Boyd Meyer

17. Molly Coolidge, American (1881–1962), *Peacock Medallion*, 1899, carved, painted, and gilded white pine, 22.9 x 22.9 x 3.2 cm (9 x 9 x 1¼ in.). William H. Perkins

18. Madeline Yale Wynne, American (1847–1918), *Belt Buckle*, about 1900, hammered silver and turquoise, 4 x 6.5 x 1.1 cm (1⁹⁄₁₆ x 2⁹⁄₁₆ x ⁷⁄₁₆ in.). Pocumtuck Valley Memorial Association, Memorial Hall Museum, Deerfield, Massachusetts

19. Madeline Yale Wynne, American (1847–1918), *Watch Fob with Crystal Drop*, about 1900, silver and crystal, 6.5 x 7.8 x 12.9 cm (2⁹⁄₁₆ x 3¹⁄₁₆ x 5¹⁄₁₆ in.). Pocumtuck Valley Memorial Association, Memorial Hall Museum, Deerfield, Massachusetts

20. Josephine Hartwell Shaw, American (1865–1941), *Brooch*, about 1913, gold and blister pearls, 2.9 x 2.5 x 1 cm (1⅛ x 1 x ⅜ in.). Museum of Fine Arts, Boston. Gift of J. T. Coolidge, Jr. and others 13.1698

†*Different copy of this book used in exhibition.*

SELECTED BIBLIOGRAPHY

(For references on individual artists, please see the biographies)

"Art Schools for Girls." *The Literary Digest* 46 (May 3, 1913): 1010–11.

Ball, Thomas. *My Threescore Years and Ten.* Boston: Roberts Brothers, 1892.

Banner, Lois W. *Women in Modern America: A Brief History.* New York: Harcourt Brace, 1995.

Banta, Martha. *Imaging American Women: Idea and Ideals in Cultural History.* New York: Columbia University Press, 1987.

Bartlett, Truman H. *The Art Life of William Rimmer.* Boston: James R. Osgood and Company, 1882.

E. H. B. [Elizabeth Howard Bartol], "Some Women Artists of Massachusetts." Unidentified clipping, Richard Morris Hunt Archive, American Institute of Architects, Washington, D.C.

Birmingham, Doris A. "Boston's St. Botolph Club: Home of the Impressionists," *Archives of American Art Journal* 31 (1991): 26–34.

Bisland, Elizabeth. "The Modern Woman and Marriage." *North American Review* 160 (June 1895): 753–55.

Blanchard, Mary Warner. *Oscar Wilde's America: Counterculture in the Gilded Age.* New Haven: Yale University Press, 1998.

Bogart, Michele H. "American Garden Sculpture: A New Perspective," in *Fauns and Fountains: American Garden Statuary, 1880–1930.* Southampton, N.Y.: The Parrish Art Museum, 1985.

Bontemps, Arna Alexander, and Jacqueline Fonvielle-Bontemps. *Forever Free: Art by African-American Women, 1862–1980.* Alexandria, Va.: Stephenson, Incorporated, 1980.

Brandt, Frederick R. *Designed to Sell: Turn-of-the-Century American Posters.* Richmond, Va.: Virginia Museum of Fine Arts, 1995.

Burke, Doreen, et al. *In Pursuit of Beauty: Americans and the Aesthetic Movement.* New York: The Metropolitan Museum of Art, 1986.

Burns, Sarah. *Inventing the Modern Artist: Art and Culture in Gilded Age America.* New Haven: Yale University Press, 1996.

[J. E. C.], "Women's Sphere in Art." *The Limner* 1 (March 1895): 8–9.

Callen, Anthea. "Sexual Division of Labor in the Arts and Crafts Movement." *Woman's Art Journal* 5 (Fall 1984/Winter 1985): 1–6.

Chadwick, Whitney. *Women, Art, and Society.* London: Thames and Hudson, 1990.

Chapman, John Jay. *Memories and Milestones.* New York: Moffat, Yard, and Company, 1915.

Cheney, Ednah Dow. *Reminiscences of Ednah Dow Cheney.* Boston: Lee and Shepard, Publishers, 1902.

Cherry, Deborah. *Painting Women: Victorian Women Artists.* London & New York: Routledge, 1993.

Chesterton, Laura Prieto. "A Cultural History of Professional Women Artists in the United States, 1830–1930." Ph.D. diss., Brown University, 1998.

Clement, Clara Erskine. *Women in the Fine Arts.* Boston: Houghton, Mifflin and Company, 1904.

Cox, Louise. "Should Women Artists Marry." *The Limner* 1 (May 1895): 6–7

Deutsch, Sarah. *Women and the City: Gender, Space, and Power in Boston, 1870–1940.* New York: Oxford University Press, 2000.

Dodge, Grace, et al. *What Women Can Earn: Occupations of Women and Their Compensation.* New York: Frederick A. Stokes, Company, 1899.

Downes, William Howe. "Boston Art and Artists." In F. Hopkinson Smith et al. *Essays on Art and Artists.* Boston: American Art League, 1896.

Edgerton, Giles [Mary Fanton Roberts]. "Is There a Sex Distinction in Art? The Attitude of the Critic Toward Women's Exhibits." *The Craftsman* 14 (June 1908): 239–51.

Efland, Arthur D. *A History of Art Education.* New York: Teachers College Press, 1990.

Faderman, Lillian. *Surpassing the Love of Men: Romantic Friendship and Love Between Women from the Renaissance to the Present.* New York: Quality Paperback Book Club, 1981.

Fairbrother, Trevor J., et al. *The Bostonians: Painters of an Elegant Age.* Boston: Museum of Fine Arts, 1986.

Faxon, Alicia, and Sylvia Moore. *Pilgrims and Pioneers: New England Women in the Arts.* New York: Midmarch Arts Press, 1987.

Fehrer, Catherine. "Women in the Académie Julian in Paris." *Burlington Magazine* 136 (November 1994): 752–57.

Fenno-Gendrot, Mrs. Almira B. *Artists I Have Known.* Boston: The Warren Press, 1923.

Fifty Years of Boston. Edited by Elisabeth M. Herlihy. Boston: Tercentenary Committee, 1932.

Finlay, Nancy. *Artists of the Book in Boston, 1890–1910*. Cambridge, Mass.: Department of Printing and Graphic Arts, The Houghton Library, Harvard College Library, 1985.

Gammell, R. H. Ives. *The Boston Painters, 1900–1930*. Edited by Elizabeth Ives Hunter. Orleans, Mass.: Parnassus Imprints, 1986.

Garb, Tamar. "'L'art Feminin': The Formation of a Critical Category in Late Nineteenth-Century France." *Art History* 12 (March 1989): 39–65.

Graham, Julie. "American Women Artists' Groups: 1867–1930." *Woman's Art Journal* 1 (Spring/Summer 1980): 7–12

Green, Harvey. *The Light of the Home: An Intimate View of the Lives of Women in Victorian America*. New York: Pantheon Books, 1983.

Greenthal, Kathryn, Paula M. Kozol, and Jan Seidler Ramirez. *American Figurative Sculpture in the Museum of Fine Arts, Boston*. Boston: Museum of Fine Arts and Northeastern University Press, 1986.

Havice, Christine. "In a Class by Herself: 19th Century Images of the Woman Artist as Student." *Woman's Art Journal* 2 (Spring/Summer 1981): 35–40.

Holmes, C. J. "Women as Painters." *The Dome* 3 (April–July 1899): 2–9.

Hoppin, Martha J. "Women Artists in Boston, 1870–1900: The Pupils of William Morris Hunt." *The American Art Journal* 13 (Winter 1981): 17–46.

Huber, Christine Jones. *The Pennsylvania Academy and Its Women, 1850–1920*. Philadelphia: Pennsylvania Academy of the Fine Arts, 1974.

Jarzombek, Nancy Allyn. *Mary Bradish Titcomb and Her Contemporaries*. Boston: Vose Galleries, Inc., 1998.

Jarzombek, Nancy Allyn. *"A Taste for High Art": Boston and the Boston Art Club, 1855–1950*. Boston: Vose Galleries, Inc., 2000.

Kaplan, Wendy. *"The Art That Is Life": The Arts and Crafts Movement in America, 1875–1920*. Boston: Museum of Fine Arts, 1987.

Kasson, Joy S. *Marble Queens and Captives: Women in Nineteenth-Century American Sculpture*. New Haven and London: Yale University Press, 1990.

Kiehl, David W. *American Art Posters of the 1890s*. New York: The Metropolitan Museum of Art, 1987.

Knowlton, Helen M. *The Art-Life of William Morris Hunt*. Boston: Little, Brown, and Company, 1899.

Korzenik, Diana. *Drawn to Art: A Nineteenth Century American Dream*. Hanover, N.H.: University Press of New England, 1985.

Leader, Bernice Kramer. "The Boston Lady as a Work of Art: Paintings by the Boston School at the Turn of the Century." Ph.D. diss., Columbia University, 1980.

Leader, Bernice Kramer. "Antifeminism in the Paintings of the Boston School." *Arts* 56 (January 1982): 112–19.

Lears, T. J. Jackson. *No Place of Grace: Antimodernism and the Transformation of American Culture*. New York: Pantheon, 1981.

Levine, Lawrence. *Highbrow/Lowbrow: The Emergence of Cultural Hierarchy in America*. Cambridge, Mass.: Harvard University Press, 1988.

Lipton, Leah. "The Boston Five." *American Art Review* 6 (August/September 1994): 132–39, 157, 159.

Mathews, Nancy Mowll. "American Women Artists at the Turn of the Century: Opportunities and Choices." In Martindale, Meredith. *Lilla Cabot Perry: An American Impressionist*. Washington, D.C.: The National Museum of Women in the Arts, 1990.

McCarthy, Kathleen D. *Women's Culture, American Philanthropy and Art, 1830–1930*. Chicago: University of Chicago Press, 1991.

Meister, Laura Elise. "Missing from the Picture: Boston Women Photographers 1880–1920." Master's thesis, Tufts University, 1998.

The Memorial History of Boston. Edited by Justin Winsor. 4 vols. Boston: Ticknor and Company, 1880–81.

Merritt, Anna Lea. "A Letter to Artists: Especially Women Artists." *Lippincott's Monthly Magazine* 65 (March 1900): 463–69.

Meyer, Marilee Boyd, ed. *Inspiring Reform: Boston's Arts and Crafts Movement*. New York: Harry N. Abrams, Inc., 1997.

Nieriker, May Alcott. *Studying Art Abroad, and How to Do It Cheaply*. Boston: Roberts Brothers, 1879.

Nochlin, Linda. *Women, Art, and Power and Other Essays*. New York: Harper & Row, 1988.

Parker, Rozsika, and Griselda Pollock. *Old Mistresses: Women, Art and Ideology*. New York: Harper Collins, 1981.

Peabody, Marian Lawrence. *To Be Young Was Very Heaven*. Boston: Houghton Mifflin Company, 1967.

Peirce, H. Winthrop. *Early Days of the Copley Society*. Boston: Rockwell and Churchill Press, 1903.

Peirce, H. Winthrop. *The History of the School of the Museum of Fine Arts*. Boston: Museum of Fine Arts, 1930.

Pène du Bois, Guy. "The Boston Group of Painters." *Arts and Decoration* 5 (October 1915): 457–60.

Pollock, Griselda. *Vision and Difference: Femininity, Feminism and Histories of Art*. London: Routledge, 1988.

Radycki, J. Diane. "The Life of Lady Art Students: Changing Art Education at the Turn of the Century." *Art Journal* 42 (Spring 1982): 9–13.

Randall, E. A. "The Artistic Impulse in Man and Woman." *The Arena* 24 (October 1900): 415–20.

Riley, Glenda. *Inventing the American Woman*. Vol. 2. Wheeling, Ill.: Harlan Davidson, Inc., 1987.

Rosenblum, Naomi. *A History of Women Photographers*. New York: Abbeville Press Publishers, 1994.

Rothblum, Esther D., and Kathleen A. Brehony, eds. *Boston Marriages: Romantic But Asexual Relationships Among Contemporary Lesbians*. Amherst: The University of Massachusetts Press, 1993.

Rothman, Sheila M. *Woman's Proper Place: A History of Changing Ideals and Practices, 1870 to the Present*. New York: Basic Books, Inc., 1978.

Rubinstein, Charlotte Streifer. *American Women Artists from Early Indian Times to the Present*. Boston: G. K. Hall & Co., 1982.

Rubinstein, Charlotte Streifer. *American Women Sculptors: A History of Women Working in Three Dimensions*. Boston: G. K. Hall & Co., 1990.

Seawell, Molly Elliot. "On the Absence of the Creative Faculty in Women." *The Critic* 19 (November 28, 1891): 292–94.

Shand-Tucci, Douglass. *Boston Bohemia, 1881–1900*. Amherst: University of Massachusetts Press, 1995.

Shannon, Martha A. S. *Boston Days of William Morris Hunt*. Boston: Marshall Jones Company, 1923.

Smith-Rosenberg, Carroll. *Disorderly Conduct: Visions of Gender in Victorian America*. New York: Alfred A. Knopf, 1985.

Soissons, S. C. de. *Boston Artists: A Parisian Critic's Notes*. Boston: Carl Schoenhof, 1894.

Sullivan, Constance, ed. *Women Photographers*. New York: Harry N. Abrams, Inc., Publishers, 1990.

Swinth, Kirsten N. "Painting Professionals: Women Artists and the Development of a Professional Ideal in American Art, 1870–1920," Ph.D. diss., Yale University, 1995.

Tager, Jack, and John W. Ifkovic, eds. *Massachusetts in the Gilded Age: Selected Essays*. Amherst: University of Massachusetts Press, 1985.

Talbott, Page, and Patricia Tanis Sydney. *The Philadelphia Ten: A Women's Artist Group 1917–1945*. Kansas City: American Art Review Press, 1998.

Tarbell, Ida M. "The Business of Being a Woman." *American Magazine* 73 (March 1912): 563–68.

Tickner, Lisa. *The Spectacle of Women: Imagery of the Suffrage Campaign, 1907–14*. Chicago: The University of Chicago Press, 1988.

Todd, Ellen Wiley. *The "New Woman" Revised*. Berkeley: University of California Press, 1993.

Trimble, Jessie. "Studying and Succeeding in Art." *New Idea Woman's Magazine* 14 (October 1936): 12–15.

Tufts, Eleanor. *American Women Artists, 1830–1930*. Washington, D.C.: National Museum of Women in the Arts, 1987.

Van Hook, Bailey. *Angels of Art: Women and Art in American Society, 1876–1914*. University Park, Pa.: The Pennsylvania State University Press, 1996.

Verbrugge, Martha H. *Able-Bodied Womanhood: Personal Health and Social Change in Nineteenth-Century Boston*. New York: Oxford University Press, 1988.

Wein, Jo Ann. "The Parisian Training of American Women Artists." *Woman's Art Journal* 2 (Spring/Summer 1981): 41–44.

Gabriel Weisberg and Jane R. Becker, eds. *Overcoming All Obstacles: The Women of the Académie Julian*. New York: Dahesh Museum, 1999.

Wheeler, Candace. "Art Education for Women." *The Outlook* 55 (January 2, 1897): 81–87.

Yount, Sylvia L. "'Give the People What They Want': The American Aesthetic Movement, Art Worlds, and Consumer Culture, 1876–1890," Ph.D. diss., University of Pennsylvania, 1995.

INDEX